Jasper Johns

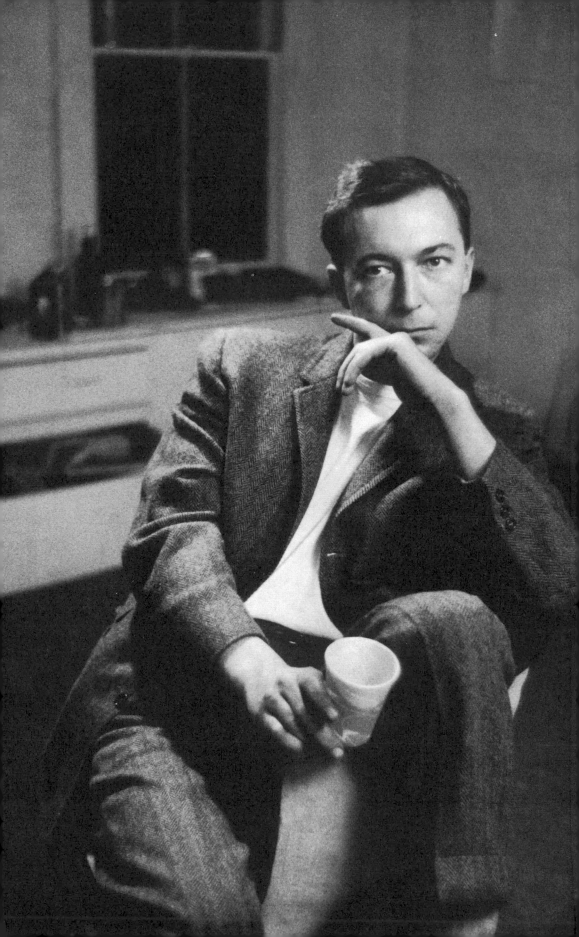

Jasper Johns

Writings, Sketchbook Notes, Interviews

EDITED BY

KIRK VARNEDOE

COMPILED BY

CHRISTEL HOLLEVOET

The Museum of Modern Art, New York

Distributed by Harry N. Abrams, Inc., New York

Published in conjunction with the exhibition
"Jasper Johns: A Retrospective," at The Museum
of Modern Art, New York, October 20, 1996–
January 21, 1997, directed by Kirk Varnedoe,
Chief Curator, Department of Painting and
Sculpture

This exhibition is sponsored by
Philip Morris Companies Inc.

Additional support is provided by the National
Endowment for the Arts. An indemnity for
the exhibition has been granted by the Federal
Council on the Arts and the Humanities.

This publication is made possible by a generous
gift from Emily Fisher Landau.

Produced by the Department of Publications
The Museum of Modern Art, New York
Osa Brown, Director of Publications
Edited by Stephen R. Frankel
Designed by Bethany Johns Design, New York
Production by Cynthia Ehrhardt
Composition by U.S. Litho, New York
Printed by Science Press, Ephrata, Pennsylvania

Library of Congress Catalogue
Card Number: 96-078189
ISBN 0-87070-386-2
 (The Museum of Modern Art)
ISBN 0-8109-6166-0
 (Harry N. Abrams, Inc.)

Published by The Museum of Modern Art
11 West 53 Street
New York, New York 10019

Distributed in the United States and Canada
by Harry N. Abrams, Inc., New York, a Times
Mirror Company
Distributed outside the United States and
Canada by Thames and Hudson, Ltd., London

Cover: Jasper Johns. Sketchbook note. C. 1960.
See plate 2. Back cover: Jasper Johns, quoted
from David Sylvester, interview recorded for
the BBC in June 1965 in Edisto Beach, South
Carolina; first radio broadcast on October 10,
1965, and excerpted in *Jasper Johns Drawings*,
exh. cat. (London: Arts Council of Great
Britain, 1974). See item 1-14. Frontispiece: Jasper
Johns in his studio on Front Street, New York,
in 1962. Photograph: Edward Meneeley.

The presentation of the exhibition "Jasper Johns:
A Retrospective" at the Museum Ludwig,
Cologne, is supported by Ford Motor Company.

Contents

Interviews

This publication is made possible

by a generous gift from

EMILY FISHER LANDAU

Introduction

KIRK VARNEDOE

We may think of Jasper Johns as a man of few words. He neither issues nor signs manifestos, he leads a famously low-profile private life, and by all evidence he harbors no trace of the self-promoter in his soul. In demeanor as well as looks, he has long been compared to American icons of the stoically mute deadpan such as Buster Keaton and the cowboy of early silent Westerns, William S. Hart. Yet words are crucial for this man, as a lifelong lover of poetry, a reader of Ludwig Wittgenstein's later philosophy of language, and a courteously skilled conversationalist; and the select clusters of his phrases that have found their way into print have been indispensable to our understanding of his art. Johns has consented to our efforts to assemble a broadly representative selection of these words in print, even if he has been unable to revisit for possible correction all the many quotations given to him in previous publications.

The few texts Johns has written expressly for publication deal predominantly with admirations for other artists, and are revealing for that as for their tersely efficient candor. Especially important in this regard are the statement Johns wrote in 1959 to explain his formation as an artist (see pp. 19–20), and his series of brief commentaries on the work of Marcel Duchamp (see pp. 20–21 and 22–23). More central to our picture of him, though, have been the fragmentary sketchbook notes that have sporadically come to light, often in small foreign journals, since the early 1960s. These published notes are now gathered here, with many appearing for the first time in their original English form; and with the artist's generous permission, we have added several previously unpublished images and transcriptions. Johns's sketchbooks in fact contain more words than pictures. Early on, especially at times when he was working on complex assemblage pieces such as *Watchman*, there are sketches that involve planning and prefiguration (see plates 6 and 7). Motifs involving precise measurement, planned proportions, or calculated sequences have also required advance plottings (see plates 14 and 15), and later works, where rendering of objects and found images becomes a concern, have spurred more traditionally experimental freehand essays in developing forms (see plates 18 and 21). Principally, though, the sketchbooks feature verbal ruminations, rememberings, self-instructions, and the formulation of conceptual problems or of ideas for possible works of art, typically inscribed in columns of short lines that can suggest prose poetry (see plate 1). These jottings seem to offer truncated glimpses into a subtle private monologue that blends clinically lean directness with recondite personal resonances. Many of their published lines have become mantras for younger artists, and texts such as the speculation on the "watchman and the spy" (see pp. 59–60) have become canonical points of reference for interpreters of Johns's work.

Still, the vast majority of what we know about Johns's life and his attitudes toward art has come from the interviews he has granted to journalists, critics, and art historians. Reputed as being difficult of access, even reclusive, the artist has actually been quite open to interviews in connection with all of his major exhibitions throughout his career, and has been both patient and forthcoming in more intensive recorded dialogues with friends. As the evidence of these exchanges shows, he is not in fact a reluctant or obstructive subject, but an engaged, extraordinarily attentive (and thus some would say very guarded) interlocutor whose consistently thoughtful responses may often seem koanlike in their embedded ambiguity, but who never condescends to or trivializes the occasion of discussion.

Having gathered the full volume of these interviews, including lesser-known texts, unpublished recordings, and previously untranscribed conversations on film, we have been obliged to edit the material severely in order to make a manageable and coherent anthology. Naturally focusing on Johns's own words even when the interviewer's comments may have been more dominant, we have tried to emphasize substantive content — passages that inform us about Johns's life, his art, and his ideas or attitudes — while eliminating repetitions and apparent redundancies. A few major interviews (such as that with Nan Rosenthal and Ruth Fine, published in the 1990 catalogue of the retrospective of Johns's drawings at the National Gallery of Art, Washington, D.C.), or prominent texts that quote the artist (such as Michael Crichton's 1977 monograph on Johns, revised and updated in 1994), were not anthologized here because of their familiarity, broad distribution, and independent ease of retrieval.

This anthology was published to accompany, and complement, the larger, heavily illustrated catalogue, *Jasper Johns: A Retrospective*, on the occasion of the 1996–97 exhibition of the same title at The Museum of Modern Art. The gathered words are of course no substitute for the visual examination of the art, which that other volume facilitates. But as an extended record of the artist's life and as a source of information about his thought, this compendium of Johns in his own words should constitute, for all those interested in creativity in our time, a fundamental resource.

Johns's Life and Work: A Brief Overview

Jasper Johns was born in Augusta, Georgia, in 1930, and grew up in small towns in South Carolina. Having shown a childhood affinity for drawing, he nurtured interests in art and poetry during his early education, at the University of South Carolina. After a brief period at art school in New York, he served in the army in 1951–53, in South Carolina and then in Japan. On his release from the army he moved back to New York. There his contacts with artists, especially Robert Rauschenberg, prompted him to a higher level of commitment to his art— a commitment that entailed his destruction of virtually all his previous work.

Johns's first mature painting, *Flag* (1954–55; The Museum of Modern Art, New York), was painstakingly fabricated, predominantly with newspaper collage and encaustic. Immediately following came a series of encaustic paintings of

numbers and targets (two of the latter including, in rows of boxes above the bull's-eye, plaster casts of body parts and face fragments respectively). These works were all but unknown until Johns's first solo exhibition, at the Leo Castelli Gallery, in January 1958. With that show and its attendant critical attention, Johns was immediately pegged as one of the most important figures in a new wave of American art that was to eclipse the dominance of Abstract Expressionist painting.

Fortified by his close friendships with Rauschenberg and with the musician John Cage and the dancer/choreographer Merce Cunningham, and strongly drawn to the subversive legacy of Marcel Duchamp, Johns became universally recognized as a key progenitor of both the Pop and the Minimal art of the 1960s. His appropriation of bold flat imagery such as the American flag, and his strategies of working by systematic repetition, catalyzed whole schools of new painting, sculpture, and Conceptual art. However, as was already clear in his first retrospective exhibition, at The Jewish Museum, New York, in 1964, his own work resisted any clear stylistic label or group affiliation, as it blended attached objects, inscribed words, and a complex richness of surface elaboration, within an alternation between concrete literalness and painterly abstraction. A mood of private, enigmatic thoughtfulness, often ironic, melancholic, or gravely repressed in its overtones, linked together his concern with language, the sensuosity of his work's surfaces, and his recurrent imagery of the body in parts. In the early 1960s he also produced a small but influential body of actual-size sculptures of commonplace objects such as beer cans, light bulbs, and flashlights, and by the end of that decade he had gained a reputation as a master printmaker.

For ten years beginning in 1972, Johns's paintings were virtually exclusively abstract, conceived in allover "cross-hatch" patterns of clusters of parallel lines. Toward the end of that decade, following a major retrospective at New York's Whitney Museum of American Art in 1977, his art began to evoke, in titles and in motifs, an eclectic new set of references to other art, including that of the Norwegian painter Edvard Munch, as well as Tantric Buddhist devotional imagery. In 1982 the look of Johns's paintings once again changed dramatically, as he began a series of representational works that assembled traced and copied imagery both from his own past art and from diverse sources in art history, ranging from Barnett Newman's graphic work to Matthias Grünewald's Isenheim Altarpiece. The mid-1980s saw the emergence of overtly autobiographical paintings, their centerpiece being a group of four *Seasons* canvases allegorizing a cycle of youth and old age with symbols related to the epochs of the artist's work and to his various residences. Near the same time, he developed a new motif, a rectangular "face" with widely dislocated features, that related to the art of Pablo Picasso.

Since the late 1980s Johns's art appears to have centered on issues of childhood and memory, often employing a base of motifs recovered from earlier works, layered over with a new skein of imagery ranging from a floor plan of his grandfather's house to a ghostly spiraling galaxy. Johns currently lives and works in a new home in Connecticut, a short distance from New York, and also maintains a house and studio on the island of Saint Martin, in the Caribbean.

Writings

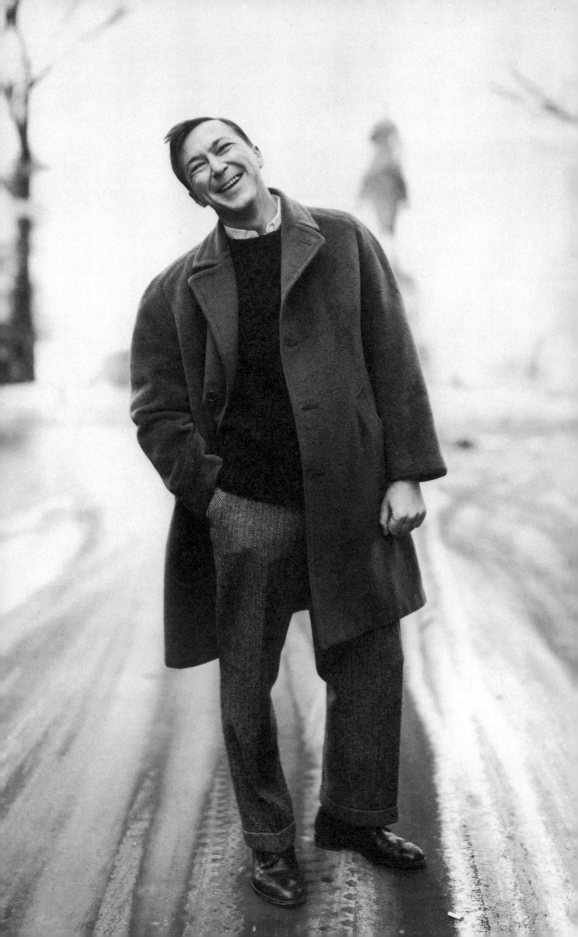

W-1. Jasper Johns, "Collage" (letter to the editor), *Arts* 33 no. 6 (March 1959): 7. Response to a "Month in Review" piece by Hilton Kramer in the magazine's February 1959 issue.

To the Editor:

Beginning on a level of critical pretension which supposes the functions of an art medium to be predetermined, Hilton Kramer (assured of his insight into "the full range of possibilities" of that medium [...]), proceeds to evaluate, defame, categorize and/or predict past, present and future art activity in that medium.

A kind of rottenness runs through the entire article — Mr. Kramer's presumed insight into intentions ("to 'offend'") and aims ("to please"), his "exploration" of [Joseph] Cornell's reputation, the report of Alfred H. Barr, Jr.'s falsely "reported" acquisition of a work of mine for a colleague, the funny and vicious "Like Narcissus at the pool, they see only the gutter," and in the insinuation that artists are fooling themselves.

Without mentioning individual works (for Mr. Kramer the works are not valid as themselves anyway: he sees them, historically and aesthetically, as a sort of substitute painting), he shoves [Robert] Motherwell, [Esteban] Vicente, [Corrado] Marca-Relli, [George L. K.] Morris, and [Alfred] Leslie into one large pigeonhole. [George] Cohen goes into another which will, "sooner or later," let him into one marked PAINTING. Then come the THING WHICH IS NOT THE THING and the THING WHICH IS ANOTHER THING labels. [George] Ortman gets the SCULPTOR MANQUÉ; [Robert] Rauschenberg, the OFFENSE WHICH IS DELIGHT; and I, the DADA WHICH IS NOT DADA.

Mr. Kramer then ends where he began, stating again that all possibilities of a medium have been exhausted. There follows his generous allowance that artists may do whatever they please: and Mr. Kramer already has *that* classified.

Well, thank God, art tends to be less what critics write than what artists make. Because of that, no number of slipshod generalities and no abundance of false labels will establish the witless hierarchy that Mr. Kramer suggested.

Jasper Johns
New York City

W-2. Jasper Johns, artist's statement, in Dorothy C. Miller, ed., *Sixteen Americans* (New York: The Museum of Modern Art, 1959), p. 22.

Sometimes I see it and then paint it. Other times I paint it and then see it. Both are impure situations, and I prefer neither.

Jasper Johns, New York, January 15, 1965.
Photograph: Richard Avedon.

At every point in nature there is something to see. My work contains similar possibilities for the changing focus of the eye.

Three academic ideas which have been of interest to me are what a teacher of mine (speaking of Cézanne and Cubism) called "the rotating point of view" (Larry Rivers recently pointed to a black rectangle, two or three feet away from where he had been looking in a painting, and said " ... like there's something happening over there, too."); Marcel Duchamp's suggestion "to reach the Impossibility of sufficient visual memory to transfer from one like object to another the memory imprint"; and Leonardo's idea ("Therefore, O painter, do not surround your bodies with lines ... ") that the boundary of a body is neither a part of the enclosed body nor a part of the surrounding atmosphere.

Generally, I am opposed to painting which is concerned with conceptions of simplicity. Everything looks very busy to me.

Jasper Johns

W-3. Jasper Johns, "Duchamp," *Scrap* (New York) no. 2 (December 23, 1960): [4]. Review of *The Bride Stripped Bare by Her Bachelors, Even: A Typographic Version by Richard Hamilton of Marcel Duchamp's Green Box*, trans. George Heard Hamilton (New York: Wittenborn, 1960, The Documents of Modern Art no. 14).

Finally, all the notes from the *Green Box* are published in English, and Richard Hamilton has arranged them typographically so one may follow the chronological development of the invention of the Bride and her bachelors.

The fascinating layout of the erotic machinery may be overbalanced in the book by the revelation of the extraordinary qualities of Duchamp's thinking, and in the final unfinished *Large Glass* (1915–23) as well it seems less the machines' True-Story capacities for romance than the capacity of the work to contain Duchamp's huge precisions of thought-in-art that is conveyed by its vitality.

The force of the externality of the multidimensional work seems taken for granted in the notes. However, when the bachelors "shoot," once each, this "Hilarious" glass house is pierced through—and the signs of this action are joined some years later by more haphazard breakage.

Like "The Clock *in profile*," from the rear or side, the Glass "no longer tells the time." But it is Marcel Duchamp's "*Inspector* of Space" participating and, at times, getting lost in its environment. The walls of the Philadelphia Museum show through it, attack it, are absorbed or reflected by it. It is "painting of precision, and beauty of indifference"; allowing the changing focus of the eye, of the mind, to place the viewer where he is, not elsewhere.

The lavish care and constant readjustment-towards-precision (Delight in the necessity of the artist's hand is left unexplored, as though the best operation would leave no souvenir of the Surgeon) ... not only in the imagined machine, but in the true physicality of the work (The glass is mirrored and scraped away; dust is allowed to settle on the "sieves" for 3 or 4 months and is then fixed to the glass—"just as good today as it was 30 years ago") ... are countered by Duchamp's

curious frugality.* The carbon paper used to transfer the image of the OCULIST WITNESSES onto the glass becomes a drawing in itself; the machined ready-mades *serve* as works of art and *become* works of art through this service; and the aristocratic [*sic*] decision to work little or not at all is made.

Duchamp's wit and high common sense ("Limit the no. of readymades yearly"), the mind slapping at thoughtless values ("Use a Rembrandt as an ironing-board"), his brilliantly inventive questioning of visual, mental and verbal focus and order (the beautiful Wilson-Lincoln system, which was never added to the glass; "lose the possibility of identifying ... 2 colors, 2 laces, 2 hats, 2 forms"; the vision of an alphabet "only suitable for the description of this picture") inform and brighten the whole of this valuable book.**

Jasper Johns

* This remark about the dust was made by Duchamp in conversation. All other quotations are from the book.
** In reviewing this book, I searched for the cartoon whose caption was, "O.K., so he invented fire — but what did he do after that?" but could not find it.

W-4. Jasper Johns, letter to the editor, *Portable Gallery Bulletin* (New York) no. 3 [December 1962]: n.p. Response to an article by Albert Vanderburg in the magazine's October issue, regarding a photograph of Robert Rauschenberg's *Short Circuit*.

Dear Sir:
I've always supposed that artists were allowed to paint however-whatever they pleased and to do whatever they pleased with their work — to or not to give, sell, lend, allow reproduction, rework, destroy, repair, or exhibit it. Albert Vanderburg's use of Robert Rauschenberg's refusal to the Portable Gallery of the use of a photograph as an excuse to charge him with "political maneuvering" seems unfitting. Rauschenberg's decision was part of a solution of differences of opinion between him and me over commercial and aesthetic values relating to that work. The painting itself has been publicly exhibited at least twice and, I believe, slides of it have been used in connection with public lectures.

Mr. Vanderburg's writing offers no evidence of any "over-strenuous political involvement" of Robert Rauschenberg, and has rendered an unnecessary disservice to one of our liveliest and most inventive artists, as well as to your Bulletin.

Jasper Johns, NY[1]

W-5. Jasper Johns, "'This Week's Cover': *White Flag*, Tokyo, 25 Oct. '66," *Asahi Magazine* (Tokyo) 8 no. 46 (November 6, 1966): 110. In Japanese and English. Notes provided to the magazine by Johns during his stay in Tokyo on the occasion of the exhibition "American Contemporary Art," at the Modern Museum, Tokyo.

An equation of object and space.
OBJECT-FILLED SPACE
SPACE-FILLED OBJECT

(to locate this ambiguity?)
The focus of the eye, the focus of the mind, can change.
The price of this entertainment—
the work becomes beautiful.

The painting remains indifferent.

W-6. Jasper Johns, "Marcel Duchamp (1887–1968)," *Artforum* 7 no. 3 (November 1968): 6.

The self attempts balance, descends. Perfume—the air was to stink of artists' egos. Himself, quickly torn to pieces. His tongue in his cheek.

Marcel Duchamp, one of this century's pioneer artists, moved his work through the retinal boundaries which had been established with Impressionism into a field where language, thought and vision act upon one another. There it changed form through a complex interplay of new mental and physical materials, heralding many of the technical, mental and visual details to be found in more recent art.

He said that he was ahead of his time. One guesses at a certain loneliness there. Wittgenstein said that "'Time has only one direction' must be a piece of nonsense." In the 1920s Duchamp gave up, quit painting. He allowed, perhaps encouraged, the attendant mythology. One thought of his decision, his willing this stopping. Yet on one occasion, he said it was not like that. He spoke of breaking a leg. "You don't mean to do it," he said.

The Large Glass. A greenhouse for his intuition. Erotic machinery, the Bride, held in a see-through cage—"a Hilarious picture." Its cross-references of sight and thought, the changing focus of the eyes and mind, give fresh sense to the time and space we occupy, negate any concern with art as transportation. No end is in view in this fragment of a new perspective. "In the end you lose interest, so I didn't feel the necessity to finish it."

He declared that he wanted to kill art ("for myself") but his persistent attempts to destroy frames of reference altered our thinking, established new units of thought, "a new thought for that object."

The art community feels Duchamp's presence and his absence. He has changed the condition of being here.

Jasper Johns

W-7. Jasper Johns, "Thoughts on Duchamp," in Cleve Gray, ed., "Feature: Marcel Duchamp 1887–1968," *Art in America* 57 no. 4 (July–August 1969): 31.

Shortly after his death, there were those interviews published in two art magazines. Toward the end of one, Duchamp said, "I'm nothing else but an artist, I'm sure, and delighted to be." The other ended, "Oh yes. I act like an artist although I'm not one." There may be some malice in these contradictory self-descriptions or, perhaps, an unwillingness to consider any definition as being final.

A fascination with the tentativeness of all states-of-affairs was reflected by Marcel's indifferent manipulation of values and definitions attached to works of art. He was the first to see or say that the artist does not have full control of the aesthetic virtues of his work, that others contribute to the determination of quality. He seemed to picture the work of art as involved in a sort of chain reaction until it is in some way caught or stopped, fixed by posterity's "final verdict." This concern for things moving and stopped, exemplified in his work (Nude Descending, The Passage, Three Standard Stoppages, the "draft pistons" and fixed dust in the Large Glass, the Rotoreliefs, etc.), brings into focus the shifting weights of things, the instability of our definitions and measurements.

The ready-made was moved mentally and, later, physically into a place previously occupied by the work of art. The consequences of this simple rearrangement are probably not yet complete. But, for the time being, the ready-made seems to remain in that place, an example of what art is, a new unit of thought.

It may be a great work of his to have brought doubt into the air that surrounds art. He seems never to have exaggerated any of the conditions for art, attacking the ideas of object, artist and spectator with equal force and observing their interaction with detachment and some amusement, never with any special show of optimism, and often from conflicting points of view.

But Marcel never gave you the confidence to be sure of any statement you might make about him. He never made the claims that you might make for him.

Jasper Johns

W-8. Jasper Johns, statement on Willem de Kooning, dated January 1983, in *Art Journal* 48 no. 3 (Fall 1989): 232. This issue of *Art Journal*, edited by Bill Berkson and Rackstraw Downes, is dedicated to de Kooning.

A few weeks ago I saw Willem de Kooning's wonderful painting *Bolton Landing* (1957), and said to Xavier Fourcade that it made me want to go out and buy a big brush. That reminded me that years ago de Kooning had remarked to me that, whereas I was a signpainter, he was a housepainter. I understood that he might say such a thing about me but wondered then and still wonder what he meant about himself.

Here, in New York and the U.S.A., there has long been a community or network of artists focused upon the means through which the heroic character of de Kooning's work finds expression and amplification. We react with excitement to the inventive and idiosyncratic details of his paintings and, in their formal and structural clarity, we sense stability and courage.

Jasper Johns
January 1983

Notes

1. Editor's note: At one point, it was customary for artists of the Stable Gallery to recommend two new painters to participate in its annual show. Robert Rauschenberg intended to recommend his exwife, Susan Weil, and Jasper Johns for the gallery's "Fourth Annual Exhibition of Painting and Sculpture," held April 26–May 21, 1955. When the decision was made not to include them, Rauschenberg exhibited a combine-painting, *Short Circuit*, which incorporated a small encaustic flag by Johns (13¼ x 17¼ in.) and a landscape by Weil, each behind a hinged door. See *Robert Rauschenberg*, exh. cat. (Washington, D.C.: National Collection of Fine Arts, Smithsonian Institution, 1976), p. 85.

The Portable Gallery was a kind of slide/image bank. Johns's letter addresses the following passage by Vanderburg, associate editor of the *Portable Gallery Bulletin,* in his "Comment" column in the October 1962 issue: "Before the first show and succeeding success of Jasper Johns, Rauschenberg gave him a 'helping hand' by including, in a piece of combine painting, a small flag by Johns. There is a photograph of that piece which has not been released publicly due to the personal insistence of Robert Rauschenberg. The piece itself is a good one by the standard set by Rauschenberg's other work, and the historical value of the piece and the photograph of it is indisputable. The suppression of the photograph can, then, possibly be explained as a cover-up of political maneuvering."

Johns's flag was later stolen (before June 8, 1965) from Rauschenberg's combine while the latter was stored in Leo Castelli's warehouse; see Michael Crichton, *Jasper Johns* (New York: Harry N. Abrams, Inc., in association with the Whitney Museum of American Art, 1977), p. 67 (note 32). A photograph of the combine with the original flag can be found in the Leo Castelli Archives (Johns 1965 file).

Sketchbook Notes

During the preparation of the exhibition "Jasper Johns: A Retrospective" at The Museum of Modern Art, the artist generously consented to my request to study his sketchbooks. I had access to six sketchbooks and one photo album recording a lost sketchbook. All were without page numbers. Some contained (albeit rarely) specifically dated drawings. The lost album, which was burned with the other contents of Johns's house in Edisto Beach, South Carolina, in 1966, was photographed in Tokyo in 1964 — thus providing a *terminus ante quem* dating for these pages. Based on this point of reference in that one instance, and more generally on proximity to dated pages and relations to known paintings, I have assigned approximate, hypothetical dates to the texts and drawings that follow. Like the transcriptions themselves, these datings are my own and not the artist's.

In the sixty-two textual transcriptions that here follow the reproductions of twenty-one sketchbook pages, I have chosen to present together the notes from each of five selected albums, rather than putting all the notes into one chronological sequence. This allows the order of presentation to reflect contiguity of pages, and the chronological overlapping between some albums. For the first twenty-eight transcribed items, from the lost sketchbook, the "page numbers" given are drawn from the sequence in which Johns has organized the photos in their present album.

Many of the texts included here have been previously published, sometimes in fragmentary form and often in other languages. In all cases possible we have recurred here to the original texts in the sketchbooks themselves. Citations of previously published versions, where such exist, are given in the References section at the end of the book.

Wherever possible, we have tried to remain true to the line-by-line structure of the texts as they were written. In their original form, the notes are sometimes written in block (uppercase) letters and at other times in cursive script; here they are uniformly presented in standard upper- and lowercase type, except in cases where block capitalization is used to reflect what seem to be special emphases in the original text. Many of the sketchbook pages contain images, and some of the language transcribed here takes the form of notes on those images; we have not attempted to describe these drawings, however. Similarly, although a modest attempt has been made to respect and represent the major spatial relationships of the writings on Johns's pages where possible, detailed typographical duplication of the layout of each page is beyond the scope of the present anthology, as is the inclusion of all of Johns's markers, such as many of the directional arrows that he uses to indicate linkages and inserts. A feel for the varieties of Johns's arrangements of words and images on the sketchbook pages can be gleaned from the examples reproduced here.

— KV

Focus –
Include one's looking,
" " "seeing"
" " using
It + its use +
its action.
as it is, was, might be.
(each as a single tense,
all as one)

A = B
A is B
A represents B
(do what I do,
do what I say)

the relationship between the object
+ the event. Can they ② be
seperated? Is one a detail
of the other? What is
the meeting? Air?

It moves
" moved
" was moved
" Can, will, might move
" has been moved
" will be "
(can't have just it)

not a drawing
not a speech
but if it were
all would be
described +
swallowed up
by the drawing,
the speech.

← not a Construction
" "a" structure

the air must
move in as
well as out —
no sakuen,)
just disaster

_ "_" differs from
a "_"

object
will this be destroyed

It is the representation
of an event

find one way to describe the event
+ the objects
not a drawing

an object that tells
of the loss, destruction,
disappearance of objects.
Does not speak of
itself. Tells of
others. Will it
include them?
DELUGE

1. Book A, p. 8, c. 1960.
Transcribed in item s-2.

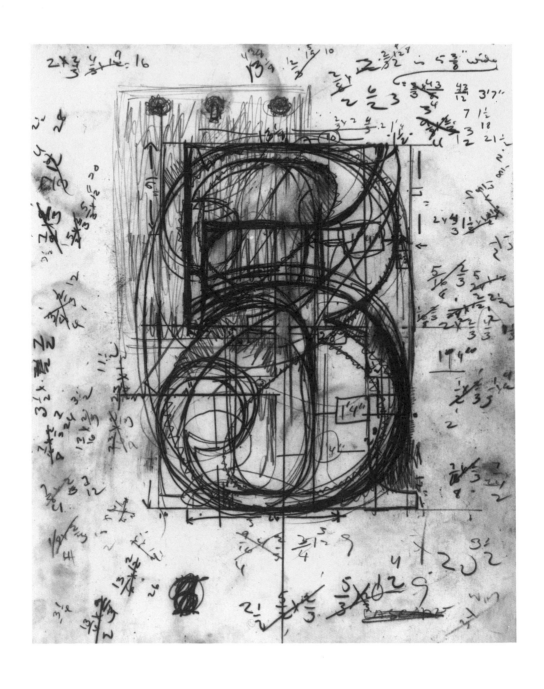

2. Book A, p. 16, c. 1960.
Item s-5.

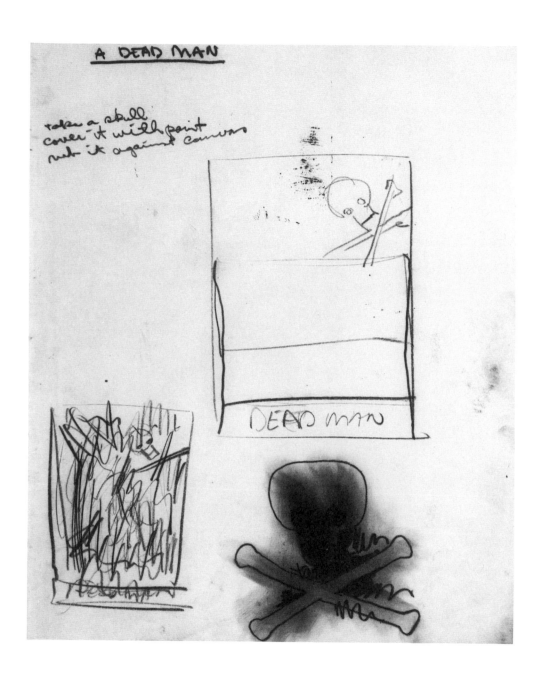

3. Book A, p. 18, c. 1960–61.
Transcribed in item s-6.

Johns' Theatre

gray Numbers
Encaustic
Heavy Collage

relief (4 Machine photos Merce)
Carol?
Foreign Colors + images

← SAME OR
SHIFTING POSE?

Hinged elements?
will it have to be protected
by glass? Hope not.

$$\frac{10}{12!/12!}$$

$$\frac{11!/}{\frac{1!}{12}}$$

$$\frac{9}{108}$$

$$11\overline{)108}$$ 9 9/11 "tall each rectangle
$$\frac{99}{9}$$
$$\frac{1!}{}$$

121 Canvasses

order 150 "

OVERCOME
THIS
MODULE
with
(VISUAL VIRTUOSITY

$$\frac{12!}{36!}\frac{30°}{30°}$$
181

REVERSE SOME?
HINGE SOME? — MIRROR IMAGE
ON REVERSE

OR MERCE'S FOOT?)
ANOTHER KIND OF RULER

4. Book A, p. 28, c. 1963.
Transcribed in item s-8.

theatre Piece
if Horizontal

6' x 10 $\frac{1}{1 20}$

$\frac{5\frac{4}{9\frac{1}{2}}}{}$
$4\frac{3}{4}$

if Vertical

108" x 54"

one thing working one way
another " " another "
one thing working different ways
at different times

TAKE AN OBJECT
DO SOMETHING TO IT
DO SOMETHING ELSE TO IT
" " " " "

MAKE SOMETHING
FIND A USE FOR IT
AND/OR
INVENT A FUNCTION
FIND AN OBJECT

TAKE A CANVAS
PUT A MARK ON IT
PUT ANOTHER MARK ON IT
" " " " "

5. Book A, p. 42, c. 1963–64.
Transcribed in item s-16.

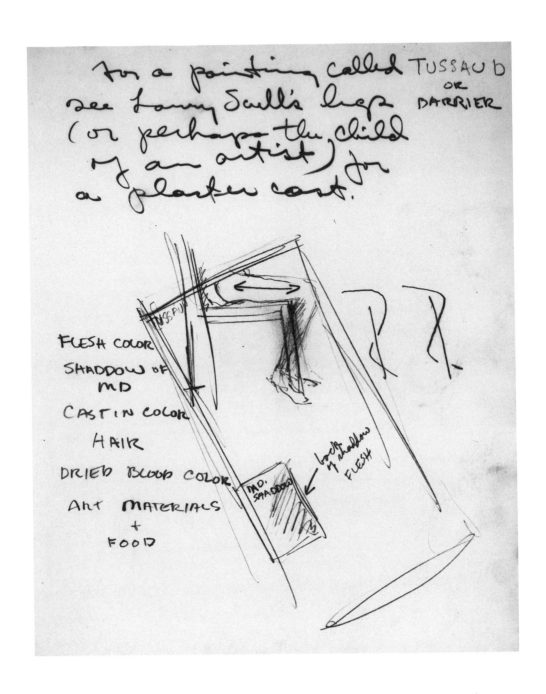

6. Book A, p. 44, 1964.
Transcribed in item s-18.

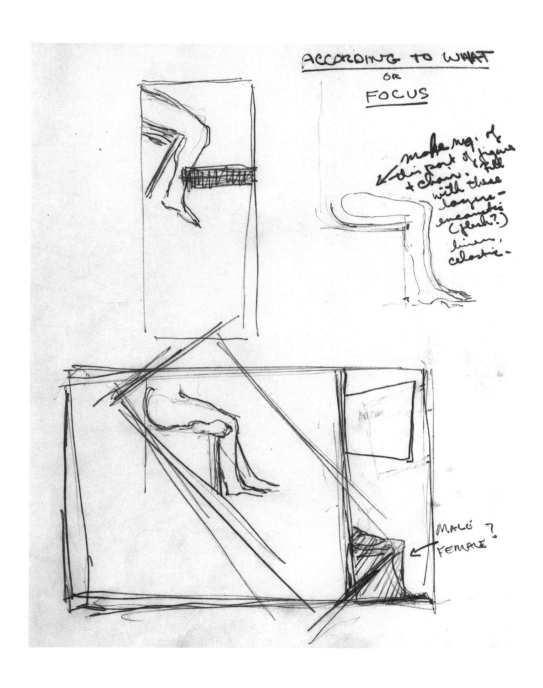

7. Book A, p. 48, 1964.
Transcribed in item s-20.

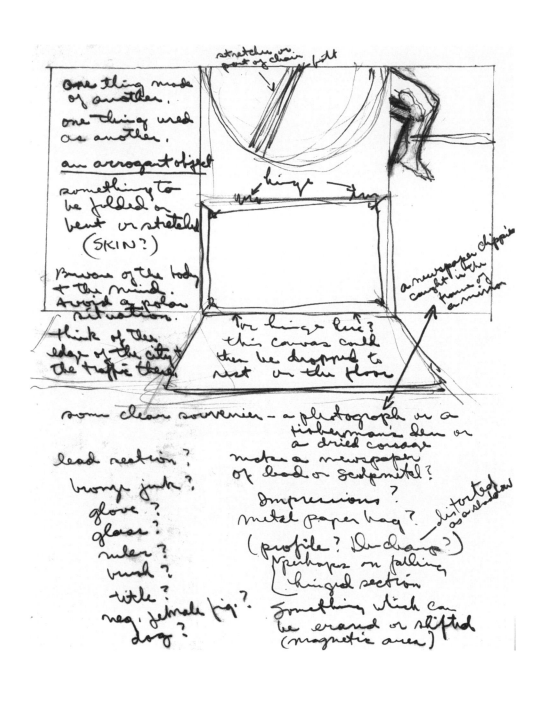

8. Book A, p. 49, 1964.
Transcribed in item s-21.

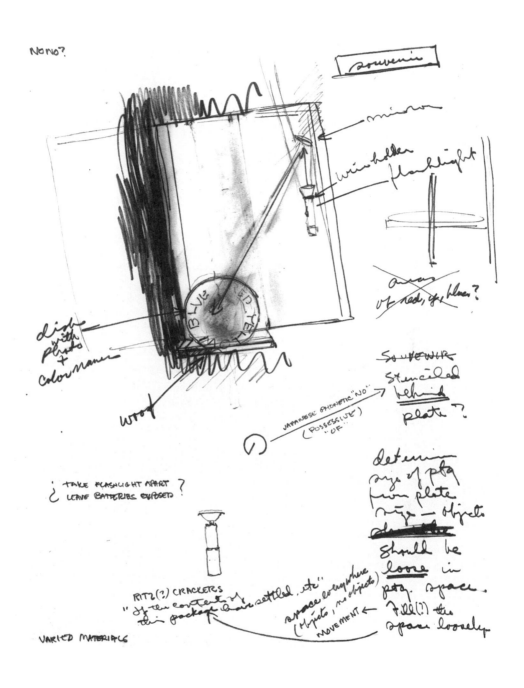

9. Book A, p. 53, 1964.
Transcribed in item S-25.

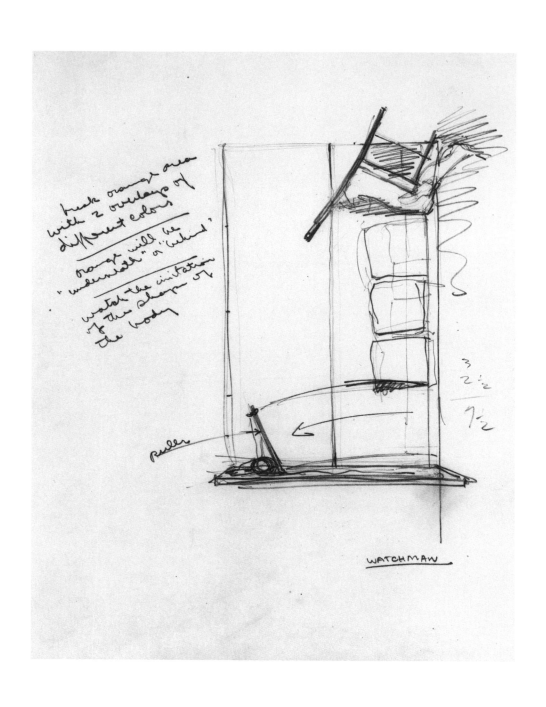

10. Book A, p. 54, 1964.
Transcribed in item s-26.

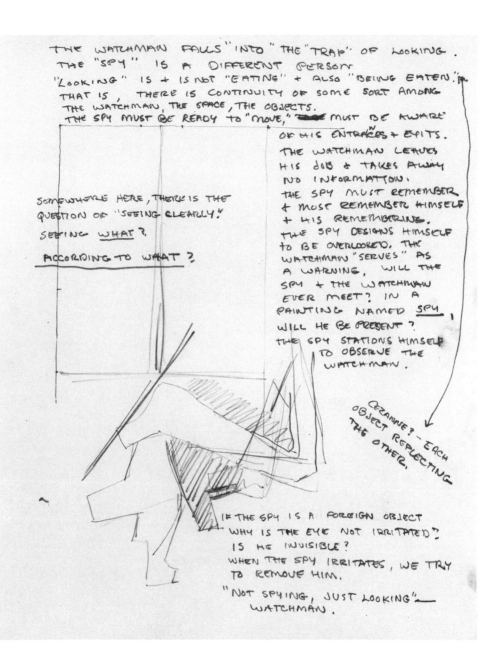

THE WATCHMAN FALLS "INTO" THE "TRAP" OF LOOKING.
THE "SPY" IS A DIFFERENT PERSON
"LOOKING" IS + IS NOT "EATING" + ALSO "BEING EATEN."
THAT IS, THERE IS CONTINUITY OF SOME SORT AMONG
THE WATCHMAN, THE SPACE, THE OBJECTS.
THE SPY MUST BE READY TO "MOVE," MUST BE AWARE
OF HIS ENTRANCES + EXITS.
THE WATCHMAN LEAVES
HIS JOB + TAKES AWAY
NO INFORMATION.
THE SPY MUST REMEMBER
+ MUST REMEMBER HIMSELF
+ HIS REMEMBERING.
THE SPY DESIGNS HIMSELF
TO BE OVERLOOKED. THE
WATCHMAN "SERVES" AS
A WARNING. WILL THE
SPY + THE WATCHMAN
EVER MEET? IN A
PAINTING NAMED SPY,
WILL HE BE PRESENT?
THE SPY STATIONS HIMSELF
TO OBSERVE THE
WATCHMAN.

SOMEWHERE HERE, THERE IS THE
QUESTION OF "SEEING CLEARLY."
SEEING WHAT?

ACCORDING TO WHAT?

CEZANNE? — EACH
OBJECT REFLECTING
THE OTHER.

IF THE SPY IS A FOREIGN OBJECT
WHY IS THE EYE NOT IRRITATED?
IS HE INVISIBLE?
WHEN THE SPY IRRITATES, WE TRY
TO REMOVE HIM.

"NOT SPYING, JUST LOOKING."—
WATCHMAN.

11. Book A, p. 55, 1964.
Transcribed in item s-27.

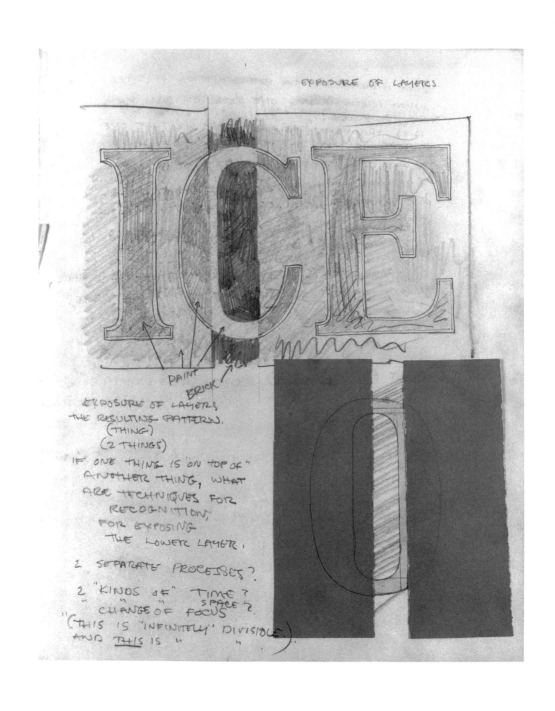

PAINT
BRICK

EXPOSURE OF LAYERS
THE RESULTING PATTERN.
(THING)
(2 THINGS)
"IF ONE THING IS 'ON TOP OF'
ANOTHER THING, WHAT
ARE TECHNIQUES FOR
RECOGNITION,
FOR EXPOSING
THE LOWER LAYER.

2 SEPARATE PROCESSES?

2 "KINDS OF" TIME?
" " " SPACE?
" CHANGE OF FOCUS
"(THIS IS "INFINITELY" DIVISIBLE.)
AND THIS IS " "

12. Book B, c. 1967, 13 ½ x 11 ¾″.
Transcribed in item s-30.

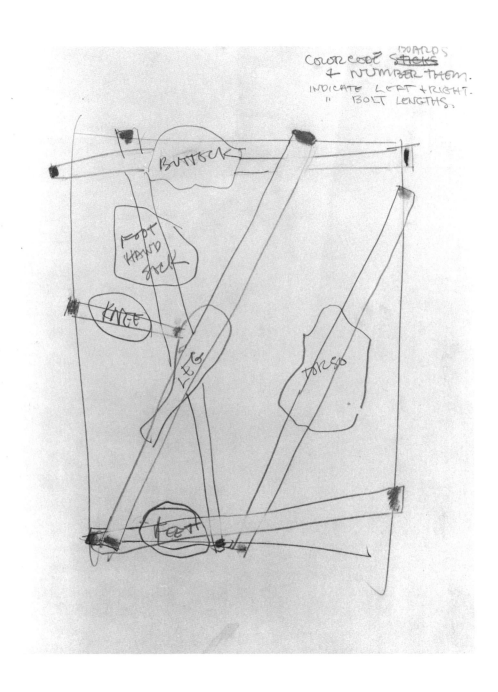

13. Book B, c. 1971–72, 13 ½ x 11 ¾″.
Transcribed in item s-40.

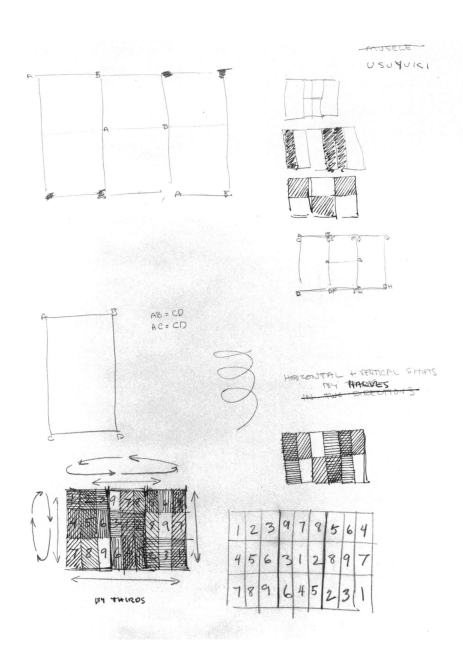

14. Book B, c. 1976, 13 ½ x 11 ¾".
Item s-42.

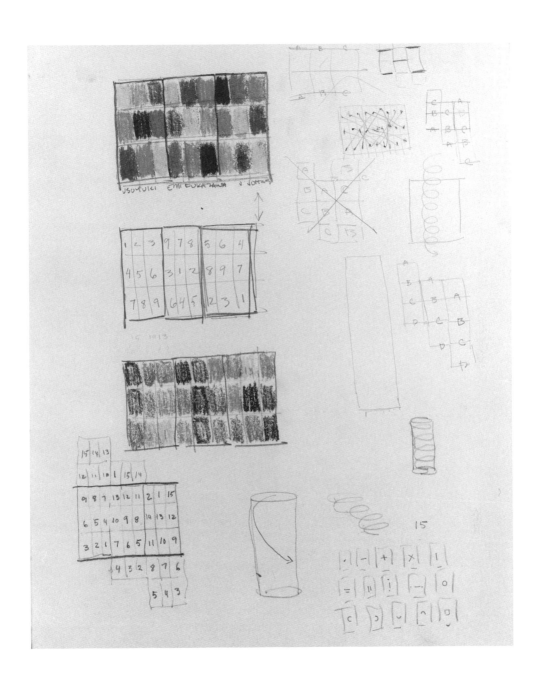

15. Book B, c. 1976, 13 ½ x 11 ¾".
Item s-43.

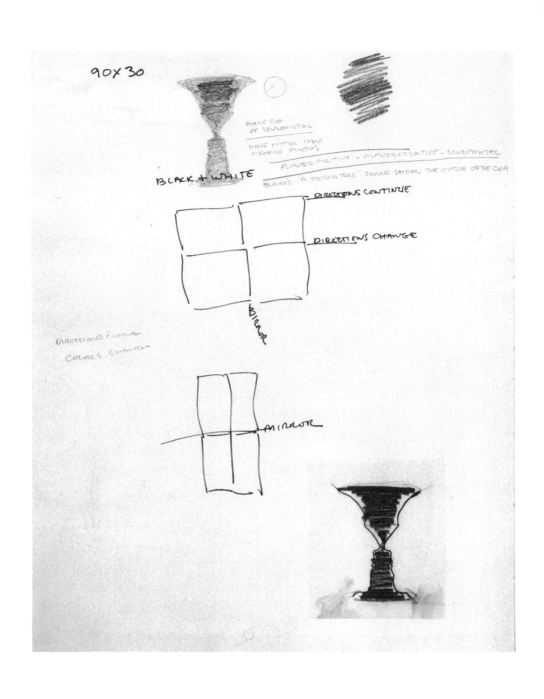

90x30

MAKE CUP
OF SCULPMETAL

HAVE MARK TAKE
PROFILE PHOTOS

PLASTER POSITIVE - PLASTER NEGATIVE - SCULPMETAL

BLAKE'S "A POISON TREE" SHOULD SPIRAL THE OUTSIDE OF THE CUP

BLACK + WHITE

DIRECTIONS CONTINUE

DIRECTIONS CHANGE

MIRROR

DIRECTIONS CHANGE

COLORS CHANGE

MIRROR

16. Book B, c. 1979, 13 ½ x 11 ¾".
Transcribed in item s-44.

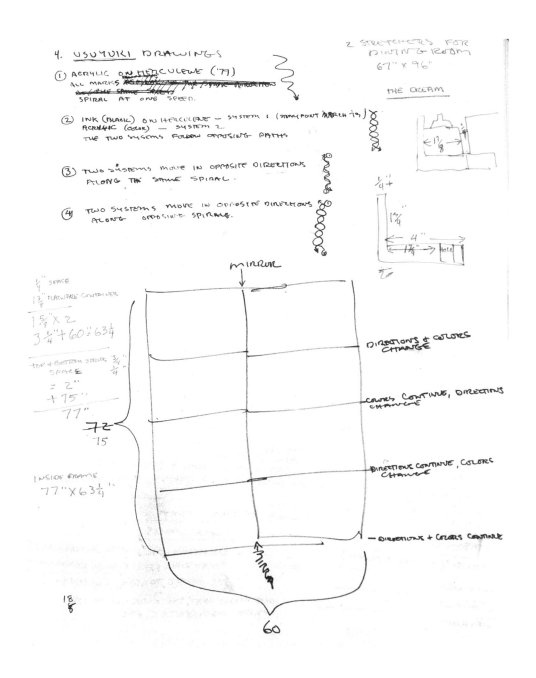

4. USUYUKI DRAWINGS

① ACRYLIC ON HERCULENE ('79)
ALL MARKS ~~ACTIVATED~~ ~~THE SAME~~ ~~FACE~~ ~~THE SAME DIRECTION~~
~~A (THE SAME FACE)~~
SPIRAL AT ONE SPEED.

② INK (BLACK) ON HERCULENE — SYSTEM 1 (STARTING POINT MARCH 79.)
ACRYLIC (COLOR) — SYSTEM 2
THE TWO SYSTEMS FOLLOW OPPOSING PATHS

③ TWO SYSTEMS MOVE IN OPPOSITE DIRECTIONS
ALONG THE SAME SPIRAL.

④ TWO SYSTEMS MOVE IN OPPOSITE DIRECTIONS
ALONG OPPOSITE SPIRALS.

2 STRETCHERS FOR
DINING ROOM
67" X 96"

THE DREAM

¼+
1¾
← 4" →
← 1¼ → HOLE

MIRROR

¼" SPACE
1 ⅜ FLATWARE CONTAINER

1 ⅝ X 2
3 ¼" + 60 = 63¼

TOP + BOTTOM STRIPS ¾"
SPACE ¼"
= 2"
+ 75"
77"

72
15

INSIDE FRAME
77" X 63¼"

18
8

DIRECTIONS + COLORS CHANGE

COLORS CONTINUE, DIRECTIONS CHANGE

DIRECTIONS CONTINUE, COLORS CHANGE

DIRECTIONS + COLORS CONTINUE

MIRROR

60

17. Book B, c. 1979, 13 ½ x 11 ¾".
Transcribed in item S-45.

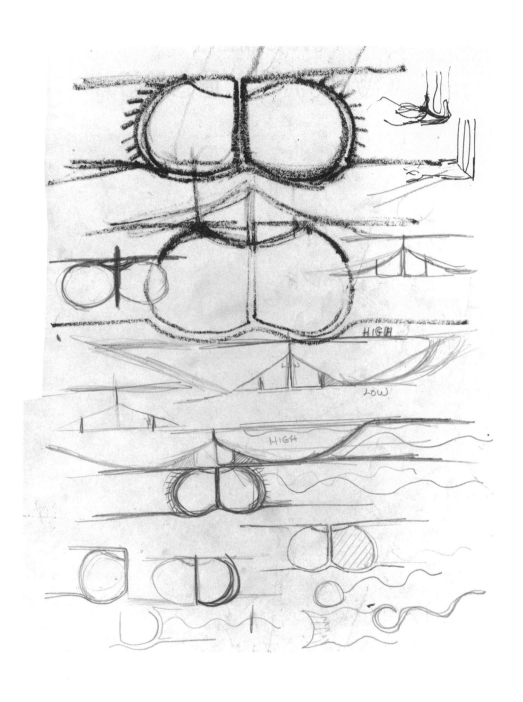

18. Loose sheet in Book B, c. 1979–80, 12 x 8½″.
Item s-48.

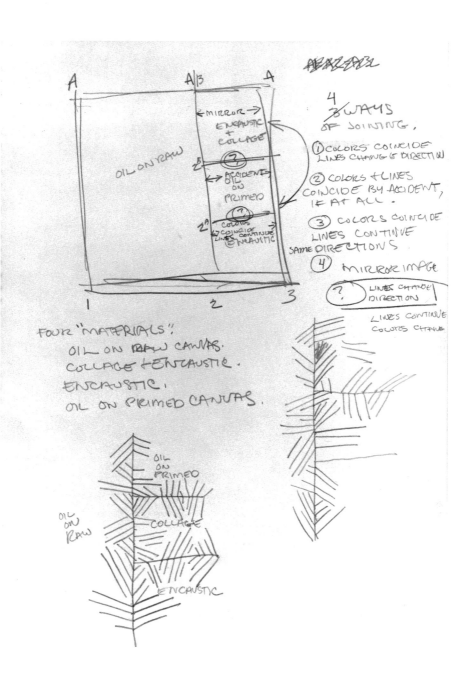

ABXXXXXX

4
3 WAYS
OF JOINING.

① COLORS COINCIDE
LINES CHANGE DIRECTION

② COLORS + LINES
COINCIDE BY ACCIDENT,
IF AT ALL.

③ COLORS COINCIDE
LINES CONTINUE
SAME DIRECTIONS

④ MIRROR IMAGE

? LINES CHANGE
DIRECTION

LINES CONTINUE
COLORS CHANGE

Within the diagram:
A A/3 A

OIL ON RAW

← MIRROR →
ENCAUSTIC
+
COLLAGE

② ?

← ACCIDENTS
OIL
ON
PRIMED

2ª ?
COLORS
③ COINCIDE
LINES CONTINUE
③ ENCAUSTIC

1 2 3

FOUR "MATERIALS".
OIL ON RAW CANVAS.
COLLAGE + ENCAUSTIC.
ENCAUSTIC.
OIL ON PRIMED CANVAS.

OIL
ON
PRIMED

OIL
ON
RAW

COLLAGE

ENCAUSTIC

19. Book D, c. 1975, 12 x 9″.
Transcribed in item s-62.

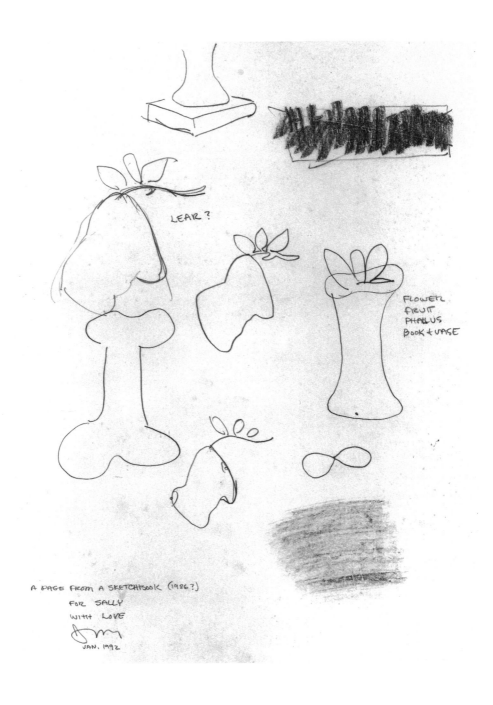

LEAR ?

FLOWER
FRUIT
PHALLUS
BOOK + VASE

A PAGE FROM A SKETCHBOOK (1986?)
FOR SALLY
WITH LOVE

JAN. 1992

20. Book E, 1986?, 13 ⅝ x 10 ¾″.
Transcribed in item s-63. Collection Sally Ganz.

21. Book E, c. 1990–91, 13 ⅝ x 10 ¾".
Item s-64.

BOOK A

Sketchbook A was lost in the fire that destroyed Johns's house in Edisto Beach, South Carolina, in November 1966. Fortunately, the Japanese critic Yoshiaki Tono had had a photographer shoot the book's pages while the artist was in Tokyo in 1964. The wording and sequence of the following notes are based on these photographs, courtesy Jasper Johns.

S-1. Book A, p. 4, c. 1960.

Make this and get it cast. (Painting with ruler and "gray.") Sculpt a folded flag and a stool. Make a target in bronze so that the circles can be turned to any relationship. All the numbers zero through nine. 0 Through 9. Strip painting before tying it with rope (Painting with a rope). Do Not Combine the 4 Disappearances. A through Z.

S-2. Book A, p. 8, c. 1960. Reproduced in plate 1.

Focus—
Include one's looking
 " " "seeing"
 " " using
It & its use &
its action.
As it is, was, might be.
(each as a single tense,
all as one)

A = B
A is B
A represents B
(Do what I do
Do what I say)

The relationship between the object
& the event. Can they ② be
separated? Is one a detail
of the other? What is
the meeting? Air?

It moves
" moved
" was moved
" can, will, might move
" has been moved
" will be moved
(can't have just it)

not a drawing
not a speech
but if it were
all would be
described &
swallowed up
by the drawing,
the speech.

←not a construction
 " "a" structure

←↑"—" differs from
a "—"

The air must
move in as
well as out—
no sadness,
just disaster.

Will this object be destroyed? →

It is the <u>representation</u>
of an event

Find <u>one</u> way to describe the event
& the objects.
 Not a drawing.

An object that tells
of the loss, destruction,
disappearance of objects.
Does not speak of
itself. Tells of
others. Will it
include them?
DELUGE.

S-3. Book A, p. 9, c. 1960.

Make something, a kind of object, which as it changes or falls
apart (dies as it were) or increases in its parts (grows as it
were) offers no clue as to what its state or form or
nature was at any previous time. Physical and Metaphysical
Obstinacy. Could this be a useful object?

S-4. Book A, p. 10, c. 1960.

Can a rubber face be stretched in such a way that some mirror will reorganize
it into normal proportion?

Find Scientific American with
information dealing with mirror
that will reverse normal image
 ↑mirror

The overthrow of parity

IN — OUT

Anti-matter.

S-5. Book A, p. 16, c. 1960. See plate 2.

S-6. Book A, p. 18, c. 1960–61. Reproduced in plate 3.

<u>A DEAD MAN</u>

Take a skull
cover it with paint
rub it against canvas

S-7. Book A, p. 23, c. 1960.

Make a plaster negative of whole head.
Make a thin rubber positive of this.
Cut this so it can be (stretched) laid

on a board fairly flatly. Have it cast in
bronze and title it <u>Skin</u>.

Make Shirl Hendryx's shoe in Sculpmetal with a mirror in the toe—to be used
for looking up girls' dresses. High School Days. (There is no way to make this
before 1955.)

S-8. Book A, p. 28, c. 1963. Reproduced in plate 4.

Johnson's Theatre

Gray Numbers
Encaustic
Heavy Collage
relief (4 machine photos Merce) ←Same or
 Carol? shifting pose?
Foreign colors & images
Hinged elements?
Will it have to be protected
by glass? Hope not.

9 9/11″ tall each rectangle
 121 canvases
order 150 ″
 ↑
Reverse some?
Hinge some?—mirror image
 on reverse

Overcome
this
module
with
(visual virtuosity,
or Merce's foot?)
 kind of
Another ↑ ruler

S-9. Book A, p. 29, c. 1963.

God is a way maker

Full—Empty

I take it to mean

———————————

I use it to mean

Foreground
Background

Figure as a space (or hole?)
in the _____ (landscape?)

<u>Leonardo</u>

Meeting of figure
& ground in (?)
Dimensions—silence (Cage)

The mind makes
marks, language,
measurements.

Competition as definition of one kind of focus.
Competition (?) for different kinds of focus.
 ↑
What Prize? Price? Value? Quantity?

S-10. Book A, p. 31, c. 1963.

Judd spoke of a "neutral"
surface but what is meant? Neutrality
must involve some relationship (to other
ways of painting, thinking?) He would have to include these in his work
to establish the neutrality of that surface. He also used "non" or "not"
expressive
this is an early problem
a negative solution or
expression of new sense
which can help one into
what one has not known

"Neutral" expresses an intention.

S-11. Book A, p. 32, c. 1963.

Find ways to apply/make paint
with simple movements
of objects—the hand
a board, feather, string,
sponge, rag, shaped tools, comb
(and move the canvas against paint-smeared objects).
How

(What) can this be used to mean if it were language? In what ways can one intend to use them.

S-12. Book A, p. 33, c. 1963–64.

Imagine
a circle
or an oval
a sort of
spectrum
Twist it
Render this
in paint

S-13. Book A, p. 34, c. 1963–64.

There seems to be a sort
of "pressure area" "underneath"
 (spatializing)
 (find another
 way to picture
 this)
language which operates in
such a way as to force the
language to change. (I'm
believing painting to be
a language, or wishing
language to be any sort
of recognition). If one
takes delight in that
kind of changing process
one moves toward new
recognitions (?), names,
images.

S-14. Book A, p. 40, c. 1963–64.

An invisible drawing
made in the air.
Make a drawing
behind your back.
Make a stolen painting.

S-15. Book A, p. 41, c. 1963–64.

Use chicken wire (or other)
as a canvas. Something
can be "behind" this.

S-16. Book A, p. 42, c. 1963–64. Reproduced in plate 5.

Theatre Piece
if Horizontal
6′ x 10
 120

if Vertical
108″ x 54″

 One thing working one way
Another " " another "
 One thing working different ways
 <u>at different times</u>

Take an object
Do something to it
Do something else to it
 " " " " "

Take a canvas
Put a mark on it
Put another mark on it
 " " " " "

Make something
Find a use for it
 and / or
Invent a function
Find an object

S-17. Book A, p. 43, c. 1962.

Bend color names which should
be made of neon or copper
tubing. Place an object on
a surface—trace the object—
then bend the object—leaving
some part of it attached.

S-18. Book A, p. 44, 1964. Reproduced in plate 6.

For a painting called TUSSAUD
<div align="center">OR</div>
<div align="center">BARRIER</div>

see Larry Scull's legs
(or perhaps the child
of an artist) for
a plaster cast.

Flesh color
shaddow of
 MD
cast in color
 hair
dried blood color
art materials
 &
 food

MD shaddow

back of shaddow
Flesh

S-19. Book A, p. 47, 1964.

<u>Summer Critic</u>

dark glass→mouth mouth mouth—colored wax

 concrete brick

 gray glass

<div align="center">OCCUPATION</div>
<div align="center">↓</div>
<div align="center">Take up the space with "what you do."</div>

S-20. Book A, p. 48, 1964. Reproduced in plate 7.

<u>ACCORDING TO WHAT</u>
or
<u>FOCUS</u>

Make neg. of
this part of figure
& chair. Fill
with these

layers—
encaustic
(flesh?)
linen
celastic.　　　　　[Editor's note: "Celastic" is a trade name for a fabric treated with resin.]

MALE

　　　?

FEMALE

S-21. Book A, p. 49, 1964. Reproduced in plate 8.

One thing made
of another.
One thing used
as another.
an arrogant object.
Something to
be folded or
bent or stretched.
　(SKIN?)
Beware of the body
& the mind.
Avoid a polar
situation.
Think of the
edge of the city &
the traffic there.

Some clear souvenir—a photograph or a　　　↔ a newspaper clipping
　　　　　　　　　　fisherman's den or　　　　　caught in the
　　　　　　　　　　a dried corsage　　　　　　frame of
　　　　　　　　　　　　　　　　　　　　　　a mirror

lead section?　　　make a newspaper
bronze junk?　　　of lead or Sculpmetal?
glove?　　　　　　Impressions?
glass?　　　　　　Metal paper bag?
ruler?　　　　　　(Profile? Duchamp?) — distorted
brush?　　　　　　Perhaps on falling　　as a shadow
title?　　　　　　hinged section
neg. female fig.?　Something which can
dog?　　　　　　　be erased or shifted
　　　　　　　　　(magnetic area)

stretcher or
part of chair
 bolt

 hinge

or hinge here?
this canvas could
then be dropped to
rest on the floor

S-22. Book A, p. 50, 1964.

Skull
against
canvas.

Scull
against
canvas.

S-23. Book A, p. 51, 1964.

IF
the body were oiled what kind
Step onto a canvas
Prone
Up
Walk until the feet
are just beyond
where the head
was on the canvas
Prone
Up
This would make it
canvas about 12 feet
tall or wide

IF
One sprays the oil marks
with powdered graphite
and fixes the graphite
with what?
In <u>WHAT</u> use a light & a mirror. The mirror will throw the light to some
other part of the painting.

S-24. Book A, p. 52, 1964.

Put a lot of paint
& a wooden ball or
other object on a board.
Push to the other end of
the board. Use this in
a painting.

ruler on board

S-25. Book A, p. 53, 1964. Reproduced in plate 9.

NO NO?

souvenir

mirror

wire holder
flashlight

~~areas of red, y, blue?~~

dish with photo & color names

BLUE RED YELLOW

wood

~~Souvenir~~

Japanese phonetic "no" →stenciled / <u>behind</u> / plate?
(possessive
"of")

¿Take flashlight apart
Leave batteries exposed?

Determine
size of ptg
from plate
size—objects
should be
<u>loose</u> in
ptg. space.
Fill (?) the
space loosely.

→ Space everywhere
 (objects, no objects)
 MOVEMENT.

→ RITZ (?) CRACKERS
 "if the contents of
 this package have settled, etc."

VARIED MATERIALS.

S-26. Book A, p. 54, 1964. Reproduced in plate 10.

Break orange area
with 2 overlays of
different colors

Orange will be
"underneath" or "behind"

Watch the imitation
of the shape of
the body.

Ruler

<u>WATCHMAN</u>

S-27. Book A, p. 55, 1964. Reproduced in plate 11.

The Watchman falls "into" the "trap" of looking.
The "spy" is a different person
"Looking" is & is not "eating" & also "being eaten" ↔ Cezanne? Each
That is, there is continuity of some sort among object reflecting
the watchman, the space, the objects. the other
The spy must be ready to "move," must be aware
of his entrances & exits.
The watchman leaves
his job & takes away
no information.
The spy must remember
& must remember himself
& his remembering.
The spy designs himself
to be overlooked. The
watchman "serves" as
a warning. Will the
spy & the watchman

ever meet? In a
painting named <u>Spy,</u>
will he be present?
The spy stations himself
to observe the
watchman.

If the spy is a foreign object
why is the eye not irritated?
Is he invisible?
When the spy irritates, we try
to remove him.
"Not spying, just looking"—
Watchman.

Somewhere here, there is the
question of "seeing clearly."
Seeing <u>what</u>?
<u>According to what</u>?

S-28. Book A, c. 1965.

Color chart, rectangles or circles. (Circles on black to white rectangles.) Metal
stencil attached and bent away.

Cut into a canvas & use the canvas to reinforce a cast of a section of a figure. The
figure will have one edge coming out of the canvas "plane" & the other edge will
overlap cut or will show the wall behind. A chain of objects (with half negative?)
Cast RED, YELLOW, BLUE or cut them from metal. Bend or crush them. String
them up. (OR) Hinge them as in FIELD PAINTING. Bend them. Measurements
or objects or fields which have changed their "directions." Something which has a
name. Something which has no name. Processes of which one "knows the results."
Avoid them. City planning, etc.

BOOK B
13 ½ x 11 ¾ inches

S-29. Book B, c. 1967.

The possibility

of fineness
of broadness

what emerges in the one case
" disappears " " other "

2 kinds of "space"

one on top of the other
 and / or
 side by side
 and / or
one "inside" the other (is one a detail of the other?)
 " "around" " "

What can one do with "one includes the other"?

Distinguishing one thing from another
(Duchamps "2 like objects")

Making distinctions where

 { none has existed
 { none has been said to exist
 { none has been made

 ?
How does the (eye) make such distinctions
↓
Linguistically, perhaps, the verb is important.
But what about such a case in painting?

S-30. Book B, c. 1967. Reproduced in plate 12.

exposure of layers
ICE
paint brick
exposure of layers
the resulting pattern
 (thing)
 (2 things)
if one thing is "on top of"
another thing, what
are techniques for
recognition,
for exposing
the lower layer.

2 separate processes?

2 "kinds of" time?
 " " " space?

Change of focus
(This is "infinitely" divisible
and <u>this</u> is " ")

S-31. [Book B, c. 1967.]

We say one thing is not another thing.
Or sometimes we say it is.
Or we say "they are the same".

S-32. [Book B, c. 1967.]

<u>ways of putting things together</u>
skin and air together

The act of taking food.
The act of preparing and taking food.
The act of hunting.
Water.

S-33. Book B, c. 1967.

What is meant by "the representation of space"?
What distinguishes one representation from
another?
Does this mean "how does one see that one
thing is not another thing"?
What constitutes a change of focus?
(We speak of "another way of seeing things.")
("Another way of looking at things.")
What about "another way of establishing (?)
'thingness'"?
"Something" can be either one thing or another
(without turning the rabbit on its side).
↑
This requires the idea of representation (or "picture").
A rabbit (a real rabbit) on its side is not a duck.

S-34. Book B, c. 1967.

IN MEMORY OF MY FEELINGS

a resist (transfer?) from wet flatware
and over that
black or dark wash

the mouth (?) and the teeth (?) as in Anita's letter
(There is the possibility of oil as a resist.)
(oil or Vaseline on the teeth to prevent erosion near the gums.)

S-35. Book B, c. 1967.

try to use together
the wall
the layers
the imprint

S-36. Book B, c. 1967.

Whenever they mention culture, I reach for my Brownie.

S-37. Book B, c. 1967.

Have made a silk-screen
of Baudelaire's
description of
sculpture as an
inferior art. Use
this in VOICE (2) or
somewhere else.
Perhaps fragment
it so that its
legibility is interfered
with.

S-38. Book B, c. 1967.

in a context
within a context

variety

its own work
its own
its
it
its shape, color, weight, etc.
it is not another (?)
and shape is not color (?)

Aspects and movable aspects.
To what degree movable?

Entities

splitting

the idea of background
(and background music) Satie's "Furniture Music" now
idea of neutrality serving as background for music
air and the idea of air as well as background for conver-
(in breathing—in and out) sation. Puns on intentions.
the body as a tube
moisture—such as sweat
rain
re-processing
renaming

S-39. Book B, c. 1968.

Shake (shift) parts of some of the letters in VOICE (2).
A not complete unit or a new unit. The elements in the
3 parts should neither fit nor not fit together.
One would like not to be led. Avoid the idea of a puzzle
which could be solved. Remove the signs of "thought."
It is not the "thought" which needs showing.

the application of the eye

the business of the eye

The condition of a presence.
The condition of being here.

It is not interesting and should not be shown
to be as interesting that the parts
can be shifted.
It was always true that they can be shifted.
Duchamp's ironing
board. Does
Teeny Duchamp
have an ironing
board?

S-40. Book B, c. 1971–72. Reproduced in plate 13.

Color code ~~sticks~~ boards
& number them.
Indicate left & right
 " bolt lengths.
Buttock

Foot
Hand
Sock

Knee

Leg

Torso

Feet

S-41. Book B, c. 1972–74.

Say that one thing is
in part a "mirror" for or of
another thing.
As an apple may reflect
the color of a grape.
Keep in mind the reversal.
Now say that the parts
other than the "mirroring"
part are of the same
"substance" as the part
which is being reflected.
—Illustrate this in a
 painting—
A pattern formation
which is in part repeated
in reverse.
This is to be a visual not
a musical idea.

Mirror
———
Magician

Consider the possibility
of having made
photographs from
the live models
of the parts used
in UNTITLED.
These photos to
be put on offset plates
and printed over
or under photos
of the casts.
The superimposition
of 2 not quite
identical images.
2 things occupying
the same space
(a fist & a hand).

S-42. Book B, c. 1976. See plate 14.

S-43. Book B, c. 1976. See plate 15.

S-44. Book B, c. 1979. Reproduced in plate 16.

black & white

Make cup
of sculpmetal

———————————

Have Mark take
profile photos

———————————

Plaster positive—plaster negative—sculpmetal

Blake's "A Poison Tree" should spiral the outside of the cup

directions continue

directions change

mirror

directions change
colors change

mirror

S-45. Book B, c. 1979. Reproduced in plate 17.

4 <u>Usuyuki</u> Drawings

1. acrylic on Herculene ('79)
all marks
spiral at one speed

2. ink (black) on Herculene—system 1 (Stony Point March '79)
acrylic (color)—system 2
the two systems follow opposing paths

3. two systems move in opposite directions
along the same spiral

4. two systems move in opposite directions
along opposing spirals

2 stretchers for dining room
67" x 96"

<u>The dream</u>

mirror

mirror

directions & colors change

colors continue, directions change

directions continue, colors change

directions & colors continue.

¼″ space
1 ⅜″ flatware container

S-46. Book B, c. 1979.

2 systems } figure, ground

3 colors } 2 figures, one ground

~~AT CERTAIN~~

In certain areas of the ground
the two systems become one.

<div align="center">or</div>

One system is laid over another.
In certain areas the information in one system
matches the information in the other.

<div align="center">or</div>

Systems which <u>seem</u> to exist on two "planes"
match in certain areas and, in these areas, seem
to exist on one plane.

Two kinds of space can, in part, be one kind of space

2 figure/ground systems

In certain areas, one figure becomes the ground for
the other figure

2 kinds of space which are joined to one another
The possibility that one of these expands
 that the other contracts
 (at different rates)
 (<u>Moving</u> in different directions)

Observations made from within these systems
(expanding or contracting).

Observations made from the exterior.
Visual description, mathematical description.

S-47. Book B, c. 1979.

Events occur without permission

in one "space"
a field of events
another field of events
one attitude toward the space (?)
which lets us locate these

Corpse & Mirror

 the duet

The mirror collects dust
 " corpse " "

one or two or three is the question

 The mirror tends to reflect
 the dust on the mirror, the
 dust on the corpse, the
 corpse
The mirror is perhaps
not the object
but the subject
 The mirror reflects whatever
 is not in the mirror

 In some way the mirror
 shows "What we do not
 otherwise see."

 corpse & mirror

once the symmetrical image
has been established—continue the work
mirroring all marks

a mirror—but colors—or direction
 are transferred
in color, this could be done chemically

S-48. Loose sheet in Book B, c. 1979–80. See plate 18.
Irregular, 12 x 8 ½ inches

BOOK C

8 ½ x 11 inches

S-49. Book C, c. 1968–69.

one multiple moving "out"
another " " "in"

(in the same time)

S-50. Book C, c. 1968–69.

A dotted roller?
A lined roller?

S-51. Book C, c. 1968–69.

EMBOSS

High School Days
0 Through 9
Hanging light
The Critic Smiles
Flag
Slice of bread?
A through Z
Paper bag with Duchamp's signature (get photo from Bob Benson)
Ale Cans
Thermometer
Relief Target (Frank Stella)

S-52. Book C, 1968–69.

color sequence

─────────

ten figures

possible overprinting
use preceding set of
colors in list

RYB—0—OVG
VRY—1—RYB
BVR—2—VRY
GBV—3—BVR
YGB—4—GBV
OYG—5—YGB
ROY—6—OYG
VRO—7—ROY
GVR—8—VRO
OGV—9—GVR

Use a squeegee
as a diameter
as a radius

———————————

(a radius)
pivoting to give
circular color formations
(through a screen).

Will there be a
straight line at
beginning/end? Yes.

S-53. Book C, c. 1968–69.

Silk screens to apply areas of different values.
Pos. & neg. dots.

Writing or painting as a way
of writing or painting or as
a way of doing something else.
(A tendency here to involve the
eye & the arm)
What "way" can be used to mean
"This is the way I do this."
"This is the way he does this."
"This is the way he does it. I do it this way."

S-54. Book C, c. 1970.

Object in/and space
The first impulse may be to give the object
a position—to place the object.
(The object had a position to begin with.)
Next—to change the position
of the object.

Rauschenberg's early sculptures—
~~A board with some rocks on it.~~
 The rocks can be anywhere on
 the board.
Cage's Japanese rock garden—
 The rocks can be anywhere
 (within the garden).

That any color	That anywhere	That anything
be anywhere	be anything	be any color
and anything	and any color	and be anywhere

S-55. Book C, c. 1968–69.

Flagstone ptg.
2 panels.
one in oil.
 " " encaustic.

An imagined unit the square of the height of these
canvases.
The flagstones enclosed by a border (within this
imagined square).
The left rectangle (oil?) will include area A.B.C.D. The right (encaustic?) will
include E.F.G.H. The meeting B.D. and E.G. will not have borders. (Or will they?
Aim for maximum difficulty in determining
what has happened?)
(The possibility of these—or others—in gray.)

Whether to see the 2 parts as one thing
 or as two things.

Another possibility: to see that something has happened.
Is this best shown by "pointing to" it or by "hiding" it?

S-56. Book C, c. 1969–70.

Claes exaggerates Color A
(and not "in order to over
make a point") Color B

 We got that
 a long time ago.
 There it is.

 It is what it does
 What can you do with it?
 Alternatives
 Not a logical system
 That is, not contained
 continuity/discontinuity

The colors (?)
The thickness of the paint
The canvas
(The paint on the canvas)
The kind of paint
The time
The drying time
(as though thought were
rapid)
(The objects do not
whirl or float in
space)
Coming & going
but no task
A social drying time

The dots can be "gathered together"
into a line or a mass.
(stewed tomatoes)

The limited use of whatever
ingredient in cooking

Test the sense of time
during a period of indifference
The nature of the object produced
during such a period.
To get rid of (destroy) the language value of
anything at all.

S-57. Book C, c. 1969–70.

So far: To work (act, move, exist)
in a space
at (during) some time
A way of behaving
An accumulation of what
An explosion " "
An expulsion " "

To pick up these things
and move them (and oneself)
about.

S-58. Book C, c. 1970.

Consider
two metals
of similar
colors

Steel & Al

Lead & Al

Zinc

English
lt. bulb

one
sculpmetal
for Mark

one
bronze
or
3 bronze
(1 to be painted)

Find a device
for displaying
sea shells
to support Mark's
Light Bulb

S-59. Book C, c. 1970–71.

Anything could
perhaps be
something else.
(Design). Marcel
cemented a
spoon to the
handle of his
door latch.
(Used to open,
never to shut,
the door). There
may be the
question of
resemblance
or substitution
(Freud)—one
term & another—

Devise technique
to imitate "magic
picture pad"—
image printed in
invisible size on
paper becomes
visible when
scribbled over
with pencil.
Use silkscreen of
dish from Souvenir
as image.
Also try photo
screen of an
existing drawing—
and a painting
↑

but there may be
the possibility of
a state of affairs
in which there is
no priority. And
there is the possibility
of forms of thought (?)
that I do not suspect.
First, disgust.

(this was already
done in the
skin drawings.
Using oil.)

S-60. Book C, c. 1970–71.

Move the "inside" of the picture
 " " outside " " "
 Shifting the facts
Move the frame (or the canvas)
 A rearrangement
What is considered to be the "material"

"Activity" can be part of the "information."

A certain kind of behaviour but also
" " " " attitude.

A new responsibility (as though one
thing were asked to be another)
A new function
A new description

S-61. Book C, c. 1970–71.

To give up
 or
To do the work
To doubt that the work needs doing?
At any rate, the time passes.

A clear object.
An unclear object.

To begin to do.
A way to begin
(which might or might not
include a way to end)

The nature of ideas for paintings which

can't be accomplished. Is the problem (?)
in the ideas? There is nonsense of another
sort (other sorts) than verbal!

BOOK D
12 x 9 inches

S-62. Book D, c. 1975. Reproduced in plate 19.

oil on raw

mirror

encaustic
&
collage

accidents

oil
on
primed

colors
coincide
lines continue
encaustic

3 4 ways
of joining.
1. colors coincide
lines change direction
2. colors & lines
coincide by accident,
if at all.
3. colors coincide
lines continue
same directions.
4. mirror image
? lines change
direction
lines continue
colors change

Four "materials."
oil on raw canvas.
collage & encaustic.
encaustic.
oil on primed canvas.

BOOK E
13 ⅝ x 10 ¾ inches

S-63. Book E, 1986? Reproduced in plate 20.

Lear?

Flower
Fruit
Phallus
Book & vase

S-64. Book E, c. 1990–91. See plate 21.

S-65. Book E, c. 1992–93.

The painted space/The space of painting
seems mutable
The continuing reinterpretation→ Things which were not there can appear in it or
of works of art be put into it
shows this. Is there any need to enhance
this characteristic?
Or to counter it?
Or to recognize it?
What seems literal can twist or be twisted
into something else—as rigidly
literal works tend to become transcendental.
The space of works of Zen
seems mutable.

S-66. Book E, c. 1993–94.

The maze is <u>one thing</u>—
a trap, a confinement.
The nature of the maze—
in/of itself.
To follow a thread (in/of itself).
A way out, the way out.
To enter the maze, to exit—
not the maze itself.

Transmutation of images
Spoor
Larger and smaller
Glancing connecting sensitized fields
Ideas —events for which there are not yet ideas.
Ideas which have been freed from events which
brought them into being.
Non-simultaneity in "a" space (or the <u>idea</u> of this)
(could this be memory
or a sense of time?)

What (for me?) drives form
in a certain way? The
possibilities for connection,
division, modulation are
numerous and, themselves,
subject to such connective,
divisive, modulating forces.
Odd, that any <u>thing</u> is arrived
at, if it is. For some, the
question of style might be
important here.

2 similar systems (of lines)
follow* different principles
or follow one principle.

 *In relation to everything
 that is given.

The style of (other?) artists
depends on the kinds of space
which they neglect to recognize.
(Or (perhaps more importantly) which
cannot be mentioned
in these circumstances.)

Executing
 } 2 similar systems
Perceiving

Differences of meaning
 " " beheavior
 Rules

One thing may include another thing
 or
may exclude another thing.

The space in which
different systems
exist. Describe
this space.

One doesn't have the idea
that all things which have not
been included have been excluded.
Still, they have not been included.

To describe the space.
 " " a system.

 ?

One thing may or may not include another thing.
 " " " " " " exclude " " .
 ?
With reference to certain things
other things may have no existence?

"Stupid as a painter" Duchamp
"Jealous as an artist" Flaubert
(As jealous as an artist
 or
as an artist, he was jealous?)

Interviews

Throughout the following chapter, all of Johns's words appear in roman type. Other writers' and speakers' words appear in italic type.

In their original forms, the interviews below sometimes repeat each other, the same subjects being discussed on different occasions over the years. Such repetitions have been largely deleted. These and other editorial cuts are indicated by ellipses within square brackets. When these bracketed ellipses are printed in roman type, the deletions include remarks by Johns. Ellipses not in square brackets appear in the original texts.

Some of the interviews in this book were originally published in other languages, in translation from Johns's English. Where possible, English transcripts of the original interviews are used here. Other interviews, however, have been translated back into English from the language in which they were first published, and are noted as translations in the "References" section. Although they convey the sense of what was said, they do not reflect Johns's exact words.

Interviews are ordered chronologically by the date of the interview where known. When that date is unknown, the sequence follows the date of the interview's publication.

I-1. "Trend to the Anti-Art: Targets and Flags," *Newsweek* 51 no. 13 (March 31, 1958): 96. Published on the occasion of Johns's first solo exhibition, at the Leo Castelli Gallery, New York.

Jasper Johns, 28, says, "I make what it pleases me to make." *[...]*

Johns studied art for two years at the University of South Carolina, then did his Army stint and has, since 1952, worked painstakingly in a loft just below Rauschenberg's. "I have no ideas about what the paintings imply about the world," *he says.* "I don't think that's a painter's business. He just paints paintings without a conscious reason. I intuitively like to paint flags." *[...]*

I-2. "His Heart Belongs to Dada," *Time* 73 (May 4, 1959): 58. Published on the occasion of the "Recent Acquisitions" exhibition at The Museum of Modern Art, New York.

[...] Johns paints the American flag in various colors, including the conventional ones. Or he paints targets, or numbers arranged in little squares. Or, tiring of that, he will put a frame around an opened book and paint the whole thing red [Book, 1957]. Or he will attach a music box to the back of a blue collage with the key sticking through the front [Tango, 1955]. "The music box played *Silent Night*," *he remarks.* "I fixed it to go 'ping—ting—click' instead." *[...]*

In his studio on East 63rd Street, New York, in 1990. Photograph: Cori Wells Braun.

[…] "It all began," *he says,* "with my painting a picture of an American flag. Using this design took care of a great deal for me because I didn't have to design it. So I went on to similar things like the targets—things the mind already knows. That gave me room to work on other levels. For instance, I've always thought of a painting as a surface; painting it in one color made this very clear. Then I decided that looking at a painting should not require a special kind of focus like going to church. A picture ought to be looked at the same way you look at a radiator." […]

I-3. Selden Rodman, *The Insiders: Rejection and Rediscovery of Man in the Arts of Our Time* (Baton Rouge: Louisiana State University Press, 1960), p. 36. From chapter 6, "The Artist as Antihumanist."

[…] *I visited Robert Rauschenberg, the foremost exponent of this new Dadaism, in the studio he shares with Jasper Johns, renowned for his meticulously painted "targets" and "flags."* […]

Both painters—Johns entered the studio at this point—insist that they paint compulsively, without any conscious aims or sense of what is happening while actually working. Johns says: "My primary concern is visual form. The visual meaning may be discovered afterward—by those who look for it. Two meanings have been ascribed to these American Flag paintings of mine. One position is: 'He's painted a flag so you don't have to think of it as a flag but only as a painting.' The other is: 'You are enabled by the way he has painted it to see it *as a flag* and *not* as a painting.' Actually both positions are implicit in the paintings, so you don't have to choose."

Johns pulled out a smaller painting, gray on gray with a gray wooden knob inserted near the top on which hung an ordinary wire coathanger, also painted gray. "This," *he continued,* "is not surrealism. I feel that what I am doing is quite literal. Some labeled it neo-Dada, which made me rush to the library to find out what Dada actually was. I still don't know, except that it seems to have been given shape by a political agreement of some sort. As for me, I'm only interested in *looking* at things, not in deciding, with other artists in conference, what they ought to be." […]

I-4. D. K. (Donald Key), "Johns Adds Plaster Casts to Focus Target Paintings," *Milwaukee Journal*, June 19, 1960, pt. 5, p. 6.

[…] "I don't think you can talk about art and get anywhere," *Johns said.* "I think you can only look at it."

[…] *In the last two years [Johns] has almost zoomed to fame for his paintings of targets, flags, numbers, and words.*

Why does he paint such subjects? "They are just the forms that interest me and which I have chosen to limit and describe space."

Johns feels that these subjects cause a viewer to focus on the canvas, and it is his painting of the surface of the canvas that contains the essence of his art. […]

"I once painted an American flag that had sixty-eight stars," *he said, laughing*

at his own error. "Didn't find it out for months, until I looked at it in a display and counted the stars. No one else had noticed it either."

Was the error relevant to the work? "Well, it was an unintentional mistake," *Johns said.* […]

"I'm especially interested in the music of John Cage," *he said, referring to the prominent experimental composer whose works are nonthematic and nonharmonic.* "I would like to do some experimenting with the relationship between his free-form sound and free-form art."

And he added: "Sometime I would like to do a set for an off-Broadway play or a ballet." […]

I-5. D. R. Rickborn, "Art's Fair-Haired Boy: Allendale's Jasper Johns Wins Fame with Flags," *The State Magazine* (Columbia, S.C.), January 15, 1961, pp. 20–21.

[…] "I started drawing when I was three, and I've never stopped," he says matter-of-factly to allay any false notion that his interest in art is new. […]

"This is all I've ever wanted to do." […]

On January 20, 1958, [Leo] Castelli presented the young man from South Carolina. The result was bewildering to the artist.

"I didn't know if anyone would even like what I had done. I wouldn't have been surprised if they had despised it," *Johns says in retrospect.*

What happened was that the show was phenomenal. Every painting was sold, including the three to the Museum of Modern Art.[1]

I-6. Leo Steinberg, "Jasper Johns," *Metro* (Milan) no. 4/5 (May 1962): 94, 98. The excerpt that follows is from the revised form of this essay that appeared in Steinberg's *Other Criteria* (New York: Oxford University Press, 1972), pp. 31–33.

[…] *When you ask Johns why he did this or that in a painting, he answers so as to clear himself of responsibility. A given decision was made for him by the way things are, or was suggested by an accident he never invited.*

Regarding the four casts of faces that he placed in four oblong boxes over one of the targets:

Q: *Why did you cut them off just under the eyes?*

A: They wouldn't have fitted into the boxes if I'd left them whole.

He was asked why his bronze sculpture of an electric bulb was broken up into bulb, socket, and cord:

A: Because, when the parts came back from the foundry, the bulb wouldn't screw into the socket.

Q: *Could you have had it done over?*

A: I could have.

Q: *Then you liked it in fragments and you chose to leave it that way?*

A: Of course.

The distinction I try to make between necessity and subjective preference seems unintelligible to Johns. I asked him about the type of numbers and letters he uses—

coarse, standardized, unartistic—the type you associate with packing cases and grocery signs.

Q: *You nearly always use this same type. Any particular reason?*

A: That's how the stencils come.

Q: *But if you preferred another typeface, would you think it improper to cut your own stencils?*

A: Of course not.

Q: *Then you really do like these best?*

A: Yes.

This answer is so self-evident that I wonder why I asked the question at all; ah yes—because Johns would not see the obvious distinction between free choice and external necessity. Let me try again:

Q: *Do you use these letter types because you like them or because that's how the stencils come?*

A: But that's what I like about them, that they come that way.

Does this mean that it is Johns's choice to prefer given conditions—the shape of commercial stencils, inaccurate workmanship at the foundry, boxes too low to contain plaster masks, etc.? that he so wills what occurs that what comes from without becomes indistinguishable from what he chooses? The theoretic distinction I tried to impose had been fetched from elsewhere; hence its irrelevance.

I had tried to distinguish between designed lettering subject to expressive inflection, i.e. letters that exist in the world of art, and those functional letters that come in mass-produced stencils to spell THIS END UP *on a crate. Proceeding by rote from this distinction between life and art, I asked whether the painter entertained an aesthetic preference for these crude stenciled forms. Johns answers that he will not recognize the distinction. He knows that letters of more striking design do exist or can be made to exist. But they would be Art. And what he likes about those stencils is that they are Art not quite yet. He is the realist for whom preformed subject matter is a condition of painting.*

[Editor's note: when this essay was reprinted in Susan Brundage, ed., Jasper Johns— 35 Years—Leo Castelli *(New York: Harry N. Abrams, 1993), Steinberg added the following disclaimer, dated December 13, 1992: "During these exchanges, no tapes were used. The dialogue between Q & A was patched together from things Jasper had said to me, or to others in published interviews, supplemented by things I thought he would say, given the right provocation. The made-up answers were shown to Jasper, and when he agreed, 'Yes, I could have said that,' the catechism was sealed. To convey a sense of Johns' far-out position, I cast myself in the dialogue as a slightly bewildered stooge, not an easy role for [my humble self] to adopt."]*

I-7. Billy Klüver, interview conducted in March 1963 at Johns's studio, then at 128 Front Street, New York.

[Excerpt published, together with other artists' interviews, as a 33 ⅓-r.p.m. record included in The Popular Image, *exh. cat. (Washington, D.C.: Washington Gallery of Modern Art, 1963). —Ed.]*

… The difference is technically, and the difference is in what a different technique can be used to mean. So if you do one thing and then you do another thing that's different, obviously different, you'll tend not to be able to attach the same meaning to these two things. The early paintings of mine seem to me to have been about, partly, with what we were talking about earlier, accuracy, and questioning whether there are such things, so that the paintings tended to be a sum of corrections in terms of painting, in terms of strokes. So that there are many, many strokes and everything is built up on a very simple frame but there is a great deal of work in it, and the work tends to correct what lies underneath constantly until finally you quit and you say 'It's this one.' It seems to me that the work I do now is more concerned with … I don't know what it's more concerned with.… It is less concerned with accuracy—it's taken—since there didn't seem to be any such thing anyway, it was never achieved. The more recent work of mine seems to be involved with the nature of various technical devices, not questioning them in terms of their relation to the concept of accuracy. It seems to me that the effect of the more recent work is that it is more related to feeling or emotion or … (pause) … Let's say emotional or erotic content in that there is no superimposition of another point of view immediately in terms of a stroke of a brush, so that one responds directly to the physical situation rather than to a complex physical situation which immediately has to be resolved intellectually. So it seems to me the earlier paintings would tend to appear to be more intellectual because of this. Because everything is very close and variations are slight and the lines and everything that follow are very clear. So one only has a dual situation in the early paintings. You questioned whether it is a painting or whether it is what is being represented. I think in the more recent paintings you don't question that. You know what is painting and you know what the objects are that are involved, and you may or may not know what the sense of it is. That's your own business. They are also less arbitrary. However, I think the current idea would be the opposite, because they have no references outside of the actions which were made. The earlier paintings refer to specific designs or lines or whatever, which had to be dealt with, and the liveliness of the painting tends to be what I called earlier, corrections, very complex set of corrections, in relationship to these lines. Whereas the more recent works don't have that involvement. There isn't the constant attempt to do something over and over and over in the more recent works. Like drawing a straight line—you draw a straight line and it's crooked and you draw another straight line on top of it and it's crooked a different way and then you draw another one and eventually you have a very rich thing on your hands which is not a straight line.

If you can do that then it seems to me you are doing more than most people. The thing is, it is very difficult to know oneself whether one is doing that or not, whether you mean what you do; and there is the other problem of the way you do it and whether sometimes you do more than you mean or you do less than you mean. It's very good if you can establish a language where it's clear that that is what you are doing—that you do what you mean to do.

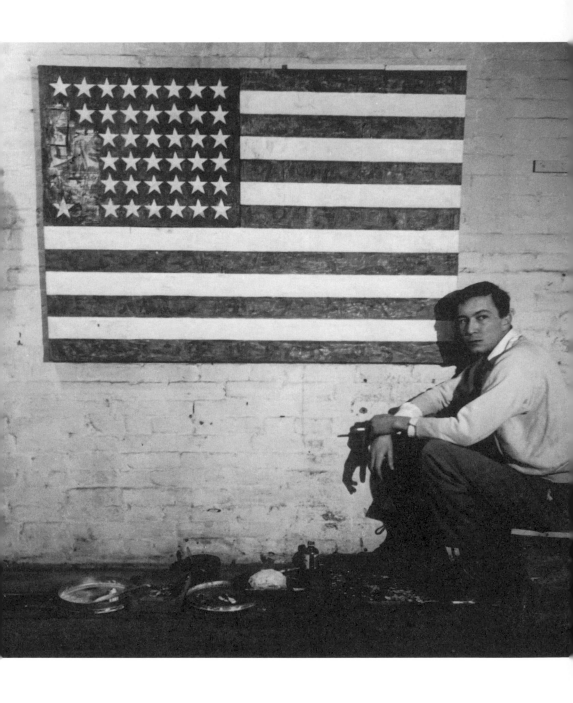

Jasper Johns in his studio on Pearl Street,
New York, with *Flag* (1954–55), in 1955.
Photograph: Robert Rauschenberg.

[Previously unpublished excerpts from the interview. Note: Klüver's questions have been edited, but Johns's answers are more or less verbatim. —Ed.]

[...] BK: *Do you want to keep a distance from things, ideas, concepts which are immediately associative of anything specific?*

JJ: Not particularly, because the mind is working with all sorts of things. If one would make any rule, it might be a good rule to avoid anything one knows, and still act. If one can do that, then one has something that one did not have before. I don't see any point in simply stating something that is easily available. But then that may just be my own psychology, a kind of negative position. It seems to me that if you avoid everything you can avoid, then you do what you can't avoid doing, and you do what is helpless, and unavoidable. That seems to me to be more interesting than any other position at this moment—for me, anyway.

BK: *[...] If you know a thing, then you already covered the subject, as you say, and there is no reason to....*

JJ: No. Frequently, there's an attempt to state what is known and the involvement is then on the level of skill, sometimes. Or how persuasive can you be with your position. Or, one can have a stylistic sort of obsession. [...]

BK: *[...] Everybody seems to disassociate themselves one way or another from the Pop artists. I have yet to find one that says, "I am a Pop artist" (laughing). [...] If you define Pop art as something that makes deliberate use of the popular elements in a culture ... [...]*

JJ: Well, you can use anything, it's a question of the intention, I think. [...] One situation which can develop is that [...] one's concerns are social in terms of the effect or content or meaning of the work. And that doesn't interest me particularly. [...] I can't imagine my work being used to accomplish anything socially.

BK: *You mean if there had to be a social accomplishment the work would be propagandistic, or educational?*

JJ: It would seem to me. [...] It seems to me that if social reaction is one of the things one has in mind, that the success of the work then would depend on obtaining that reaction. [...]

BK: *It's like a spectrum. On the one hand you have objects which are obviously more loaded with meaning than others, and on the other hand you have objects which are not as loaded.*

JJ: My idea would be that it would be nice, either to give all of those possibilities or to avoid all of them, and either of those accomplishments, it seems to me, would be very valuable in defining what that object was.

BK: *You use the objects in the second sense, in other words, you try to avoid all possibilities?*

JJ: Not always (laughing); I'm not that good.

BK: *Why do you use objects at all? Why do you use motifs that have a definite character?*

JJ: My use of objects comes out of, originally, thinking of the painting as an object and considering the materialistic aspect of painting: seeing that painting was

paint on canvas, and then by extension seeing that it occupied a space and sat on the wall, and all that, and then, if those elements seemed to be necessary to what I was doing. And so I thought to use this idea and extend that kind of physicality by bringing what is usually concealed behind the painting in front of the painting. So that, if the painting must project from the wall (which maybe it need not, but they seem to), then how far must it. And maybe you can exaggerate that. At a certain point I exaggerated by putting frames on the paintings which brought the paintings out by four or five inches from the wall, and began to use that depth by including cabinets and doors that could be opened. Later on, all the flat things I took off, because I could see it anyway. It didn't seem important to stress it.

BK: *When you have finished a painting, you know nothing about it?*

JJ: I know more than anybody else. I know how I made it.

BK: *That's a lot. Physicality implies finality, doesn't it?*

JJ: It depends on whether you question it or not. It seems to me that once one has an idea about it, it seems to me quite questionable. At a certain moment it may take on the aspect of a fact, and may provide a certain security in that sense, but it seems to me that if part of what one is doing is making ideas about it, then it seems to me that it becomes very questionable.

BK: *You mean the fact of the physicality becomes questionable?*

JJ: Yes. Because if one is involved with stating it, then at what moment is it stated, and then, as soon as there is some form of statement, you have already escaped your physicality in the situation. You can't have your cake and eat it too (laughing). […]

BK: *The uniqueness of a painting is in itself the finality, but the painting leaves something open within itself. Once the painting is finished, and the statement has been made…*

JJ: Well, there's no finality in the painting except that one finishes it. I mean, that is a final thing. But making a painting and looking at a painting don't necessarily correspond. The use of painting is to do something else. It seems to me that you are trying to continue the artist's action as though it were one thing from the time he began until the time someone looked.

BK: *Yes. In other words you don't believe that the spectator brings anything more to the painting?*

JJ: I think he brings everything more. He brings himself, which is something else again. And then it is a question of how he can use it. Maybe he can, maybe he can't, and maybe he will use it in a way similar, or maybe he won't. Because, generally, a new painting doesn't carry all of the conventions that one is used to, so that it can be misused since there is no set way of dealing with it.

BK: *How do you mean misused?*

JJ: I mean, the use of it need not involve the intentions of the maker. It can be used for other purposes.

BK: *Yes, but can the intentions of the maker be misunderstood? Isn't that just like not seeing? Isn't that just like not being able to see red or something?*

JJ: You are assuming there is something to see. You are assuming red exists, and "red" only exists once there's been a widespread agreement that there is such a thing. Doesn't it? You'd never ask me that question if you were suspicious that I had not seen red. You are assuming that I am going to agree that there is such a thing.

BK: *Yes, and I would be surprised if I found out that you haven't seen it.*

JJ: But in a new language or in new painting, all of those things have not been determined on any general level. And also the artist is frequently in a position of doing more or less or different from his intentions, I think. It's not so well formed to begin with.

BK: *That sort of means that the spectator in time finds out about the artist.*

JJ: I don't think you find out anything about the artist. I think you find out what use you have for things. I don't see anything else to find out. Because the attitude toward painting from any particular time and the use of it vary from minute to minute. And you can't think that it's going to be a static representation of anything. Our verbal language changes in the same way. You use a word one day and then the next day it means something else and then eventually it's gone.

BK: *Yes. But then I don't understand the idea of the red, because that is such a definite thing; we all agree that it is red.*

JJ: Well, you and I agree that there is red, but once there is an agreement then you use it in that way in terms of that convention. If we disagreed as to what red was, you said it was red and I said it was yellow, then what we have is a situation to which we would both respond differently. And I think that's frequently the case in painting. *[...]*

[The following exchange comes after discussion of science and of continuity and discontinuity in language and thought. —Ed.]

BK: *It is true that things are continuous but only in retrospect. Actually discontinuous things are those which we do not know. It's almost like a definition of the unknowable: the mysteries are the discontinuities. We tend to build a continuity around them. We create and learn a new language so that they can be absorbed.*

JJ: Why? I don't see exactly why you say that, because it seems to me that you could take the opposite point of view, and say that continuity is the thing that is so distressing and that what one can do is attempt to create a discontinuous situation. It seems to me that continuity is almost a static concept. And since we have the concept of discontinuity it seems to me that it would be more interesting to attempt to establish that. It seems to me much less in evidence.

BK: *In science, the discontinuity that you create when you discover something new, which upsets all the other previous notions or concepts, has to be related to what went before.*

JJ: I don't know what exactly you mean by "has to."

BK: *In other words, a new theory that matches like a glove to a hand, has to be created, which makes this discontinuity continuous.*

JJ: That's a secondhand experience. [...] That is to say that generally, one isn't willing to make such a leap, that one wants to cover the ground inch by inch. So I'm saying the further away one can get from continuity, the better off one is. [...] That is what I was talking about earlier, about what one thinks one knows, and what one thinks one doesn't know. And if one can avoid what one knows, then one is apt to end up in another place. Whereas, if one deals with what one knows, one is apt to be where one began.

[...] If you believe that a situation exists which you are not familiar with; if you can avoid everything you know about that situation, and still make an action, then you must still be dealing with the situation; you must be making a positive action, even though your means are negative. You say no to this and no to that, and so forth, and you get somewhere. There is no point in reinforcing one's knowledge. I don't see the value of that.

BK: *No. But isn't it true that in painting there can exist really true discontinuities?*

JJ: There can only exist an illusion of those things when you are looking, because at the moment (I think, as far as I'm concerned) you are making anything you are stuck with your own logic. We are talking and we are talking in words and these words make up our thoughts and if thought is part of the process, you're stuck with thinking. You can't think what you don't think. But to trick one's thinking, which seems to me to be a valuable thing to do, one might make something happen which would not have happened had one simply relied on what one was assured of. [...]

BK: *When people come and look at your paintings and say stupid things, what do you feel?*

JJ: If someone came to you and said they can't drink out of a teacup, they have to drink out of a glass with the stem on it, that's their business. You may have a thought about it, but it doesn't have anything to do with teacups, or your thought about them. Hearing someone say something about a painting of mine that I don't agree with doesn't mean that I judge the painting badly, or nicely. That's a human relationship one has been dealing with. One very rarely has people, or I very rarely have people, who say things about what I do that influence my actions. There are a couple who do that. But otherwise one would be constantly altering everything, thinking that there was some kind of audience that should be pleased, and there isn't.

BK: *But it's not like you could bring a person into the room and make you alter your actions.*

JJ: Yes it is. I'm talking about specific people. There are about two people that I know who can say things about my work that I respond to as though I were talking about my work and react to it. But there aren't any more than that; just about two. Occasionally one knows someone that has ideas that one values in that way, or one feels that someone is familiar with what one does enough and has the removal from it that one seldom has in time. Or just a remark may carry a certain meaning.

JJ: It's called *Periscope (For Hart Crane)*. Do you know him? He is an American poet.

BK: *There is an arrow.*

JJ: There are all kinds of things.

BK: *What's the physicality like?*

JJ: This is the least physical painting of any work I've done recently. At least, I hope so. Physicality is purely illusionistic, or tends to be illusionistic. One might or might not think that circle has been made by that hand.

BK: *Isn't that using physicality in the true sense?*

JJ: It's what I call questioning it. […]

It's a difference in context. At one point you rule a line and you say, "This is a straight line," made with the narrow point of a pencil, and this is called a straight line. And in another situation you make it with a very fluffy brush and with your arm however it happens to work in terms of your mind, and you end up with what you call a straight line. But they're very different one from another. The references may be more or less similar but the mood would be quite different. The way you would describe it may be similar but its actual nature and the way it affects the senses are different. […]

BK: *On the one hand you have the possibility of using something like the neons....*

JJ: Well, anyone has the possibility of using anything. […] The whole world is available. It's a question, I think, of what anybody means. […]

BK: *Is there a danger implied in the flirtation with the new, with what's possible, with new ideas? […]*

JJ: […] When I use it in my painting it's no longer new. How long is something new? How long does newness last? But confronted with a new physical situa-tion I can use, if I have some use for it, I'll use it. I would not use it because it was new. […] The idea of something being new has to do with the fact that one hasn't had much to do with it. But its newness doesn't mean it's not avail-able. Everything is available, what's old and what's new. I don't see that there's any difference betwen the two. Or if there is, at what point is there that differ-ence? One's interest isn't in cataloguing. One's interest is in what will meet one's requirements, isn't it?

I-8. Lil Picard, "Jasper Johns," *Das Kunstwerk* (Stuttgart) 17 no. 5 (November 1963): 6–12. Interview conducted at Johns's studio on Front Street.

[…] *What occupies Johns is the [question of the moment when the transformation starts].* He says: "The moment one says something, it is something—at a certain point, though, it becomes something else, as object, as idea. In which moment is it an object? If one burns a book, in which moment is it something else than a book?" *The obsession to find out this moment of transformation induces Jasper Johns to scribble marginal notes into the paintings and collages or to put in letters which*

he applies with stencils. The gray pictures at the spring show with Castelli were filled with analytical markings, signals, clues.

To my question why in his last paintings he had attached a fork with a wire clamped in so that he obtains a sharper horizontal, he answered: "I heard as a child that a man had repaired an aeroplane with chewing gum." *Here is a psychological association which occupies him—the wire as chewing gum which holds the fork; the fork as an aeroplane. When I asked Johns why he chose the American flag as object he said:* "I dreamt one night that I painted the flag of America. The next day I did it." *Question:* "Why don't you paint the flag anymore?" *Answer:* "They added two stars. Since then the design does not interest me anymore."

[…] *A coat hanger, as Johns has painted it, is* the *American expression of a functional matter-of-factness. He tells the following anecdote:* "A negress saw at the home of one of my collectors my coat hanger picture. She said: 'I love this picture, it is so beautiful. When I come home in the evening to Harlem and take off my uniform—then I feel exactly as a coat hanger in an empty closet.'" *[…]*

I-9. Gene R. Swenson, "What Is Pop Art? Part II," *Artnews* 62 no. 10 (February 1964): 43, 66–67. The article is the second in a two-part series of interviews with painters who had recently become internationally prominent.

GRS: *What is Pop art?*

JJ: There has been an attempt to say that those classified under that term use images from the popular representations of things. Isn't that so?

GRS: *Possibly. But people like [Jim] Dine and [Robert] Indiana—even you were included in the exhibitions....*

JJ: I'm not a Pop artist! Once a term is set, everybody tries to relate anybody they can to it because there are so few terms in the art world. Labeling is a popular way of dealing with things.

GRS: *Is there any term you object to?*

JJ: I object to none anymore. I used to object to each as it occurred.

GRS: *It has been said that the new attitude toward painting is "cool." Is yours?*

JJ: Cool or hot, one way seems to be just about as good as another. Whatever you're thinking or feeling, you're left with what you do; the painting is what you've done. Some painters, perhaps, rely on particular emotions. They attempt to establish certain emotional situations for themselves and that's the way they like to work.

I've taken different attitudes at different times. That allows different kinds of actions. In focusing your eye or your mind, if you focus in one way, your actions will tend to be of one nature; if you focus another way, they will be different. I prefer work that appears to come out of a changing focus—not just one relationship or even a number of them but constantly changing and shifting relationships to things in terms of focus. Often, however, one is very single-minded and pursues one particular point; often one is blind to the fact that there is another way to see what is there.

GRS: *Are you aspiring to objectivity?*

JJ: My paintings are not simply expressive gestures. Some of them I have thought of as facts, or at any rate there has been some attempt to say that a thing has a certain nature. Saying that, one hopes to avoid saying I feel this way about this thing; one says this thing is this thing, and one responds to what one thinks is so.

I am concerned with a thing's not being what it was, with its becoming something other than what it is, with any moment in which one identifies a thing precisely and with the slipping away of that moment, with at any moment seeing or saying and letting it go at that.

GRS: *What would you consider the difference between subject matter and content, between what is depicted and what it means?*

JJ: Meaning implies that something is happening; you can say meaning is determined by the use of the thing, the way an audience uses a painting once it is put in public. When you speak of what is depicted, I tend to think in terms of an intention. But the intention is with the artist. "Subject matter"? Where would you focus to determine subject matter?

GRS: *What a thing is. In your* Device *paintings it would be the ruler.*

JJ: Why do you pick ruler rather than wood or varnish or any other element? What it is—subject matter, then—is simply determined by what you're willing to say it is. What it means is simply a question of what you're willing to let it do.

There is a great deal of intention in painting; it's rather inevitable. But when a work is let out by the artist and said to be complete, the intention loosens. Then it's subject to all kinds of use and misuse and pun. Occasionally someone will see the work in a way that even changes its significance for the person who made it; the work is no longer "intention," but the thing being seen and someone responding to it. They will see it in a way that makes you think that is a possible way of seeing it. Then you, as the artist, can enjoy it—that's possible—or you can lament it. If you like, you can try to express the intention more clearly in another work. But what is interesting is anyone having the experience he has.

GRS: *Are you talking about the viewer or the artist?*

JJ: I think either. We're not ants or bees; I don't see that we ought to take limited roles in relationship to things. I think one might just as well pretend that he is the center of what he's doing and what his experience is, and that it's only he who can do it.

GRS: *If you cast a beer can, is that a comment?*

JJ: On what?

GRS: *On beer cans or society. When you deal with things in the world, social attitudes are connected with them—aren't they?*

JJ: Basically, artists work out of rather stupid kinds of impulses and then the work is done. After that the work is used. In terms of comment, the work probably has it, some aspect which resembles language. Publicly a work becomes not

just intention, but the way it is used. If an artist makes something—or if you make chewing gum and everybody ends up using it as glue, whoever made it is given the responsibility of making glue, even if what he really intends is chewing gum. You can't control that kind of thing. As far as beginning to make a work, one can do it for any reason.

GRS: *If you cast a beer can, you don't have to have a social attitude on beer cans or art?*

JJ: No. It occurs to me you're talking about *my* beer cans, which have a story behind them. I was doing at that time sculptures of small objects—flashlights and light bulbs. Then I heard a story about Willem de Kooning. He was annoyed with my dealer, Leo Castelli, for some reason, and said something like, "That son of a bitch, you could give him two beer cans and he could sell them." I heard this and thought, "What a sculpture—two beer cans." It seemed to me to fit in perfectly with what I was doing, so I did them—and Leo sold them.

GRS: *Should an artist accept suggestions—or his environment—so easily?*

JJ: I think basically that's a false way of thinking. Accept or reject—where's the ease or difficulty? I don't put any value on a kind of thinking that puts limits on things. I prefer that the artist do what he does than that, after he's done it, someone says he should have done it. I would encourage everybody to do more rather than less. I think one has to assume that the artist is free to do what he pleases so that whatever he does is his own business, that he had choices, that he could do something else.

GRS: *But shouldn't the artist have an attitude to his subject, shouldn't he transform it?*

JJ: Transformation is in the head. If you have one thing and make another thing, there is no transformation, but there are two things. I don't think you would mistake one for another.

GRS: *Does art change with time?*

JJ: One can be content just to do something over and over again in a kind of blindness. But every aspect of a work of art changes in time, in five minutes or longer.

GRS: *Some painters have tried to paint Ageless Art.*

JJ: The whole business here in America, of my training and even more the people before me, was rooted in the mythology that the artist was separated and isolated from society and working alone, unappreciated, then dying and after that his work becoming very valuable, and that this was sad. That was part of the way I was trained. I think it's even less true than thinking that one is finding one's own values in the act of painting. One does it—paints—and wishes to do it. If not, you're making it into a kind of martyr situation which doesn't interest me very much.

GRS: *With what has been called the "New Audience" that situation seems reversed.*

JJ: Things are picked up and publicized as quickly as the mediums for doing those things allow. To say it is bad one has to have some idea about the social role art *should* have, that communication about art should be restricted because artists have a secret weapon or something which shouldn't be announced for twenty

In his studio on Front Street, New York, c. 1959.
Photograph: Walt Silver.

years for some reason—or because it may go out of date or someone will find something better. It's silly to say that art shouldn't get to be so well-known so quickly. How quickly should it get to be known? It should be publicized just as quickly as somebody wants to publicize it.

GRS: *But weren't you just saying that art should not be used as a social force?*

JJ: For myself I would choose to be as much as possible outside that area. It's difficult because we are constantly faced with social situations and our work is being used in ways we didn't ask for it to be used. We're not idiots.

GRS: *Then is it being misused in a social situation?*

JJ: My point of view tends to be that work is being misused in *most* situations. Nevertheless I find it a very interesting possibility, that one can't control the situation, the way one's work is viewed, that once one offers it to be seen then anybody is able to see it as he pleases.

I-10. Yoshiaki Tono, "I Want Images to Free Themselves from Me" (in Japanese), in *Geijutsu Shincho* (Tokyo) 15 no. 8 (August 1964): 54–57. Interview conducted in spring 1964 in Japan.

[...] YT: *You came to Japan unexpectedly from Honolulu, and during your two months in Tokyo you've made work, visited Kyoto, and met many people. This is your first visit in twelve years—you were in Japan when you were in the army, during the Korean War. You've made two works here—a big one,* Watchman, *and a relatively small one,* Souvenir—*as well as several sketches. Let's begin by talking about* Watchman, *in which the wax leg of a person sitting on a chair is stuck to the canvas. When did you get the idea for that work?*

JJ: The idea for this work first occurred to me two years ago, when I visited Madame Tussaud's, in London. The image of flesh, the image of skin—images I had never used before. I've tried since then to include those images in my work, but in vain. The idea of the leg of a person sitting on a chair came to me about a year ago. My first idea was the leg of a child sitting on a chair. I changed it into an adult's leg, and then into a man's leg. The sitting position also changed from a normal position low in the canvas to an upside-down position high up in the canvas. In the process of these changes, I continued to draw sketches in Honolulu and then in Tokyo until I finalized the composition.[2]

YT: *The other day you showed me a sketchbook, which [...] was different from an ordinary drawing sketchbook: like Marcel Duchamp's* Green Box, *it contained more words and expressions of ideas than drawings. Under the title "Watchman," it also contained an amusing piece of writing, "The Watchman and the Spy" [see plate 11— Ed.]. Was this influenced by the detective stories you enjoy?*

JJ: Of course I read a lot of detective stories. I wrote that after I drew the picture, in which I tried many ways of seeing things. A watchman's role is just to watch the other party, while a spy's role is to watch the other party and steal information from him without being seen. They have these characteristics.

I wrote that piece of writing because I like that sort of play on words.

The essay did come from the picture after I drew it, but I don't want you to associate the essay with the picture.

YT: *The poet Shin Ooka said that your picture made him feel some essence of various human dramas, or the trace of something that had abruptly passed away. […] The canvas made me feel somewhat empty, as if I had witnessed the end of a drama.*

JJ: Everyone is of course free to interpret the work in his own way. I think seeing a picture is one thing and interpreting it is another. For me the picture implies the fall of something, an interpretation I think is clear from the leg's position in the overall composition. Interestingly, a Japanese friend of mine who came to see this picture yesterday interpreted it as signifying an explosion (laughter). It was a totally unexpected interpretation, but it is interesting per se. The leg will naturally fall, however, if you cut the support that attaches the chair to the canvas.

YT: *[…] The Abstract Expressionists relied on action, chance, and large scale in their search for freedom of expression. As a member of the subsequent generation, by contrast, you have denied any sort of romantic self-expression, have restricted your- self to the use of simple, daily elements such as the three primary colors and the alphabet, and have consciously contained [your work's size], isn't that right?*

JJ: Yes, I have. I am in any case interested in measuring the size of things and naming them. I am also interested in picking up a set of circumstances and naming them, X. Come to think of it, X may turn out not to be X a little later, or the circumstances may not have been X immediately before they were named so, but we are satisfied simply to call them X. For instance, there is the word "red." But what is "red" out of many shades of red, or which "red" is the real red, this red or that red? When we gradually add yellow, exactly how much yellow will turn "red" into "orange"? I find this way of seeing things very interesting. If you take up something, for instance, and you name it "some- thing," then you and I can understand exactly what the other party means through this naming. This is useful and necessary in our daily life. If we come closer and closer to that "something" to identify it, however, we will begin to wonder whether that "something" is really "something" or not.

YT: *You mean you want to bring out the difference between the term "red" and the color called "red," or the difference between sign and referent?*

JJ: No, I don't want to show the difference, or the distance, to other people. I just want to examine it for my own benefit. In other words, I want to exam- ine various stages to see whether or not the sign adequately coincides with what's perceivable.

YT: *When you painted a flag, I wonder if you were strongly aware of the difference between the title "Flag" and the picture itself titled* Flag. *We have varieties of flags—a white flag, a green flag, an orange flag, and an ordinary flag depicted in the colors of the Stars and Stripes.*

JJ: Not always so. While I was painting a flag, I was aware that it was not a flag that I was painting. If I say that it was a flag and at the same time it was not a flag, I am answering the question you have asked, am I not?

YT: *What do you mean by saying that it wasn't a flag?*

JJ: It was a picture, after all (laughter). It was a work. What I've said concerns the theoretical aspect of a flag. There is another aspect, or the visual aspect of a work. For instance, when you're going to paint a flag, you put red where you think there should be red, blue where you think there should be blue, white where you think there should be white, and stars and stripes where you think there should be stars and stripes. Then at first everybody tends to regard it as a flag, and not to take it for a picture. However, if I paint a flag in white only, using various brushstrokes and tone variations, or many painterly elements, then people would tend to regard it as a picture and not as a flag. It is the gray zone between these two extremes that I'm interested in—the area [where it] is neither a flag nor a painting. It can be both and still be neither. You can have a certain view of a thing at one time and a different view of it at another. This phenomenon interests me.

It may be too simplistic to divide a thing into two opposing poles (i.e., into the picture and its title, as was the case with the flag), but let me do so for the sake of simplicity and easy understanding. Then mightn't I say this: suppose there are two portions, and one is external and the other is internal. Let's try to consider the reverse case too. Now even if you take up the external portion and draw it into a picture, the internal portion continues to exist all the while. I think this fact should be kept in mind.

YT: *In other words, it's the dualism of idea and sense, work and its title, or language and picture, isn't it?*

JJ: Well, I'm interested in seeing a thing through as many approaches as possible. I may sound as if I'm disposed to think in terms of dualism, but I don't want to advance dualism of my own accord. For one thing, if you divide a thing into two parts, they may then break into further parts.

YT: *Allow me to repeat. You have used simple objects such as flags and targets. Does this mean, in a paradoxical way, that you cannot ensure rich possibilities of seeing things without such simplicity?*

JJ: The term "paradoxical" comes from your attitude as a critic. I did paint flags and targets, but it was years ago. In my recent works I use more complex subjects. Anyhow, I don't mean to simplify things when I choose one object. It's the natural course of my thinking. In my thinking at that time, this thing was this thing, or this canvas was this canvas, and was nothing more than that. So I didn't see any need to go to the trouble of simplifying things. Conversely, I was just interested in enriching things as much as possible. One way to do this was to stare at a certain situation without allowing my attention to waver, and focus my attention on it. Then you could read between the lines, so to speak, and could see diversity behind them, partly overlapping them. You could see the other, totally different aspect emerging behind them.

YT: *Why did you start painting flags? Everybody wants the answer to this question. I would appreciate a brief comment.*

JJ: I can answer this question very simply, because I have answered it many times.

One night I had a dream, in which I painted a picture of a big Stars and Stripes. The next morning I actually painted a picture of the American flag. I've never told you about this dream because I was afraid you might think me a fool. Even if I did, I'm afraid few people would believe me.

YT: *Another question is about Pop art. Pop art is much talked about, both in the States and in Japan, although there are lots of pros and cons.*

JJ: Undoubtedly Pop art is an art trend reflecting new ideas, which originated in the United States. Young Japanese artists tend to see it only in reproductions, which interest them. This isn't always bad, however.

I don't see myself as a Pop artist, and I feel no temptation to lecture on Pop art. The names of new trends like this one are often unreliable and groundless. I presume those pros and cons come from insubstantial discussions of new trends.

YT: *But you and [Robert] Rauschenberg are generally considered the pioneers and originators of Pop art.*

JJ: It is probably because it was only Bob and I who were painting images (figurative art) during the age of action painting, when so-called images were not yet used. Today, what we used to do has become a matter of course. Yet I pride myself on the fact that our initial works broke with the latest academicism in those days.

YT: *Are you interested in what critics or other people say or write about your pictures?*

JJ: Yes, very interested. My works are pictures and not words. Different people express their own views on my pictures in different words, and those different views and different words interest me immensely.

YT: *Then do you find both positive and negative views of your pictures equally interesting?*

JJ: Yes, I do, because I am the first and best critic of my own pictures. I know and understand everything about my pictures from beginning to end. I can make both very good pictures and very bad pictures. I can make middling pictures too. After all, I am a versatile painter, aren't I? (laughter)

YT: *That way of speaking is very critical of critics, isn't it? (laughter)*

JJ: No, not at all. I have no interest in what criticism should be, what it is, what it was, or that sort of thing. Reviews are written expressions, aren't they? If a review is expressed beautifully and perfectly as a critic's own expression, I will find it interesting per se, even if it denies my pictures. Writing's value goes beyond the level of favorable or unfavorable views of works. Criticism's significance is there and nowhere else. To be plain, the best critic of a picture is another picture.

YT: *Your style has now changed from the depiction of simple images such as flags or numbers to a style involving actions such as pasting or painting objects on the canvas, as in recent works including* Watchman. *Would you comment on this change?*

JJ: According to your categorization, I used to be within the framework of numbers and targets, but I began to think I didn't necessarily have to stick to that framework. As a result, I have begun to use images more freely and to choose

whatever objects I like; I have begun to want an object to be free from the way I see it.

YT: *[Jackson] Pollock, for instance, struggled to be free from established images by accumulating actions. His intention is very clear when we see his painting process: his pictures are like accumulations of image-denying actions. Yet undeniably humanlike images emerge from the depths of his works. You, on the other hand, seem to have tried to free yourself from images by giving yourself over to simple, established images such as flags and numbers.*

JJ: No, that's not correct. I never want to free myself from images at all; I want images to free themselves from me. That may be why I often use objects on the canvas in my recent works. For this purpose I try to use not only paint but also many more materials. The reason for this, however, is not because I am attracted by the novelty of objects. Nor do I choose these materials as a sort of design, or for aesthetic reasons. I only try to find a way to leap from one material to another. In other words, I simply want the object to be free, as it is in a picture, without changing its quality and without confining itself within the picture. I said a leap between materials, but to be exact, such leaps also occur between colors. When I used white and gray, there was a leap between them. When I used white and black, or green and red, I felt the difference between materials. Then, when I wanted to make a three-dimensional work, I had to paint it with materials of the same nature, called paints. Then I wanted to put some materials different in nature from each other on the canvas. I did so, not for aesthetic reasons, nor for artistic arrangements of materials. I just wanted to show on the canvas the simple fact that some materials are different from others.

YT: *That reminds me of a letter to you from Shuzo Takiguchi, then on tour in Osaka. I understand the letter said something to the effect that you are Marcel Duchamp's "only son," because he had no sons. Indeed I think there is a strong link between you and Duchamp.*

JJ: Yes. Mr. Takiguchi is like an adult child. His letter was very interesting. Marcel Duchamp has achieved a wonderful miracle of turning "something" he used as "something" into "something" as it is. In other words, in ordinary works there is a process of making them; in his case he has assimilated that process itself into his work. This is the point I am attracted to. If he uses a telephone as a readymade, then it becomes an art object. This is really wonderful, isn't it?

YT: *Is it because he declared that a urinal was an art object, for example?*

JJ: No, it's because he "used" it as a material. He could appropriate objects from the outside world and call them "art objects." As a result, they became art objects, and we are willing to call them so. This approach is now helping to perform all the roles that art is supposed to perform. The fact that Duchamp has accomplished that approach is really wonderful. He has demonstrated that what we once regarded as "out of the question" can now be realized. He has never done what [Pablo] Picasso did. Picasso used everything from the past

and commented on the past; Duchamp has never done so. However, if you say Duchamp is my forerunner, I can't entirely agree with you. Duchamp, who has created those works, is no one else but Duchamp.

I-11. Yoshiaki Tono, "Jasper Johns in Tokyo" (in Japanese), *Bijutsu Techô* (Tokyo) (August 1964): 5–8.

[…] Day X of month X: I went to Hotel F to see [Jasper Johns], and found him amusing himself by playing Scrabble with his best friend, the architect Todd Bogatay. […] After emptying five glasses of bourbon and soda, J.J. made short work of a steak as large as a hot-water bottle at [the steak restaurant] Suehiro. On our way home, he spotted a plate in the show window of a tourist souvenir shop on the first floor of the restaurant. He was greatly attracted by the plate, which had a color portrait-photograph baked on it. "I want to use a plate with my face baked on it in my work."

(Comment: Two plates were finished two months later. He had his face photographed in a ten-minute automatic machine at Takashimaya Department Store. Then he baked the picture on two plates, one in color and the other in black and white. The names of his favorite colors, RED, YELLOW, *and* BLUE, *were baked on the rims. The plates were placed on a ledge attached to the lower left-hand side of the canvas. The rearview mirror of a bicycle fixed on the upper-right-hand side reflects the light from a flashlight placed below. The canvas is painted grayish black all over. A small reversed canvas is pasted on it [*Souvenir 2*]. The wrong side of the canvas is visible. J.J. confided,* "I've drawn too much, and I just wanted to conceal it." *Their title is* Souvenir, *no. 1 and no. 2.*[3]*)*

Day X of month X: J.J., Yusuke Nakahara and I visited Shuzo Takiguchi, who was drawing a picture in Sam Francis's (S.F.'s) studio. […] [T]he only visible thing on a big white canvas was a vague egg shape with its lower half clouded in thin black ink. We were told that Takiguchi had been staring at the canvas for two days, unable to use colors for some reason. Then he drew the egg shape by wiping the canvas with a cloth because he was scared of using a brush. […]

In a bar that evening, J.J. recalled, "That canvas was propped against the ladder. The corners of the ladder pressed into the canvas from the reverse side, making some protrusions on the surface. Their shades were beautiful. I'm more interested in that than in expressing myself or things." *[…]*

Day X of month X: J.J. has begun to confine himself to a rented studio on the seventh floor of the Artists' Hall on the Ginza. He bought wax refined from honeybee hives, and looked for an old chair. He complained that all Japanese chairs were designed too nicely, and that perfectly ordinary old chairs were unavailable. Then he ordered a wooden sphere with a diameter of about fifteen centimeters and purchased plain brushes of the type used by sign-board painters, in order "to reduce the effects of nice *matière* as much as possible." *I have no idea of what he has in mind to achieve.*

Day X of month X: J.J. has begun to make frequent visits to bars L and G on the Ginza. He can "down sake by the barrel," *but he never loses control of himself.*

At work on a lithograph at the Universal Limited
Art Editions print workshop (ULAE), West Islip,
New York, in June 1962. Photograph: Hans Namuth.

Monologues in these bars:

"The best criticism of a painting is another painting."

"What a ridiculous job painting is, mixing paints and smearing the canvas with them! It's almost an act of madness. I don't like any painter's work, least of all mine." […]

"As you [Tono] have written, people say that my works are 'neutral.' But if you paint something, it is 'something,' and it cannot be neutral. Being neutral is a mere expression of a form of intention."

[…] Day X of month X: As the Artists' Hall and its studios are closed on Sundays, we visited the studio of Shinjiro Okamoto, Ushio Shinohara, Shintaro Tanaka, and Tomio Miki. J.J. was overjoyed to see the entirely different materials and colors used in Shinohara's imitation art of Rauschenberg's Coca Cola Plan. *But he became suddenly lost in thought when he saw that the imitation of his own* Three Flags *had been inconsiderately painted with fluorescent orange. He was impressed by Miki's huge aluminum* Ear *and confided that he wanted to see it on the walls of a spacious museum.*

In the car on our way home, J.J. said, "While looking at Shinohara's *Three Flags* I decided on the image of a work I have been thinking about making. The title is *Optical Echo: Two Flags.* On the upper half of the canvas I will paint an American flag with the complementaries of red, white, and blue, with the stars and white lines in black, the background of the stars in orange, and the red lines in green. It will be a very ugly flag. Another flag of the same size will be painted all in gray, just under the first flag. I wonder if the background should be gray. If you gaze at the upper flag, and then suddenly look at the flag below, you will see the primary colors. Even if you don't, I don't care. But this idea is wonderful, isn't it? Is this multiplication or addition of a painting? *[…]*

Day X of month X: J.J. was impressed by a doll with a cloth on its head at Nobuaki Kojima's one-man show, and asked many questions about the technique. He was moved by a color photo on the cover of the [weekly magazine] Mainichi Graph, *showing Picasso in a yellow beach-gown with a dog. He earnestly requested an enlarged print of the photo.*

"I understand that Picasso was very fond of American comic strips, […] and that Gertrude Stein often showed them to him. Picasso's girlfriend [Fernande Olivier] was also fascinated by them, and even after Picasso left her, she asked Stein to continue to send those comics." […]

*Day X of month X: J.J. phoned and asked me to come and see a work he had just finished [*Watchman*]. It is a month and a half since he started. […]*

The canvas gives the impression of dead silence, in which a drama has ended, leaving a sense of emptiness yet substantialness. Conversation is scarce.

"It looks like a fallen angel."

"I have made the leg unlike a real one. I wanted to leave the trace of my own making."

"The space at the bottom is the very essence of your work."

"On the street, you will look up at the sky and then look down at a building,

or you will look at a woman and then at a construction site. In this work you shift your eyes from the leg to the ball, or from the colored squares to the 'scraping,' don't you? When I painted flags or targets, I used to see the whole picture at a time, only to make 'seeing' meaningless. Recently I've been using such objects and traces of action in order to diversify the ways to see things."

"*It is a sort of Cubism, I presume?*"

"No. Cubism is an anatomical chart of a way of seeing external objects. But I want to confuse the meaning of the act of looking." [...]

*Day X of month X: I went to J.J.'s studio with Jun Miyakawa, my rival critic, who had criticized my attitude toward J.J. in this magazine [*Bijutsu Techô*]. Also with us were the magazine's reporter O [Takahiko Okada] and photographer T [Kenichi Tsunoda]. I found* Watchman *greatly changed from what I had seen the other day.* RED, YELLOW, *and* BLUE *were written in big letters in the left-hand half of the canvas, and the background had been painted thickly with a dull, deep grayish black.* [...]

I acted as Miyakawa's interpreter: [...] "All the key elements on the canvas are placed toward the left side. Is this intentional?"

"Unfortunately, everything I do is intentional!" [...]

J.J. is a devoted reader of Ian Fleming's "007" series. He is a fan of Pussy Galore, the female gangster in "Goldfinger."

Day X of month X: [...] [Johns] said that since he had been lazy in his work, he had nothing to exhibit at his one-man show in New York despite his promise. He had taken pains to prepare a list of works and showed it to me. It said, "Yours and Mine," "Corner Painting," etc.

"I have no works or even their images yet. All I have done is name them."

I-12. Jay Nash and James Holmstrand, "Zeroing In on Jasper Johns," *Literary Times* **(Chicago) 3 no. 7 (September 1964): 1, 9, 14. Interview conducted at Johns's apartment and studio, then at 340 Riverside Drive, New York.**

[...] JN&JH: *We hear you're leaving for South Carolina in the next week or so. Is this your home?*

JJ: I try to live there as much as I can but I have to be in New York most of the time. I'm from there originally. Three or four years ago I got a house down there but then I got a commission to do some work at Lincoln Center [*Numbers*, 1964, in the New York State Theater] so I had to be here.

JN&JH: *Where do you live down there?*

JJ: I live on Edisto Island. Except during the resort season, there are only four families living on the island. My place is on the beach ... forty miles to the nearest movie. [...]

JN&JH: *Although you deny being a Pop artist, you sometimes use such things as beer cans, light bulbs, etc., in your work. Doesn't this seem inconsistent?*

JJ: No. I don't think of myself as a Pop artist. Generally, people called the Pop movement single-minded It is technically more restrictive and deals

mostly with images. I am not so much interested in dealing with images as working for form.

JN&JH: *A number of painters—not only the Pop painters, but people like [Larry] Rivers and yourself—have concerned themselves with American subject matter (maps of the U.S., Confederate flags and soldiers, portraits of George Washington, etc.). Do you think this reflects an increasing nationalistic pride in artists?*

JJ: I don't think so. I'm merely concerned with looking and seeing and not much else. I'm not involved in patriotism or politics. […]

JN&JH: *Do you feel that the use of commercial subject matter such as Campbell's soup cans, Brillo boxes, etc., reflects an acceptance of or at least a coming to terms on the part of American artists with American materialism?*

JJ: It is not one of my subjects. [Andy] Warhol does that sort of thing.

JN&JH: *Speaking of Brillo boxes, we understand that the designer of the boxes is upset because of Warhol's use of his exact design. Are there any problems of plagiarism involved here?*

JJ: In the world of trademarks it is difficult to claim ownership of anything.

JN&JH: *In the 1950s were you consciously reacting against "the flood tide exploitation of Abstract Expressionism"?*

JJ: Who said *that*?

JN&JH: *[Betty] Kaufman in* Commonweal.[4] *Or, rather, as someone else stated it, is your stylism a logical step beyond Abstract Expressionism?*

JJ: Well, the work I was doing then probably came because of some awareness of what was happening in art. I tried to consciously avoid making statements that were already being made well. The 1940s did something valuable with the work of Pollock and others. In the 1950s there was a hangover where they were not producing private [pictures] but painting public pictures and refining statements. I am not interested in refinement. I try to avoid resemblances. While I am working on a picture, if it begins to suggest what someone else has done, I try to work it some other way.

JN&JH: *You stated in an interview in* Artnews *that you are concerned with a thing not being what it was, but with its becoming something other than what it was.[5] Is this related at all to the double or ambiguous images of [Salvador] Dali and [Pavel] Tchelitchew?*

JJ: I don't identify in such a way, nor am I concerned with that judgment—good or bad. I don't know what elements enter into it. Dali? He uses mental images and not visual ones. I know it is difficult to define the difference between the two but it is all tied up with the Freudian concepts—that kind of juxtaposition. I am not interested in that. It all centers around the idea of dreams—one image juxtaposed with another. But modern images take on this juxtaposition without any intention on the viewers' part. This is not Freudian. The mind has never made images such as Dali thinks they do. To focus on this is false because you are then unable to see the right kind of meaning.

JN&JH: *Do you feel today more than ever [that] you must promote your art as a*

public figure much the same way [Francis] Picabia and Duchamp of the Dada movement did?

JJ: Painters are not public but rather are born in private. The public has made it their business; however, for the painter, art will never be public. Of course one man's humor is another man's seriousness. For example, Duchamp said, "I must destroy art for myself so that it will not be destroyed for you." But basically it is not so much a public action. [...]

I-13. Walter Hopps, "An Interview with Jasper Johns," *Artforum* 3 no. 6 (March 1965): 32–36. Published on the occasion of John's one-man exhibition at the Pasadena Art Museum.

WH: *Jasper, from what point in your life would you date the beginnings of your career, your sense that you were an artist, or going to be an artist?*

JJ: Going to be an artist since childhood. Until about 1953 when it occurred to me that there was a difference between going to be and being, and I decided I shouldn't always be "going to be" an artist.

WH: *And in 1953 were you then working in New York or were you still in the South?*

JJ: I was in New York.

WH: *Some of the earlier works such as the small green piece that's in the showing at the museum, did you do that when you were in New York or outside of New York?*

JJ: New York.

WH: *Were you at Black Mountain? This has never been clear to me.*

JJ: No.

WH: *Do you recall the year you did the first flag?*

JJ: '54, but I'm not certain.

WH: *Does it exist? It hasn't been in any of the shows.*

JJ: It was in the [1964] show at the Jewish Museum. It's a large painting; it belongs to Philip Johnson. It's in sort of bad shape; it tends to fall to pieces.

WH: *Does it have bits of the collage paper or little photographs ... does it have other materials coming through, such as the small one of 1955 that's in the present show?*

JJ: Nothing so obvious as that series of photographs. I suppose some of the type is visible. In a few places there are a few embossed papers which probably come through.

WH: *Was there any iconographic significance in the material that showed through or were your thoughts essentially formal?*

JJ: I think only in the instance, say, where there are those photographs [*Flag above White with Collage*, 1955]—that's a very deliberate kind of thing clearly left to be shown, not automatically used, but used quite consciously. But generally, whatever printing shows has no significance to me. Sometimes I looked at the paper for different kinds of color, different sizes of type, of course, and perhaps some of the words went into my mind; I was not conscious of it.

WH: *This is certainly the case with the book, the little painted book construction [Book] which you said was merely a book you weren't about to read, but was exactly the shape you wanted, and had nothing to do with it being a specific book.*

JJ: Right.

WH: *But then we get to a little target such as Michael Blankfort's small one of 1958 and it has always struck me as a marvelous bit of gratuitousness that the one looming bit of newspaper type that comes through near the center of it says "A very far-sighted man."*

JJ: I was not aware of that. (Laughing) That's the first I heard of it.

WH: *Were there historical artists whose ideas or work were involved in your thinking?*

JJ: I think not. I think I had never organized any thinking, any of my own thinking, so that I don't think other people's thought was very interesting to me.

WH: *What about the case with your own peers and contemporaries? The working relationship that you had with Bob Rauschenberg is spoken of quite a bit and I assume there was a mutual working regard for one another's activities at the time. Who beyond Rauschenberg, if anyone?*

JJ: Personally, no one, I think, because I didn't meet any people at that time, any artists, and so my contact was only public contact with work. I saw Rauschenberg's work, and I saw [Cy] Twombly's work, perhaps a bit of Jack Tworkov's work at that time in a studio situation, but most of the painting I saw was in galleries.

WH: *You mentioned once that you admired Tworkov's painting; was there some particular aspect of it?*

JJ: I have admired his painting. I saw a good deal of his work and it was meaningful for me to see it and this work, of course, changes a great deal from piece to piece even within a very short time. One painting may be quite different from another.

WH: *I would say this is true in your own work. It was very fascinating to me to see the three different paintings you had in progress in your studio in South Carolina. There they all were, being worked on close to the same moment, and yet some years from now, superficially we could place them at different moments of your career.*

JJ: Yes.

WH: *When did this sort of thing begin to happen, and do you feel that it's an important part of your working way to go back and pick up images that began perhaps five, six, or more years before? Is this something you would expect to be the case?*

JJ: Well, sometimes it happens unconsciously that we return to something; some aspect of something which is done returns in another painting unconsciously. There's another thing. In working, if you attempt to work in a way that changes, which I try to do, it can be exhausting at times and you may go back to something more familiar just as a rest. And then sometimes there is some deliberate reason for perhaps doing something that you had always meant to do and had never done.

WH: *Your first show in New York was in 1958. I've often wondered if you chose the occasion for that to be your first show there or did circumstances choose it.*

JJ: Circumstances. I guess around 1957, I had a good deal of work and I decided that I would like to show it; and there was no place that I wanted to show it because most of the galleries were involved in particular kinds of painting that

I didn't think I'd be happy to enter. I didn't think I'd be happy to enter this kind of situation, the gallery situation. Then the only place I wanted to show was Betty Parsons who seemed to have no kind of … nothing that they were promoting, so I felt kind of free in that situation. Then I contacted Betty and she said she was on her way to Mexico and wouldn't be back for six months. She said she had more artists in the gallery than she could take care of … she did this all very nicely, but.…

WH: *Had she not gone to Mexico, things might have been different for all of us.*

JJ: Maybe, I don't know. At any rate, she didn't come down to see the paintings. There was no one else I wanted to see them. Then a painting of mine in some way got into a show at the Jewish Museum. Leo Castelli saw it and Leo, I guess, had just opened a gallery, and I had never been there, and he came to see the paintings and wanted to show them.

WH: *Yes, that was the large green target that The Museum of Modern Art has. What sort of ideas led you from the flag to the target and some of the other images you then began working on? Did you see a kind of strain of a single idea?*

JJ: Yes, I think so. The target seemed to me to occupy a certain kind of relationship to seeing the way we see and to things in the world which we see, and this is the same kind of relationship that the flag had. We say it comes automatically. Automatically you tend to do this, but you see that there are relationships which can be made and those seem to me the relationships that could be made between two images. They're both things which are seen and not looked at, not examined, and they both have clearly defined areas which could be measured and transferred to canvas.

WH: *They both exist on a flat surface.*

JJ: Yes.

WH: *Was this also the case when you began with a number painting as well?*

JJ: I believe so, if I'm right, that the first number paintings were just single figures. And that seemed to me very much the same. Then I saw a chart. You know the gray alphabet painting? I saw a chart in a book that had that arrangement of the alphabet. Then I of course realized I could do the numbers that way too. But earlier than that, with the first numbers, I didn't do every number and I didn't work on them in any order and I deliberately didn't do them all, so that there wouldn't be implied that relationship of moving through things.

WH: *Duchamp emphasizes the idea that his artworks are idea-carrying. He's often very unconcerned with how they look. To what extent has your painting at some particular point assumed idea-carrying qualities that weigh to a significant factor, along with making visual or formal choices?*

JJ: My idea has always been that in painting the way ideas are conveyed is through the way it looks and I see no way to avoid that, and I don't think Duchamp can either. To say that you don't care how it looks suggests something that I think is not quite possible, if what you're doing is making something to be looked at. Then, if it looks one way, it's one thing, and if it looks another way, it's another thing. But one thing is not another thing. I understand that if you

have an idea for a picture and if you make a picture, and if you take certain characteristics of a picture or whatever and make another picture, that they will share something, there will be some information, perhaps, which is conveyed by either of them. But I think what is more interesting to me is the particular object encountered at any moment. Oh, that's questionable, but I tend to think that the one object which is being examined is what's important.

WH: *One might paint a number—the number 2, for example—because one merely likes the way it looks in some way, or one might decide to paint the number 2 because in the abstract sense the idea of painting a number was interesting. At some point did you find yourself interested in the idea of the number as an abstract idea or did it remain the case as you described with the alphabet chart? You saw it and you liked the way it looked.*

JJ: Well, I don't understand what abstract sense can be implied. I don't know what would be meant there; I'm certainly not putting the numbers to any use, numbers are used all the time, and what's being done is making something to be looked at. I don't know how to answer. I don't want to insist upon making a beautiful object, which is not what I mean, but in making a painting, you work with what you see and what you do and the painting seems to me to be primarily concerned with those two things. The physical actions you take to make the painting, and the responses to looking at it.

WH: *The work up through '58 or so had a far more static quality. There was less movement in the imagery and so on, until suddenly you did* Device Circle *and* Shade. *Something different happened there, and I wondered what you might tell us about your thoughts, what went on in your work, or what led to this change? How would you characterize the change?*

JJ: There was a change. I don't think of it as drastic.

WH: *Somehow looking at all the work together, I don't either, which interested me very much. If I looked one day at the* Flag on Orange *[Field] and another day at* False Start, *they seemed to be two drastically different things, and yet seeing it all together was less of a change.*

JJ: Well, of course, the *Flag on Orange* was involved with how to have more than one element in the painting and how to be able to extend the space beyond the limits of the image, the predetermined image. And then the problem, I think, was how to make a painting without having that kind of object at all.

WH: *So this was the decision: to introduce from your point of view a more complex range of elements that would work together within the painting.*

JJ: Right. It got rather monotonous, making flags on a piece of canvas, and I wanted to add something—go beyond the limits of the flag, and to have different canvas space. I did it early with the little flags with the white below, making the flag hit three edges of the canvas and then just adding something else. And then in the *Orange,* I carried it all the way around.

The early things to me were very strongly objects. Then it occurs that, well, any painting is an object, but there was … I don't know how to describe the sense alterations that I went through in doing this in thinking and in seeing.

But I thought how then to make an object which is not so easily defined as an object, and how to add space and still keep it an object painting. And I think in, say, *False Start* and those paintings, the object is put in even greater doubt and I think you question whether it's an object or whether it's not.

WH: *Then it would seem that a third stage was introducing actual objects into it in a very overt way. I was very struck by this in your recent work. What might have been the first work where this began? Of course, it's implied a bit in* Shade.

JJ: Well, it's in the targets with plaster casts and in the *Gray Canvas* it's quite clear, I think. I think if there was any thinking at all, or if I have any now, it would be that if the painting is an object, then the object can be a painting... and I think that's what happened. That if on this area you can make something, then on this area you can make something.

WH: *I wondered how you might characterize the greater art situation in New York, your relationship to it.*

JJ: It is very busy.... I think it's difficult to make any kind of judgment there because it's very complicated. Many levels are not publicly acknowledged. The best thing about it is that there are many people working and a great deal of work is being done. I think that's what's lively about it.

WH: *Have you felt merely an increased liveliness or any kind of change in the character of the situation? I mean in the working art scene. Have you felt any change in that during the time you've been in New York?*

JJ: I've never been very close to very many artists; I was very close to Bob Rauschenberg and during a certain period was very familiar with Jim Dine's work and saw it being made. That's always lively, being close at hand when things are being done rather than simply seeing things presented. But I've seen very little in that way; I've seen a good deal publicly but not really been involved with people who were working because I haven't been there very much.

WH: *Are there any works that you've done that seem particularly germinal to you, or that seem to particularly achieve what you may have wanted of them?*

JJ: I think the problem is more what to want rather than whether you get what you want in painting. If you want something, you just make it. But I'm avoiding your question.... Certain paintings are meaningful because they allow you to shift weight in a different way.

WH: *In other words, you might have what could be considered a specific image, an image that's open and could be shifted in format, handling, and so on?*

JJ: No. I mean that some paintings involve elements which are not involved in other paintings and when those elements become involved then one is free from the boundaries of what one had been doing and can move. That kind of thing can happen either by dropping something, letting go of it, or by attaching something else, bringing something else in. For me, say, a painting like *False Start* offered certain possibilities that I had not had.

WH: *Why did you call it* False Start?

JJ: Because I was working on the painting and I didn't know what to call it and

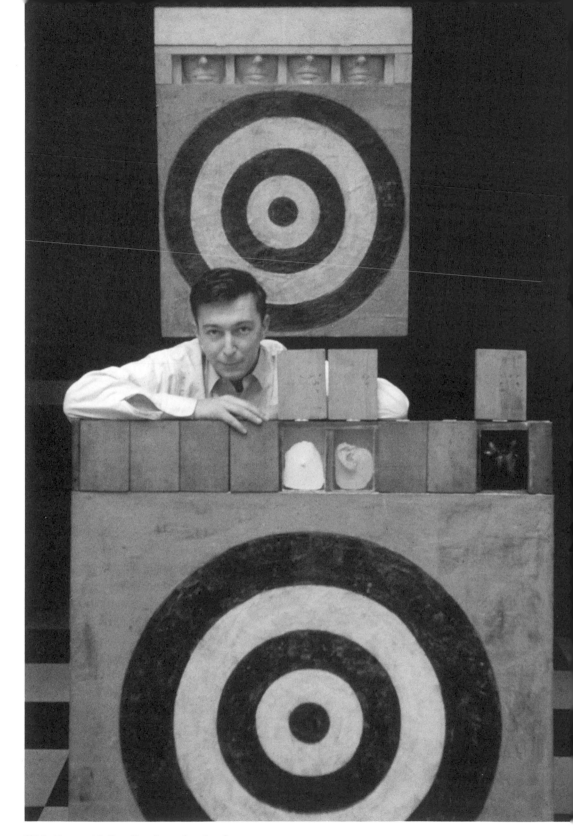

With *Target with Four Faces* (1955, above) and
Target with Plaster Casts (1955, below), in 1964.
Photograph: Dan Budnick.

it wasn't like my other paintings, and one day I was sitting in the Cedar Bar and looked up at a print of a horse race which was called *The False Start,* and I said that was going to be the title of my painting.

WH: *Some of your drawings… is this correct?… are sketches before the fact of something that will be achieved in painting. Is it true that there are those that are drawings after the fact?*

JJ: Most are after. Only a couple, three or four, have been sketches or ideas which then were made into paintings, and were done with that intention. Generally the drawings have been made just to make the drawing, and the simplest way for me to do it was to base it on a painting which existed, although they generally don't follow the painting very closely.

WH: *One drawing that I had never seen before was called* Memory Piece. *It looks as though it's diagrammed for a piece of sculpture—an object to be made.*

JJ: Yes, it is; it's never been made. I keep a sketchbook and sometimes I do little sketches in that for ideas. I believe, I'm not certain, that I had sketches in the notebook trying to figure out how to do that piece. I may have done that drawing as a diagram for a carpenter who was going to make the cabinet, build a cabinet with drawers. But it never got made.

WH: *The sculpture seemed to come at a time when a good deal of your art was based closely on some of your own personal, immediately accessible objects. Has there been a feedback in some of the things you began to do in the sculptures into the sense of your painting? I felt that some of the things that you did, the painted bronzes and so on, began to, in one sense, influence some of the painting that you have done.*

JJ: In what way do you sense that? In the use of objects in the paintings?

WH: *I began to feel it a little bit in the case of the flashlight. It is not entirely a general thing. Flashlights look very different, one from the other, so that having done the flashlight, it would seem to be yours. The beer cans, something that you would have had around in the course of your own life, and the brushes and the Savarin can, and so on, seem very much yours, very closely identified.*

JJ: Right out of the studio. They'd been sitting there a couple of years before I noticed.

WH: *Exactly. Out of the studio. Particularly in a painting like* Studio, *where it is literally the imprint of your own studio door, certain qualities seem more closely identified with your own life, working from some general area to more personal things.*

JJ: My only idea is that one ought to be able to use anything that one can see and any quality one can perceive. It's difficult for me to just do that because, I don't know, because I formed habits which only let in certain things or sometimes because the qualities simply are not visible, until a certain time. Suddenly you see something you have not seen. I don't know for what reason, it's clearly not something you've invented.

WH: *The problem is then not really finding things that are hard to find, but suddenly recognizing what's just there.*

JJ: Yes, I think that, and also being able to use them, and just because they're there doesn't necessarily mean you're about to put them in the painting.

Also what happens is you form habits, ways of doing things, and you're so used to moving your body in a certain way, and your mind as well, that you never think to do another kind of action which would give you a different result.

WH: *I was thinking that one of the curious things about* Paint Brushes *[*Painted Bronze *(Savarin can), 1960] is that they were in fact probably very much as we see them in the sculpture in bronze. In no other works, not even the beer cans, have you gone through all of the rather arduous process of creating them as a work of sculpture and bringing them right back to what is extraordinarily close to the way they actually were.*

JJ: Well, I think this is part of it. You have a model, and you paint a thing to be very close to the model. Then you have the possibility of completely fooling the situation, making one exactly like the other, which doesn't particularly interest me. (In that case, you lose the fact of what you actually have done.) I think what I hoped for was to get very close to that but to still have a sense of what the thing was, what it is. I like that there is the possibility that one might take the one for the other, but I also like that, with just a little examination, it's very clear that one is not the other.

I-14. Interview with David Sylvester, recorded for the BBC in June 1965 in Edisto Beach, South Carolina; first radio broadcast on October 10, 1965. The excerpt below was published in *Jasper Johns Drawings*, exh. cat. (London: Arts Council of Great Britain, 1974), pp. 7–19.[6]

DS: *What was it first made you use things such as flags, targets, maps, numbers, and letters and so on as starting-points?*

JJ: They seemed to me preformed, conventional, depersonalized, factual, exterior elements.

DS: *And what was the attraction of depersonalized elements?*

JJ: I'm interested in things which suggest the world rather than suggest the personality. I'm interested in things which suggest things which are, rather than in judgments. The most conventional thing, the most ordinary thing—it seems to me that those things can be dealt with without having to judge them; they seem to me to exist as clear facts, not involving aesthetic hierarchy.

DS: *If you were to begin with a common object such as a bottle or a loaf of bread, something again which has a conventional and recognizable form—I suppose the nearest you've come to that was in using a wire clothes-hanger—this would be another way of dealing with something impersonal and external and factual and working upon it, reinforcing it and obliterating it. But you prefer to begin with, say, numbers, letters, flags, geometric divisions of the canvas. I take it that this is a matter of instinctive preference rather than doctrine?*

JJ: Oh certainly, but instinct tends to become doctrine. But the thing certainly has not been reasoned in this way before beginning. They have simply been begun. And one also thinks of things as having a certain quality, and in time these qualities change. The flag, for instance: one thinks it has forty-eight stars and

suddenly it has fifty stars; it is no longer of any great interest. The Coke bottle, which seemed like a most ordinary untransformable object in our society, suddenly some years ago appeared quart-sized: the small bottle had been enlarged to make a very large bottle which looked most peculiar except the top of the bottle remained the same size—they used the same cap on it. The flashlight: I had a particular idea in my mind what a flashlight looked like—I hadn't really handled a flashlight since, I guess, I was a child—and I had this image of a flashlight in my head and I wanted to go and buy one as a model. I looked for a week for what I thought looked like an ordinary flashlight, and I found all kinds of flashlights with red plastic shields, wings on the sides, all kinds of things, and I finally found the one I wanted. And it made me very suspect of my idea, because it was so difficult to find this thing I had thought was so common. And about that old ale can which I thought was very standard and unchanging, not very long ago they changed the design of that.

DS: *So the flashlight you wanted was an ideal flashlight, without particular excrescences, a kind of universal flashlight, and in reality it was peculiarly elusive.*

JJ: Yes, it turns out that actually the choice is quite personal and it's not really based on one's observations at all.

DS: *But, given the element that you begin with, with what degree of intention do you work upon it? Or do you simply paint it, round it, over it, across it, and see what happens?*

JJ: I work with it always in mind, enough to allow it to be realized if someone examines the work. And in working I am the one examining the work, so I work with it so that I can always find it. I work with any image so that perhaps from painting to painting of, say, similar images, a different focus is required to find it, to find the image, but I don't think that it is ever doubtful that it is there.

DS: *But are you aware of any end to which you are directed while working on it?*

JJ: I may be imitating something I heard somebody else say, but I think I work until my energy runs out on that particular thing. I have no more energy to give to it, and then I stop.

DS: *And then you stop.*

JJ: But by the time a painting is finished, it has usually got quite boring to look at for me.

DS: *But is it finished because you get bored, or do you sometimes finish before you get bored?*

JJ: I think I usually get bored before I finish. I think it is having no other suggestions to make in the painting, no more energy to rearrange things, no more energy to see it differently; and then I think the painting is the way it is.

DS: *Is what you are doing in working on it investigating the possibilities of the different ways in which the elements you began with can be seen and not seen and half seen?*

JJ: That is certainly part. But I wouldn't say that is it, but it certainly is part of it. My idea is this, I think. You do something in painting and you see it. Now the idea of "thing" or "it" can be subjected to great alterations, so that we look in

a certain direction and we see one thing, we look in another way and we see another thing. So that what we call "thing" becomes very elusive and very flexible, and it involves the arrangement of elements before us, and it also involves the arrangement of our senses at the time of encountering this thing. It involves the way we focus, what we are willing to accept as being there. In the process of working on a painting, all of these things interest me. I tend, while setting one thing up, to move away from it to another possibility within the painting, I believe. At least that would be an ambition of mine; whether it is an accomplishment I don't know. And the process of my working involves this indirect, unanchored way of looking at what I am doing.

DS: *Obviously each new move is determined by what is already on the canvas; what else is it determined by?*

JJ: By what is not on the canvas.

DS: *But there is a great number of possibilities of what might go on the canvas.*

JJ: That is true, but one's thinking, just the process of thinking, excludes many possibilities. And the process of looking excludes many possibilities, because from moment to moment as we look we see what we see, at another moment in looking we might see differently. At any one moment one can't see all the possibilities. And one proceeds as one proceeds, one does something and then one does something else.

DS: *But the marks you make are not made automatically?*

JJ: But how *are* they made?

DS: *That is what I would like to know. Are you conscious of the different ways in which you are making them?*

JJ: At times, yes. At times I am conscious of making a mark with some directional idea which I've got from the painting. Sometimes I am conscious of making a mark to alter what seems to me the primary concern of the painting, to force it to be different, to strengthen, to weaken, in purely academic terms. At times I will attempt to do something which seems quite uncalled for in the painting, so that the work won't proceed so logically from where it is, but will go somewhere else. At a certain moment, a configuration of marks on the canvas may suggest one type of organization or one type of academic idea or one type of emotional idea or whatever. And at that moment one may decide to do two things—to strengthen it, by proceeding to do everything you can do to reinforce it, or to deny it, by introducing an element which is not called for in that situation, and then to proceed from there towards a greater complexity.

DS: *So you are aware that the painting has taken on a certain dominant emotional idea?*

JJ: Emotional or visual or technical—one's awareness can be focused on any kind of idea ... I guess it's an idea: it is a suggestion.

DS: *You are conscious that the painting might have a certain mood?*

JJ: Certainly.

DS: *Is it often a mood that you intended to have in the first place or one that has simply evolved?*

JJ: I think in my paintings it has evolved, because I'm not interested in any partic-
ular mood. Mentally my preference would be the mood of keeping your eyes
open and looking, without any focusing, without any constricted viewpoint. I
think paintings by the time they are finished tend to take on a particular char-
acteristic. That is one of the reasons they are finished, because everything has
gone in that direction, and there is no recovery. The energy, the logic, every-
thing which you do takes a form in working; the energy tends to run, the form
tends to be accomplished or finalized. Then either it is what one intended (or
what one is willing to settle for) or one has been involved in a process which has
gone in a way that perhaps one did not intend, but has been done so thoroughly
that there is no recovery from that situation. You have to leave that situation as
itself, and then proceed with something else, begin again, begin a new work.

DS: *And you want the finished painting to embody a sense of the experience of looking?*

JJ: Yes.

DS: *Of looking in general, or of looking at the particular elements which are intro-
duced into the painting?*

JJ: I want the painting to be a thing which can be looked at. I don't know. I don't
know whether one wants anything other than to just work and stop work.

DS: *Do you have a very clear idea of what you don't want to do?*

JJ: Yes, and that is a lot to have.

DS: *Yes, indeed. Is the result, perhaps, that which is left when you have found out for
yourself what you don't want to do?*

JJ: Well, the result is what is left when you have done what you have done and
when you don't do any more. I think one's attitude towards the result, the way
you are introducing it now, is about judging what you have done, which one
will tend to do, but it's not very interesting. The most interesting judgment
about a painting that I make is the way I proceed after it. Not always. But one
of the possibilities is that you do something which allows you to do something
the next time that you would not have been able to have done the last time.
Another is reaching a kind of illusion of perfection—either visual perfection
or intellectual perfection or emotional perfection or perfection of energy.

DS: *You were saying before that you wanted to make something that somebody might
find interesting to look at. But what you are making is not simply an aesthetic object.*

JJ: Did I say that?

DS: *I think so, though you weren't sure of it.*

JJ: If I said it, I would like now to deny it and say something else. I think when
one is working, generally, one is not concerned with that sort of result. One
goes about one's business and does what one has to do and one's energy runs
out. And one isn't looking throughout, but then one looks at it as an object. It's
no longer part of one's life process. At that moment, none of us being purely
anything, you become involved with looking, judging, etc. I don't think it's a
purposeful thing to make something to be looked at, but I think the percep-
tion of the object is through looking and through thinking. And I think any
meaning we give to it comes through our looking at it.

DS: *By the object you mean the work of art?*

JJ: Yes, yes.

DS: *But what of the objects you begin with?*

JJ: The empty canvas?

DS: *No. Not only the empty canvas; well, the motif, if you like, such as the letters, the flag and so on, or whatever it may be.*

JJ: I think it's just a way of beginning.

DS: *In other words the painting is not about the elements with which you have begun.*

JJ: No more than it is about the elements which enter it at any moment. Say, the painting of a flag is always about a flag, but it is no more about a flag than it is about a brushstroke or about a color or about the physicality of the paint.

DS: *Which is why you might as well use again and again such things as numbers or letters as the elements with which to begin, because the painting is not about those elements.*

JJ: It is about them, but it is not only about them.

DS: *But the process which is recorded as it were in the finished object, this process has an analogy to certain processes outside painting?*

JJ: You said it.

DS: *I'm asking you.*

JJ: Well, it has this analogy: you do one thing and then you do another thing. If you mean that it pictures your idea of a process that is elsewhere I think that's more questionable. I think that at times one has the idea that that is true, and I think at times one has the idea that that is not true. Whatever idea one has, it's always susceptible to doubt, and to the possibility that something else has been or might be introduced to that arrangement which would alter it. What I think this means is, that, say in a painting, the processes involved in the painting are of greater certainty and of, I believe, greater meaning, than the referential aspects of the painting. I think the processes involved in the painting in themselves mean as much or more than any reference value that the painting has.

DS: *And what would their meaning be?*

JJ: Visual, intellectual activity, perhaps; "recreation."

DS: *But, for example, I don't, in looking at your painting, have the sense that I can pin down references, but I feel there are references there, and that these are what give the paintings their intensity, and their sense that something important is happening or has happened. Is it possible that what has happened in the painting can be analogous to certain processes outside painting, for example, on the one hand, psychological processes, such as concentrating either one's vision or one's mind on something, attention wandering, returning, the process of clarifying, of losing, of remembering or of recalling, of clarifying again, or that again there might be an analogy to certain processes in nature, such as the process of disintegration and reintegration, the idea of something falling apart, the idea of something being held together?*

JJ: I think it is quite possible that the painting can suggest those things. I think as a painter one cannot proceed to suggest those things, that, when you begin to work with the idea of suggesting, say, a particular psychological state of affairs,

you have eliminated so much from the process of painting that you make an artificial statement which is, I think, not desirable. I think one has to work with everything and accept the kind of statement which results as unavoidable or as a helpless situation. I think that most art which begins to make a statement fails to make a statement because the methods used are too schematic or too artificial. I think that one wants from painting a sense of life. The final suggestion, the final statement, has to be not a deliberate statement but a helpless statement. It has to be what you can't avoid saying, not what you set out to say. I think one ought to use everything one can use, all of the energy should be wasted in painting it, so that one hasn't the reserve of energy which is able to use this thing. One shouldn't really know what to do with it, because it should match what one is already; it shouldn't just be something one likes.

DS: *You frequently carry out commissions, making new variants of things you've done before.*

JJ: Yes.

DS: *You obviously have no economic need to do this, since you can sell another kind of painting just as easily as you could sell the work you do on commission.*

JJ: We don't know that yet, if the work hasn't been made, if it's an unforeseen variety.

DS: *Well, you have a fair chance, let's say. I take it your motive is not purely economic.*

JJ: No, it is not.

DS: *What is it that you enjoy, then, about doing this, about making another one?*

JJ: Well, I don't always enjoy it. I frequently do paintings I don't enjoy doing. I think pleasure is not the prime reason for painting.

DS: *You frequently incorporate into your paintings pieces of reality or casts, such as spoons and forks and the casts of faces. Has it ever occurred to you to make, say, an illusionistic representation of a spoon or fork, rather than to attach the spoon and fork by wire?*

JJ: I've done schematic drawings of such things, generally in opposition to the actual thing or in the same visual range. Sometimes I have done sketches; they are usually working sketches or descriptive sketches.

DS: *But all the same, when you are actually making a painting, you prefer to incorporate the real thing or a part of the real thing to representing it?*

JJ: That's my tendency, yes, so far.

DS: *Do you know why?*

JJ: No, but I can make up a reason. I think my thinking is perhaps dependent on real things and is not very sophisticated abstract thinking. I think I'm not willing to accept the representation of a thing as being the real thing, and I am frequently unwilling to work with the representation of the thing as, you know, as standing for the real thing. I like what I see to be real, or to be my idea of what is real. And I think I have a kind of resentment against illusion when I can recognize it. Also, a large part of my work has been involved with the painting as object, as a real thing in itself. And in the face of that "tragedy," so far my general development, it seems to me, has moved in the direction of

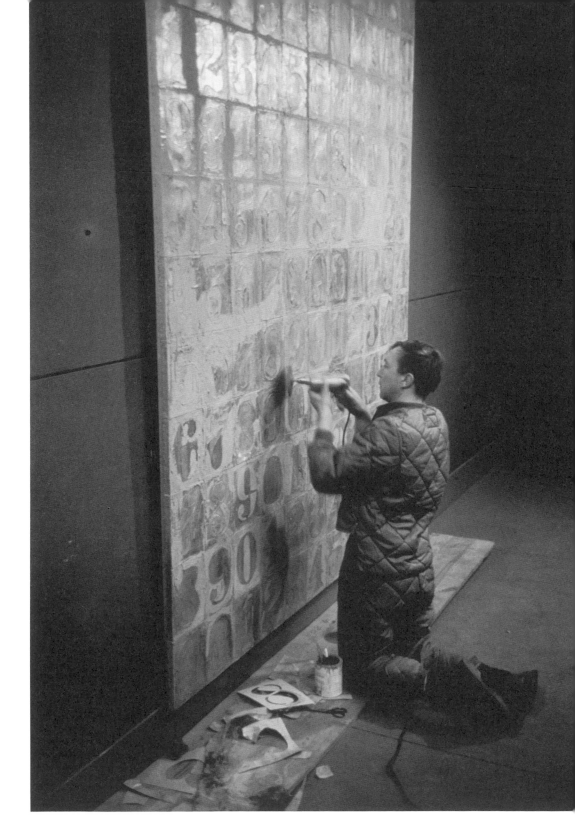

At work on the painting *Numbers* (1964),
commissioned by Philip Johnson for the
New York State Theater, in Manhattan's
Lincoln Center. Photograph: Dan Budnick.

using real things as painting. That is to say I find it more interesting to use a real fork as painting than it is to use painting as a real fork.

DS: *It doesn't have a meaning for you as it did for, say, [Kurt] Schwitters, that the real fork is something that has been actually used and handled; or has it?*

JJ: I don't think so. I don't think that has any value for me, the patina of wear and the sentimental association; that something has been attached to someone doesn't interest me very much. I tend to dislike that, actually. I think the object itself is a somewhat dubious concept. I think one is ready to accept the illusionistic painting as an object and it is of no great interest that an illusion has been made. I think the object itself is perhaps in greater doubt than the illusion of an object. I don't mean as illusion but as object. I think one is ready to accept illusionistic painting, the illusionistic representation of an object, as an object—I don't mean the illusion but I mean the conception of the work— one is ready to take that as an object. I think one is now able to question the object itself, whether it has any real body or any real use—what we call reality, I guess. I think one wonders if one couldn't simply shift one's focus a bit in looking at a thing, and have the object be somewhere else, not be there at all. I think it is questionable now whether the object is the dish or whether it is a section of the dish and part of the table. (And I think now that our main conception of an object is that it will hold something.)

DS: *Apart from any particular suggestion that the paint may make, are you conscious of the total texture of the paint's having a total general reference to something else? To be specific, do you feel that paint is in some way the embodiment of the quality of your sensations? What is the relation between what is in a painting and what you see when you look about you?*

JJ: The relation is that there is always something to see and anywhere one looks one sees something.

DS: *What is the difference between seeing when you look about you and seeing when you look at a painting?*

JJ: At its best there is no difference.

DS: *So that the painting is then in some way a crystallization or a trapping of the sensation you have when you look about you?*

JJ: Perhaps, but I wouldn't want to push that idea. I think one likes to think there is no difference between the experience of looking at a work of art and looking at not a work of art. There probably is some difference, but I don't know what it is. In the work of art there is probably a more directed sense of seeing, but that is questionable too, because one can face a work and not have that sense.

DS: *Of course the way a painting exists is nothing like the way reality exists, so what you are really trying to do is to invest the canvas and the paint with a life that does make the sensation of looking at it resemble the sensation of looking at reality. Is that what you are saying?*

JJ: Well, that has perhaps been said, but I wouldn't like to exaggerate that idea, that the painting is a language which is separated from one's general experience. I think it is in part, but I don't think that it should be made too strong an idea.

DS: *But the paint is more than the result of your making certain marks and arriving at an order which sometimes satisfies you?*

JJ: What is it the result of, if not that?

DS: *Well, it is that. But is that all it is?*

JJ: Well, all it is is whatever you are willing to say—all it is is whatever you say it is; however you can use it, that's what it is. I think the experience of looking at painting involves putting the paint to use, taking the painting as something which exists. Then, what one sees one tends to suppose was intended by the artist. I don't know that that is so. I think one works and makes what one makes and then one looks at it and sees what one sees. And I think that the picture isn't preformed, I think it is formed as it is made; and might be anything. I think it resembles life, in that in any, say, ten-year period in one's life, anything one may intend might be something quite different by the time the time is up—that one may not do what one had in mind, and certainly one would do much more than one had in mind. But, once one has spent that time, then one can make some statement about it; but that is a different experience from the experience of spending the time. And I think the experience of looking at a painting is different from the experience of planning a painting or of painting a painting. And I think the statements one makes about finished work are different from the statements one can make about the experience of making it.

DS: *Again and again you return to the way in which something is posed and then contradicted or departed from, so that you are constantly interested in the way in which intention and improvisation work together. In other words, it seems to me your constant preoccupation is the interplay between affirmation and denial, expectation and fulfillment, the degree in which things happen as one would expect and the degree in which things happen as one would not expect.*

JJ: Well, intention involves such a small fragment of our consciousness and of our mind and of our life. I think a painting should include more experience than simply intended statement. I personally would like to keep the painting in a state of "shunning statement," so that one is left with the fact that one can experience individually as one pleases; that is, not to focus the attention in one way, but to leave the situation as a kind of actual thing, so that the experience of it is variable.

DS: *In other words, if your painting says something that could be pinned down, what it says is that nothing can be pinned down, that nothing is pure, that nothing is simple.*

JJ: I don't like saying that it says that. I would like it to be that.

I-15. Sylvia L. McKenzie, "Jasper Johns Art Hailed Worldwide," *Charleston (S.C.) News and Courier*, October 10, 1965, p. 13B.

[...] [Johns] enrolled at the University of South Carolina where he studied for about two years with Catharine Rembert, Augusta Wittkowsky, and Edmund Yaghjian. They encouraged him, but he decided to leave school and go to New York.

Next came the Army, during which he continued to study and paint.

"After the Army, I wondered when I was going to stop 'going to be' an artist and start being one. I wondered what was the difference between these two states and I decided that it was one of responsibility," *Johns said.*

In an honest and straightforward manner, he explained his feeling as he recalled it: [...]

"I could not excuse the quality of what I did with the idea that I was 'going somewhere' or that I was 'going to be something.' What I did would have to represent itself. I would be responsible to it now, in the present tense, and though everything would keep changing, I was as I was and the work was as it was at any moment. This became more important to me than any idea about 'where things were going.'"

He feels that his work changed at that time, either as a result of the change in his way of seeing things, or for some other reason. "At any rate, it changed," *he says. [...]*

This was around 1954. [...]

"Some artists like to talk about their work and some don't. Either is O.K. with me. What one has when one looks is one's own experience. Some prefer to look in their own way, some may prefer to follow the directions of others.

[...] "I don't feel responsible for the work of others. The nature of art at any particular time seems to suggest certain kinds of attitudes. We can say that these attitudes are in the air, that they are called for by the existing state of affairs, that they are the product of our intuitions and actions within the complex of our artistic, mental, spiritual, material, technological environment." *[...]*

Several critics seem to feel that Johns, by requiring this reexamination of a preconceived image, is not denying his responsibility as an artist but insisting that there is a need for questioning the established values in order, perhaps, to arrive at newer and richer values.

He points out that art mirrors the times. "A six-year-old may be able to tell you what brand of gas is sold at a service station, but chances are he cannot tell one tree from another. Our fifty-year-old [is] frequently in the same fix. Our younger artists have grown up in a world in which visual emphasis has shifted from the natural to the manmade and they are using their experience in their work," *he says. Soup cans, soap boxes, and soft drink bottles—are they art?* "If they belong in our life, why not in our art?"

Of his own work he says:

"My work is largely concerned with relations between seeing and knowing, seeing and saying, seeing and believing. Preconceptions which are a sort of 'knowing' may be placed in doubt or may be affirmed by seeing." *[...]*

I-16. *U.S.A. Artists 8: Jasper Johns*, 1966, 30-minute film in black and white, 16 mm. Produced and directed by Lane Slate, written by Alan R. Solomon, narrated by Norman Rose. TV documentary produced by N.E.T. (National Educational Television Network) and Radio Center.

[Features interviews with Johns and with Leo Castelli. Filmed in Johns's New York studio (then on Riverside Drive, New York), his Edisto Beach studio, and the Universal Limited Art Editions (ULAE) workshop in Long Island.

Line-space divisions in the excerpts that follow reflect the different segments of the film, or cuts to a different location. —Ed.]

[Johns in a car, driving]: I was in Florida once, in the winter, and working, and I decided I liked going out of New York when it was cold, going somewhere to work, so I decided I should have a house of my own and I couldn't find anything in Florida where I was that I could afford, and on my way back to New York, I was having a show at the Columbia Museum of Art in Columbia, South Carolina, and this turned out to be a kind of family reunion. Someone said they knew of a house at Edisto Beach, and I said, "Has it got a tree?" They said yes. And I went down. It was December or January, it was very very cold, and I went inside this house which had been locked up all winter. It was terribly cold, the house was not very attractive, everything was pink inside. I went to the kitchen, I opened the cabinet below the sink and there was a half bottle of Bourbon; and I said, "I'll buy the house." (laughs). […] I try to spend at least half the year there. Last year I spent about eight or nine months. I live and work there.

[Johns seated, holding a drink]: The first flag painting I did came in the 1950s, when I was trying to become a painter and I had been working in various styles, I guess, nothing seeming to mean much to me, except that one made a picture, and there it was. One night I dreamed that I'd painted a flag of the United States of America, and I got up the next morning, and went out, and bought materials and began to paint this flag. That's the way the first painting, as is generally known, was done. My reactions to it were neutral. It seemed to me to get rid of a lot of the problems I had been dealing with in trying to figure out what I was doing. I had simply done something there was to do. I learned certain attitudes, I think, I learned that there was a possibility of making something which didn't have to filter through judgments that one made about what one was doing, but one could set out to do something and do it.

The paintings that followed immediately, which were paintings of targets and numbers, gave me the same opportunity to feel removed from the work, neutral toward it, involved in the making but not involved in the judging of it.

[Johns seated, holding a drink]: In my work, I have attempted to take an action, or to do something, and then to see that it can be done differently, and then to try to do it differently, rather than seeing what was the best thing to do and following through with this idea of the best thing. And I've simply gone about experimenting with alterations of my ideas, I think, rather than settling for any

particular idea as being important or useful. I've more taken as useful the idea that the mind can adjust itself in different ways to anything. I try, when I recognize something is a kind of repetition or is a habit, I try to disregard it and to get rid of it and to find something else to work with.

[Johns seated, holding a drink]: I don't have any working habits. I work very erratically. Yes, I'm quite lazy. But beyond that, I think there is a tendency in American art not to form habits of work, good working habits. And I certainly… at any rate, I have not formed any. And so it's most convenient that I be where my work is, so that at any moment I might do something, rather than having the idea that you go somewhere at a certain hour and spend so many hours there doing things.

[Johns seated on the stairs of his house at Edisto Beach]: The country is very different from the city. The summer I swim, I walk in the woods, I visit friends; many friends come down, quite often, from New York, and locally too. I read a lot of detective stories, I read other things, but I don't think a lot. There's less social life, less social activity. The landscape is very different here, one moves through it differently.

One would think there is more time in which to work here, because there are fewer distractions, but it tends to be so pleasant that one doesn't tend to work any more than one would work in New York, where one feels pressed to work, one feels that there are things you ought to be doing, instead of doing what you're doing. Here one never feels that, because you feel you can work at any time you want to.

[Johns entering his studio, which is on the ground floor, below the house proper]: In the summer—when I'm here in the summer—I get up very early, and go down to the studio, and work in a sort of darkness with electric light, and then as the sun comes up, I'm working with a combination of electric light and daylight, and then later you turn out the light and work by daylight. This kind of changing light condition doesn't exist in New York.

[Johns working on his encaustic painting Targets, *1966]:* Sometimes I work a long time, sometimes I don't. Partly it depends on what state the picture is in. In the beginning… well it depends on how I thought of the picture—if it's something which has been more or less thought out, and the canvas has to be divided in such and such a way, then it's very easy to work for a long time doing what's required. When the painting reaches a state where the divisions are less clear, when what has to be done is less clear, I tend to work in small stretches of time.

[Johns in a rocking chair, on the porch of his house at Edisto Beach]: I used to work on one picture at a time. In the last two years, I guess, I've tended to work on a couple of pictures at once. Part of that has come about because of living here and frequently being in New York, and, say, having a painting going here, which I didn't finish when I had to leave, then having a painting going in New York, which I work on when I'm there.

[Johns on the terrace of his apartment on Riverside Drive, New York, looking over the Hudson. Then seated, holding a drink]: One of the things that happens in painting is that one does something interesting, one has the possibility of doing something interesting. Frequently the idea of what's "interesting" has to do with its novelty value. Its novelty value always has to do with positions one has taken toward things, that is, that one sees oneself as having a position towards things, and then one sees that something either out of that position, outside that position, or some particular thing within that position is interesting.

I think there is a possibility of getting away from that idea, and then one has two possibilities: to do what is necessary or to do what has no necessity whatever. I think those are very similar. They both get rid of the necessity to judge. This idea of neutrality has been very important to me; I don't know whether it still is or not, I can't tell. I think it still is, but it takes a different form. I think the earlier things of mine involved kind of invisible images which have no particular quality, and I think more recently certain things in my paintings have curiously charged images: a leg or an object or a paint area seems to imply a kind of feeling or an attitude and I think—I hope—that within the context of my paintings, those are neutralized in some way; at least I hope that my relation to them is neutral.

[Johns working at ULAE with printer Ben Burns]: Well I go up to [ULAE director] Tanya Grosman's not every so often but whenever I want to, when I'm in town and working. Usually someone is working at printing one of the prints and at the same time I'm working on another stone. That's the way I try to work at any rate.

In the map lithograph, I was in South Carolina and I asked Tanya to send me some aluminum plates. I had never worked on plates, I had always worked on stones before. I made one drawing of the map. In printing it, I decided I didn't like it very much, and remembered an idea of John Cage's that if something wasn't very pleasant once, then you should repeat it and perhaps it would become more interesting; then if that wasn't interesting, repeat it again. I repeated the map drawing twice, and I found it less interesting than once. So then I made another stone, and overprinted these two prints. You never know exactly what a print is going to look like until it's printed, and then there is the possibility of changing: you can print it in any color, and generally I think in terms of black and white.

The light bulb lithograph involved two stones and somehow a miscalculation had been made in registration of the two stones, and they were all printed off, so it all had to be redone, and the first printing had to be destroyed.

In terms of images, lithography is a different way of presenting an image. Once the image is established on the plate, then you still have the possibility of altering it by how it's printed, on what paper, in what colors, with what pressure. You could take one stone and print it in twenty different ways, if you wanted to, and get completely different effects.

[Johns seated]: I think there are lots of people working who are making very clear statements in their work; their work is very clear; from one artist to another the work is very varied. One can take this like that and simply like it, or one can want

With Tatyana Grosman and Ben Burns of
ULAE at the ULAE workshop, West Islip,
New York, in c. 1966. Photograph: Ugo Mulas.

Left to right: composer Toru Takemitsu,
critic Yoshiaki Tono, and Johns, probably at
the Imperial Hotel, Tokyo, in c. June 1964.
Photograph: Kanayama.

to assimilate all this in some way. I don't know what ought to be done, I guess one simply does what one does. I hesitate to take any one position; to make any clear statement. At any rate that's the way I see my work. I don't feel that I have some particular thing to say that needs to be said, and needs to be stressed and emphasized and reinforced. I think most of my work is involved with a kind of ambiguous statement, or multiple possibilities of some way of working, or of some ways of working. Now that may be very backward, it may be that what anyone should want is really to find something to say, one thing that one believes. I don't think I've done that. It seems to me that a lot of young people are tending to do that. Yet from one to the other they are in that position so you have a kind of battle of meanings and strengths. And that doesn't interest me very much, unless I was willing to believe in one of them, and I'm not.

[A sketch is shown for a canvas hinged to another—Passage II, 1966. Johns is at work with stencil technique]: Sometimes I have an idea for a picture. It may just be a detail that I want to use in a picture and I may make a sketch of it, and at a certain point it seems that it's time to begin, and I begin. It doesn't mean that the painting is formed before but it means that at least there is enough that has to be done that I can start doing it. I thought that one thing to do with the written word was to pretend that it was an object that could be bent, turned upside-down, and I began more or less folding words, or painting the illusion of a folded word, I guess that's what you say. Then once you fold the word then you get part of it in reverse. This painting is involved with the word written in neon; the word made all of wood which can stand one way and be legible, or can be upside down and backwards if you drop it, and with the written word, legible and illegible, as it bends, and backwards and forwards. The cast of the leg comes from two other paintings. The neon comes from other things. These are all ideas or details that I've used in other pictures. It's somewhat different from other pictures in the way that things hinge out from the rectangle and alter the silhouette. They can either extend beyond the picture, like the letters at the bottom can drop down, the canvas at the top can be raised, or all of this can be compressed within the rectangle of the painting, and make a rectangle on the wall. That was what interested me about the picture.

[Johns seated]: Well I try to make pictures which for me pictures have not done before. Once a painting is made there is a kind of ... I don't know how to describe it ... tragedy that you have made it and there it is, and that's all there is to it. Occasionally there may be an indication of something else you could do in another picture, but nevertheless having made a picture makes you somewhat acquainted with it; you're not going to be very astonished by it. It becomes a kind of real object; you have to pick it up and move it about the room and pack it in a box and all that. But sometimes it sets you off toward doing something else, and that may be lively, that it gives you some idea. Sometimes it gives you no idea. This gives me no idea at all—of anything to do (laughs). I like it when a painting reaches a situation which implies that it was done in the best way it

could be done, that that's all there is to do with that, and I like very much when a painting seems kind of rich in unformed elements—or even just the inclusion of one unformed element is very lively to me. It implies that you may still have another picture to paint. That's nice.

I-17. Grace Glueck, "No Business like No Business," *New York Times*, January 16, 1966, sec. 2, p. 26. Published on the occasion of Johns's exhibition at the Leo Castelli Gallery, New York.

[…] "A lot of the things in my paintings are involved with measurement," *Johns said the other day. That was obvious (once he'd pointed it out). The paintings bear spoons, rulers, color charts, either attached to the canvas or painted on—finite gauges set against* "the immeasurability that art is supposed to have." *[…]*

According to What, *[…] a wide painting that fills one wall, has a vertical crevasse. Down it ramble brightly painted, stick-up letters made of cast aluminum that spell out colors. Some of them are bent, though their flat replicas on canvas aren't.*

"I couldn't bend them myself," *says Johns,* "so I had to send them to a metal worker, to have them broken, then filled in. I'm a real liar."

Johns has more or less abandoned the early images—flags, targets, and numbers— that caused a stir when they were first exhibited in 1958 (although a recent "op" flag painting appears in the Whitney Museum's current annual survey). "A lot of what one does is work toward an idea. Once established, it can be discarded. I was concerned with the invisibility those images had acquired, and the idea of knowing an image rather than just seeing it out of the corner of your eye. I wanted to make the flags and targets very concrete, to see them as objects. I hoped in the end no one could discard my work, as the eye discards a real flag because it has seen it so often."

At the tender age of thirty-six, Johns has already weathered three summit-type shows (all in 1964)—at the Venice Biennale, New York's Jewish Museum, and London's Whitechapel Gallery. Wasn't it unsettling to be that big a winner early on in one's career? Johns says "it's neither depressing nor elating. At first I thought it might be instructive to see all my paintings together—but actually they just looked like a lot of old paintings." *[…]*

I-18. Charlotte Willard, "Eye to I," *Art in America* 54 no. 2 (March–April 1966): 57. Johns discusses his painting *Souvenir 2*, 1964.[7]

Jasper Johns, one of the most prominent younger painters in the U.S., has been an inspiration to still younger artists through his use of common object imagery.

"After a concert at the Tape Center in San Francisco I saw spots of reflected light moving on the wall.

"In a store window in Tokyo I saw plates upon which had been printed some photographs of Japanese baseball players, wrestlers, and family groups.

"In 1950 or '51 a painter whom I admired said that he was to have an exhibition of eight or ten canvases which were turned face to the wall in the kitchen where

we were talking. He said the works were very new and good and that he would not show them to anyone before the scheduled exhibition. When he left the room, another friend looked at the fronts of the canvases and found that they had not been painted.

"Thinking anything could be a souvenir of something else, not specifically meaning a self-portrait. Ego was not clear. Maybe, just another way of dishing up a Johns."

I-19. Hubert Saal, "Merce," *Newsweek* 71 no. 22 (May 27, 1968): 88. Review of Cunningham's performance *RainForest*.

[…] *Long before the public recognized Merce Cunningham, he had the admiration of his fellow artists in every medium. Among those who have supplied décor are Frank Stella, Robert Rauschenberg, and Jasper Johns, currently the company's artistic adviser, who says:* "Merce is my favorite artist in any field. Sometimes I'm pleased by the complexity of a work I paint. By the fourth day I realize it's simple. Nothing Merce does is simple. Everything has a fascinating richness and multiplicity of direction." […]

I-20. Joseph E. Young, "Jasper Johns: An Appraisal," *Art International* 13 no. 7 (September 1969): 50–56. Based on an interview conducted on January 24, 1969, in Los Angeles.

[…] *Where Johns in his early works relied on the preexistent imagery of the flag or target to determine the iconography of his object-paintings, Frank Stella later used the literal shape of the canvas to determine what was depicted on the canvas, thereby rejecting the need for a depicted external reference. Frank Stella's early striped paintings were black with blurred stripes of canvas showing through the paint. Perhaps this was in reaction to Johns' earlier gray encaustic works of which Johns stated:*

I used gray encaustic to avoid the color situation. The encaustic paintings were done in gray because to me this suggested a different kind of literal quality that was unmoved or unmovable by coloration and thus avoided all the emotional and dramatic quality of color. Black and white is very leading. It tells you what to say or do. The gray encaustic paintings seemed to me to allow the literal qualities of the painting to predominate over any of the others. […]

From the very beginning of his career Jasper Johns began introducing external elements into his paintings. […] Later, as Johns's work began to mature, they also began to fall into disfavor with some critics whose alienation […] perhaps stemmed from one of Johns's basic approaches to art which he recently described:

Most of my thoughts involve impurities…. I think it is a form of play, or a form of exercise, and it's in part mental and in part visual (and God knows what that is) but that is one of the things we like about the visual arts. The terms in which we're accustomed to thinking are adulterated or are used. Or, a term that we're not used to using or which we have not used in our experience becomes very clear. Or what is explicit suddenly isn't. We like the novelty of giving up what

we know, and we like the novelty of coming to know something we did not know. Otherwise, we would just hold on to what we have, and that's not very interesting.

This is the thinking of an artist whose complex works can be easily misunderstood or extremely challenging for those who take the time to confront them on their own terms. His aesthetic approach is described by him as sometimes involving:

... And it's playing about with the ideas of what one could have around an idea. Say that you have an idea. Well, one can then defend and separate that idea from all the other ideas which one has ever heard of or perhaps with all the techniques which one has heard of and make the idea less clear. And that whole range from precision to imprecision to disappearance interests me. A large part of my work has been involved with this. [...]

Johns's printmaking activities began in 1960 when Tatyana Grosman of Universal Limited Art Editions approached him to make lithographs [....] Then, after making lithographs [there] for eight years, Jasper Johns came to Los Angeles to make lithographs at Gemini Graphic Editions Limited with Kenneth E. Tyler, Master Printer.

When asked why he decided to work at another lithography workshop when he had been so successful with Mrs. Grosman, Johns related that:

Ken Tyler asked me to come to Gemini several times. All of my work that I had done before I came here was done at Tatyana Grosman's shop, and I wanted to see what another printing situation was like. I wanted to find out what differences there were. Gemini, for instance, is much bigger than Tatyana Grosman's. One's contact with the printers at Gemini, however, is rather close. It's not as impersonal as one would think. I would say there is a different tempo because of the different numbers of people at the two different places. Consequently, one's thought is altered a little bit. Everything one does can alter the time sense of the people around one and do something. I would, for example, think something would take two days, and it might take much longer or shorter. One's predictions are not that accurate. In coming to Gemini, I wanted to try different working conditions to see how that would affect the prints.

From the very beginning, Kenneth Tyler responded to working with Jasper Johns by producing technically superb lithographs, with one notable exception. The first Gemini lithograph Johns made was rejected by the artist, who gave the following reason:

The first lithograph at Gemini involved something Ken was experimenting with, so I thought I would try it. It was a different kind of stone, a piece of alabaster. The stone didn't take the ink properly. It didn't accept the grease in the proper way and interfered with what I wanted. The prints which turned out seemed inferior to me even though the drawing on the stone and the work of the printers were good. When the stone was printed, the lithographs were not getting enough value change from black to gray.

This first incident at Gemini indicates the degree to which Jasper Johns is willing to experiment in lithography. For Johns, experimentation has a special significance in printmaking:

The paintings and the prints are two different situations.... Primarily, it's the printmaking techniques that interest me. My impulse to make prints has nothing

to do with my thinking it's a good way to express myself. It's more a means to experiment in the technique. What interests me is the technical innovation possible for me in printmaking.

Although for many years Johns has explored the possibilities inherent in lithography, and in spite of the well-deserved praise he has often received for his prints, Jasper Johns finds printmaking unsatisfactory for a number of reasons:

I think partly, I find printmaking an unsatisfactory medium. I keep working at it, trying to make it better. It encourages ideas because of the lapse of time involved, and one wants to use those ideas. The medium itself suggests things changed or left out. Whatever you think the medium is you find out it isn't, so you try to test it some other way. I don't really enjoy the idea that it's a reproductive process. A lot of time is taken to make printmaking reproductive, and that's not very interesting to me. In terms of making things, you do something. Then you have to wait for processing. Then you do something else. And then you wait—like a long-distance call through an overseas operator. *[…]*

Recently, Jasper Johns completed a portfolio of six etchings which were executed in line only and entitled The First Etchings. *This first portfolio has already been released by Universal Limited Art Editions.* "In the second series," *Johns stated,* "I'm adding areas of tone with aquatint." *[…] Among contemporary artists, Jasper Johns would seem a likely candidate for etching, which traditionally offers a wide range of possible technical effects for the artist. Jasper Johns has his own view of etching:*

I don't like the medium, although I'm going to do some more etchings. It's extremely seductive. That line. You draw a line in the metal, and it has a very sensitive, sort of human quality—much more so than lithography, which tends to go flat and simplify. I think that in etching what you traditionally call "sensitivity" is magnified. I don't like etching because I have the feeling that I have more control over drawing than etching. In any medium, I've never wanted a seductive quality. I've always considered myself a very literal artist. I've always wanted to do what *I've* wanted to do. In etching, there is the distraction of the line, which takes on the quality of a seismograph, as if the body were the earth. Within a short unit of an etching line there are fantastic things happening in the black ink, and none of those things are what one had in mind.

One might ask why Jasper Johns makes prints rather than confining his aesthetic explorations to drawing, painting, or even sculpture, where he seems to enjoy more control than within the medium of printmaking. Johns' reasons for making prints seem to probe even the philosophy of printmaking:

Basically, what's interesting to me in printmaking is the idea that the medium seems to have a limited range. The steps seem to be well defined. Each stone or plate has its special color or quality. A special stone is to be printed black, green, or whatever in the case of lithography, and by combining a number of plates or stones one can get different effects. But the tendency in printmaking is to think in terms of discrete operations and discrete objects. In printmaking, the making of a print is actually accomplished by making discrete operations.

This whole idea that anything can be one thing is an idea that interests me.

I like the idea of taking these discrete operations and using them in such a way that doubt is cast upon them, and one is not sure what to regard as a discrete thing.

During the months of March through May, 1968, Jasper Johns worked at Gemini G.E.L. in Los Angeles on a series of ten black and gray Figure *lithographs which were executed using one lithographic stone and one aluminum plate for each print. The stone was used for the print's numeral image, and the aluminum plate was used for the gray overprinting. Johns related that each of these* Figure *lithographs from "0" to "9" is distinctive because:*

I had worked on the different stones in different ways, trying to make each one different from the other, and in my doing that in a series, in trying to do that one to another one, I relied to a large degree on obvious nuances. I may have gone in sequence, but I don't remember. The "9" was the last, and I had used so many devices earlier that I thought to make the "9" as "unartful" as possible. So, I drew on the stone in a very simple-minded way with gum, and this appears white in the print. Then, I worked the stone over with tusche, and this became the black. With the "9" there is a kind of "break." I was trying to do something outside the series, not just another thing that I hadn't done before, but something that would negate what had been done before—something that would make the whole group questionable. [...]

From August 1968 through January 1969, the artist used his black and gray Figures *as a point of departure to explore color lithography. The result of his exploration is Jasper Johns's* Color Numerals, *a series of ten lithographs [....] Johns related that the impetus for this investigation of color lithography stems from earlier work he did at Universal Limited Art Editions:*

In a print I did a couple of years ago at Tatyana Grosman's, a thought came to me, and I thought it was my invention. I had the idea of putting several inks on a roller at once. I did this in two prints for Tatyana. One was a large print, but the area treated in this manner was small. The other one was a small print which was treated all over in this manner. I thought to do the *Color Numerals* that way. Then it turned out that in order to do it there was no roller large enough since the area of the print cannot be larger than the circumference of the roller. First they had to make a roller large enough for this process. [...]

Regarding the use of color in the Color Numerals, *Jasper Johns related:*

At first I thought of vertical bands of color, but I didn't like them. So, I had them changed to horizontal bands. It was kind of a pseudo-system. Counting seemed so reasonable, I thought to make the color system seem as simple. I tried to give it the quality of logic—to make it rational. It begins with the primary colors, then introduces the secondaries, and ends up with all the secondary colors. [...]

In the Color Numeral *lithographs,* Figure 1 *retains the same basic image that it had in the earlier black and gray series, but it has additional imagery on the left side of the depicted numeral—a simulated newspaper page. Of this addition John related:*

A lot of my pictures have used newspaper collage. In fact a lot of my encaustic pictures are made with newspaper dipped in encaustic. It's one of those situations

where instead of the real thing you use the image of the real thing. I had already in my paintings used silkscreen instead of real newspaper. I thought of using silkscreen on a lithograph stone, and then have it printed as a lithograph—another one of my impure ideas. I had a life-size silk screen and silkscreened with tusche on the stone.

For Figure 7 *in both the* Color Numeral *series and the black and gray* Figure *series, the image of the Mona Lisa is clearly evident. For Jasper Johns:*

The Mona Lisa painting is one of my favorite paintings, and da Vinci is one of my favorite artists. Duchamp is also one of my favorite artists, and he painted a moustache on a reproduction of the Mona Lisa. Also, just before I came to work at Gemini someone gave me some iron-on decal "Mona Lisas" which you would get from sending in something like bubble gum wrappers and a quarter. With the decals all one has to do is iron the decal on cloth and one makes his own "Mona Lisa." I had some of these decals when I came to Gemini, and I thought I would use the Mona Lisa decal because I like introducing things which have their own quality and are not influenced by one's handling them. It was a great problem getting it on to the stone. We tried solvents and everything. I finally ironed it to the stone and it came out very nicely. [...]

[...] The working "proofs" which had no imagery other than three bands of color seem to lack aesthetic unity because the illusionism of the color bands surrounded by white margins of paper appears to deny the object-quality of the "prints" in the same manner that a two-dimensional painting which depicts a three-dimensional illusion of external reality denies the inherent two-dimensionality of the painting surface. Jasper Johns, however, had another opinion regarding them:

Some I thought were beautiful, but I would not use them as my work. Most of my thoughts involve impurities. Those kind of technically or visually pure situations which can be shown in a work are not interesting to me in my work. They interest me in other people's work, but I don't focus on these particular conditions.

Jasper Johns was confronted with the supposition that his Color Numerals *had reconciled the major conflict facing the "modernist" color painters—the object-destroying illusionism of color—by restoring the object-quality to the work of art through the convincing introduction of drawing. It was further suggested that the "modernist" color painters had returned to abstract drawing in their works less successfully than Johns to counteract the illusionism of color. Johns's reaction was as follows:*

In one person's work, say in my work, where there are two or three formal possibilities—and in another person's work where only one of these formal pursuits is developed—it doesn't mean necessarily that he has less present in his work than I have in mine. This can simply mean that there is a new language or aspect of art. I don't believe in the quantity of invention or aesthetic quality. When two things come out of the air so closely, one is apt to see the two artists whose work is related, and one is apt to compare them and to say that one does more or less than another. This, I feel, is just an aspect of your attention at that time. I don't believe in negating one man's work in relation to another's.

Johns's thinking then turned to that contemporary art criticism which uses a linear historical basis for its evaluations:

If you prefer this instead of that, I think that you should accept the responsibility for your personal coloring which prefers one over the other. Always what's novel in one's experience is interesting. When one is shocked by something, that's marvelous. But just to allocate precedents I don't think is interesting. I think what is of interest is in the "air" of which all art comes from. I'm very suspicious of a linear development. I believe the world presents its ideas to you. If you look at my work, your ideas are thereby altered. Then if you turn and see something else you have a lag in which you bring to the next work part of what you experienced from the first. I think one should be suspicious of that. Even if a linear development in art were true, I don't think I would be interested in it.

In 1959, when Jasper Johns was still painting flags, targets, and numbers, he stated that a painting should be looked at the same way one looks at an automobile radiator. Since that time ten years have passed, and Johns's thinking has changed:

The things that you mention were certainly true at one point. I thought at the time that a radiator is a radiator. We can agree on this. Now, I'm not so sure. At that time, I was willing to take the radiator as a concrete object with definition and spatial characteristics. If you please, as a real object. I was even willing to take it as a reference—something steady and set. Art has so often involved ambiguities and the possibility of ambiguities. I originally thought the radiator was not ambiguous, that it was a basis on which we might agree. I am not sure any longer that I believe or am secure in that type of thinking. I would now question the reference as much as the work. Originally, I meant the radiator was a secure object one didn't have to bring any special psychological attitude to. Now, I'm not so sure. […]

[…] When asked recently how he liked his finished prints at Gemini he responded quite simply, "I consider it to be my work. I wouldn't approve it if I weren't pleased with it." *On the same date he made an observation which involves the entire art community:*

One of the crucial problems in art is the business of "meaning it." If you are a painter, meaning the paintings you make; if you are an observer, meaning what you see. It is very difficult for us to mean what we say or do. We would like to, but society makes this very hard for us to succeed in doing. […]

I-21. Gunnar Jespersen, "*Møde med Jasper Johns*," *Berlingske Tidende* (Copenhagen), February 23, 1969, p. 14.

[…] GJ: *You said once that one ought to try to hold back one's feelings when one works?*

JJ: Did I say that? Really? I believe that's a little extreme. It's impossible to hold back your feelings when you work. […]

GJ: *Was the purpose of making paintings of simple things, such as a flag, a map, a target, letters and numbers, a way to create a new vocabulary for painting?*

JJ: In the earlier paintings you refer to, I looked for subject matter that was recognizable. Letters and numbers, for example. These were things people knew,

With Leo Castelli in the Leo Castelli Gallery
(4 East 77th Street) for the exhibition "Jasper
Johns, Roy Lichtenstein, Robert Rauschenberg,
John Chamberlain," February 1964. Lithographs
from the *0–9* portfolios (1963) hang on the wall
behind. Photograph: Dan Budnick.

and did not know, in the sense that everyone had an everyday relationship to numbers and letters, but never before had they seen them in the context of a painting. I wanted to make people see something new. I am interested in the idea of sight, in the use of the eye. I am interested in how we see and why we see the way we do.

GJ: *What did you mean by the expression "to make something new for people"?*

JJ: When something is new to us, we treat it is an experience. We feel that all our senses are awake and clear. We are alive.

GJ: *As the son of a farmer in Augusta, Georgia, how did you ever come to painting?*

JJ: When you live in such a place as I did, you search for something, something that represents another possibility, another opportunity. I could also have chosen to become a sailor, but became a painter instead because that was a fantasy.

GJ: *Was it a dream?*

JJ: Well, yes, a very impractical dream! But that's the way it is. You react against your surroundings to carry out something else. But I have to say that I wanted to be a painter from childhood. I just didn't know how to go about it practically. For sure there was no one in [Allendale] who had any idea about that sort of thing.

GJ: *Does the audience have any significance for you?*

JJ: The artist begins by speaking to others, and many times ends up with only one listener.

GJ: *Jasper Johns's own profound self?*

JJ: In one way it's the most patient listener you can find. A painter has to try to be his own audience.

GJ: *Do you ever get inspiration from your own exhibitions?*

JJ: Exhibitions really have nothing to do with it. They don't provide me with any contact. Remember, it's not me that arranges them, but my art dealer, Leo Castelli. Exhibitions are business. Naturally, I am thankful that they take place because they make it possible for me to live and work.

GJ: *You are obviously distant from your own exhibitions?*

JJ: Personally they mean nothing. I'm neither a teacher nor an author of manifestos. I don't think along the same lines as the Abstract Expressionists, who took those sorts of things all too seriously. But of course it is very difficult not to take yourself seriously. Your very best audience is within yourself.

GJ: *The critic John Ashbery has written that your work apparently does not lend itself to critical analysis. Do you agree?*

JJ: For me, criticism is a lyrical display about a subject directed toward the public. It is meant as an invitation. But when the critic also gives genuine information, then the artist is naturally interested.

GJ: *You said once: "Sometimes I see it and then paint it. Other times I paint it and then see it."*

JJ: I said that only to emphasize that I wanted to keep open all the possibilities. I couldn't imagine resigning myself to one particular method. I am the one who decides.

GJ: *Do you sketch before you paint?*

JJ: As a rule, I make sketches after I have done the paintings.

GJ: *Are there some things in your sketches you had rejected in the paintings?*

JJ: Sometimes there is a hint of the next painting in the sketches, but the sketch is for me a thing in itself.

GJ: *How long does it take for you to do a painting?*

JJ: It varies. I have painted three paintings within the course of a year. I like to have time. I like to talk to people. You stop in the middle of a brushstroke, answer the telephone, and then continue later. […]

I-22. Roberta Brandes Gratz, "Daily Closeup: After the Flag," *New York Post*, December 30, 1970, p. 25 (p. 3 of magazine section). Published on the occasion of the exhibition "Jasper Johns: Lithographs," at The Museum of Modern Art, New York.

[…] "[The Flag paintings] were such a clear image that it was vaguely shocking. People didn't know what to think but it made them think, which is always nice." *[…]*

The subjects of his canvases are often "fragmented images put back together in some formula, a grid of fragments of meaning, they are the restructuring of a familiar image," *Johns explains.* "As you focus on an object, the eye can take in different areas of information. The thing itself is not one thing. You are using your life experience to regard it in different ways. So what it really is is very unclear. Everything falls apart with examination."

[…] Viewers have seen a strong association in his work to Duchamp, often called the Dada and the Grandpa of Pop; Johns doesn't dispute that assessment but adds: "There are certain kinds of things that occur in my work that can be related to Duchamp and Dada in general, like his ideas about objects, about things not invented but ready-made. Duchamp took from the environment objects that were already existing, like a urinal, and just signed them.

"His idea was that anything could be art by focusing the mind to think of it as art. My images are similar but at the time my work was first being shown, 1958–59, I was unfamiliar with Duchamp and Dada. Everyone said my work was Dada so I read up on it, went to Philadelphia to see the Arensberg Duchamp collection, was delighted by it and later met him.

"But it was all more a coincidence. Perhaps it's that certain ideas get into the air, ideas that come out of our living and out of the environment automatically."

One of the popular ideas today is to create nonownable art, earth works such as a mound of dirt or a waterfall, objects that are good for a one-time happening or museum exhibit.

Comments Johns: "There is no reason for art to be owned except to take care of it. An object that is delicate should be sheltered, which has been the function of museums and collectors. If art can take a form that it doesn't have to be taken care of, that's excellent. People are looking for ways to manifest ideas that don't require the physical object. That's terrific because we need our space for other things."

[...] He considers his upbringing to have been "entirely Southern, small-town, unsophisticated, a middle class background in the Depression years of the '30s.

"I drew as a child and decided I would be an artist. Sure, I was always encouraged, like you were encouraged to tap dance, to entertain people. It was a trivial kind of encouragement. To have a high regard for art was considered silly, far-fetched." *[...]*

"Every artist feels alone and isolated," *says Johns.* "Friends are very important in terms of all sorts of definitions of oneself. They tell you what you are and what they are aside from the intellectual aspects."

I-23. John Coplans, "Fragments according to Johns: An Interview with Jasper Johns," ***The Print Collector's Newsletter*** **3 no. 2 (May–June 1972): 29–32. Interview conducted in 1971 in Los Angeles. Johns discusses his lithograph series** ***Fragments— According to What,*** **made at Gemini G.E.L., Los Angeles, in 1971.**

JC: *I understand the six hand-printed lithographs are fragments from the painting* According to What *(1964). If I remember correctly, the painting consists of several linked panels. How many are there?*

JJ: Six, I believe—either five or six.

JC: *So each print relates to one of the panels of the painting?*

JJ: No, not really, because *Hinged Canvas* and *Leg and Chair* relate to the same panel. *Bent "Blue"* is from the lower part of the lettering. *Bent Stencil* is from the lower part of the center of the painting. *Coathanger and Spoon* is from the lower right side of the painting. *Bent "U"* is just an element of *Bent "Blue"*.

JC: *How did you transfer these images from the paintings to the prints?*

JJ: I used photographs. The leg, the bent stencil, the letters, and the coathanger all derive from photographs I had specially made. A lot of the perspective of things in the drawing of the prints is derived from photographs, so in certain situations I thought it easier to use the actual photograph than to avoid it.

JC: *You did say the complexity of the letters "blue" would have been a horrible task to render in drawing?*

JJ: Well, actually, I couldn't have done it because in the original painting they are fake. I can tell you what happened: I had aluminum letters cast for the painting—red, yellow, blue—and it was my intention to bend all the letters of the word "blue." I took them out on the terrace and began hammering at them, and I couldn't make them bend because they were so resistant. So I had to send them back to the man that made them, who also couldn't bend them. He had to saw into them, then bend them and fill in the joints with solder, so the letters are not literal, they suggest something they are not. All of the letters— red, yellow, and blue—are painted backwards as a mirror image; then between the painted image is a hinge carrying the three-dimensional bent letters.

JC: *You've used the words "red," "yellow," "blue" a lot in your paintings.*

JJ: I've used all the primary and secondary colors as words.

JC: *What are the elements of* Bent Stencil *in the actual painting?*

JJ: They are just circles in squares. The squares are treated as value, a kind of progression from white to black; the colors are a spectrum progression—yellow to orange, then it skips. To explain that: yellow, green, blue, violet, red, orange are right out of the spectrum, but adding and subtracting—yellow plus blue equals green; minus yellow equals blue; plus red equals violet; minus blue equals red; plus yellow equals orange; plus black equals brown; minus orange equals black; plus white equals gray; minus black equals white. The only place where there is any disturbance in the order is with the brown, which always seems to me to be a separate color. Then the value scale went from white through gray to black, and then from dark to light again by adding a violet.

JC: *The prints refer to … ?*

JJ: The piece of metal attached to the painting is the template I used to paint all the circles; when I got to the bottom I bent it and attached it to the lower part of the painting.

JC: *The drawing in* Coathanger and Spoon *is quite different from the painting.*

JJ: It is as though the coathanger was positioned flat against the surface, traced onto the canvas and then bent away. So the gray represents the tracing of the coathanger before it was bent, and the black is the coathanger bent backwards.

JC: *The spoon is on a piece of wire attached to the canvas?*

JJ: No, it's on a piece of wire attached to the coathanger, but loose, swinging in the air.

JC: *What about* Leg *and* Chair?

JJ: The first time I used this kind of element was in Japan, in a painting called *Watchman* (1964), in which I did a section of figure seated in a chair. It was used with the realistic or imitative surface shown forward. After I finished the painting, I invited various people to come and look at it. My Japanese friends all went up against the painting to look behind to see how it was made. So when I made this painting, which I already had in mind, I turned it the other way to show the back of the cast, as it were, or the inside of the cast rather than the outside.

JC: *Where does the title* According to What *come from?*

JJ: I made it up. Recently I found something on this wording. I think the note appearing in my sketchbook goes like "somewhere there is the question of seeing *clearly,* seeing *what,* according to *what.*" And that's where the title came from *[see plate 11—Ed.].*

JC: *The hinged canvas is at the bottom of* According to What, *face to the painting and signed on the back. I presume the print is of the image concealed on the inner face of the hinged canvas. Does the* Hinged Canvas *lithograph correspond pretty much to the original image?*

JJ: Yes, fairly exactly. In the painting the canvas is hinged and drops to the floor. The print simultaneously shows the hinged canvas closed and open. On the face of the canvas is the shadow of Duchamp.

JC: *But in the original painting everything is flat—there is no illusion of perspective.*

JJ: Yes, but in the print I just made the image symmetrical, so the top is the same as the bottom.

JC: *And the reference to Duchamp?*

JJ: Duchamp did a work which was a torn square (I think it's called something like *Myself Torn to Pieces*).[8] I took a tracing of the profile, hung it by a string and cast its shadow so it became distorted and no longer square. I used that image in the painting. There is in Duchamp a reference to a hinged picture, which of course is what this canvas is. Beyond that I don't know what to say because I work more or less intuitively.

JC: *And the black splattered blob to the side of the Duchamp profile with the trickle coming down?*

JJ: I sprayed that with a spray gun.

JC: *But does that have a particular reference?*

JJ: The painting was made up of different ways of doing things, different ways of applying paint, so the language becomes somewhat unclear. If you do everything from one position, with consistency, then everything can be referred to that. You understand the deviation from the point to which everything refers. But if you don't have a point to which these things refer, then you get a different situation, which is unclear. That was my idea.

JC: *In the original painting you applied paint by brush. Are there so many different ways of applying paint?*

JJ: It's applied through a stencil, it's applied with the idea of an image of Marcel, it's applied with air—with spray. I think this is also the first painting that I let drips go sideways—I turned the painting to let this happen. It has squares and circles of paint, is shaded and unpainted and all that kind of thing. I tried to involve the paint in the area of thought that moves from representation to material or dimensional objects, and tried to make them all equal, more or less.

JC: *Were the shadows ever a concern to you?*

JJ: The shadows change according to what happens around the painting. Everything changes according to that. Everything changes according to something, and I tried to make a situation that allows things to change.

JC: *Back to the prints. Did you try any other aspects of the painting and not use them?*

JJ: No, I didn't. What I did was to take those things which are elements and are more or less lost in the painting, and made these details the subject of the painting [sic; *should probably read "print." —Ed.*].

JC: *You dropped the use of the wide range of color as used in the painting.*

JJ: The prints are all in various cold and warm grays.

JC: *What is the portion of a comic on the top right-hand corner of* Bent "Blue"?

JJ: In the print each image is different—that area is a monotype.

JC: *Of the sixty-six numbered prints in the edition, each is different?*

JJ: Yes, each is a different fragment of newsprint—comics, want ads, sports, all kinds of things.

JC: *One would never deduce that from a single print.*

JJ: You would never deduce it from looking at one print because you tend to think that the prints are all the same.

JC: *Are any of the other prints different in this way?*

JJ: No, only *Bent "Blue"*.

JC: *And all the prints employ the same range of color?*

JJ: Yes, except in the newsprint in *Bent "Blue"*, which is a direct transfer from the newspaper.

JC: *What is the multicolored arrowed line on* Bent "U"?

JJ: Just to indicate the line at which the letters are bent.

JC: *It also repeats the colors red, yellow, and blue as used in the lettering on the painting. I notice the double arrowed line across* Coathanger and Spoon *also repeats the colors.*

JJ: In both situations it represents a line which is turned back. The words "hinge" are also in spectrum colors. I use the spectrum colors at every point where a part has the ability to turn in a different way.

JC: *Why did you cross out your signature on* Hinged Canvas *with blue lines?*

JJ: Well, I didn't cross it out. The cross was there before I signed it, but I planned to sign it that way. I have deliberately taken Duchamp's own work and slightly changed it, and thought to make a kind of play on whose work it is, whether mine or his.

JC: *Why did you cross out the printed matter in* Bent "Blue" *in the same way?*

JJ: In a sense, to say it is of no importance, because in *Bent "Blue"*, that area is constantly changing, so it's not too important what's there. But obviously it's of great importance what's there, because that is what is there. But it could be anything else—that or the next image.

JC: *Apart from color, did you use as great a variety of techniques in the lithographs as in the paintings?*

JJ: No, what I did in the prints was to get rid of color and replace it with a gray field—gray, gray-violet, and that kind of thing. Where I've used color, like red, yellow, and blue, the colorful elements generally would be those normally without color—as an indication they are directions, for instance, to bend something.

JC: *Some of the prints are also signed in different colors.* Hinged Canvas *is signed in purple,* Leg and Chair *in blue,* Coathanger and Spoon *in green. Do you have any general remarks on the prints—something that came to mind as you were making the lithographs?*

JJ: Without exception, the prints are highly representational. In every case, objects are represented, so they are very conventional illustrations. But in making what is a detail in the painting—and is often lost—the subject of each print, I made it more obvious, I think. What I did then was to print them in such a way that the suggestion of other things happening occurred. One of the ways I chose to do this is not to center the printing on the paper. Only the subject is centered, so the printing runs off the paper without margins. In every case they bleed, and this suggests they are fragments of something else.

I-24. Vivien Raynor, "Jasper Johns: 'I have attempted to develop my thinking in such a way that the work I've done is not me,'" *Artnews* 72 no. 3 (March 1973): 20–22.

[…] This seminal figure of a radical movement says: "I've never been interested in the idea of movements. I'm very devoted to the idea of one person working, and seeing what he does." *Furthermore, he disposes of the whole matter of influence by observing,* "The problem with influences is that the thing or person you say is an influence has to accept some of the blame for what you've done," *and laughing uproariously.*

[…] On occasion, as when the conversation veered toward Rauschenberg's dedication to art and technology, Johns's discretion is lowered like a portcullis: "I have an idea about that, but I don't think it would be useful." *He has a remoteness that, while very amiable, makes all questions sound vaguely coarse and irrelevant. One feels all too much a part of the outside world that he perceives as continually* "trying to figure out what's going to happen, rather than seeing what happens. Everyone is looking for reassurance about what is about to take place!" *[…]*

There is a rumor that Jasper Johns has recently been concentrating a great deal on making prints, and that in the process, he has been experimenting, perhaps even revolutionizing lithography with techniques that are either new or that are new combinations of existing ones. Johns says: "The prints may be more public now, but I've not been any more absorbed in them. I am still painting.... I don't know what people would call new techniques, I don't know what they mean. All of them are known and are fairly conventional. The only thing that's been new in my work is the use of the offset press at Tanya Grosman's. She got the press for the purpose of ... I don't know why she got it, but anyway she got one. She was always opposed to it, you know. She always wanted everything on stone. [With offset] the image comes out the same way you did it [not reversed, as in lithography], so it's a different kind of thinking—if backwards and forwards means anything to you. It has, of course, been very important to me, because I have worked with things that have a left and right orientation."

The proliferation of prints by Johns and other well-known artists has sometimes been considered as part of a general impulse to make art less exclusive. Johns likes the fact that his art is more available—"if indeed it is, and if that is the function of printmaking. I don't really believe it's true, because prints appeal to possessiveness in people even more than painting does. It's probably interesting what prints you have and what you don't have, and you know there's always the possibility of getting what you don't have; whereas in painting, that's just not true."

"You started in 1960 with Tanya Grosman."

"Yes, I'd never made a print. I still don't know how to do it. I don't know how to treat a stone, how to make it print. If I were left in the studio, I think I could figure it out, because I've seen a good deal done, but I've never done it. I simply draw on the stone and then watch what the other people do to it.... It's marvelous when you're working with someone who seems to know really what he is doing."

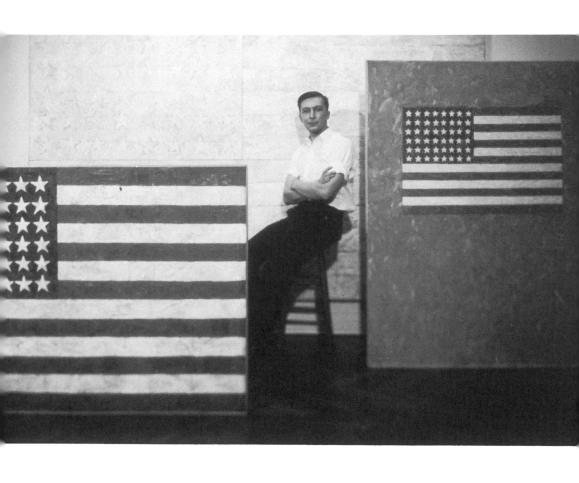

With the paintings *White Flag* (1955), *Flag*
(1954–55), and *Flag on Orange Field* (1957),
in 1964. Photograph: Dan Budnick.

"Is it that prints are just a change of medium for you, or is there something extra you don't find in painting?"

"Well—one thing is that in printmaking, one works with other people. That to me is of very great importance. If I go into a shop where there are three or four people to help me work, then I feel I have to be at work. I work a little differently from if I'm in my studio with nobody about."

"Are you a gregarious person?"

"I don't know. I just know that in the studio I'm doing all of the work and I'm fairly lazy, and have never taken any pleasure in compulsive work."

"Max Kozloff wrote once of your way of caressing a canvas all over with brushstrokes as if it were some enormous erogenous zone. It's surprising to hear you're not interested in the sheer act of work."

"Well—I try to do it as well as I can."

"Do you have anything that could be called a routine?"

"I have worked at Gemini two or three times in the past four years."

"They said you were the hardest of all to print!"

"They like to exaggerate. When I go there, I don't just go to California to make one print—it's with some idea of doing a fair-sized body of work.... But I have no work habit, I grew up with none." [...]

"Well, then, should we conclude that there's no great significance—creative or financial—to your having made prints for the last ten years or so?"

"The significance is probably in the terms of whoever thought to ask this. That is, my prints fetch higher prices on the market than most people's, but then my paintings also fetch high prices. [...]"

For some time now, Johns has been rebuilding a house in [Saint Martin], with a view to living there most of the time. Recalling combat stories told by other Caribbean settlers about the difficulties of transporting objects as mundane as refrigerators, let alone lithographic equipment, I asked how he would continue to print.

"I won't."

"What will you do?"

"Swim! No, I'm trying to get it set up so that I can paint. I assume I'll continue printing. I don't know. I don't have that kind of plan, really. What I've been doing is, I print and I paint and I occasionally make a sculpture, and every now and again I make drawings. I don't feel very programmed."

We drifted for a while into a discussion of whether art had become just another industry. For him this was not the precise word for the situation, but it led him to comment on what he called the "unclearness" of society, so that "the things which were the foundations of art—the conventions and oppositions to conventions—no longer apply. Society is now too rich to accommodate that kind of simplemindedness, so someone like me—I end up with just me, and I do what I do without any strong sense of its importance. At a certain point, one feels idealistic—that one will put oneself to good use ... being a painter. Then later on, one comes up with the question of whether it *is* of any use—I'm not sure whether it is or not. But in my life, it's too late—I mean, it would just be a hideous tragedy if I decided it

were completely useless"—*he broke out laughing at the thought*—"unless I just did it with some sense of humor, and I'm willing to do that. Nevertheless, I've trained myself to deal with the things I deal with too completely to throw them aside. I don't think I could just throw over my devotion to the visual arts."

"Do you believe new art is a criticism of the old?"

"I think art criticizes art, I don't know if it's in terms of new and old. It seems to me old art offers just as good a criticism of new art as new art offers of old."

Ambiguity and enigma being important qualities in Johns's work, the question arose as to whether their presence did not explain or even justify public misunderstanding and misuse of his work. "I think," *he said, in parry rather than reply,* "the artist is not tied to the public use of his work. There can be feedback, but if one has to identify with the way one's work is used, then I think most artists would feel misused. So I think it's best to cut oneself off from what happens after."

"Can you conceive of some ideal reception?"

"No, because my work is in part concerned with the possibility of things being taken for one thing or another—with questionable areas of identification and usage and procedure—with thought rather than with secure things."

"Is there any one person who has said the right thing about it, any one interpreter?"

"I'm always astonished anyone has *anything* to say about it and I'm always interested if they can, because I find it very hard to say anything.... If I felt my work was any one thing, if it was saying—like a teacher—this is the way you're to behave toward it, then I might have some ideas about it. Mostly I think I've dealt with things by pointing at them in a certain way, seeing if it would change what the thing was, and that allows anyone to do whatever he pleases. There are certain things a writer could say that I would reply to, 'You're wrong,' or, 'Isn't it marvelous that you feel close to the way I feel?'"

"You have in the past shown some impatience with critics. Would you care to reveal your present feeling?"

After an especially long pause, he answered in a very small voice, "I'm very tolerant," *and laughed.*

It is hard to be in Jasper Johns's company for long without being impressed by his philosophical detachment, and relaxed by it. I asked if he had always enjoyed this state of apparent grace, whether he had achieved it in his earlier, poorer days.

"No, it isn't a product of luxury. I have attempted to develop my thinking in such a way that the work I've done is not me—not to confuse my feelings with what I produced. I didn't want my work to be an exposure of my feelings. Abstract Expressionism was so lively—personal identity and painting were more or less the same, and I tried to operate the same way. But I found I couldn't do anything that would be identical with my feelings. So I worked in such a way that I could say that it's not me. That accounts for the separation."

[...] *"Have you ever taught?"*

"No. I've been asked to teach and have hedged. Then when it became apparent I wouldn't have to, I said no. The reason is that I've never studied formally...."

"Not at Black Mountain with [Josef] Albers?"

"No. I know it's come out in a number of books, but I never went to Black Mountain. I met Albers when we were photographed together by Mr. [Irving] Penn, but I don't know him. I've always been terrified of walking into a room and telling people what to do. Have you ever taught?"

"No, I've always been terrified, too. My fear is giving a talk on some artist, and waking up at the end to find I've been calling him by the wrong name."

"That happened to me once—I was introduced to Cartier-Bresson and spent the whole evening calling him Mr. Breton."

[…] It is […] difficult to visualize exactly what [Johns] means when he says, a propos his friendship with other artists like Rauschenberg and Cage and their mutual understanding and influence, that any ideas for art that came out of the association were "ideas that came out of living, not about making something artificial." *[…]*

I-25. Yoshiaki Tono, interview with Johns conducted in 1975 at Johns's studio, then on East Houston Street, New York.

[This transcription approximates the conversation on the tape as closely as possible; there are sections that are hard to hear, however, and these are indicated by brackets. Tono has decided to ask Johns some of the same questions that David Sylvester had put to him in an interview ten years earlier; see item I-14. —Ed.]

*[…]*YT: *So could we experiment, in a funny way. I pose some of these questions, the same questions, and you just talk. Not all of them.*

JJ: I don't know that I can respond to those questions, it's been a long time, but I'll try. *[…]*

YT: *David asks […], "You were saying before that you wanted to make something that somebody might find interesting to look at. But what you are making is not simply an aesthetic object."*

JJ: Well, one hopes not. Aesthetic objects have, I think, relatively limited interest. Don't you think?

YT: *It's a privileged object to look at.*

JJ: Once you are certain that that's what they are … it's not only privileged in that sense but once you have identified it as an aesthetic object, then the attitude you bring to it, the way you use it, is very limited. Because you've already iden-tified what is proper for your … what is the proper approach to it. You already know how to behave. It's more interesting if you're not certain. […]

YT: *[…] So that when we talk about aesthetic objects, and when you see, in a museum, a Van Gogh painting or a Matisse drawing, at the very beginning you are armed with the concept that it is art. After that, you enjoy how it's beautiful, or how it's bad, or how you like it or not. But the problem you [addressed] from the very beginning with flags and things, [is that] you try to provoke people to look [at] things as naturally as possible, not in this sacred way.*

JJ: Now that's the problem that anyone has facing even a bona fide work of art, which we know—

YT: *Bona fide?*

JJ: Yes, I don't know how to say it in Japanese (laughs): Something which is guaranteed to be a work of art, a legitimate work of art, a thorough work of art. One of the things that one has to do in examining such a work is, of course, to get rid of that limitation which has said what it is. When we look at a work of art, what we want to see is not that it is a work of art. We already know that it is a work of art. So that is really not what's of interest about it; what we want to do is strip away that use for it and find what makes it lively to us.

YT: *To have you aware of looking.*

JJ: Of that, or of who knows what. It could have many effects. But what one wants to do, more than anything, is to get rid of the category in which we know it belongs, as it were.

YT: *So let me say that when you showed for the first time the flags, people's reaction was not like that. They were not used to think of the flag as a work of art, and the first reaction of shock was related to the subject, not to how it was painted.*

JJ: I don't think it was that simple. The first thing I'd like to say is that the pictures weren't made for that purpose, to be encountered by a public. That was not their primary excuse for being. But then, of course, one does see what happens, in a public situation, to works. And given that there was an arrangement to show works and the people looked at them, the reaction was not that simple, really. Some people rejected the works on the grounds that the images were offensive, or something. Some accepted them on the grounds that the handling of the paint, that the way they were painted, was beautiful. Some found it interesting that there were these two things at once, something offensive and something acceptable. Something you would say yes to and something you'd say no to, in a very simpleminded way. Some people found that interesting. You saw my work very early, you didn't... you were interested in some way. I don't know what the level of your interest was.

YT: *This interest was very abrupt, I should say. Like when you want to get into a room and the door was suddenly shut closed and you couldn't get in, but you couldn't leave that place. Not only because of the door, but because of the shock. I couldn't explain more, but this kind of a shock.*

JJ: What I'm trying to say is that you represent the public as much as anyone who would look, and your reaction was not immediate disapproval. In some way, you found it interesting.

YT: *Yes, certainly. It was not approval; it was not a conventional approval.*

JJ: No, but one doesn't need ... who cares, approval or disapproval.

YT: *But now, for example, people are so used to look at your paintings as works of art (you know, the flags and things), as masterpieces of American art. They don't feel this kind of "shock."*

JJ: Not so many people do ... very few.... (laughs)

YT: *But still, the flag painting is very much categorized as an "artwork." But I think this "shock" should work always.*

JJ: Well, I don't think it can. Things change.

YT: *And you change.*

JJ: The use that people have for things changes. There's no way to avoid that. Then, in a situation like, an artist, like me and my work, one thing that happens is that people, very few people, who are interested in my work have to, in some way, use what I have already done to condition themselves with what I'm doing now. So that work from the past, for people who are familiar with my work, is already in a kind of context of time, of a length of time. It's not as though it just happened. Because obviously it hasn't just happened. Certain pictures were done fifteen years ago and then certain other pictures were done twelve years ago and certain others were done eight years ago and etc. etc., so that anyone at all familiar with my work would know that I have been alive for a certain length of time and that even for me the work has altered in its nature simply as a result of acts that I have made later in time—in painting is what I mean. I don't know whether that is fortunate or unfortunate but that is what happens. We can't deal with the entire world, every detail of it, as though it were an utter surprise (laughs). I mean, it's nice to have surprises, but not every moment.

YT: *And you didn't do it just for that?*

JJ: No. *[...]*

YT: *[...] [Tono reads another of Sylvester's questions:] "I don't, in looking at your painting, have the sense that I can pin down references, but I feel there are references there, and that these are what give the paintings their intensity, and their sense that something important is happening or has happened. Is it possible that what has happened in the painting can be analogous to certain processes outside painting, for example, on the one hand, psychological processes, such as concentrating either one's vision or one's mind on something, attention wandering, returning, the process of clarifying, of losing, of remembering or of recalling, of clarifying again, or that again there might be an analogy to certain processes in nature, such as the process of disintegration and reintegration, the idea of something falling apart, the idea of something being held together?" [...]*

JJ: I think he means that in smaller details of the painting, that there seems to have been a decision made, and to direct it in this way, and that must refer to something outside the painting. And he's suggesting that it refers, perhaps, to psychological processes, such as concentrating on something and losing that concentration, and coming back; a kind of process of... I don't know what you call it... a kind of life process where something happens, becomes intense, becomes less intense, rots, dies, maybe something else happens because of it. I think that is what he has in mind, but I'm not sure.

YT: *Do you want to know what you answered, or no?*

JJ: (laughs) No, I don't really want to know. *[Tono shows it to him anyway]* Well, this is what I seem to have.... I don't know how much this has been edited from the original tapes, probably some, because when one talks, one talks in a way that one doesn't write. Often when you see written down what you said, it looks like nonsense, because when you write down what you say, you've left out the way you hold your cigarette, the way you look at the other person, the

pauses, the accent of the voice, and the hesitation and the energy that is used. *[…] [Johns reads from Sylvester's interview aloud]* I'll read the answer, but you are aware that it is an answer to that question over ten years ago, and I don't know how it's been edited. It says here that I said, "I think it is quite possible that the painting can suggest those things. I think as a painter one cannot proceed to suggest those things"—see, that doesn't make sense—"that when you begin to work with the idea of, say, suggesting a particular psychological state of affairs, you have eliminated so much from the process of painting that you make an artificial statement, which is, I think, not desirable." I'm interrupting what I said. What I think I meant there is that if painting … if you can say that painting can be interpreted in such a way, you have to realize that you are limiting the meaning of the painting, that the painting doesn't really mean what you say. Because saying means what you say and painting means something else. Though one might agree that what you say is a reasonable thing to say, it may be the best description you can make of the painting, but it is not the painting.

YT: *But people who quote this statement identify it with the paintings easily. That's what I don't like.*

JJ: Yes, it's a hard problem, isn't it? "I think one has to work with everything and accept the kind of statement which results as unavoidable or as a helpless situation. I think that most art which begins to make a statement fails to make a statement because the methods used are too schematic or too artificial." And that is simply to reverse what I just said—that I think if you set out, in painting, to say something you could say, you would have been better to say it, rather than to paint it. Painting has a nature which is not entirely translatable into verbal language. I think painting is a language, actually. It's linguistic in a sense, but not in a verbal sense. "I think that one wants from painting a sense of life." And I think that is true. One wants to be able to use all of one's facilities, when one looks at a picture, or at least to be aware of all of one's facilities in all aspects of one's life…. *[…]* You may have to choose how to respond and you may respond in a limited way, but you have been aware that you are alive. "The final suggestion, the final statement, has to be not a deliberate statement but a helpless statement."

YT: *I like this expression, "helpless statement."*

JJ: "It has to be what you can't avoid saying, not what you set out to say." I still feel that way about art, really. "I think one ought to use everything one can use, all of the energy should be wasted in painting it, so that one hasn't the reserve of energy which is able to use this thing." It's not very good language for this. I still feel close to it. "One shouldn't really know what to do with it, because it should match what one is already; it shouldn't just be something one likes." It makes me feel very sentimental, it's so old (laughs). It makes me wish David were here too. *[…]*

JJ: David sent me a proper transcription of these tapes when I had my house in Edisto and asked me to correct them and of course they were so bad, there were so many mistakes. There are so many things you say that really don't

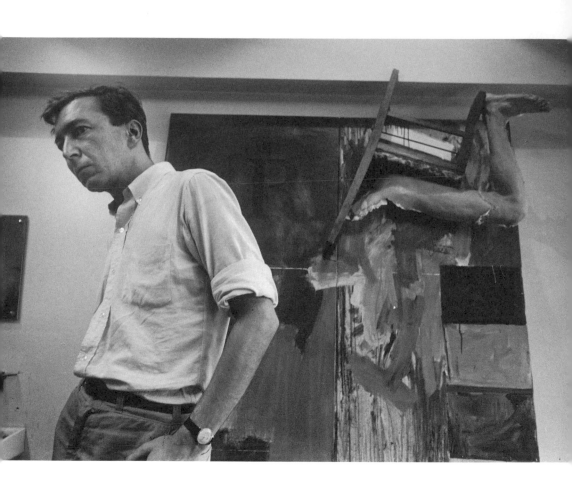

With *Watchman* (1964) in Tokyo, c. June 1964.
Photograph: Kunitoshi Matsuzaki.

make any sense written down, and I began to do it and I had more or less completed it ... I had done everything I could do to correct it. There were things I'd like to change, but they wouldn't have been corrections, they would have been changes. I worked very hard on it and that was in the house when the house burned down, and I refused after that to do it again. So this has been put together out of these tapes without my help.

YT: *Could I try this last question?*

JJ: Sure.

YT: *"You frequently incorporate into your paintings pieces of reality or casts, such as spoons and forks and the casts of faces. Has it ever occurred to you to make, say, an illusionistic representation of a spoon or fork, rather than to attach the spoon and fork by wire?" I don't know why I picked this question.*

JJ: I don't know either (laughs). [...]

YT: *I mean, why he insisted on asking this question ...*

JJ: I think it is because David is very interested in classical painting and also particularly surrealism, where something *is* "represented."

YT: *Or collage....*

JJ: Or [René] Magritte; he did that Magritte show, I think. It's a question simply out of his mind and his kind of concern. He probably simply wanted me to say that I *had* done it. When he asked, "had it ever occurred to me ...," he knew perfectly well that I had done it (laughs). [...]

JJ: [...] One of the things I most remember about Marcel [Duchamp] was at a dinner that I had with him at Christmas. I think it was Christmas, some years ago, right after I met him, when Rauschenberg and I said something to Marcel and [his wife] Teeny about meeting at some point, meeting again, coming together to see one another. And Teeny said, "Do you celebrate Christmas?" And I said, "No." And she said, "We don't either, why don't we see one another on Christmas." So we met on Christmas day [1959]: they came down to Front Street, where Bob Rauschenberg and I had studios, where you visited.

YT: *So you knew him at that time already?*

JJ: I had just met him, yes. Early... it would have been about 1960, I guess. When did I meet you, '59 '60?

YT: *'58, I think.*

JJ: So, somewhere between then and 1960. At any rate, we went out to dinner in Chinatown and Duchamp had, either that day, or the day before, come from taping a T.V. interview. I think it was T.V., it could have been radio ... but anyway, an interview with someone. He said he was not happy with the way he had dealt with the questions that this man had raised.

YT: *The way he had been questioned?*

JJ: No, he was not happy with his responses. And I said, "In what way?" and he said, "Well, this man wanted to know why I stopped painting." [...] And he had said [it was] because of dealers and money and various reasons. Largely moralistic reasons. And then he looked up and said, "But you know, it wasn't like that. It's like you break a leg; you didn't mean to do it." And I thought

that was an incredible answer, and probably very correct. It probably wasn't a decision, it was probably something that happened to him.

YT: *It's funny; the title of the last chapter in my Duchamp book,* Johns and Duchamp, *is subtitled, "About Legs"* (laughter).[9]

JJ: I thought it was a beautiful thing to say. [...]

I-26. James Klosty, "Jasper Johns," in Klosty, ed., *Merce Cunningham* (New York: Saturday Review Press/E. P. Dutton & Co., Inc., 1975), pp. 85–86.

[...] JK: *How did the idea for the* Walkaround Time *set come about? Were any fundamental aesthetic or conceptual ties between Merce's work and Duchamp's work involved in the choice of* The Large Glass *beyond the belief that visually it would make an excellent decor?*

JJ: I said to Merce Cunningham that I thought there should be a Duchamp set. He said that would be nice and that he was working on a new dance. I had just come upon a little booklet with line drawings of details of *The Large Glass*, and I thought the set could be based on these. We visited Duchamp, and I mentioned the idea to him. He asked in a shocked tone of voice, "But who would do the work?" I said that I would do it, and he said, "Certainly." I gave Cunningham the approximate number and sizes of boxes so that in making the dance he could work with cardboard substitutes, and said that any of them could be anywhere on the stage.

I painted the images on plastic in David Whitney's Canal Street loft. He and David White helped me with the large silkscreens and with filling in the colors. Jim Baird (I think) found someone to fabricate the boxes.

When they had been completed I took Duchamp to the Canal Street studio to look at them. He seemed pleased and said that at some point in the dance he would like to see the pieces put together so that the different elements would relate to one another as they do in *The Large Glass*.

Cunningham saw the set and I the dance for the first time, I think, on the day before the premiere in Buffalo, and the final decisions about placement were made then. At the end of the first performance, I told Duchamp that he should go on stage for a bow. He asked wasn't I going too. I said no. He said, as he went, "I'm just as frightened as you are."[10]

I-27. Edmund White, "Jasper Johns and Samuel Beckett," *Christopher Street* 2 no. 4 (October 1977): 20–24. Published on the occasion of Johns's retrospective "Jasper Johns," at the Whitney Museum of American Art, New York.

[...] *One of the paintings on view, the recently completed* End Paper, *is the indirect result of Johns's collaboration with Samuel Beckett. In 1976 the Petersburg Press published five texts by Beckett illustrated by thirty-three etchings by Jasper Johns. The book is called* Fizzles. [...] *When I visited Johns last summer he explained to me how the collaboration came about.* "I met Beckett through the exwife [Véra Lindsay] of an art critic. She wanted me to do illustrations to *Waiting for Godot*, but I said I'd like

to work with Beckett on something new. She didn't seem to understand and kept sending me other published texts. Then, when I was in Paris with Merce Cunningham and his dance company, I met Beckett. I told him I wanted to illustrate something new. He looked horrified. 'A *new* work?' he asked me. 'You mean you want me to write *another* book?'

"I said, 'Don't you have some unpublished fragments, just some words or phrases?' At that time I was thinking I'd use his words inside the image, phrases included within the picture. 'Yes,' he said, 'I have something like that but they're in French.' I told him I don't read French. He agreed to translate them into English. Only later did I learn what an arduous process translation is for Beckett—he makes something altogether new when he translates. Finally he sent me two or three beautifully polished pieces; they were finished works and not fragments at all. Then I coaxed another one out of him. In the end he sent me five pieces. I decided to print both the French and the English in order to make the book longer and so that people who know both languages could compare the texts. I did etchings of the numerals and derived the other images from two patterns I've been working with in the last few years—a wall of flagstones and slanted lines on the diagonal, a sort of cross-hatching.

"When I showed the etchings to Beckett he held them very close to his face and scrutinized them for ages, scanning up and down (his eyesight is very bad). I was terrified he'd hate what I had done. I said, 'Sam, I'll be happy to explain—' 'No, no,' he said, 'it's perfectly clear,' and he made approving noises. Then I showed him the endpapers. He said he hoped that I would place the cross-hatching design at the front of the book and the flagstones at the back. I asked him why. He said, 'Here you try all these different directions but no matter which way you turn you always come up against a stone wall.'" *Johns followed Beckett's suggestion, which he liked so much that he later did the painting called* End Paper, *in which the left panel is cross-hatching and the right flagstones. [...]*

I-28. Edmund White, "Enigmas and Double Visions" *Horizon* (London) 20 no. 2 (October 1977): 48–55. Published on the occasion of Johns's retrospective at the Whitney Museum of American Art, New York.

[...] This month the Whitney Museum of American Art in New York is opening a retrospective of Johns's work, his first museum show in twelve years and by far the largest exhibition of his work to date. [...]

The prospect of seeing so many of his pictures together intrigues Johns; he expects the show to tell him something about himself. "I've always thought that my work is too much of a piece," *he says.* "One wants one's mind to be agile and not overly repetitive, yet any painter has unavoidably formed unconscious habits. The habits should show up in the exhibition." *[...]*

In [...] recent years Johns has been obsessed with two motifs, both "given" to him by chance. One of these is what looks something like a stone wall. Johns found it while driving through Harlem. [...] he spotted a storefront on which fake stonework was

painted. […] he eventually painted the motif from memory. But he found that approach less than ideal. "Whatever I do seems artificial and false to me," *he has said.* "They—whoever painted the wall—had an idea. If I could have traced it, I would have felt secure that I had it right. Because what's interesting to me is the fact that it isn't designed, but taken. It's not mine."

The other motif of Johns's recent work is a herringbone pattern that he saw on a passing hot rod. "For some reason," *Johns recalls,* "I decided that would be my next painting, though I didn't get around to it for a year and a half." *[…]*

When asked about his relationship to Duchamp, Johns is quick to say that they knew each other only slightly. "Nicolas Calas, the poet and critic, introduced Duchamp to Bob Rauschenberg and me in 1960. *[…]* I met him no more than a dozen times. I was always, perhaps foolishly, very formal toward him because I feared he'd find intimacy unpleasant. Later John Cage *[…]* studied chess with Marcel, and I saw Marcel a few times through John. Then I decided to do a set for Merce Cunningham *[…]* based on Marcel's *Bride Stripped Bare. […]*

Johns went ahead with the set, and when the dance later had its premiere in Buffalo, Duchamp attended. As Johns recalls, "Marcel decided we should all visit Niagara Falls. Though he had never seen the falls, he described everything in detail. He had also worked out our excursion arrangements down to the last second. After lunch, when we were ready to go, Marcel said, 'Have a nice time.' 'Aren't you coming?' someone asked in amazement. 'But I haven't the least interest in Niagara Falls,' he said."

[…] After [Johns] had read about the [Dada] movement and visited the Arensberg collection of Duchamp's work in Philadelphia, he became genuinely and thoroughly interested. "Meeting him was important to me," *Johns says.* "Just his physical presence was impressive. I suppose all the mythology sensitizes you, prepares you to be impressed, to feel awe; yet I do think that Marcel projected an intense sense of—what do they call it?—'inner space.'"

In talking about his favorite contemporary painters, Johns declares the greatest admiration for Willem de Kooning. Then he singles out Philip Guston, Jack Tworkov, Cy Twombly, and Robert Rauschenberg—all, except Rauschenberg, Abstract Expressionists. But hasn't he always been regarded as the man who revolted against the Abstract Expressionists? "That's just sociology," *Johns insists.* "That's not me. I never set out to create a revolution."

As the years go by, Johns makes fewer and fewer paintings. "If I go too long not painting," *he remarks,* "that becomes a psychological problem for me. I mean *(roar of explosive, nervous laughter)* I begin to wonder if I'll ever paint again. But objectively I don't worry about my diminished productivity. A while ago I went to a show of my drawings in England. I walked through them and was appalled— so much stuff. The amount of work was outrageous. Then the director told me there was another floor of them. No, really, I think I've already taken up too much space."

The future of American painting is not a cheering prospect for Johns. He rejects the term "avant-garde," *explaining that* "it implies we know where we're going—

but do we? I feel painting could either be dissipated or it could be translated into entirely new terms. I don't know the terms."

Recently Joan Mondale, the vice president's wife, invited Johns and several other artists to offer suggestions about what the federal government should do for the arts. Johns came up with an idea that reflects his uncertainty about the path of art in the future. "They should use the lottery system. If we, the society, knew what we wanted, then we could pay for it, subsidize it. But we don't. I wouldn't want to choose the people for grants. My own choices are private and subjective and not necessarily for the good. We're in a funny, broken society. It's not easy to know what's to be done." *He pauses, then adds,* "It's hard, of course, to determine how much is real rotting and how much is just the normal movement in a field of change." *[…]*

I-29. Amei Wallach, "Jasper Johns, Enigma," *Newsday* (New York), October 2, 1977, pt. II, pp. 4–5, 14. Published on the occasion of Johns's retrospective at the Whitney Museum of American Art, New York.

[…] Things are seldom what they seem in a work by Johns, and the details make all the difference.

"Details offer a kind of thought," *Johns said.* "Details offer a way of thinking. I'm picky that way. I don't think it's necessarily a virtue." *[…]*

I-30. David Bourdon, interview conducted on October 11, 1977, at the Whitney Museum of American Art, New York. Published, in a shorter excerpt than the following, as "Jasper Johns: 'I Never Sensed Myself as Being Static,'" *The Village Voice*, October 31, 1977, p. 75, on the occasion of Johns's retrospective at the Whitney.

[…] DB: *Were you going to galleries [when you came to New York after serving in the Army]?*

JJ: Occasionally. I saw some of those things […] around 1950, I should think. I saw a Pollock in the old downtown-Whitney annual; I saw a beautiful [Isamu] Noguchi sculpture, I think in that same show. These were single pieces, a [Hans] Hofmann…. These are the first of these artists' works I ever saw, I believe. In an annual at the Whitney downtown on Eighth Street… a series of gouaches that Jacob Lawrence had done […], shown all together at that time. Then I don't know whether it was before or after I went into the Army, I saw a [Barnett] Newman show at Betty's [Betty Parsons's gallery]; I saw Jackson [Pollock]'s paintings on glass at Betty's. I think all of those are before the army, or possibly during a trip to New York while I was in the army. […] Then after the army I saw some [Willem] de Koonings. I don't think I saw a show of de Kooning's, though; a de Kooning painting would be in the Stable [Gallery] annual. I don't remember when I saw my first show of de Kooning. […] I saw a beautiful [Philip] Guston show at [Sidney] Janis, and I saw a [Franz] Kline show, possibly at Janis.

DB: *In [your] recent painting* Scent *[1973–74], a big deal has been made of that having the same title as the Pollock. Is there in fact any connection?*

JJ: You mean intentionally? No, I started *not* to name it *Scent.* The title *Scent* occurred to me as the proper title for the picture, and I started not to name it that because I thought it would make associations with the Pollock picture. Then I saw a picture of Bob Rauschenberg's which was called *Scent* and I thought it was a modest enough work to have freed the title as far as I was concerned. [...]

DB: *The connection seemed very attractive, since Pollock's* Scent *belonged to Leo [Castelli].*

JJ: Oh I knew the picture, of course. The painting itself had nothing to do with that painting.

DB: *Since so much of your work has to do with clues and puzzling various things out, does* Scent *have the connotation of clue, being on the scent of something?*

JJ: [...] There are certain ideas in the painting that brought the painting into being, and I thought that, in looking at the picture without knowing that, one would have a kind of sense that there was something, but I didn't think anyone would ever be interested in figuring it out; I just thought it would be like an odor. [...] That's how I got to the title. I thought there would be something that couldn't be identified but would be sensed in a certain way.

DB: *In the [Michael] Crichton text [the catalogue for the Whitney retrospective], one of the most interesting parts was where he went into discussion of the cross-hatch paintings and the Exquisite Corpse connection, which never occurred to me. That was a conscious decision to extend from one panel to another in the Exquisite Corpse tradition?*

JJ: Yes.

DB: *Did you do that because it freed you in a way by determining part of the composition [...]?*

JJ: Well, it did a couple of things. One thing it did was, it allowed me to continue doing what I was doing, making the kind of mark that I was making, and yet by hiding the previous section, and only having the ends of the marks, introduced a variation that I didn't have to consider, a kind of automatic complication to the picture.

DB: *The three parts of* Scent *are a continuum; part A can be moved to part C in a sense. What determined the final position, the ABC?*

JJ: You mean the three panels? I just had to put it together some way, so that's the way I put it together (laughs). It could be put together in any other way, I think. I probably preferred it for some reason I don't remember.

DB: *Visually, it would look different. Isn't it the third panel that's in a different medium?*

JJ: Each one has a different quality: Two of them are in oil, but one is on unsized canvas with no gloss on it. One is wax. [...]

DB: *The* Painting with Two Balls *[1960], was that title an ironic reference to the [macho] Abstract Expressionist sentiment of the time?*

JJ: It's a phrase I used to hear all the time. I used to hear that remark.

DB: *About ballsy painting?*

JJ: Yes—"It was a ballsy painting," [meaning] that "he was really painting with two balls"—and I thought perhaps that was intended.... [...]

DB: *Some of your friends compose with the I Ching. Have you ever composed anything completely generated by chance?*

JJ: No, I think that's very hard to do in painting. I don't know how you would do it. [...]

DB: *According to Barbara Rose, Cézanne was one of the influences in your drawing.*

JJ: "Influence." ... It's very hard for me to play with that word, because one is influenced by everything. [...] My familiarity with Cézanne in the flesh dates from the show the Metropolitan did. They did a huge Cézanne show, probably it would have been in '49 or '50 I think. A beautiful, big show. And since then, only where there are Cézannes here that are easily available, and I saw a Cézanne show last year or the year before in Paris—it was very beautiful— of things from French collections. [...]

DB: *But I don't see much connection between your drawings and the Cézanne drawings I've seen.*

JJ: Nor do I.

DB: *How did it feel when Pop art came along and people began putting you in the position of father of Pop art or proto-Pop, when they began to elevate you and Rauschenberg? How did it feel to be put in that position of suddenly being switched from a junior Abstract Expressionist to a father of Pop art? Were you annoyed, pleased, baffled?*

JJ: Well, I never accepted the role. I never sensed myself as being static. I never wanted to be anything specially (laughs), to be identified in that way.

DB: *I think Pop art wouldn't have happened if you hadn't done what you did.*

JJ: It's very hard to know that. One likes to think in terms of cause and effect like that, but it's very hard to know what's in the air. It's very hard to know what wouldn't have happened "if...."

DB: *Did you feel that Pop painting was less serious than what had gone on before?*

JJ: Well, painting isn't very interesting for me in those terms, having a school.... I mean, I like special paintings and I like some special painters' works, and that's about as far as it goes. [...]

The first time I saw Andy [Warhol]'s pictures, Emile de Antonio took me to his studio, and I said I had a sense of what was left out of the pictures that I didn't enjoy; the deliberate leaving out of something that had been noticed. And I had that feeling in some early pictures of Andy's. My feeling at the time was that the pictures were accomplished by deliberately leaving out information that he had.... It's very hard to explain ... before the newsphotos ... the nose job ... I don't remember all the pictures I saw. [...]

DB: *Does it please you to have your work concentrated in a small number of collections or would you prefer to have it more dispersed?*

JJ: Actually, I think I enjoy it grouped, partly because it makes it easy to know where to go to look at it. Part of that is caused by the quantity of work that I make. It's not as large as some people's. [...]

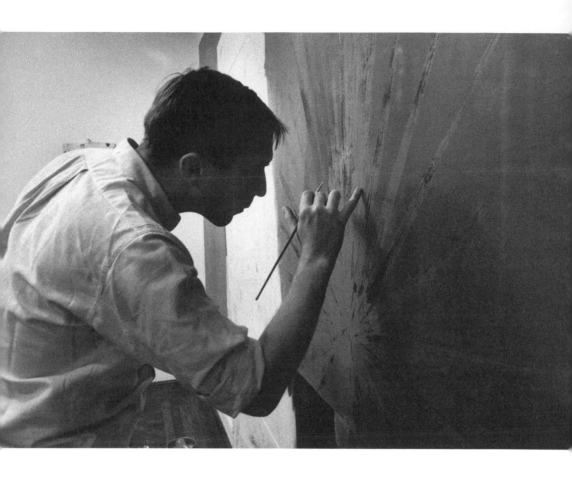

Working on the painting *Studio* (1964), 1964.
Photograph: Ugo Mulas.

DB: *What are your feelings about artists' rights? Do you share Rauschenberg's attitude concerning royalties?*

JJ: I don't know. I think it would be useful, but I'm not willing to fight about it really. Is it fair? [...] It's not a question of whether it's fair—it's fair if you decide that's what you are going to do. It would certainly be useful to many artists if it happened. I would be delighted. When a musician's work is played, I think it's marvelous that he gets some money. I would love to get some money from my paintings. I would like to have as secure an income as possible in this wonderful world we live in (laughs).

DB: *Do you still look forward to selling a painting for a million dollars?*

JJ: I would love to sell a painting for a million dollars, yes.

DB: *At what point did you realize that you were what society regards as a "successful" artist?*

JJ: Well, it hasn't happened quite yet. Except I was in L. A., I guess last year, some time while Michael [Crichton] was working on that catalogue and I saw him and he asked me some question about being a famous artist and I said, "I don't think I am a famous artist" and he said, "Of course you are a famous artist." And I said, "Well, Marcel Duchamp always said that you were only a famous artist if a cab driver recognized you, and that's never happened to me." And the next morning I was leaving L. A. to come back here and the cab driver came into the Château Marmont [Hotel] to pick up my bag and put it in the car and he did not recognize me, but he recognized my name on my suitcase (laughs), and he talked to me about art all the way to the airport. So then I was a little tempted to think along those lines (laughs). That was very recent.

DB: *What about your reputation for being so enigmatic? Are you put on the spot, feeling you have to be more enigmatic than you would ordinarily be?*

JJ: I try to be *less* enigmatic. You think I'm enigmatic?

DB: *Yes, sometimes I do, because I've had some baffling conversations with you where you seem to argue one thing.... [...]*

JJ: I try to be straightforward, but I don't know. [...] Sometimes I can't think of what to say, and sometimes my mind tends to conjure up the negative of what I am thinking, and I try to see if that's equally valid as what I am saying. I may get tied up in a kind of activity. [...]

DB: *Several of your things are named after authors; you collaborated with Beckett.... Do you read a lot? Do you care about literature?*

JJ: I really don't know whether I read a lot or not. Sometimes I read and sometimes I don't read for a long time. I don't go very long without reading some poetry.

DB: *Which are your favorite poets?*

JJ: I like Edwin Arlington Robinson's long poems; I love them, just for pleasure.... I haven't read John [Ashbery]'s work for several years actually. [...]

DB: *Do you make the rounds of the art galleries? Do you keep in touch with the scene?*

JJ: Not as much as I should or would like to.

DB: *How often do you make the rounds?*

JJ: I have no habits. I'm away from New York a lot and I don't live here.

DB: *I was going to ask you how the New York art world strikes you now compared to when you first came to New York.*

JJ: Well, the superficial answer is that it's so much larger, more activity. It's more fragmented, isn't it?

DB: *I get the feeling it's more open, [that there are] more avenues in which to get ahead. When I first came to New York, there seemed to be more limited ways, fewer galleries, magazines....*

JJ: I think there was less of everything. There was less business, fewer galleries, fewer artists, there was almost nothing in the papers, a couple of magazines, kind of one powerful group or one sort of interesting group. Now, it seems to me, there are lots of separate centers; everything is sort of diffuse.

DB: *How do you divide your year? Do you have a house in every country?*

JJ: This is marvelous—this is the first thing I wanted you to put in your piece. I'll tell you but I don't mean it. Someone did a piece on [the photographer] Hiro in *The Village Voice*, and the subheading or whatever you call it said something like, "Why can't photographers have houses in the Hamptons like Jasper Johns?" And I don't have a house in the Hamptons. I've just been investigating apartments in the city, one of which turns out to be Hiro's in the Dakota. And I want to know why I can't have an apartment in the Dakota like Hiro (laughs). [...] I moved out of New York and live in Stony Point now, and I have a house in Saint Martin. [...]

DB: *Do you travel to other countries a lot?*

JJ: I very rarely travel. I travel a great deal between here and Saint Martin, but mainly only when I have to. I don't like the winter, so when it's cold here I like to go there. In the last couple of years I was working in Paris on the Beckett project with [printer Aldo] Crommelynck and I don't know how many trips over there I made, maybe four or five. And I go to L.A. to work at Gemini G.E.L. on prints. Those are the only places I go to.

DB: *Are you able to work when you're on Saint Martin?*

JJ: Yes, I have a kind of studio there, but at any rate I work. I worked in the garage until about a year ago, then I moved out of my bedroom and turned it into a studio. It's still a very small space.

DB: *Does travel appeal to you?*

JJ: I don't like traveling. I like to be anywhere and I always say I want to go somewhere, but what I really mean is I wish I had already been there (laughs). I'm not very good at planning.

DB: *People need servants to make arrangements.*

JJ: And to speak the language, which I find very upsetting. I've never been able to enjoy Paris because I couldn't speak French. But working there with Crommelynck, and going for a number of times in a fairly short time—a couple of years going five or six times—I got so that I enjoyed it.

DB: *Didn't you take one day of French lessons some twenty years ago?*

JJ: One day, yes, but I didn't understand it.

DB: *And you never wanted to resume instructions?*

JJ: Actually, it's like traveling. I always wish I had but I don't. I think part of it is that when I go to France I am around people who can speak English so well, I wouldn't dare say a word in front of them in their language. [...]

DB: *Why did you leave New York?*

JJ: It was accidental. John Cage was living up there in Stony Point in the summertime only, in a little house on a creek, and he called me one day to say that the person he rented the house from had another little house for sale on the other side of the creek, and was I interested in it? And I went up and looked and I took it and then I started spending time there and I liked it so much. And I got so that I didn't like being down on Houston Street and I found that if I came into the city it's not very far away, it's only a half hour from the George Washington Bridge. I found that if I came into the city I got more done than I did usually in a day when I was in the city. Because my habit at Houston Street was never to go out. [...]

DB: *What do you do for entertainment?*

JJ: [...] In Saint Martin, my entertainment is swimming, and working in the yard. Up here, I just fiddle around the studio and walk in the woods. I like to look for mushrooms.

DB: *Do you grow things? Are you a gardener?*

JJ: Well, of a very poor variety. I planted carnations in the spring, and tomatoes came up (laughs). [...]

DB: *What was most technically challenging?*

JJ: At the moment the most technically challenging thing is filling up the cracks in the old pictures (laughs).

DB: *Isn't encaustic one of the most permanent mediums?*

JJ: The colors are supposed to be permanent, but that's in very classical terms, and the way I use it is not very classical, with newsprint in it which becomes brittle and cracks and yellows.

DB: *I recall seeing a white flag that was no longer very white.*

JJ: That's not only from newsprint, that's from the lead, which, unless it's in sunlight, becomes yellow.

DB: *Do you welcome this kind of morphological change in color? Does it seem agreeable?*

JJ: Not especially. I think certain materials changing very quickly add a kind of fake time to the thing that I don't really like, a patina, and give it a nostalgic quality that it doesn't have originally. But I don't think my work suffers really very badly from that.

DB: *What is the visual appeal of newsprint for you?*

JJ: Well, it's cheap and easy, that was probably one of the original things, and it had a different kind of information on it, an information that was contrary, had nothing to do with the activity. And in that thing of focusing, you can do that within one material. You keep narrowing the focus and seeing something else. I like the fact that the newspaper introduced an intellectually different focus. It also gives a three-dimensional sense to the work. You know that

what you're used to doing with a newspaper is turning [the pages], and I think there's probably a kinetic response. [...]

DB: Any works in the show you'll be particularly happy to see again?

JJ: I'll be happy to see the pictures I haven't seen in a long time. The big *[1964-65]* untitled picture that's been in Amsterdam: I haven't seen it in years. And *Watchman*, which is coming from Tokyo. [...] I'll be pleased to see them all. I'll be *interested* to see them all, I don't know that I'll be pleased.

I-31. Grace Glueck, "'Once Established,' Says Jasper Johns, 'Ideas Can Be Discarded,'" *New York Times*, October 16, 1977, sec. 2, pp. 1, 31. Published on the occasion of Johns's retrospective at the Whitney Museum of American Art, New York.

[...] Always devoted to literal images, [Johns] had a surprise for Johns-watchers. In designing the poster for the show he made a lithograph that poises the Savarin coffee can, done in 1960, against a background of the totally abstract "cross-hatch" painting he is doing now, suggesting the time span covered. "In most of my work I respect the real size of objects," *he says.* "But here I've made the coffee can larger than life— I figured since it's advertising, I could do it." *[...]*

As befits the nature of his show, Johns was in a mood to talk retrospectively. [...] [He] first came to New York from Allendale, South Carolina, at the beginning of the 1950s (he is vague on the dates), after a year and a half at that state's university.

"I'd wanted to be an artist from age five. No one in my immediate family was involved with art (I had a grandmother who painted, though I never knew her), but somehow the idea must have been conveyed to me that an artist is someone of interest in a society. I didn't know artists, but at an early age I realized that in order to be one I'd have to be somewhere else." *He roars with laughter. [...]* "I always had a tendency to try to be somewhere else."

Since Johns had made an agreement with his family that he'd go to commercial art school, he tried that for six months and then quit—after having applied for a scholarship and being told that he could have one even though his work did not merit it. "If that was true, I didn't want it," *he says, his face clouding with anger. Johns became a messenger boy and a shipping clerk for six months, then went into the army for a two-year hitch.*

"When I came back I thought I really didn't know much, so I'd go to school on the G.I. bill. I enrolled at Hunter and assumed I was going to the Park Avenue branch. But no—that was only for girls then, and I had to go up to the Bronx. The first day I had a class in *Beowulf*, then a French class in which I couldn't understand a word, and then an art class in which a handsome, red-haired lady in a hat told me I drew a 'marvelous line.' Near home, I passed out on the street. I was rescued and stayed in bed for a week and that ended my career in higher education."

Johns hadn't a clue, he recalls, as to how to operate as an artist. "I didn't know about the scene or getting a loft or anything like that. I got a job in a bookstore and though I looked at art from the first, it seemed to me to exist on a different

plane from the one I lived on. Now, from my present perspective, I remember seeing things like Pollock's paintings on glass and an incredible Noguchi sculpture of balsa wood and string, but then it was hard to give what I saw a value."

At soirées given by the artist Sari Dienes, whom Johns met while working at the bookstore, he encountered people who "moved in a larger society"—*particularly the composer John Cage, the choreographer Merce Cunningham, and a young artist slightly older than himself named Robert Rauschenberg. Though Cage and Cunningham were to become important to Johns, his friendship with Rauschenberg was crucial to his development as an artist:*

"He was a kind of *enfant terrible* at the time, and I thought of him as an accomplished professional. He'd already had a number of shows, knew everybody, had been to Black Mountain College in South Carolina working with all those avant-garde people." *How had a friendship between two ambitious and potentially rivalrous young men worked as well as it did? (Today, although the two men still admire each other's work, they no longer see each other.)*

Johns notes that Rauschenberg was between galleries at the time they met "and focused very much on working. I was prepared to do that, too. He was also involved with Merce Cunningham's dance group and totally unconcerned with his success, in the cliché term. All of the activity had a lively quality, quite separate from any commercial situation."

Johns began to help Rauschenberg do window decoration for Gene Moore at Bonwit Teller's to earn pocket money, and moved into a downtown loft while still working for the bookstore. "Bob and I began to get jobs together. I realized I could do what he did—work only when I was broke and needed money. So I quit my regular job."

Rauschenberg moved into a loft in Johns's building, and for several years the two worked closely together, sharing not so much ideas as painting itself. "You get a lot by doing. It's very important for a young artist to see how things are done. The kind of exchange we had was stronger than talking. If you do something then I do something then you do something, it means more than what you say. It's nice to have verbal ideas about painting but better to express them through the medium itself."

Early on, Johns did small collages that had a Joseph Cornell–like quality, but in 1954 he dreamed that he was painting "a big American flag. I got up and began to do it. But these ideas came after the beginning of working," *he says.* [...]

Later in the 1950s Johns decided to make sculpture. "I wanted to make a 3-D form that would sit on a flat surface and I couldn't think of what I wanted to do. The painting I was doing at the time had to do with certain literal qualities and that's what I wanted to do in sculpture. First I thought of [...] spheres broken open, but that seemed too arty. Then I thought of colored wax sculptures of people, like in posters or cartoons—that didn't work. I wanted it to be something which already existed.

"Then," *he continues,* "there came to me in a flash the idea of a flashlight, of light bulbs, which did exist, had scale, which I could imitate, and which were still subject to a certain kind of transformation. You could retain a great deal of what

they were and still alter them. The first was an actual flashlight covered in Sculp-metal, the rest I made."

Although it has often been suggested, he does not think he had been influenced by Marcel Duchamp's Dada ready-made objects of nearly four decades earlier. "I didn't really know Duchamp at the time." […]

In 1960 Johns took up prints, a medium for which he has become almost as famous as his painting. "Prints are no less important to me," *he says.* "In them I'm able to use images and ideas I work over in painting and subject them to transformation. It's a different physique entirely." *He pauses.* "The business of making prints is involved with people. I always resented it but now I tend to like it if it works well."

Johns has gone on to other images, of course—but slowly, as is his wont. "A lot of what one does is work towards an idea," *he said.* "Once established, it can be discarded." *He does not discard images quite so quickly, however: His tendency is to build from one to another, incorporating bits and pieces as he goes along.*

His ideas are apt to come from the observance of fleeting visual phenomena: In 1967, for example, while driving through Harlem, he spotted out of the corner of his eye a store with a wall painted to resemble flagstones. Later, preparing to paint it, he sent David Whitney to look for and photograph it. Whitney couldn't find it; neither could Johns when he himself went to track it down. But he claimed the image for himself—"what's interesting to me is the fact that it isn't designed, but taken. It's not mine."

He still uses parts of the flagstone image, often combining it with the cross-hatching that since 1972 has become his principal visual motif: small, clustered lines of color that jackstraw out over the painting surface. He saw the cross-hatching originally painted on a car that went bucketing past him on the Long Island Expressway. Describing his working methods, Johns says, "Sometimes there are slight things I want to do in a slightly different way; I do one thing, the next thing will be done slightly differently. I suppose in fashionable terms you'd call the way I work a 'set.'"

[…] *For Johns the future holds more of the same.* "I'll go on painting—unless seeing all the work together changes things."

I-32. Mark Stevens with Cathleen McGuigan, "Super Artist: Jasper Johns, Today's Master," *Newsweek* 90 no. 17 (October 24, 1977): 66–79. Published on the occasion of Johns's retrospective at the Whitney Museum of American Art, New York.

[…] *[Johns] now spends part of the year in a house on the Caribbean island of Saint Martin, and part in a house in Stony Point, N.Y., an hour's drive from New York. He used to live in a converted bank in Manhattan—he kept his paintings in the vault—but grew tired of the city.* "I liked New York when it was an up-and-down city for me, low streets and high buildings," *he says, characteristically using a visual perception to express his feelings.* "But then, for me, it grew horizontal—monotonous." […]

He answers all questions as factually as possible; his mind is tuned to the literal—that is the way to see ambiguities clearly. […]

"I work by putting parts together," *he begins,* "canvases together ... of different natures ... seeing what happens, whether they become one thing, how they change ... how you deal with these things." *[...]*

As a child, Johns went to spend a summer with his Aunt Gladys in a town called the Corner. He stayed six years, attending a two-room schoolhouse called Climax. By the time he graduated from high school in 1947, he had gone to five different schools. He attended the University of South Carolina for a year and a half and disliked art history. "Art history is *about* paintings, isn't it?" *he says.* "I never really saw paintings. You understand, there were no paintings in South Carolina to see, so you just looked at things, these little things in books." *[...]*

Johns [...]settled in New York in 1953 [...] "I remember the first Picasso I ever saw, the first real Picasso," *he says.* "I could not believe it was a Picasso, I thought it was the ugliest thing I'd ever seen. I'd been used to the light coming through color slides; I didn't realize I would have to revise my notions of what painting was." *[...] In 1954, he destroyed all his work. (He has since tried to buy back early work that others own.)* "It was an attempt to destroy some idea about myself," *he said.* "It gets to sound very religious, which I don't like, but it's true."

Soon he met Robert Rauschenberg, another poor Southern artist, who was several years older than Johns. [...] "Bob was the first person I knew who was a real artist," *says Johns.* "Everything was arranged to accommodate that fact." *[...]*

[...] [Johns] soon met Duchamp, who was living in New York, and became an admirer. There was much he disliked in Duda: its nose-thumbing politics and its belief that it does not matter how art looks so long as the idea is sound. But he respected Duchamp's turn of mind—what he called his "slapping at thoughtless values." *Johns also read Ludwig Wittgenstein, attracted by the Austrian philosopher's analysis of the* "way we can abuse the structure of language to create new meaning." *[...]*

[...] Characteristically, Johns thinks his lithography has become "decadent." "The nature of the technique is that I end up with great facility. In painting, I don't think there is less pretension, but it maintains its original clumsiness for me."

[...] Johns refuses to discusses the feelings his paintings may provoke. To discuss them in those terms would, in his view, steal from the viewer the freedom of his eyes.

But he does not, as some think, consider emotional reactions to his work suspect. "I find all use of space emotionally affective," *he says.* "But there's no intention on my part to achieve that— then you lead people on. There's a Leonardo drawing that shows the end of the world, and there's this little figure standing there, and I assume it's Leonardo." *He laughs.* "For me, it's an incredibly moving piece of work—but you can't say that, in any way, was an interest of Leonardo's."

[...] In his studio, he leafs through a book he recently made with Samuel Beckett, Foirades/Fizzles. [...] As Johns turns the pages, he carefully removes the pieces of soft paper that protect the etchings and examines his own work. When the silence of seeing grows unpleasantly precious, he smiles, raises one of the paper dividers and announces: "They're made from the same material as tea bags."

Johns says he remembers Beckett's blue eyes and "his incredible sense of internal space." *[...] Over lunch, he tries to explain why he feels it necessary to keep producing*

pictures that are so different from each other, why he is so restless. "If society were different," *he says,* "we might be content just to do something well. But no one is pleased to do simply what they do. What's important for us is always what doesn't exist."

That curse can also be a blessing. "If you repeat what you know," *he says,* "it's not really very interesting. When you make something new you feel more lively."

I-33. Grace Glueck, "The 20th-Century Artists Most Admired by Other Artists," *Artnews* 76 no. 9 (November 1977): 87, 89.

Artnews asked nearly 100 artists: what specific work(s) or artist(s) of the past seventy-five years have you admired or been influenced by—and why? [...]

Three works from the past have been important to me: Picasso's *Les Demoiselles d'Avignon,* Marcel Duchamp's *Large Glass,* and Cézanne's *The Bather.* But also, for any artist, things that occur during the period in which he's working have equal importance, as Rauschenberg's paintings do for me.

The Picasso painting has a kind of coarseness that's interesting. It makes available different kinds of qualities that are meaningful to me. Duchamp's *Large Glass* shows his conception of work as a mental, not a visual or a sensual, experience, in which one thing can mean another. With Duchamp language has primacy, and the *Glass* is a pun on opaque meaning and transparent material. He presents in literal terms the difficulty of knowing what anything means—you look through the glass and don't see the piece itself.

As for the Cézanne, it has a synesthetic quality that gives it great sensuality—it makes looking equivalent to touching.

These might be considered great, but in one's own working things not great often have equal or deeper meaning. One isn't attached just to great things.

I-34. Roberta J. M. Olson, "Jasper Johns: Getting Rid of Ideas," *The SoHo Weekly News* 5 no. 5 (November 3, 1977): 24–25. Published on the occasion of Johns's retrospective at the Whitney Museum of American Art, New York.

[...] Johns's well-known use of the archaic media encaustic—painting with pigment suspended in hot wax—went further with the manipulation of the painting's surface than some of the Abstract Expressionists. "I don't know *why* I turned to it," *he said.* "I was using enamel paint for my flag paintings. And although I wanted the strokes to remain separate, the enamel wouldn't dry fast enough to allow this. But encaustic allowed me not only to keep my strokes separate but to paint over them very soon after."

Johns confessed that he now works more often in oils. "It got so that I didn't like to get burned! Actually my concerns in the paintings have shifted. My marks in the early pictures were shorter and more discrete."

Asked about the nature of his subject matter and the change in his more recent work, Johns replied: "What unites things like the flags and flagstone pattern which I once fleetingly saw on a Harlem wall is that in both cases one does not examine

On the porch of his house in Edisto Beach,
South Carolina, in 1964. Photograph: Ugo Mulas.

the objects very closely. You could easily identify them, without looking very closely. One would ordinarily respond to them visually by looking at them quickly and then forgetting them." [...]

One of the most intriguing works is entitled Untitled *(1972). It is composed of four panels—the first with cross-hatchings, the middle two with flagstones and the last, startlingly macabre for Johns's refined oeuvre, with cast segments of human bodies realistically painted and juxtaposed with a seemingly random grid of wooden boards.* "It seemed that the cross-hatchings could be equated with flagstones. I know that the last section is psychologically loaded, but I wanted to see what would happen if the same artistic attitude was taken toward all of the sections." *Was he successful?* "I think that I did take the same *[formal]* attitude toward them all. The size of the body fragments is related to the size of the flagstones as well as echoing their placement on the canvas."

Johns had previously used partial body casts, for example, in one target where they were "neutralized" by being painted in bright colors. The artist did, however, admit that these recent Duane Hanson–like casts did not present that same kind of neutrality. Instead, to many viewers' eyes they were disquieting, far from formalist devices and closer to the contemporary atrocities committed in Viet Nam. [...]

During his early days in New York City, Johns and Robert Rauschenberg [...] shared a closely knit friendship of cross-fertilization. [...] It has been said that during this period the two artists also painted works in each other's styles.

I asked whether any so-called "Johns" paintings by Rauschenberg existed in collections today? "No, but there is one 'Rauschenberg' by Johns. Really, though, it is a Rauschenberg because after I finished it, Bob fooled around with it and I do believe that he eventually signed it. It was a small painting and I don't know its whereabouts today.... The only time I remember Bob actually working on a painting of mine was when he picked up the red paintbrush and went to work on one of the white stripes in a flag painting." [...]

Johns once related that the source for his flag painting came to him in a dream, "but that was the only instance where a dream was my inspiration," *he told me.* "All other ideas have occurred during my waking hours. Whenever an idea comes or whenever you think that you see something it is as astonishing as a dream, and as natural. And afterwards you wonder why you never saw it that way before." *Although Johns's work reveals an interest in linguistics and philosophy, and it is known that Johns has read Wittgenstein, Johns cryptically stated that,* "Yes, I once read Wittgenstein, but no longer. However, I do read."

Rather, the intensely private Johns preferred to talk about his methodology, appropriate for his art which itself is so concerned with process. "I usually begin with some sort of an idea of what I want to do. Sometimes it is an image. I always want to see what it will make. Then, I actually start working. During the process I don't have any morality about changing my mind. In fact, I often find that having an idea in my head prevents me from doing something else. It can blind me. Working is therefore a way of getting rid of an idea. The manner in which I work constantly

involves a feedback. I paint out parts, change others, and add and subtract as I go along. I don't think about chance. One's initial ideas may have to do with chance, but as one continues, one watches and controls the effects." [...]

Since in his formative years Johns knew Cage, a strong advocate of chance, I was curious how and why he denied chance as an important element in his work. "Music is very different from painting, for it is written and it gets performed by different people, while a painting is just the work itself. Chance does interest me as a concept, but I don't see any place where it plays a major role in my work."

When asked if he had any mentors when he first came to New York [...], the artist replied: "My first mentors were the people whom I met and whose work I saw in New York. [...]

"The few painters whom I admired and knew when I came to New York were Philip Guston and Jack Tworkov. I met them during the mid-'50s. I first saw Guston's work at the Sidney Janis Gallery and thought that it was very beautiful. I saw more of Jack and visited both his home and his studio. He said some very important statements about painting and I believe that he is one of the least self-centered artists. He is able to look at the work of other people without always thinking about his own." [...]

Much has been written about how Johns's work requires a great deal from the spectator. Johns's comment on that assessment: "The spectator gets everything that I get." *Johns's titles are generally literal, simple clues to the nature of his explorations.* "I have always loved it when works could be called what they really are."

Johns has always seemed to be an artist who works more comfortably in monochrome, or more specifically in grisaillelike tones. Johns candidly remarked, "I believe that I'm not a very accomplished colorist, although I do think that I've improved somewhat. I think that I can improve even more. I've always used schematic coloring and since there's always a tendency to move on to something, I want to do something different with color."

How much of a concern is sculpture for him?

"I think that picture-making is the central concern of making for me. As far as sculpture goes, I'm currently working on a few things that relate back to older works, but I don't have too many ideas which relate directly to that medium. Even though I do incorporate sculptural objects into my works, I tend to think of sculpture as something that sits on the ground and painting as something that projects from the wall."

There was one mystery about Johns's work which I wanted to clear up: why did he stop working on Skin *(1962), a work in which he intended eventually to cast a flattened, maplike rubber mask of Jim Dine's head?*

"Originally I wanted to use Jim Dine because he had just shaved his head. I never finished the work because I had attempted some sort of partial cast and had botched it, but I had caused Jim so much agony that I couldn't continue." [...]

I-35. Annelie Pohlen, "*Interview mit Jasper Johns*," *Heute Kunst* (Milan) no. 22 (May–June 1978): 21–22. Interview conducted on February 10, 1978, at the Kunsthalle Köln, on the occasion of Johns's traveling retrospective there.

AP: *Around 1964, you stated in an interview: "I prefer work that appears to come out of a changing focus." What is the meaning of this concept and of another term you used, "indecisions"?*[11]

JJ: Well, I meant it in the sense of undefined, or what I consider an undecided situation, one that offers more possibilities to examine a situation. I think an undecided situation—something conditional—leads to a broader spectrum of facts.

AP: *Could you define this in the context of your work?*

JJ: I think the works speak for themselves—by the way, what I say is not always true (laughter). Well, I believe many of my works offer the possibility of making relationships and creating an idea that is not pointed out implicitly. One can go one's own way, or can form an opinion that was not necessarily suggested by me. But one can establish connections between different forms of existence of things and develop one idea.

AP: *Does this concern both your own freedom and that of the viewer? In other words, the viewer is not restricted to adhering to specific points of view?*

JJ: Yes, that's it. But in order to achieve this, both freedoms must be anchored in the work. […] At least one must avoid channeling reactions. […] There are types of works that prescribe for the viewer what to think and how to react. One has a predetermined idea, and everything is pointed toward that perception, and one adjusts oneself to be in conformity with that idea. But there is another approach, a way that leaves more air around the elements. You don't have to encounter [the work] in a direct confrontation; you can approach it in a different way, a way you prefer.

AP: *You have often been called the father of Pop art, and you have in fact made objects that come very close to Pop. What are your ties to that movement?*

JJ: […] I simply believe that my contemporaries, as well as some members of a younger generation, who were working during a certain period, shared some attitudes and some forms of communication. I don't know exactly what it is, but I think what we shared was probably something in the air, and not the concept of any individual person.

AP: *Your work contains a multitude of objects that you have addressed time and time again over the years—here in Europe the most noticeable ones include the flags, the targets, and the numbers. What significance does the object have for your painting?*

JJ: Well, one of the most interesting things one can do is use something in a variety of adaptations, and then ask the question "What does it mean?" I am not quite sure.

AP: *But your oeuvre encompasses the medium of painting as well as object art. I remember a discussion in which somebody confessed to not understanding why you use objects to paint.*

JJ: Well, that person could just as well have asked the opposite question (laughter), why I use painting for these objects (laughter). I can't give you the answer. For me, the decisive factor is my interest in this ambivalence.

AP: *An ambivalence between object and painting?*

JJ: Yes, I think that's a far more complex matter than the interplay between two things. I hope that there's at least the possibility of a greater complexity. I really hope so.

AP: *Is there anywhere in your works some implication for or against the "American way of life"—against consumerism?*

JJ: I haven't dealt with such questions in my work. I don't quite understand what you mean.

AP: *I'm thinking of the many objects in everyday life, things everybody needs or believes they need. Isn't there anywhere in your work a touch of either criticism or condoning of the American or even the universal way of living?*

JJ: Certainly not! What captured my interest in the works you describe was the invisibility of certain things we surround ourselves with—the question [of] whether or not we perceive the table we are sitting at, whether we see it or don't see it. Or the flag, for instance—this certainly doesn't hold for Europeans, but to me the flag turned out to be something I had never observed before. I knew it was a flag, and had used the word "flag"; yet I had never consciously seen it. I became interested in contemplating objects I had never before taken a really good look at. In my mind that is the significance of these objects.

AP: *Does this also hold true for the trompe l'oeil technique you applied around 1964, in the beer cans, for instance? Is this too motivated by the problem that we see everything without really comprehending it?*

JJ: In many ways yes. If one creates such objects, the question arises of whether or not the audience will recognize them as the objects they portray—and some people did actually believe those cans were real beer cans. But in any case, the effect is no longer fresh by this time, because so much has been written about it, so many people have seen them. So the perception is already predetermined. Before, an unprepared viewer could explore the work and have his own experience with it. Observed that way, the works are quite funny. [...]

AP: *Is there a link to Marcel Duchamp and to his "readymades"?*

JJ: Well, I think there is quite an obvious connection, although not an intentional one, as far as I'm concerned. But I believe one could possibly see here some sort of reversal of Duchamp's problem—that is, to do nothing, in other words to take a manufactured object as is and then declare, "Now this is a piece of art." That's the way those things work, like the bottle rack and many other objects Duchamp produced. Viewers established a connection to my pieces, which are handmade but do look like the readymade objects he turned out.

AP: *I don't remember right now whether it was you who told me this story: a viewer, looking at your flag picture, asked "Is that a flag?" and you replied, "No, that's a picture." Another person asked "Is that a picture?" and you replied, "No, that's a flag."*

JJ: The hell with those kind of stories (laughter). In fact it's both.

AP: *John Cage said the same thing, didn't he? In any case, for several years now, since about 1972, there seems to have been a break in your work, at least in terms of its optical impact. Earlier works suggested material objects from the real environment; there's nothing left of that now. Is this a break or not?*

JJ: I don't know. To me it represents a continuation of what you consider no longer of the real world, yet originally it did come from that world. I am using it without giving much thought to that factor. Everything I call an idea evolves from an actual experience.

AP: *And what is the experience behind, say,* Corpse and Mirror?

JJ: Well, that cross-hatch motif first appeared in a large untitled painting (1972), together with other elements, such as body parts, etc. [...] A year later I started using that motif in this large painting [in which] the bodily images had a somewhat stronger, more subjective quality. I thought it would be interesting to abandon them in favor of those mere traces. And that is why I love working with them and plan to continue in the same genre.

AP: *Doesn't this aspect of painting thus become more overt than in earlier works that still contained objects, or is it more liberated, say, from the objects of the environment?*

JJ: Not from my point of view, because these things are as much a part of the environment as any other object.

AP: *In other words, you don't see a break from earlier works?*

JJ: I see what you mean, but it isn't what I see. You are absolutely free to think things that may not necessarily coincide with what I have in mind. I feel that, superficially viewed, one group of pictures looks different from another group. But as far as I'm concerned, [...] [the pictures] too closely resemble what came before (laughter). In my opinion, the transformation is actually even too insignificant. It takes too much of my time to bring about a change. As far as you're concerned, you have introduced a transformation. Therefore your inter-pretation differs from mine. I am committed to what I have to do, ergo I am doing it. [...]

AP: *[Encaustic painting] looks more substantial than, say, oil on canvas. Could it have been this "materialized" aspect of the technique that stimulated your interest in it?*

JJ: In one respect it did: the encaustic technique emphasizes the object character of the pictures, particularly of the early ones. And when I added newspapers to the pictures, this quality was even further enhanced. Then I added more materials. I've always been interested in exploring the quality of various materials.

AP: *What is the connection between the support and the painting itself?*

JJ: One of the most interesting aspects is that the painting covers the surface, so that there is nothing that is not the object in one way or another. In any case, one does become very much aware of the physical size of the object and its corners. In some early pictures I painted beyond the edge, farther than neces-sary. [...] In other cases I developed a kind of mannerism in the relationship

between painting and canvas, by leaving a corner of the canvas blank. At first this happened by chance, while I was working on a large painting; as I usually do, I painted the upper part first, because I have to bend down to work on the lower part. I became aware of it and decided to leave it that way, because I liked it that much.

Also, in some popular science magazine back then, I read a piece about the psychological interpretation of space, and it [said] that the upper third [of a painting] stands for what is in the distance. It wasn't my intention to depict that, but viewers see it that way. The center represents some kind of indeterminate direction, and the lower third is the most direct part, the part that comes closest to the present situation.

AP: *Your graphic work deals with the same problems as your paintings, although the approach is different. What significance does the graphic work have for you?*

JJ: It varies. An aspect always of interest to me is to develop an idea or an image and execute it in different ways to determine what its meaning could be. If you make a picture in oil, then in encaustic, and then as a drawing, what do the variations have in common, and what are the differences? To what degree does your statement change?

I'm always interested in printing in terms of working with the material. Printing also interests me from a social point of view, because it always includes working with others, a situation that rarely came up before I really tried it. It was through the printing process that I came to like working with others, at least in most cases. At times it can be very painful as well.

AP: *In other words, you have a bundle of experimental work, in order to deal with various visual problems by using different media.*

JJ: I believe the answer to that has to be yes.

I-36. Peter Fuller, "Jasper Johns Interviewed I" and "Jasper Johns Interviewed Part II," both in *Art Monthly* (London), respectively nos. 18 (July–August 1978): 6–12, and 19 (September 1978): 5–7. Published on the occasion of Johns's traveling retrospective at the Kunsthalle Köln.

Part I

[…] PF: *You have been quoted as saying, "I've always thought that my work is too much of a piece." Do you still feel that after the show?*

JJ: Yes, I always feel it. I don't know whether that's an intellectual response. I don't know *where* one feels it. But I do feel I would like my work to be more varied than it is.

PF: *Hilton Kramer wrote about your exhibition that Johns "repeats, and endlessly, the same themes, devices and mannerisms but very quickly wears them out." That is close to saying your work is "too much of a piece," isn't it?*

JJ: No, no. I'm not talking about repetition. He seems to consider that there should be a novelty within the work. I'm not talking about that. My experience of life is that it's very fragmented. In one place, certain kinds of things occur,

and in another place, a different kind of thing occurs. I would like my work to have some vivid indication of those differences. I guess, in painting, it would amount to different kinds of space being represented in it. But when I look at what I've done, I find it too easy to see the connection between one thing and another thing. It may just be that I know how I come to make a work: I know how hard it is to discard ideas or involvements that you already have, to come up with a different approach. Even if you succeed in altering your way of thinking, you very easily attach that to the past in your own life, even though you may have changed a good deal.

PF: *What did you feel about the critical response, in general? Even your supporters like Robert Hughes, in* Time, *were writing that the show revealed you as "not the Leonardesque genius we have all been conditioned to expect."*

JJ: How many artists are criticized in that way? For not being Leonardesque! Hilton Kramer certainly didn't think my work was as interesting as Cézanne, yet he bothered to point out it wasn't. I find that an astonishing attitude to bring to that kind of exhibition.

PF: Time *also called you "the intelligent person's Andy Warhol." What does that description mean to you?*

JJ: It means nothing at all.

PF: *You once said, "whatever I do seems artificial and false to me." What did you mean by that?*

JJ: I don't know.

PF: *You don't just get bizarre negative criticisms: the positive ones are often just as strange. Barbara Rose once wrote of you, "He is among those artists for whom the activity of the canvas is the exemplar of his understanding of right human conduct." Do you accept that kind of judgment? If so, how do your works exemplify "right human conduct"?*

JJ: I don't read criticism in that way, to see if it's true (laughs). What one is touched by is the fact that anyone has anything to say about one's work. When I think how hard it is for me to say anything, and I know my work fairly well, I find it quite marvelous if other people can come up with something to say about it. It seems perfectly acceptable to me that it be rather outlandish (laughs).

PF: *She also wrote of you, "Out of negation and a refusal to compromise or to conform has come a heroic affirmation of creativity in the face of all forms of entropy, demoralization, nihilism, and despair." Do you feel your work to be a heroic affirmation of this kind?*

JJ: I tend to think that all artwork is heroic. I think it's a heroic enterprise from childhood, from the very beginning, whenever it begins.

PF: *So there's nothing especially heroic about yours?*

JJ: Certainly not from my point of view (laughs). It's just what I do. [...]

PF: *You once said that you preferred the work of de Kooning, Guston, Tworkov, and Twombly. That's Abstract Expressionism, primarily. What is your view of Abstract Expressionism as a movement now?*

At the Gemini G.E.L. print workshop, Los Angeles,
in 1969. Photograph: Malcolm Lubliner.

JJ: I don't have a strong sense of it as a movement, really. I have some sense of individual artists who were part of that movement. It's certainly not the idea of the movement that interests me.

PF: *Well, take de Kooning specifically. Why do you admire him so much? What did you learn from him?*

JJ: I think more interesting is what I have not learned from him, which seems to be there (laughs). De Kooning is a wonderful painter. But I don't know how to describe or justify the value one gives an artist's work. One tends to use cliché: "energy," "technical mastery" (laughs).

PF: *Do you think that the claims made for Abstract Expressionism in the 1950s were excessive?*

JJ: What claims?

PF: *Claims made by critics, especially [Clement] Greenberg, American art institutions and museums.*

JJ: I don't know what you are talking about when you make a statement like that. When I came to New York in the '50s, Abstract Expressionism was rampant. Everyone was concerned with it; and that made a very nice kind of screen. One felt that it was in very good hands and one did not have to be concerned with it. Because everyone was concerned with it, it made it seem very lively even though one was not going to join it. [...]

PF: *By the late 1950s, Abstract Expressionism was looking more than a little tired, wasn't it?*

JJ: Any ism will expire. By having an ism you are separating it from other things. Your attention has to deal with the entire field. Things displace one another in one's interest.

PF: *In 1958, you had your first one-man show at Castelli's. You were twenty-eight, and unknown. But you got incredible critical attention; almost all your work sold. [Alfred H.] Barr bought three pictures for MoMA. Why do you think you had this sudden success?*

JJ: A number of reasons. My work was unknown generally by the art world and particularly by other artists. There were very, very few people feeding information about my work to other people. At that time, in New York, most young artists worked in a social setting where everyone knew what everyone else was doing. But my work took shape without many people's knowing about it. Also Castelli had just begun his gallery; it had no habits, and that was important. Then there was the obvious novelty of my work in relation to what was generally being shown. Fairfield Porter came to my studio before the show opened, and did a criticism for *Artnews*. Tom Hess, who was then the editor, decided on the basis of that, I believe, to put a painting of mine on the cover. That again was something quite unprecedented, that someone no one had ever heard of had a picture on the cover of *Artnews*. Especially as Tom's primary interest was Abstract Expressionist painting.

PF: *In 1959, Ben Heller wrote, "Johns has been as much a pawn in the current art world game of power politics as the bearer of a new or individual image." Do you think that was true?*

JJ: I am not sure that I understand.

PF: *Well, in 1958 you expressed surprise at the interest in your work. You said you thought anything that you made could only be of interest to yourself. Do you then think that Leo Castelli, Alfred Barr, Tom Hess, etc., saw a cultural function for your work, which you did not see, which they then exploited?*

JJ: Not in any sinister sense. Art in the mid-1950s took on a value it had not had previously. Just look at the change in the number of publications, galleries, and artists between, say, 1955 and 1965. It's not that someone made something happen. Something was happening and people were making things. It is difficult to come up with a cause and effect. You had a complex in which many things were affecting one another. The fact that Leo was just forming his gallery was very important. All the other New York galleries that I know existed then had an attitude toward work into which my work could not comfortably have fitted. I think my work would have been seen in a very different way if I had shown at, say, the Stable Gallery. I don't think any of those dealers would have shown my work, but if they had I think it would have been treated in a very different way. The only dealer I wanted to show my work was Betty Parsons: I felt her artists were not of one kind. But that didn't work. So the fact that Leo appeared was interesting and a marvelous coincidence from my point of view; the fact that my work existed was a marvelous thing for him. Instead of putting him in competition with other galleries with the same kind of interests, it made a very clear difference between what he was doing and what other people were doing. That kind of clarity perhaps brings a sharpness to the situation. It demands either that the new work be deliberately ostracized or paid attention to.

PF: *In 1964, Sidney Tillim wrote that your work provided "an alternative to abstraction that would nonetheless preserve its principal formal characteristic—the flat picture plane." Did you ever see your work that way?*

JJ: No, of course not! (Laughs.)

PF: *Yet surely it was because that kind of claim could be made about it that you received so much art-world support in 1958.*

JJ: Why couldn't you believe that aspects of my work emphasized certain things that painting at that time generally did not emphasize, and that this change of emphasis was *useful* in the society, as well as having a novelty which engaged people?

PF: *But in what ways was it useful, useful to whom, for what, and why? Are you saying that those who wrote like Tillim about you misunderstood your work?*

JJ: I don't think work can be understood, if you mean by that it is to be *one* thing. I don't feel that. I don't even understand my own work in that sense.

PF: *The standard art-historical view of your work is that you provided a link between Abstract Expressionism and Pop art. You've dismissed this as mere "sociology." Don't you accept that much of the enthusiasm for your work at the time of your first show arose because it found a way through for Abstract Expressionism, or American-style painting, at a time when this national art looked very much in crisis?*

JJ: I don't follow you. My work expressed ideas that were not being expressed in painting that needed expressing. But it isn't clear to me. Are you trying to give it some political significance?

PF: *It is a more cultural question. Greenberg once wrote that the "abiding significance" of your art "lies mostly in the area of the formal or plastic." Do you agree?*

JJ: Isn't that where he wants the abiding significance of all work to lie? (Laughs.) I would doubt that work has "abiding significance."

PF: *Nevertheless, from the point of view of the formalists, you introduced the appurtenances of representation into what was essentially an abstract aesthetic.*

JJ: I wouldn't agree with that if you mean to give me that responsibility within the large field of art in America. I think my work drew attention to that, but it was in the air. It was also a strong aspect of Rauschenberg's work from the period of his red pictures on. Almost all the elements of his work conveyed themselves as well as some other kind of information—written, photographed, or whatever. But perhaps the superficial simplicity and blatancy of the images that I used suggests the kind of remark you just made.

PF: *But Greenberg also said about your work, "Everything that used to serve representation and illusion is left to serve nothing but itself, that is, abstraction; while everything that usually connotes the abstract or the decorative—flatness, bare outlines, all-over or symmetrical design—is put to the service of representation." Was that true?*

JJ: In a sense it is true. It's a smart thing to say. By "smart" I mean "not stupid": I don't mean "cute."

PF: *In the work which you have been making since 1972, the cross-hatching series, you have even abandoned these appurtenances of representation. This could be taken as indicating how little you ever moved from a classically Abstract Expressionist aesthetic, couldn't it?*

JJ: You could take that point of view, yes. But I am not sure of the degree to which I make the distinction between abstract and whatever it was we were opposing it to.

PF: *With the abandonment of even the appurtenances of representation, I am suggesting you are lapsing into classically Abstract Expressionist pictorial concerns.*

JJ: You can take that point of view, but I don't see it that way, I must say. You are making a point—but it is not a point of mine.

PF: *Recently, Suzi Gablik, a friend and admirer of your work, wrote about the recent paintings, "With these pictures Johns emerges as an 'all-over' painter in the sense defined by Clement Greenberg." Does the fact that you are being read in this way even by your most sympathetic viewers worry you?*

JJ: No, because I think it is very hard to have an idea about a picture. Any picture carries such a dead weight. It is very hard to tell what is interesting about a picture, and then to *state* it is even more difficult. But I don't think that my pictures are interesting because they are like abstracts.

PF: *In 1970, Hilton Kramer described your work as "de Kooning plus Duchamp." He wrote, "the de Kooning–Duchamp synthesis was a winning combination. Its large*

debt to Abstract Expressionism offered just the right obeisance to established taste, and its debt to Dada—a Dada now cleansed of any political overtones—just the right degree of innovation and surprise." Was your work "de Kooning plus Duchamp"?

JJ: It does not make sense as a formula for doing my work, but I understand that someone could see relationships between my work and that of those two artists.

PF: *You saw quite a lot of Duchamp just before his death, didn't you?*

JJ: Not really.

PF: *Why do you always play down your relationship with him?*

JJ: Only because people have assumed I was very close friends with Marcel, and I was not. I saw him perhaps a dozen times in my life. The first time, I saw him at a party. I did not speak to him. Then someone brought him to my studio. Once, I went to a Christmas dinner which he was at in Chinatown. Then I saw him again at a party. After that I did not see him for years. Then John Cage began to study chess with him and around that time I saw him perhaps eight or ten times. These were very modest encounters. They did not involve much exchange of ideas. There was a set for Merce Cunningham based on the *Large Glass*. I saw him around that a few times.

PF: *Are you saying he was not a significant influence on you?*

JJ: No, I never said that. I first went to see his work in the Arensberg Collection when someone referred to me as "neo-Dada," and I did not know what Dada was. Then I read the Motherwell book on Dada and Surrealism. The Lebel book on Marcel appeared about that time: I got it when it was remaindered. Then someone gave me the *Valise* and a year or two after that I knew that Marcel had a copy of *The Green Box* and I wanted it. But it was all in French, and I can't read French, so I decided not to get it. About that time, the translation which Richard Hamilton did the typography for appeared.[12] So then I went back to Marcel and asked if I could buy the facsimile thing, which I did. So I was very inquisitive about his work and ideas. But he was not a person that I would ever have bothered asking too much; actually I asked very little. He was not terribly generous about exposing himself.

PF: *But did you consciously try to keep politics out of your painting, as Kramer suggests?*

JJ: I don't think politics was ever a concern of mine, to keep out or to bring in.

PF: Time *wrote, "Just as Marx is said to have stood Hegel on his head, so Johns has inverted Duchamp's assault on painting. He has embraced those attempts to undermine the foundations of traditional painting and made them serve his own artistic ambitions." Is that a fair description of your relationship to Duchamp?*

JJ: What was negative in Marcel, for himself, became positive in my work, certainly. He said that he wanted to kill art, or to destroy art, himself. Then of course he said that he was nothing but an artist (laughs). My interest in his work is not from the point of view of killing art. I know one's not supposed to say this, it's not quite proper, but I regard his work as art of a positive nature. I see it as *art*.

PF: *You once said you were brought up with the idea that the artist had to be socially useful, adding, "I think artists are the elite of the servant class." Do you think it is wrong for artists to challenge the way things are in the world?*

JJ: Not at all.

PF: *Kramer once wrote that "Johns like Rauschenberg aims to please and confirm the decadent periphery of bourgeois taste." Is that a suitable function for "the elite of the servant class"?*

JJ: I have no interest in that remark. Most of what Kramer says means nothing to me. I don't want to criticize Kramer.

PF: *Asked about how the state should choose artists for support, you suggested using a lottery. But you added, "We are in a funny, broken society. It is not easy to know what is to be done." What is your view of the world beyond art? What are your politics?*

JJ: I am very stupid politically, actually.

PF: *In 1954, you had a dream in which you saw yourself painting a large American flag, and the next day you began painting one. People dream of many things. Why did you decide to make the flag?*

JJ: I don't know. I have not dreamed of any other paintings. I must be grateful for such a dream! (Laughs.) The unconscious thought was accepted by consciousness gracefully.

PF: *You tended to talk as if the flag were a neutral, given image. Is that really what you felt?*

JJ: That was my feeling at the time, but I think that has shifted. It is hard to recover the original feeling.

PF: *Flags, targets, maps, and so on belong very much to the iconography of American imperialism. Certainly, during the 1960s, such images were anything but neutral. They took on very charged connotations, didn't they?*

JJ: I never thought of that. I don't know whether it is true or not. I think that in the art world people have learned to look at kinds of images which they did not look at at that time, and so things now are visible that may not have been visible at that time. I remember once I had a painting of a flag in white: a large one, and someone leaned against it. That sort of thing is much less likely to happen now. I don't think that is a change in the picture; I think it is a change in, well, people.

PF: *But in 1958, weren't you just hoisting the flag in Abstract Expressionism? You identified the next step in modernism with peculiarly American signs and symbols.*

JJ: My training as an artist is very modest, and my exposure to painting at that time—well, even now, but certainly then—was really very slight.

PF: *Last week, in Washington, I discovered that Senator [Jacob] Javits, a Republican, has a Jasper Johns flag in his office. Everyone knows what sort of people fly the American flag at the bottom of their gardens. Wasn't the flag series, whatever you may have intended it to be, treated as a manifestation of modernism made acceptable to this element in American society? This sort of Abstract Expressionism could not be seen as a Communist plot.*

JJ: You can see it that way, I suppose. Let me think a little more about that. I'll tell you an anecdote. Once, I made a kind of sculpture of a flag in bronze: it was an edition of three, I think. One of them was given on some occasion to

President Kennedy. I became very upset that this was happening. It was given on Flag Day! (Laughs.) It seemed to me to be such a terrible thing to happen. I complained bitterly to my very good friend John Cage. He said, "Don't let it worry you. Just consider it a pun on your work!" (Laughs.)

PF: *Was that the sort of thing you had in mind when you said, "I have no idea about what the paintings imply about the world. I don't think that's a painter's business"?*

JJ: In working, one doesn't set out to make a work which will have a certain effect in the society. I don't think I have that kind of large grasp of society to begin with. I tend to relate to a smaller thing, like theater, where you have an audience. That's my image of society. And one knows that the audience is always changing. So by the time you've imagined what the audience is, and formed your ideas, it is going to be something else. So, I think the best thing to do is…. It's very tricky. As well as I can tell, I am concerned about space. With some idea about space. And then as soon as you break space, then you have things.

PF: *You cannot avoid the meanings of the signs you make. Javits can happily hang a Johns flag in his office, but it could not hang, say, in an office in Vietnam as a statement about "space," could it?*

JJ: My concerns are probably largely invisible in Javits's office. Anything can be used in some other way. That's an interesting point about our experience of the world. Things aren't necessarily what we say they are or what we want them to be. Anything, from some point of view, can be abused or can become invisible.

PF: *Do you agree that modernism, as defined by critics, dealers, and art institutions, has tended to see art as a self-evolving continuum and that this has led to the underestimation of many artists whose primary concerns are with the experience of the world rather than with the experience of art?*

JJ: At all times, when you look at one thing, you don't look at another. So, at any time in the society, some things have a kind of prominence that other things don't have. What is one to do? At a certain point anyone wants to live his own life. Part of that life is to attract attention; anyone wants to attract attention to what he is doing. That is part of it.

PF: *But you were almost a victim of modernist historicism: in fact, it turned out that you weren't because you provided a "missing link." But, in 1963, [Michael] Fried wrote about you, "The historical moment to which his style belongs is past and in effect was past by the time he came on the scene. Already Newman and [Clyfford] Still have pointed the way beyond the de Kooning problem." In fact, in art-historicist terms, Fried just made a wrong judgment: he didn't see the connection you provided into Pop art and everything that came after.*

JJ: But look at how Michael sees the world! I don't think he believes that what came after ever happened! But whether or not I was of any importance, that's what happened. […]

PF: *It is often said that you became an "Old Master" within two years because of the emergence of Pop in the early 1960s. What was your view of Pop?*

JJ: In the press, everyone is put together and called something. But that unit of thought is of no interest to me. Some artists who fall within that have done

works that have been interesting to me. And then one has friends who are artists in such an area. The meaning of one's life is different from a judgment of something like that.

PF: *But your preoccupation with the given was certainly shared by some Pop artists. It is also apparent in Minimalism, for example in [Carl] Andre's use of given industrial elements, and in "new Realism"—in Duane Hanson there is a concern with the appearance of the other as a given, a cast. This seems quite close to, say, the use of flagstones in some of your recent work. Would you agree that this pre-occupation with the given runs through all these tendencies which are often thought of as being opposed to each other?*

JJ: (After long silence.) One has to agree with that.

Part II

PF: *Why are you interested in things which are, as you say, "not mine," things which have been designed, but are taken from the world, not made by you?*

JJ: I was interested in what was seen, and what was not seen. One wanted to avoid the idea of an interpretation, and—I know how simpleminded it is—but nevertheless those sorts of images gave a sense of objectivity rather than of subjectivity. And then one could deal with the question of when you see it, when you don't see it, what do you see, what do you think it is, how do you change what you see, and what differences do these changes make to what you see and to what you think. It's a rich area for nuance there. It's a pretty limited area if you are going to make any strong point. But I was interested in the kind of nuance, modulation, play between thinking, seeing, saying and nothing.

PF: *Don't you think that this preoccupation with the given, common to so many American artists, can be correlated with a culturally widespread imaginative fail-ure among artists, a refusal to imaginatively grasp their world and to re-create it through their art?*

JJ: I don't believe that. Do you believe it about other art? I don't know what to say. I don't feel *that*. My problem is to relate myself to the other artists that you have mentioned. I see that you can see what you say, but I don't think that I would see it that way.

PF: *[David] Hockney has said that he believes modernism is dead. Many critics in Britain would agree that it is dying. In England it does seem to be almost over. In America, largely because of the buoyancy of the market, and the presence of collec-tors, it has not run down completely. But it has stopped at this idea of simply repre-senting the given. The imaginative function of the artist, his capacity to depict experience, seems to have withered.*

JJ: Well, I don't believe that's true, unless you are making the same sort of point that you made earlier about Abstract Expressionism losing its strength, and becoming repetitive. If you are suggesting that because, numerically, there is this concern with the given this constitutes a "lack of imaginative function" among artists, I don't agree. If you take, say, an extreme example—Duchamp's ready-mades. Now they, in themselves, do not mean what you say. They don't

At Gemini G.E.L., Los Angeles, in 1969.
Photograph: Malcolm Lubliner.

point to this kind of inertia. But I have never thought about this in this way, and I don't know what to think, or what to say.

PF: *Which living British artists do you respect?*

JJ: Much of my thought is affected by people I see, or meet, or whatever, socially. The people I think of immediately are, of course, [Francis] Bacon and then [Richard] Hamilton and [Bridget] Riley. Those immediately.

PF: *Stephen Buckley's work has sometimes been related to yours. Are you aware of his work?*

JJ: Yes, but not in an elaborate way. I saw his last show here whenever it was. I know Stephen. Before that I had seen photographs of some other pieces: I don't think I had seen works.

PF: *He is one of the few painters under thirty-five who have made a profession of it in England. Barbara Rose said, "Your courageous refusal to abandon the painter's craft has given all painters new hope." Are you hopeful about the future of painting?*

JJ: I am neither hopeful nor not hopeful about the future of painting.

PF: *Robert Hughes described your work as a "particularly knotty kind of conceptual art." But don't you think the ideational content of your work is often exaggerated? Or do you see yourself as an artist primarily concerned with ideas?*

JJ: That's a critical thought that is often repeated. Now this sounds an awful thing to say, but I still think it's based on people's experience of Abstract Expressionist painting, and the kind of subjectivity indicated in much of it, even in the very fine Abstract Expressionist painting. The artificial construction people make is that painting is not intellectual, and does not involve much thinking, but involves psychic or subconscious pressures which are released through the act of painting. But I think painting like mine shows obvious kinds of hesitation and reworking which people associate with thought (laughs).

PF: *Pieces like* The Critic Smiles *and* The Critic Sees *strike me as amusing, but hardly to be taken seriously at the level of ideas....*

JJ: I think of them as cartoons.

PF: *Exactly. They are the kind of ideas a good cartoonist has a dozen times a week.*

JJ: Of course. I hope so.

PF: *Don't you think that the extraordinary outpouring of critical attention such pieces have attracted is exaggerated? Kozloff, for example, once said that to engage with paintings was to engage not so much with a personality as with a way of thinking, a philosophy almost.*

JJ: As for *The Critic Sees* and *The Critic Smiles,* I think it is because critics write about them that they take them so seriously. And because they are aimed at critics.

PF: *You read Wittgenstein in the 1960s. Whom have you read since who has been a major influence on your ideas?*

JJ: I'm trying to think about whom I've read. I'm reading Céline right now.

PF: *Have you read Sartre, for example?*

JJ: Not since college.

PF: *But you read him then?*

JJ: Bits, bits.

PF: *Did you read much existentialist literature?*

JJ: Not much. I formed some kind of cheap idea about what it was (laughs).

PF: *Did you recognize its concern with the given, with what Sartre calls facticity, or being-in-itself?*

JJ: I don't know. It's very hard for me to remember what my thoughts were.

PF: *Is it true to say that rather than being "intellectual," your subject matter is often about the nature of perception?*

JJ: I don't think it quite makes it on that level.

PF: *Are you getting tired?*

JJ: No. I don't think so, I just don't seem to have many ideas. In this sense, it's not about the nature of perception, because it's too tied, in the making of it, it's too tied to ... the nature of ... I don't know how to say it.

PF: *It can't be about perception, because it's tied to the nature of perception: is that what you are saying?*

JJ: Yes.

PF: *There's a painting of yours in which the word "RED" is rendered in blue and yellow paint. A critic wrote about this, "Such works do more to force the viewer to think about representation and what it entails than almost any painting since Cubism." But the idea that you were making use of is just a commonplace, a given among ideas for anyone who thinks for half an hour about words, color, and representation. Did you consider it a major statement about representation?*

JJ: No! The importance that things have obviously is not the importance that one has assigned to them, or intends them to have. I don't think that one paints to do something important in that way.

PF: *Your work often has an extremely sensuous, sometimes almost pretty kind of quality, doesn't it?*

JJ: The physical facts of painting are very important to me.

PF: *But once you said you weren't a colorist, that you could barely differentiate between colors.*

JJ: My painting of the last few years has improved my color; I think I'm better at color than I used to be.

PF: *The explorations with colors and words: were they investigations of color for yourself because you knew this was a weakness of yours?*

JJ: You are talking about *False Start?* Well, no. For me, that was more an attempt to get rid of predetermined boundaries which had existed in the images which preceded those pictures; painting within lines, basically.

PF: *David Bourdon once asked you, "At what point did you realize you are what society regards as a 'successful' artist?" You replied, "It hasn't quite happened yet." What has to happen before you will feel that society regards you as a successful artist?*

JJ: Oh! I think society regards me as a successful artist. I think society regards any artist who makes a living from his work as successful. I probably meant

my own sense of myself. I would certainly think that if the society thought of anyone as a successful artist, they would include me (laughing). I would hate to be left out!

PF: *You have been quoted as saying you wanted to sell a painting for $1 million. Would that make you feel more successful?*

JJ: No, I think it would make me feel a lot richer. That's just the kind of remark one makes on some occasion.

PF: *But the prices reached by your works are extraordinary. In 1971,* Map *sold for $200,000; in 1973,* Two White Maps *for $240,000. Early works have reached $270,000. The beer cans passed through auction at $90,000. What kind of effect have these high market figures had on you as a painter?*

JJ: I would say none, but I would doubt that. Those things have unconscious effects that one can't determine. I don't know. I really don't know how to answer the question.

PF: *New works are fetching between $80,000 and $120,000. Don't you fear the effects of overpricing?*

JJ: I don't have anything to do with pricing. Pricing is determined by other people.

PF: *It is sometimes said there's a connection between your low production and these high prices.*

JJ: I think that's a lot of nonsense; I believe it's nonsense.

PF: *You have never held back works to maintain market prices?*

JJ: No. I've held back work because I wanted to hold it, and I've often sold because I had to sell because I needed the money.

PF: *Has your dealer ever advised you not to produce too much?*

JJ: No, I assure you he has not! (Laughing) I wish Leo could hear that!

PF: *Is there a long waiting list for your works?*

JJ: I don't know that there's a waiting list. I think there are people who would like works, who don't own them. I don't really know that. It's a guess.

PF: *Doesn't the knowledge of the kind of exchange value you are creating inhibit you when you sit down in front of a canvas?*

JJ: I often find it difficult to make a picture. That has always been true. It has nothing to do with the price of a picture. I don't think that scale has much meaning. I think that one thinks as one always thinks, that one may be making a picture that no one will be interested in.

PF: *In one passage, Crichton compared you to Adlai Stevenson, and wrote that you "perpetually risk frozen indecision." He said that you had been viewed as "a limited, inhibited artist entangled in your own past." You seem to be saying that painting is so difficult for you that you really do "risk frozen indecision."*

JJ: I think that's true.

PF: *So every time, even now, it is hard to paint?*

JJ: I would not say every time. I would say often.

PF: *I once read something by you where you said you tried to make your work "not me"; you explained that you didn't want to "confuse my feelings with what I produced." Why are you so concerned about not letting feelings through?*

JJ: I think that I either made that quote some time ago, or I intended it to refer to earlier work. Let me put it this way. My feeling about myself on the subjective level is that I'm a highly flawed person. The concerns that I have always dealt with in picture-making didn't have to do with expressing my flawed nature, or my *self*. I wanted to have an idea, or an image, or whatever you please, that was not *I*.... I don't know how to put it. I don't know what supports what. I wanted something that wouldn't have to carry my nature as part of its message. I think that's less true now.... I don't know whether my work now has bypassed that concern, or includes it, or what. But I don't think I'd express that thought now.

PF: *You said once that you disliked psychology because you had such a bad one yourself.*

JJ: Yes, that's right! (Laughing.)

PF: *Have you read Freud, or any psychoanalytic literature?*

JJ: I love Freud's writing. I still read it.

PF: *Why do you dislike talking about your early life?*

JJ: It wasn't specially cheerful.

PF: *Henry Moore once said that art was invariably an attempt to regain the intensity of earliest experience. Do you think that?*

JJ: I certainly believe that everything I do is attached to my childhood, but I would not make the statement that you just said he had made.

PF: *Despite your statements about "objectivity," and your desire to exclude feelings from your work, quite a lot of your unconscious does, and indeed, did, come through. Your obsession about things and their representations, the denial of affect itself, your interest in the sensual surface can all be seen in these terms. But most remarkable are images like that of a shattered body. This was in your earliest works, and it recurs explicitly in* Untitled, *1972, and* The Corpse and the Mirror *[sic]. These pieces seem to have very private, personal subjective meanings.*

JJ: I certainly agree with you.

PF: *Were you exaggerating the "objectivity" of your work, its separateness from your feelings, then, say twenty years ago?*

JJ: What can you say? Obviously, the idea of objectivity itself exaggerates the absence of subjectivity so that, at best, one can say that one's intention is so and so, and obviously one does not do exactly what one intends. One does more, usually, and often less, also. Or you could just say one does other.

PF: *Crichton wrote that, like Rauschenberg, you shared a belief that art sprang from life experiences. Would you agree with that?*

JJ: Yes.

PF: *What life experiences do images like the shattered body spring from? It haunts so much of your work.*

JJ: I don't think that I would want to propose an answer on the level of subjective experience. I can come up with a substitute.

PF: *But the body in several parts, which occurs in* Target with Plaster Casts, *and later works, can only be derived from your earliest fantasies, if art springs from life experience, surely. You have presumably only experienced such things at the level of fantasy?*

JJ: I don't know that it can only be that. I would not take that point of view (laughs). I think any concept of wholeness, regardless of where you place it, is.... Well, take the *Target with Plaster Casts,* the first one. Some of the casts were in my studio. They were things among other things. Then, of course, they were chosen again for use in that way. But I don't feel qualified to discuss it on that level, I must say. I've not been in analysis, and I wouldn't want to give it that meaning in such a specific way as you have done. I believe that the question of what is a part and what is a whole is a very interesting problem, on the infantile level, yes, on the psychological level, but also in ordinary, objective space.

I-37. Christian Geelhaar, "*Interview mit Jasper Johns*/Interview with Jasper Johns," in Geelhar, ed., *Jasper Johns: Working Proofs*, exh. cat. (Basel: Kunstmuseum Basel, 1979), pp. 41–62, 63–72. Interview in German and English. Interview conducted on October 16, 1978, in New York.

[...] CG: *Do the three media with which you have been concerned in printmaking, lithography, etching, and silkscreen, have individual characters for you?*

JJ: Well, the silkscreen is the stupidest because it's only a stencil. There's nothing else to it. The work consists of putting color through the opening in the stencil. That's all one can do. So I think it is best used for images which require sharp edges and smooth-textured, flat, clear areas of color. By adding a rather large number of screens and having the stencil openings follow the shapes of brush-strokes I have tried to achieve a different type of complexity, one in which the eye no longer focuses on the flatness of the colors and the sharpness of the edges. Of course, this may constitute an abuse of the medium, of its true nature.

I'm not sure how to rank lithography and etching. I know that Aldo Crommelynck thinks a lithograph is a kind of imitation drawing. I don't feel that. Lithography has very special qualities and is a genuine medium.

CG: *Etching is an addition of various states whereas lithography would rather be a combination of various states?*

JJ: It seems that etching can accept more kinds of marks than other print media can. In lithography one applies grease to the stone or plate, a greasy liquid or crayon; the result is a kind of wash effect or a crayon effect. That's about it. Complicated tone and color and complexities relating to one's sense of time have to be achieved by using more than one stone or plate. In etching, the devices for attacking the plate are more elaborate. With aquatint, for instance, the variety in the sizes of particles that are available is great and can result in a great variety of tones. And for me, the most interesting thing about etching is the ability of the copper plate to store multiple layers of information. One can work in one way on a plate, later work in another way, and the print can show these different times in one moment. This is not the nature of lithography, which can't accept that kind of work. So, in a sense, etching may seem to be more complex and subtle. [...]

CG: *Would you also say that a certain image asks for a certain technique? You've just mentioned that clear edges and flat areas of color are best suited for silkscreens.*

JJ: I don't think I would say a certain image asks for a certain technique. The mind can work in such a way that the image and technique come as one thought, or possibly one might say there is no thought. One works without thinking how to work.

CG: *If Aldo Crommelynck considers lithography to be an imitation of drawing, wouldn't it be in your case rather the other way round? Didn't the use of washes on the lithography stone or plate inspire the ink drawings on plastic film of yours?*

JJ: I'm not sure but it's apt to be the case. Lithography has affected all of my thought of course.

CG: *Your prints frequently use images which first appeared in paintings. Many of these you have repeated in other paintings as well. Some people seem to take this in a rather negative way…*

JJ: Yes, I think so too.

CG: *… and they wouldn't consider for a moment that Cézanne, for instance, did dozens of versions of* Mont Sainte-Victoire. *They also forget that other painters, like [Édouard] Manet, have used the same motifs they painted in their prints. The reason why Paul Klee repeated in some of his lithographs and etchings images he had first drawn or painted was that he obviously did not think it worthwhile to invent new images for a medium designed for mass production.*

JJ: This is Klee?

CG: *Yes, that was his approach towards printmaking in the '20s. Speaking of your prints: there are, of course, on one hand, also paintings the images of which you have never used to make a print, and then there are prints the images of which do not appear in paintings. You so far have never made a print after* Voice 2, *for instance. Is the reason that this particular image is not suited for a print?*

JJ: Well it might be. I thought about it a few times but have not done it. Much of the paint in *Voice 2* was applied through screens of different sorts. The patterns of the screens consisted of various sizes and distributions of dots and, in some cases, squares. The meaning of the work, to a large extent, depends on the existence of tiny particles within the large work. I don't know that this could be achieved in a small print. The sense of large and tiny would be difficult to get.

CG: *So the question of reduction of scale is…*

JJ: … is important, certainly. But sometimes it can be entertaining to reuse an image while drastically revising its scale.

CG: *I think there is a particular logic in your reusing images in your prints, too. After all, the flag, the ale cans, and light bulbs are also in a way replicas or "reproductions" of existing objects. In an analogous way, you may use a painting of yours as a model for a work in another medium.*

JJ: Well, perhaps because it interests me, I think of it as a complex subject. In part, it connects with Duchamp's idea that an artist has only a few ideas and … he's probably right … one's range is limited by one's interests and imagination

Working on *Map (Based on Buckminster Fuller's
Dymaxion Air Ocean World)* (1967–71) at his studio on
East Houston Street, New York, December 30, 1970.
Photograph: Hans Namuth.

At the screenprint workshop Simca Print Artists,
New York, January 28, 1976. Photograph: Hans Namuth.

and by one's passion ... but without regard for limitations of that kind, I like to repeat an image in another medium to observe the play between the two: the image and the medium. In a sense, one does the same thing two ways and can observe differences and samenesses—the stress the image takes in different media. I can understand that someone else might find that boring and repetitious, but that's not the way I see it. I enjoy working with such an idea.

CG: *There are also images which first appeared in prints and only later provided a subject for a painting.*

JJ: One or two, yes.

CG: Decoy *would be the best known example?*

JJ: Probably. If I remember correctly, my first work on the *Decoy* print was from stone printed on a hand press. At a certain point, we changed to a Mailander offset press which suggested that I could be more extravagant, increase the number of plates to achieve even rather small effects, somewhat in the way one might add brushwork to a painting. In printmaking, I would usually be more economical than that; but working with this machine, which was new to me, changed the sense of labor connected with the process. One sees results more quickly and senses less labor on the part of the printers. And working on aluminum plates eliminates the necessity of moving stones about. I don't know how many elements were in that print ... ten or fifteen?* Moving that many stones would have been a lot of hard work. Bypassing that necessity was a new experience for me and, probably, realizing that I was engaged in a thought process similar to that of painting, I decided to make a painting after the lithograph ... though not entirely after; I think I began the painting while I was still working on the print.

CG: *One of the most unusual aspects of* Decoy *is the band at the bottom with reproductions of the plates of your* First Etchings Second State.

JJ: Yes, I decided to transfer the images from the etching plates to a lithographic plate because I had recently read something that Dick Field had written about Rodolphe Bresdin, stating, I think, that some of his lithographs had been made by transferring his etchings to lithographic stone and then reworking the image.† This sort of interest seems natural to my work, but I doubt that I would have thought to do such a thing had I not read about Bresdin.

CG: *One way to do a painting after the lithograph* Decoy *would have been to introduce the actual etching plates into the painting, which you didn't do.*

JJ: No. But there are two *Decoy* paintings: the large one which we have been discussing, and a smaller one, the same size as the lithograph. The band of images at the bottom of the smaller painting was printed from the same lithographic plate used for the *Decoy* print. For the larger canvas, I had silkscreens made from photographs of some of my sculptures and these were used to make the band of images.

CG: *In some of the prints made after paintings, you have used photoplates, as in the fourth panel of* Four Panels from Untitled 1972. *In the book* Fizzles, *in the plates*

HandFootSockFloor *and* Face *you translated the images of body parts into the medium of printmaking in a way more genuine to it by making imprints directly on the plate.*

JJ: Yes, the scale worked there. Generally, when an object or thing appears in my work it's either the scale it is, it's life size, or it's done by a technique that can be taken as a kind of thing. If, say, a part of the body is going to be represented in a print, I have tended not to draw it. If there were to be a change of scale I always felt that using a photograph of the thing took care of the problem. A photograph can be any size. Of course it's very subjective, that kind of feeling; so can a drawing be any size. In *Fizzles* I did make little sketches of the images, and in the big *Savarin* print, which began because a poster was needed for my show at the Whitney Museum, I drew one of my sculptures much larger than life; but that was a deliberate attempt at advertising on my part.

CG: *[…] I find this very interesting… that in* Scent, *the juxtaposition of the three sections should have been achieved by using three different printing techniques whereas in the lithographs after* Untitled, *1975, the juxtaposition is not really expressed by means of the medium as such but rather by a technical device, by applying a varnish.*

JJ: Yes, I understand. Well, I have worked in both ways.

CG: *Am I thinking in traditional terms, when I tend to rate the genuine translation into the printing medium a higher achievement?*

JJ: Well, I don't know. It may be lively that you're given the opportunity to observe both, regardless of your value judgment. That business of the thing actually embodying the thought, rather than being an illustration of it, is tricky. Take the painting *Scent,* for example. One section was painted on sized canvas and a good deal of oil and varnish was added to the paint to increase its glossiness. One section was painted on unsized canvas and no oil or varnish was added to the paint. This allowed the paint to sink into the canvas and gave it a matte surface. A third section was painted in encaustic. One can say that the physique of the painting embodies the thought, allowing the mind to perceive both at once; or the two can be split, allowing one to sense them at different times. Again, in the printed version of *Scent,* the differences in the three media are noticeable but seem natural or effortless. In the *Untitled* prints there is a different feeling. Aspects of the painting to which they refer seem to be illustrated or pointed to. Perhaps one senses that one is looking at one thing which is about another thing. That kind of distancing is interesting to me; not so much in itself, but as one of a number of ways of perceiving.

CG: *Prints by tradition have always served a certain function. Originally they were combined with texts, illustrating the written word and making something explicit visually. The tendency to be more explicit in prints than in painting seems to be valid to some extent even today. Some of your prints seem to offer an analysis of the painting, as the six lithographs after* Untitled, *1975. Or, whereas the possibility of rearranging the four panels of the* Untitled, *1972, painting by rotation was suggested in theory, in* Fizzles *the four possibilities to permute the four panels are*

illustrated and explained. Is this one of your concerns in making prints: to state something more explicitly?

JJ: Yes, it's certainly one of the things one can do. One can take an aspect of another work and exaggerate it, draw attention to it, give it an importance that it didn't have in the original work. This relates to the kind of thing we do all the time. For instance, while looking at those de Kooning drawings with you yesterday, I realized I had made assumptions about them, and suddenly saw I need not have made those assumptions, and another person would not have made them. One assumes that one's relationship to the work is the correct or only possible one. But with a slight reemphasis of elements, one finds that one can behave very differently toward it, see it in a different way. I tend to focus upon a relationship between oneself and a thing that is flexible, that can be one thing at one time and something else at another time. I find it interesting, although it may not be very reassuring.

CG: *The concept of self-contained series is something closely related to printmaking. Perhaps, the* 0 through 9 *paintings of 1960–61 excepted, there are no such self-contained series in your painted oeuvre. In prints, however, series appear right from the beginning. In fact your very first print, the* 0 *of 1960, was conceived as an element of a series of lithographs. This was followed by other series such as the* First Etchings, *and black and white* Numerals, *or the* Color Numerals.

JJ: Well, I think printmaking automatically triggers that kind of thought. Seeing an image pulled in multiple, one thinks: should they all be identical or should each be different? What kinds of differences do you tolerate and what kinds do you encourage? In the *0 through 9* portfolio I did at ULAE I thought to print a certain number of sheets from the image I had drawn on the stone and then to change the drawing on the stone before printing another group … and so on. Some people have been interested to print an image in different colored inks or on different kinds of paper. Such thoughts are encouraged by the medium.

CG: *On various occasions you have also reused older stones or plates in making a new print. The stone of* Flag I *was reworked in making* Flag II, *and then again reworked for* Flag III. *Of your* First Etchings *there exist two states. The photoplate of* Passage I *was later used in* Decoy. *Such a way of working is presumably only possible in printmaking?*

JJ: Well, I guess that's easier to do in printmaking, but you see bits of it in other work. I think you see it in Rodin, for instance, with casts of parts appearing over and over again in different works. You see it a lot now in contemporary music. Certain material is recycled in different pieces, different compositions: this material may be transformed in some way or may simply appear in a new combination with other material. I thought it was striking in some of the music used in the Cunningham Dance Company's recent performances in New York.[‡]

In printmaking, I think it would be perfectly reasonable never to destroy the images on the plates and stones, and always to have them available for use

in new works, new combinations. One might work like that if one had a big enough studio in which to store such material.

CG: *The only instance I can think of where you did a similar thing in painting was with the screen of the fork and spoon image with the indication "Fork should be 7″ long," which you used in the* Screen Pieces. *Then it was reduced in scale to make the drawings after that painting with a flagstone section and another section....*

JJ: I think it is *Wall Piece*. I'm not sure.

CG: *Whereupon you used this screen again in* Voice 2, *I believe? I presume this was possible only by using a screen, which is again a printing technique?*

JJ: Yes, that's true. It started when I was making the lithograph *Voice*. I had made a photograph of the wire with the spoon and fork, a detail from the painting, intending to have a photographic plate made, and I indicated on the photograph that the fork should be seven inches, so that the objects would be life-sized. The people who made the plate included my written instructions as part of the image. For the *Voice* print we removed the instruction, but first we pulled some proofs of the unaltered plate. It seemed very lively to me, the various possibilities in combination: the photograph, in which the image is reduced, with a handwritten indication of its true-to-life size; the photolithograph, in which the image has been enlarged to the indicated measurement, with the handwriting enlarged along with it; and later in *Voice 2* everything very much enlarged, making the instruction suggest that everything should be reduced.

CG: *Once I had found out the origin of the instruction "Should be" in* Voice 2 *the link between this triptych and* Voice *became apparent: the fork and spoon as well as the word "Voice" appear in both works and seem to belong together. This, nevertheless, left me wondering whether in* Voice 2 *it was your using the screen of the fork and spoon image which then asked for the inclusion of the word "Voice" or whether both elements had been there right from the beginning....*

JJ: The screened image and the word?

CG: *Yes, and whether the one does not exist without the other. The use of the screen with the fork and spoon only in the* Screen Pieces *would speak against this, however.*

JJ: I don't remember. While working, you become sensitive in certain ways and insensitive in many other ways ... thank goodness. And if you work over a long period of time, it becomes difficult to describe the process, difficult to remember it. I think I told you that at one time I hoped that the three panels in *Voice 2* might be able to accommodate any order or disorder; might be upside-down, sideways, backwards. While working this way, trying to make the painting have no "should be," trying to make it be any way it wanted to be, the "should be" seemed amusing; but working with that idea became too difficult for me, too complicated. I couldn't deal with it and I settled for the more simple order.

CG: *If you reuse a title like, say,* Passage (1962), *which in 1966 you used for another painting but which looks completely different, does that still refer to an idea common to both works?*

JJ: I felt that *Passage* suggested a state of affairs that might not be static, a state of change or a detail of a larger state of affairs. I suppose it is connected to *Passage II* in that way. The relationship probably exists only in my own subjectivity.

After the first *Voice*, I suppose there was something left over, some kind of anxiety, some question about the use of the word in the first painting. Perhaps its smallness in relation to the size of the painting led me to use the word in another way, to make it big, to distort it, bend it about a bit, split it up....

CG: *Some prints of yours have played a crucial part in developing ideas which were taken up in paintings. I'm thinking, for instance, of the lithographs in black and gray,* Four Panels from Untitled, *where the margins carry on part of the imagery of the adjacent panels. This principle was applied before in* Voice 2 *but not quite in the same obvious way. This idea later became a central motif in the composition of* Scent.

JJ: That kind of repetition, I think, first appeared in my painting *Untitled*, 1972. Two sections partially repeat one another, suggesting that the given space could be compressed or that a smaller space has been enlarged by duplication. It is convenient to work with this kind of thought in prints. In lithography and screen printing it is very easy to play with a given image, to transfer it or revise it ... a kind of play that is laborious in painting.

CG: *You have been working at various shops, at Universal Limited Art Editions in West Islip, Long Island, at Gemini G.E.L. in Los Angeles, and at Atelier Crommelynck, in Paris. At Universal Limited Art Editions most of your prints have been pulled on a hand-fed offset lithographic proofing press since 1971. On this press the image is not reversed from the plate. In what ways has the reversal of an image in printing affected your work? I understand that some artists, like Cy Twombly, do not like etching precisely because the image, or in Twombly's case, the direction of his writing, is reversed.*

JJ: Of course, the images in my early prints were such that I had to be very conscious of drawing them backwards on the stone. That was a real concern to me. Unlike printing a drawing of a human figure—where the left-hand side becomes the right-hand side and it doesn't really matter perhaps—printing the kinds of figures I was drawing made a very obvious reversal. I had to draw them backwards so that they would read correctly when they were printed. It's hard to know what the effect of this kind of activity has been, but it certainly rubbed off onto my painting.

In printing, one might become interested in something like the use of transfer paper. In working with a hand press, the use of transfer paper would give one the opportunity to have the same image on more than one stone; but using the offset press, the image which exists on one plate can simply be printed onto another plate. These and other odd concerns make up the life of the work really. They are real concerns and make the working process a very lively activity, something other than the reproduction of an image; they alter what "image" is.

CG: *Would you say that reversal in printmaking is basically a technical problem whereas in painting it works more on the level of content?*

JJ: Yes. The techniques of printing may suggest the possibility of using a related idea in painting, where it has to be introduced in some deliberate way.

CG: Corpse and Mirror *would be a fine example....*

JJ: Yes, perhaps.

CG: *Has your use of color in painting also been affected in a certain way by your doing lithographs? You had been using primary colors in painting right from the beginning, but what about the superimposition of primary and secondary colors?*

JJ: I think that probably came out of printmaking. I'm not sure. I don't remember really, but it probably did in some way.

 The technical necessities in printing can give one an idea that can be used in a painting. In the new context, the idea may become freed from necessity and work in a new way. To make a lithograph it may be necessary to print one thing and then print the next thing and then print the next thing. It may be interesting the way in which these three elements work together, and it may be interesting to use in a painting a similar schematic limitation; even though in painting there is no necessity for such simplification. A painting can smear or slur, but it may be amusing to introduce an idea like "one, two, three."

CG: *Can you think of other ways in which printmaking has affected your painting?*

JJ: As much by sharpening the differences as by making relationships. In printmaking, one works with other people, and part of the work involves necessary social activity; this is hardly true of painting.

CG: *I have come to notice things in your work which, I think, are basically related to each other, but which have been developed in quite different directions. You once described the flag as a thing which is seen but not examined. The Stars and Stripes is an emblem which is taken for granted. It's a unit. If one does examine your first* Flag *painting, however, one realizes that it is composed of three panels. I can recognize ideas related to this in some of your more recent paintings. In* Untitled, *1975, or in* Scent, *the cross-hatchings create sort of an all-over pattern which you may see at first as one undivided thing which it is not. Do you think I am justified in drawing relationships between ideas such as these?*

JJ: Yes, I do. Such things run through my work, relationships of parts and wholes. Maybe that's a concern of everybody's. Probably it is, but I'm not sure it is in the same way. It seems so stressed in my work that I imagine it has a psychological basis. It must have to do with something that is necessary for me. But of course it *is* a grand idea. It relates to so much of one's life. And spatially it's an interesting problem. In painting, the concern with space can be primary... the division of space and the charges that space can have... the shifting nature of anything... how it varies when it's taken to be a whole and when it's taken to be a part. Aside from such problems of identity, the way that we use space and decide that something in the space is a thing and the rest of it isn't a thing is odd and is always changing.

CG: *You have just mentioned the word "division." Some of your images seem to me to be more of an addition of several elements or sections with the aim to create a unit as a result. As you speak of division I wonder whether you take the canvas as a unit which is then divided and split up in parts?*

JJ: What you say about my tendency to add things is correct. But, how does one make a painting? How does one deal with the space? Does one have something and then proceed to add another thing or does one have something; move into it; occupy it; divide it; make the best one can of it? I think I do different things at different times and perhaps at the same time. It interests me that a part can function as a whole or that a whole can be thrown into a situation in which it is only a part. It interests me that what one takes to be a whole subject can suddenly be miniaturized, or something, and then be inserted into another world, as it were.

* Decoy *was printed from one stone and eighteen plates.*

† *Richard S. Field, "Bresdin's Transfer Lithographs," in* Artist's Proof *8 (1968): 70–81.*

‡ *The Merce Cunningham Dance Company performed in New York at the City Center 55th Street Theater from September 26th to October 8th, 1978. Jasper Johns is referring to music composed by David Tudor for the ballet* Exchange *(1978).*

[Before the interview proper, an excerpt from Geelhaar's conversation with Johns is quoted in his "Erfahrungen auf 'anderen Ebenen,'" note 35 p. 39, in the context of a discussion of the lithographs Four Panels from Untitled 1972 *(1973–74) and of Johns's book project with Samuel Beckett. —Ed.]*

JJ: I went out to Gemini to do those prints there using the subject of that painting; and I had already agreed to do a work with Beckett. And I barely began work and I thought: "This is what I should do for Beckett because I won't ever have anything that will be more appropriate—I won't be able to think of anything." I didn't know what his texts were going to be, but I just knew—what I knew of him and what I know of myself—that I wouldn't be able to do anything better than that. I thought of stopping my work out there and saving it and then I thought "I'm going to do it in etching—it's going to be a book and the change in the medium will keep it from being boring, to me, at any rate."

I-38. Blake Green, "That Enigmatic Father of Pop Art," *San Francisco Chronicle*, October 23, 1978, p. 17. Published on the occasion of Johns's retrospective at the San Francisco Museum of Modern Art.

[…] "Some of my work plays in an area where things can be taken to be one thing or another. Or another. Or another. That kind of thing makes some people wish what one would do is make a different statement that moves toward some kind of goal, as it were."

But the revelation of some heretofore hidden social relevance, some illusion instead of just the sheer reality of what is on the canvas, is not what he is talking about here.

With John Cage in Stony Point, New York,
c. 1971. Photograph: James Klosty.

"Really the stronger feeling is not the seeing that it is one way rather than another, but that it could be one way or another.

"What critics want to do is simplify everything and have a construction of thought that can be stretched out, preferring that one thing lead to another." *Johns sighs, then laughs […]*

"My problem is quite different: what I want to do is make another picture." *[…]*

John Cage, the composer and friend of artists ("one of the first people I met with very strong intellect," *Johns says.* "He is not only generous with his ideas, but almost finds it necessary to give them to people"*), once observed, after helping Johns and Robert Rauschenberg move their studios, that when artist Rauschenberg's work was damaged, he let it be, considering the damage part of the natural life of the painting. But when Johns's work was damaged, the artist insisted on repainting it, not only fixing it but "reopening the aesthetic problem" of the piece.*

"I think what John found interesting was that I was not just matching the paint but continuing to work on the picture, disregarding what had been a finished state," *Johns explains.*

And how often does this happen? "Almost never." *What he was doing the other day was simply* "filling up a nail hole that had come through the frame."

But […] "A couple of times I have almost totally repainted pictures after I'd decided they were complete—had shown them, actually." *(One of these,* No, *is included in this exhibition of 154 of his works).*

Why? "Well, I must have had some reason. And," *another pause,* "I must have had the time." *[…]*

Johns and Rauschenberg met in the mid-'50s […] "We were very close, very dependent on each others' thoughts to get a kind of objective view that was extremely important and useful," *Johns says.*

[…] Nor is his taciturnity a particularly Southern trait. Quite often he insists that "I have no feeling about that whatsoever" *and that this "ideally" includes his state of mind while painting, although he admits that* "often I'm bored—which is better than frustration." *[…]*

While it might seem that the accoutrements of fame would have proved difficult for such an intricate, private intellect as Johns', he insists that what has concerned him about his recognition has been positive, that there has never been "a sense of myself being public. The attention paid the work *(after his first show)* was interesting to me. It made my life easier. I think it gave me confidence to go against it, to be free to do what I wanted. To be obstinate. I don't know that I ever really imagined I'd have a large audience. I thought people would find it interesting. I didn't know that they would find it very interesting. Or very awful."

Johns says that he has never regretted destroying his first works—"I only wish I'd done it a little more thoroughly." *He now, however, has a large collection of his pieces,* "because I really like it. When I first started working I just thought these things would come endlessly without any particular differences, that the work wouldn't change as much as it has."

In the end, it is the work that is important and that has always been the essence of what little self-analysis Jasper Johns has given us.

"The explanation will never be the work and for the person who makes the work, it is important to think in terms in which the work is made, not how the work can be perceived as a finished object. The fact that painting has a certain meaning doesn't mean that you can make a painting by putting in some meaning."

I-39. Roberta Bernstein, "An Interview with Jasper Johns," in *Fragments: Incompletion and Discontinuity*, ed. Lawrence D. Kritzman, *New York Literary Forum* vol. 8–9 (1981): 279–90. Interview conducted January 18, 1980.

[…] RB: *Could you talk about what the fragment suggests to you in your own work?*

JJ: One can take many approaches. One can think of all of one's work as a fragment of something else. Usually in working I tend to take something that has seemed to be a whole and put it in a context in which it becomes a fragment. And I do the opposite: take an aspect of something and treat it as a whole. What one does is affected by the focus of one's thought at the time.

RB: *I thought of two things in particular concerning the subject of the fragment in your work: first, your use of fragments of the human figure and also the fragmented structure of many of your works.*

JJ: What do you mean by fragmented structure?

RB: *For example, critics usually refer to your 1972* Untitled *painting as a fragmented work because it's made up of different panels that don't seem to go together. To me the painting suggests the idea of discontinuity—of one thing not seeming to cohere with the rest. And I thought you could talk about when you started using that kind of structure.*

JJ: I don't know how to reply to that, although I can understand what you're saying about that work. If you think of other things in the world, many are made up of developments that may become interesting when separated from the form that contains them. It's like a newspaper where the subjects are very different. But you wouldn't say that a newspaper is fragmented— or would you?

RB: *You could talk about the idea of discontinuity in that it isn't on one theme.*

JJ: You could talk about it that way or you could talk about the way the paper is folded and the typography…

RB: *… and in that sense its continuity.*

JJ: Yes.

RB: *I see* Diver *(1962) as a turning point in your work, because for the first time your use of separate panels suggests a sense of discontinuity, as if the painting is made up of discrete areas, with different kinds of imagery. But at the same time you provide links that establish continuity.*

JJ: There's no way to avoid that thought, I suppose. There are kinds of images that make a single impact and there are kinds of images that express themselves as a multiplicity. And there are multiple images that can't be sensed at

once, that have to be sensed separately in time as you focus on this thing or that thing. Such a changing sense of time and focus reinforces any indications of fragmentation.

RB: *I think a major shift in your work occurred around 1960 when you changed from using things like the flag, target, and numbers to the map, for example. The map of the United States can be seen as an entity in and of itself, but the way you painted it was as part of a larger map. It seemed, at a certain point, that the canvas wasn't confining things the way it was before; and there was a sense, not so much of incompleteness, but of seeing part of the whole, and in that sense a fragment. And the same with the "device" images […] [and some of] your more recent work. […]*

JJ: Well, the earlier pictures were whole and singular because the limits of the painting as an object coincided with the limits of the described image. The image and the object are more or less the same thing. The effect is different when aspects within the painting refer to things outside the painting.

RB: *So it was really a choice of moving from concentrating on the idea of a single image....*

JJ: I wouldn't exaggerate the idea of choice. I'm not sure what's chosen. It's what I did; it's what I've done. I've moved in that way. I don't know if it's out of choice or out of necessity—how my mind *must* move.

RB: *What about the fact that the human figure has always been presented as fragmented and incomplete in your work?*

JJ: In part, I think, it has been determined by a psychological predisposition, and partly by convenience. It is simple to cast a part of the body in the way that I do it, but a complete figure would require an enormous amount of time and a technique that I don't have. I have nothing against the total figure! And if I had a complete cast to work with I might use it, but nothing I've wanted to do has required my making that kind of effort.

RB: *But it seems to me that the fragments are so expressive* as *fragments.*

JJ: But isn't that always true of any fragment of the human form? There's a kind of automatic poignancy connected with the experience of such a thing. Any broken representation of the human physique is touching in some way; it's upsetting or provokes reactions that one can't quite account for. Maybe because one's image of one's own body is disturbed by it.

RB: *It struck me in reading Beckett's essays in* Foirades/Fizzles *(1975–76) that his presentation of the individual as fragmented and isolated conjures up feelings and reactions similar to your fragments in* Untitled, *1972. Were you thinking of that similarity when you decided to use images from that painting in your collaboration with Beckett?*

JJ: Yes; when I had the opportunity of doing the project with Samuel Beckett, I realized that that particular painting provided images which I felt could comfortably associate with his writing, even though, as you know, the painting was finished before the book was suggested.

RB: *Right. You said to me once that you had read a lot of Beckett before the collaboration with him, and I was wondering if, especially in doing that project, you could see a connection between your thinking and Beckett's?*

JJ: Only intuitively. The way one dumbly thinks of another person: "I know just how you feel." [...]

RB: *Going back to the 1955 targets and your first use of casts of body parts: they seem to come out of Dada and Surrealism. Were you conscious of works by some of those artists? I'm thinking particularly of Picabia, Cornell, Duchamp, and mostly Magritte. When you did those first casts, was it with an awareness of that artistic context?*

JJ: Not consciously. It's probably around that time that I saw the first Magritte show at the Sidney Janis Gallery. I'm not sure when.

RB: *It was (March) 1954.*

JJ: And just about that time I saw my first Cornells. But I think I made no connection. I could see that you might place the targets in that context, but I wouldn't. Though, of course, it's difficult to remember the kinds of thoughts I actually had at that time. Some of the plaster casts were in my studio before I thought to make either painting and had been intended for another purpose. I think I've told you before, that the first target originally was to have been a sort of piano. The lids of boxes would have been keys prepared in such a way that touching them caused noise from behind the painting.

RB: *I didn't know that, but I always think it looks like the Toy Piano* (Construction with Toy Piano, *1954*).

JJ: Yes, exactly. At some point it changed and the wooden keys became lids covering the boxed casts. In both plans, and in the *Target with Four Faces,* it was necessary that one come near the painting to manipulate the keys or lids. This aspect has been lost now that the pictures have become more museumized, but it was important at the time. I thought that what one saw would change as one moved toward the painting, and that one might notice the change and be aware of moving and touching and causing sound or changing what was visible. In such a complex of activity, the painting becomes something other than a simplified image. I don't want to say that I didn't understand thoughts that could be triggered by casts of body parts, but I hoped to neutralize, at least for myself, their more obvious psychological impact. Earlier, the casts were of unpainted white plaster and seemed clinically or photographically morbid. I decided to paint each a different color to counter that impression.

RB: *I always think one of the powers of your work conceptually is that there are so many different directions to your thinking, so many ambivalent, even conflicting meanings. And I find, even with the counteracting elements, there is something about those fragments that creates a disturbing quality.*

JJ: I think that's true and I think that I focused on neutralizing that aspect. Of course the fact that I felt that need indicates something about the state of affairs at the time. But it's important to see that another person in the same situation could have taken a different point of view and could have attempted to give it greater intensity, to make it a stronger part of a statement. I was trying to let the thing itself have whatever meaning it had and at the same time move in a sense against the grain of its psychological implications.

RB: *Which is the same thing that happens with the fragments in the 1972* Untitled *painting.*

JJ: But in a different way, I think. It's on a different level.

RB: *The disturbing effect of those fragments to me is stronger because they show a more complete figure.*

JJ: Most of those casts are larger and the colors are more naturalistic; they more openly suggest flesh.

RB: *It's also a female figure.*

JJ: Only in part.

RB: *Only part, but that's what seems most striking. Especially with the green high-heel shoes on the feet. One cast—the hand, foot, and sock on the floor—is very different from anything else in your work in that it seems to be part of a scene or event. It seems like a fragment out of something that happens in time.*

JJ: Yes. It's the only one of those fragments that seems attached to an environment outside the rest of the painting.

RB: *And it suggests a piece of a story or anecdote.*

JJ: Or something happening.

RB: *I think it's important to mention because it's a fragment from experience in a different way from any others you've used. Another thing I wanted to discuss is the series of lithographs called* Fragments—According to What *(1971). What was it about the painting* According to What *(1964) that made you feel it was appropriate to take those parts and make separate works of art out of them?*

JJ: The painting was made with a desire to put things in it. That was the way I thought of the painting: that I would put *this* into it. Maybe I could have thought of even more things to put into it than I finally did. Once you have the idea that things exist and you put them into a space, then you can have the idea that you can take them out of that space again.

RB: *And that they would then work artistically as separate things?*

JJ: Yes. It seemed that it should be possible to find or show what had been a thought that at one time didn't exist just in the painting, but separately. A thought in itself, even though it later functions only as a thought in the picture. It was a detail that could be looked at and studied and measured.

RB: *It seems to me with the prints (*Fragments*), you wouldn't make each selected detail an independent work of art, if it wouldn't stand as such on its own. That is apart from the fact that some, maybe most, of your audience would know the painting and therefore the context of each "fragment." Wouldn't each of the "fragments" have to have a sense of completeness of its own?*

JJ: Well, there could be a sense of a complete description of the detail, or a sense of a particular kind of description. Of course, artists traditionally have focused on a detail. Say, a hand that was going to be part of a portrait, to study as a thing in itself, even though it would eventually function in another context of the larger scene. And much thought in art is of that nature. You take a detail and study it in preparation for locating it in its proper place in a larger scene. But a lot of modern experience is of an opposite nature: you take a larger situ-

ation and extract from it some bit which you examine with great attention.

RB: *A last point I want to mention: it seems to me that you prefer a sense of the complete in your work. That you don't like the idea of something not being complete or connected to something else that it belongs with. For example, in* Decoy *(1972), where the spectrum letters get cut off at two edges. It's as if they are going to connect or that they are part of the same continuous string of words. Or with the title of* Fool's House *(1962), the way it's cut off and then comes back to complete itself. There's a sense of wanting to connect things, to see them as part of a continuum. Whereas another artist would make the point that something cut at the edge means that it's incomplete, that we don't know what's beyond the edge.*

JJ: I hear what you're saying. I can't think of it in a way ... I don't know, when you think of something being complete or incomplete, that's an idea, isn't it? When is it complete and when is it not complete? I don't think one can say what one longs for.

I-40. Katrina Martin, "An Interview with Jasper Johns about Silkscreening," in *Jasper Johns: Printed Symbols*, exh. cat. (Minneapolis: Walker Art Center, 1990), pp. 51–61. Interview conducted in December 1980 in New York.

The following interview [...] concerns Jasper Johns's screenprints Usuyuki *(1979–1981),* Usuyuki *(1980),* Cicada *(1979), and* Cicada II *(1981), several of which were copublished by the artist and Simca Print Artists. The interviewer had been watching Johns work at Simca for several months while making her film* Hanafuda/Jasper Johns *(1981, 34 minutes). Parts of this interview became the soundtrack of that film.*

KM: *Can you describe the silkscreen process?*

JJ: Well, somebody else could probably describe it better than I can. Basically it's a stencil. It's a positive and a negative, an opening through which paint is put that takes the shape of the opening of the paper.

KM: *The reason I'd ask you to describe it is that I know you work in different media. How do you go about figuring out a medium?*

JJ: Well, the medium expresses itself to you by what it is. Silkscreen, basically, is very simpleminded. It's simply an opening through which ink can go and be deposited on paper. And the fact that the silk is there allows you to have very complex openings that you couldn't simply cut out [of] a sheet of paper and have all the pieces hold together. But the silk supports these floating islands of material that block the ink, that don't allow the ink to go through.

KM: *What's peculiar in the way you use silkscreen is that you don't use it to create areas that are flat.*

JJ: But it is flat. That is its nature.

KM: *But what's peculiar in the way that you're using it is that you build up a very complex and painterly kind of surface.*

JJ: I understand that. But I think that might properly be considered an abuse of the medium (laughs). I'm not sure. Because what it does in its purest form is deposit an even coat of ink through an opening. There's never any breakdown

in the amount of ink that's deposited in any place. It's always the same amount in every spot where it touches the paper. [It's] perfectly even. What I do, what I tend to do, is first to work freely with the brush on the screens, getting whatever shapes the brush makes. Then I tend with additional screens to reinforce those shapes. And that confuses a little bit the flatness of it and suggests a different kind of activity. But it's basically an illusion created by adding.

KM: *The many layers?*

JJ: Yes. Not just many layers but layers that mimic one another, so that many of the marks mimic the marks that are already there. So that instead of seeing two things you think you're only seeing one that's richer in some way.

KM: *You don't get the same kind of accidents with silkscreen that you might get with other media […] for example, variations in tone.*

JJ: No, you don't get any variation of tone, unless you do it very deliberately by the way you color the ink. The ink going through the screen is always one quality and never varies—if you have a good printer. Well, you get accidents to the degree that you can't imagine what something will look like, if you want to call that an accident. You think you will do something that will be a certain way, and then when you see it it's a little different. Usually I think my response is just a yes or a no to it, that that's all right or that's not all right. I don't know, it's subjective judgment. There isn't much to be concerned with, and there's not much room for accident. What accidents would you have? That things don't meet that are supposed to meet, or that things overlap that are not supposed to overlap. Well, that's very easily dealt with, that kind of thing. Because you only have ink and no ink. So you have the shape that the ink takes, and that's all you have. If you can imagine it properly, then there's no reason that you don't do it properly.

KM: *How does imagining it properly take place?*

JJ: I think it just amounts to jumping in and working and then continuing until you don't do it anymore. And then you say that that's your print.

KM: *I see. You mean, in general with the print, or in general with the medium?*

JJ: Well, you begin. And you work as long as your interest holds up. And if it interests you to change something, you can change it.

KM: *How do you change it?*

JJ: Well, in this, you can change the drawing, you can change the order of the screens, you can change the inks, you can change the gloss, the physical quality of it. Things like that.

KM: *And when are you done?*

JJ: Well, sometimes when it looks hopeless to do anything more, sometimes you're done.

KM: *Yes?*

JJ: When your mind stops working in relation to the print. Basically that. I mean, when your mind stops working in relation to what you're doing, either you've finished it or you throw it away. Those seem to me the only choices.

KM: *Can you describe what a hand-cut screen is?*

JJ: A hand-cut screen is basically a sheet of film in which the parts that you want to print are removed from the sheet of film, and then the film is attached to the silk. Then the parts which have been cut out with a razor allow the ink to go through.

KM: *And the screens made with tusche?*

JJ: [With] tusche, you put waxy substance directly onto the silk. Then a material is pulled over that which becomes like the film, and where you put the tusche you wash out. Then you have an opening, so that what prints is the marks which you drew.

KM: *Do you think you could describe how the tall* Usuyuki *print (1980) is built up?*

JJ: There's a hand-cut stencil, which, if I remember correctly, follows a paste-up I did of strips of newspaper that form a kind of cross-hatch pattern. Then we had made photographically a screen, which only had the type that was on the newspaper, that was printed in a kind of a black or gray. So with those two screens you get the effect of pieces of newspaper glued to or lying on the surface of the other paper.

KM: *And then?*

JJ: Well, I'm not sure I have the order right. Then those colored areas were put down. I'm sure there's a very simple way to explain that—usually with a squeegee you move ink across the screen, and a certain amount of the ink goes through the screen and is deposited on the paper. Usually you use one-color ink. And in laying down those flat areas, the ink was blended of more than one color so that, say, instead of having a puddle of yellow ink pulled across, you had a puddle of ink that went from yellow to orange and was mixed.

KM: *They were done in sections.*

JJ: Well, that's partly because to do such a large thing would be very difficult to mix.

KM: *At the vertical edges of those sections, the colors are almost the same but not quite.*

JJ: Well, going to all that trouble to print it in five sections, I thought we shouldn't disguise the fact and should have it *not* match exactly. I thought it would be richer than hiding the fact that we were doing it in that way. There is the one idea that is suggested, that there's a smooth flow, a smooth color change from top to bottom. But literally it's not as smooth as it could be.

KM: *And the color flow is a rainbow.*

JJ: Yes, basically, a spectrum.

KM: *This is a silly question, but why?*

JJ: (Pause.) I haven't the slightest idea why! (Laughs.)

KM: *I knew that was the answer, but I thought I might ask....*

JJ: These prints relate to other works, and I've thought about it so much that often something which has a function in one work is used in another work without the function that it had.... What I did [was] I made a study for the other *Usuyuki* print as a drawing, and I used kind of rainbow-colored inks to help me locate different things easily, and having done that I decided to use that kind of color in this print, just for itself.... For instance, the cross-hatching in the three-panel painting (Usuyuki, *1977–78*) is moving in one direction.

Working on a stone at Gemini G.E.L., Los Angeles,
c. 1971. Photograph: Malcolm Lubliner.

The grid, perhaps, is moving in a different direction. I think the grid and the little shapes are always moving in the same direction; I'm not sure. But you have several possibilities of moving, and in the drawings that I've done I've moved all these things in different ways and sometimes have colored them in ways that help me just keep it in my head what I'm doing, because it gets complicated.

KM: *Could you talk about that more, how you move things in different ways in different drawings?*

JJ: Well, if you have two systems, say the cross-hatching and the grid, one of those systems, say, can move to the right and downward. This can go from the left down to the right and spiraling around. That's one system, say the cross-hatching. Say, the other could move downward to the left. So if you make three representations of this, you will have different things meeting in the different pictures because they've been displaced. Say that you have one of the shapes, say, the little circle, that's moving downward to the left, and the cross-hatching down and to the right, the section of cross-hatching that meets that shape in one picture of this movement will meet a different section of cross-hatching in the next picture of this movement. That's how you show the movement. That's what is being shown, actually.... I've tried to do all the different possibilities in the drawings and things that I've done, just to see what it looked like.... What I wanted to do was to see what happened on the paper if I did all the different possibilities. Some of them are interesting because nothing happens, really. Some of the situations don't reveal what's happening actually.

KM: *And that is the interest of an idea? That's what you sustain through the different prints?*

JJ: Well, it's interesting to me. One hopes to have an image that is interesting in itself.

KM: *See, I'm really asking maybe too broad a question, which is: where does the image come from? How do you get an image where there wasn't an image?*

JJ: Well, this comes from a thought, basically.... The thought has certain implications, you have to do a certain amount of work.... I'm always interested in the physical form of whatever I'm doing and often repeat an image in another physical form just to see what happens, what the difference is. And to see what it is that connects them and what it is that separates them. Because the experience of one is rarely the experience of the other, for me, at any rate.

KM: *You had a painting in the shop that you were working from in the* Usuyuki *prints, but there was no painting for the* Cicada *prints. Have you ever made a* Cicada *painting?*

JJ: I've made several. Three, as a matter of fact. The one print is based on one painting; the other print is based on another painting.

KM: *Why did you switch around the colors so much during the making of the first* Cicada *print (1979)?*

JJ: Well, the two paintings I did, [in] the first painting the ground is white, the central colored marks are red, yellow, and blue, and the outer edges are the

secondary colors, I think. Then I made a small painting and I reversed that, so that the white became a kind of dark gray and the secondaries were used where the primaries had been used, and the primaries were used where the secondaries had been used. And in working with the prints, I wanted to try the two other possibilities that occurred to me. One was to have the central area be the secondary colors [and] the outer edges be the primary colors on a field of white; and the reverse of that with the gray. Though I think I came back to the original situation in the print, didn't I? I'm not sure. I think the primaries run through the middle.

KM: *You had it on different-color papers. Were you really undecided at that point?*

JJ: Well, one has the opportunity to try that kind of thing while working, and it may be something you would use and it may not be.... And actually you're looking before you're doing the edition, so that at any moment you could decide to have the edition be like that.

KM: *But it's also the opportunity to see.*

JJ: Yes, of course.

KM: *For the two* Cicada *prints, I noticed that after the first edition was printed you altered the screens for the second edition. Why?*

JJ: Well, because a dark shape on a light paper has a different quality from a light shape on a light paper. And because different colors of ink overlapping do different things, make different effects.

KM: *So you'd have to alter the screens.*

JJ: Not necessarily, but I think I did have to with that print. I don't remember how much altering I did.

KM: *You basically changed the edges.*

JJ: It probably has to do with the contrast between the dark ink and the white paper.

KM: *The possibilities can become infinite.*

JJ: I always think that what I do is much simpler than that. I do what I think to do, and that's about all there is that I can do.... Just the process of printmaking allows you to do—not *allows* you to do things but makes your mind work in a different way than, say, painting with a brush does. It changes your idea of economy and what is—what becomes of—a unit. In some forms of printmaking, for instance, it's very easy to reverse an image and suddenly have exactly what you've been working with facing the other direction and allowing you to work with that. Whereas if you were doing a painting, you would only do that out of perversity—you would have to have a serious interest to go to the trouble to do that. But in printmaking things like that become easy, and you may want just to play with that and see what it amounts to. Whereas if you had to do it in a more laborious way, you wouldn't want to give it that energy. Your curiosity wouldn't be that strong. There's a lot of that in printmaking. And some of that feeds back into painting, because then you see, you find things which are necessary to printmaking that become interesting in themselves and can be used in painting where they're not necessary but become like ideas.

And in that way printmaking has affected my painting a lot.... Instead of smearing and slurring, you're to make it in steps [in printmaking]. And then, of course, the other interest goes into printmaking. It becomes very playful, because then you would like to try in printmaking something that isn't in its nature. That's that quality with the screenprinting that I think I tend to do, which I don't think is particularly appropriate.

KM: *How do you come up with a title?*

JJ: Well, the *Usuyuki*—I came upon the word in something I was reading—and the word triggered my thinking. I can't do it in a kind of cause-and-effect relationship, but I know that's what happened.

KM: *Do you know what "usuyuki" means?*

JJ: I think it means something like "thin snow."

KM: *Why was that interesting?*

JJ: (Laughs.) I don't know why anything is interesting, Katy. I think it has to do with a Japanese play or novel, and the character, the heroine of it, that is her name. And I think it was suggested that it's a kind of sentimental story that has to do with the—what do you call it?—the fleeting quality of beauty in the world, I believe. At any rate, I read this and the name stuck in my head. And then when, I think, Madame Mukai was here once, and Hiroshi [Kawanishi] was here, and I had just read this, I'd been in Saint Martin and read it, and I came back and I had dinner with them one night and I said, "Hiroshi, if I said to you, *'usuyuki,'* what would it mean?" And he said, "I think—very poetic—a little snow" (laughs). So I kept on and made my pictures using that title.

The *Cicada* title has to do with the image of something bursting through its skin, which is what they do. You have all those shells where the back splits and they've emerged. And basically that kind of splitting form is what I tried to suggest.

KM: *In this interview I've tried to talk about the specific images you've been working on, how they work, what their formal elements are, how you think about it technically....*

JJ: Well, that's a very important part of it, but I think that might be better done by someone figuring that out rather than just casual conversation. Because it's a step-by-step thing, I think it would be better if someone figured it out and arranged it in their head and said it....

KM: *But even though you don't have to be the craftsman that the printers are, you have to have some idea of how things work just to bring an image into being.*

JJ: I think you have to have a very clear idea.

KM: *And then I wanted to talk something about meaning but...*

JJ: About what?

KM: *Meaning. In the work. But I wasn't sure how far to go with that. But I can't help thinking about meaning to some degree.*

JJ: Well, you mean meaning of images? I don't like to get involved in that because I—any more than I've done—I tend to like to leave that free.... The problem

with ideas is, the idea is often simply a way to focus your interest in making a work. The work isn't necessarily, I think—a function of the work is not to express the idea.... The idea focuses your attention in a certain way that helps you to do the work.

I-41. Riki Simons, "*Gesprek met Jasper Johns: Dat ik totaal niet begrepen word, is interessant,*" NRC [Niewe Rotterdamse Courant] Handelsblad, April 23, 1982, p. CS-3. Interview conducted in Johns's house in Stony Point, New York. Published on the occasion of the exhibition "1960–1980: Attitudes–Concepts–Images," at the Stedelijk Museum, Amsterdam.

[...] JJ: My environment was completely art-free. I can't even remember any reproductions, absolutely nothing. I only know that at one time an artist had lived with us at home. He came from the city and painted mirrors in the café. I saw that he had quite a few paintbrushes, about ten, and lots of paint tubes. I pilfered some of it then; I thought he would never notice. I was very much under the impression then that he immediately noticed. But I have no recollection whatsoever of his paintings.

I think I wanted to be an artist because there was no such thing in my milieu. Therefore I had to go far away, to a different, interesting world. [...]

RS: *You have been using the subjects of your first exhibition, the flags, numbers, letters, targets, etc., for almost an entire artist's life. About these you have repeatedly said, "I didn't invent them, they existed already"; "I just ran into them"; or "they were lying in my studio" (the beer can, the can with paintbrushes). But the accidental aspect of this choice is hard to believe. The subjects have so much in common, they seem so deliberately chosen.*

JJ: Certain subjects impose themselves on you and others do not. It is a state of mind that makes you receptive to particular things that appear alive, lively, or interesting. I don't know either what it is in someone's personality and mind that determines whether one does this, or something else. The continuity of the logic is determined by something I know nothing about, that I'm not familiar with.

As soon as a subject draws me, possibilities emerge. So it's an important event. You can't just align all the possibilities in a row and then choose from them. You feel your decision is something necessary.

In 1959, as a preface to Johns's first exhibition, the American critic Leo Steinberg wrote a long, well-thought-out article that has influenced any thinking or writing about Johns's work since.[13] [...]

RS: *It's unusual for the work of a painter who is still young to be interpreted in such an erudite and penetrating way. What effect did it have on you?*

JJ: I was then still an unknown quantity. I didn't know what was common or uncommon. Of course I was flattered by Steinberg's attention and his serious approach. We did talk a lot at the time; he kept asking for my opinion, so it wasn't like I saw his article for the first time when it was ready and finished.

RS: *From 1954 until today you have kept using your very first themes over again, in addition to new ones. There are, for instance, flags from 1955, 1958, 1965, and 1973, in print, bronze reliefs, and also in paintings. How do you come to the decision, after about ten years, to make a flag again?*

JJ: It has basically nothing to do with the subject itself, but with the work process, the way you will work, the direction you will take. Sometimes all of this becomes clearer for me if I choose a subject I feel very comfortable with: then I feel free to concentrate on the work process, the print technique, the material, or whatever the case may be.

RS: *A lot keeps being written about your work, and this material is often very difficult. But you don't say much about your work yourself. How is it still to be confronted, however, given these obtrusive interpretations and philosophies?*

JJ: I often think—well, not often, let's say sometimes—that it amounts to nothing. Then sometimes I think: that's close to a thought I had myself. But the fact that you're completely misunderstood is interesting—that someone's ideas about my work are totally foreign to me. I think my work lends itself particularly well to a great deal of thought in the area between understanding and misunderstanding. To me these interpretations are never illuminating; sometimes I find them interesting and sometimes confusing.

During the period after his breakthrough, and this is true especially of his work from the period 1962–65, Johns seems to have wanted to contradict everything that had been written about him before. […] Michael Crichton, in his semiauthorized biography of Johns (the catalogue introduction to the great 1977–78 retrospective […]), writes of that time that it was a period of crisis, that Johns found himself in a downward spiral.

RS: *Is that correct?*

JJ: (laughing) Every period is a period of crisis, isn't it? Those paintings all speak some sort of unsettled language. There is something ambiguous about them. When they say something, at the same time they say the opposite, but they have no equilibrium. That's how I see it working, but I could be wrong.

RS: *At the end of the 1950s you made small bronze sculptures. Why did you stop?*

JJ: I haven't stopped. At the time I had planned to make at most three copies of each, but that's a boring thing to do, for you know in advance precisely how it's going to turn out. Once in a while I bring one out, to work further on it. I would love to make new ones, but then not on such a small scale anymore; that doesn't interest me anymore. But I just don't have any new idea.

RS: *You also work on commission?*

JJ: I used to, but normally I don't. I don't like it. You feel the commissioner has to be made happy. Often they want something they feel is typical of my work, but you don't know yourself what that is. And you certainly can't tell from a work that doesn't exist yet. Your ideas change as well. When you're young, you're very arrogant.

The first commission I made was for a collector who wanted to have a number. So I told him: pick your number (laughs hard). He said five; so I

made the big black five that now hangs at the Centre Beaubourg in Paris.

RS: *Why do you keep some paintings and sell others? Rumor has it that the owner of the most beautiful collection of Johns works is Jasper Johns.*

JJ: As far as the first paintings are concerned, they were just left over. Later, when my work sold well, I held on to some paintings. It is hard to say how one decides to keep one and sell another. When the work is very new, you'd rather keep it, but you are also curious to know whether someone else would give something for it.

RS: *You've kept that can with paintbrushes, for instance, while you sold the beer cans.*

JJ: I made [another] beer cans [piece] for myself. I don't think the can with paint-brushes can be reproduced, but that doesn't matter, for I have it (laughs). I had decided that there should be two editions of the beer cans, one of the paintbrushes, and three of the other sculptures. How I came to that decision I don't know.

RS: *I thought all your paintings were sold before they were made. John Cage […] once said that as soon as you stretch a canvas, some person already wants to buy it.*

JJ: (roaring with laughter) You should try some time to sell a painting you haven't made yet! But it did happen once, yes. I was going to make a painting for a benefit auction, and there happened to be a collector in my studio when the empty canvases arrived. He took a first option on one canvas; the size suited him, I think.

RS: *Do you have any particular recollection of the painting of yours that hangs at the Stedelijk Museum in Amsterdam,* Untitled, *1964–65?*

JJ: I made it in Edisto Beach, South Carolina. That house burnt down afterwards. I remember that in that painting two or three elements move from panel to panel according to a particular system. When I looked at a reproduction recently, I tried to rediscover that system, but I haven't succeeded yet. When I made the painting I thought it would be obvious to everyone.

RS: *That painting is used a lot for educational purposes.*

JJ: Maybe I should go there, then, at some point!

RS: *Your painting* Decoy *of 1971 looks like a summary of the themes of the preceding period. There seem to be representations of all the small sculptures, letters, and a depiction of a plaster cast. At the same time, the painting looks like some kind of farewell, for since then you have stepped over into another theme.*

JJ: It's interesting you should think so, because the depictions that appear in [*Decoy*], like the beer cans, originate from old copper plates that I didn't want to use anymore—they were refuse. In that sense it was a farewell, but whether this was also the case in the abstract sense I don't know.

 I asked this because, shortly after, in 1972, a theme surfaces for the first time in Johns's painting, one that has dominated his work since: the cross-hatchings, as these paintings have come to be known in the U.S. Literally: a pattern of stripes standing over each other obliquely in squares distributed over the canvas in all sorts of colors.

RS: *In the* Untitled *of 1972, the cross-hatching takes up only one out of four panels,*

the far left one. Plaster casts of body parts are attached to the rightmost panel;
the realism of these parts has not reappeared since.

JJ: Yes and no, because soon after I went back to using plaster casts. I made three from a child's arm, the first one six years ago, the second one three years ago, and now another one. I thought it would become a large painting, but the casts are really very small. I hadn't realized how small a child's arm is. So it won't be a large painting, but it is nevertheless one of the most important things I will use in a painting. I just don't know how yet.

Johns once told the critic Michael Crichton that he had derived the cross-hatch pattern from a fleeting encounter with a car, coming from the opposite direction, that was decorated with such motifs. He immediately thought: I'm going to use that in my next painting.

RS: *Crichton presents this story as evidence that even though your recent work looks abstract, it isn't, because you didn't invent the motif, someone else did, just as someone else invented the flag and the beer cans. Isn't this a contrived attempt to deny a rupture of style? For those who don't know the story, the cross-hatch work is thoroughly abstract.*

JJ: Precisely, but you can see that very little was made up in that picture. When you've seen such a painting, you can say, This kind of sign is used in it. It's easy to describe, and in that sense it's no different from my earlier work.

Crichton made that connection between the early and the present work immediately on hearing my story about the car. But for me there was indeed talk of a great change, for this is now ten years ago, and since then I've made so many works around this theme. I wish I could change the motif, but that hasn't happened until now. […]

I-42. April Bernard and Mimi Thompson, "Johns on … ," *Vanity Fair* 47 no. 2 (February 1984): 65.

New Work
Every image or object in *Racing Thoughts* was from something in the studio or the house. The portrait of Leo Castelli in the painting is a jigsaw puzzle—a Christmas present years ago from someone in the gallery.

Younger Artists
Those are Terry Winters's drawings. Aren't they beautiful? Lately I haven't seen much work by younger artists, but I want to see more of Eric Fischl's work—I find it very curious. And I'm a fan of Andrew Lord—I own several pots by him. The first I received as a gift, and then I bought a set of three unglazed pieces as well as some glazed pieces.

Critics
After I first showed at Leo's, the work received great attention. I don't think there is any particular right or wrong when you're viewing a painting. I was impressed with Leo Steinberg's comments on my work; it seemed to me that he tried to deal

Working at ULAE, West Islip, New York,
January 26, 1973. Photograph: Hans Namuth.

directly with the work and not put his own map of preconceptions over it.[14]
He saw the work as something new, and then tried to change himself in relation
to it, which is very hard to do. I admired him for that. I'd like to be indifferent
to critics, but I'm not. Sometimes one of them says something that jars something
in me, that makes me feel we're close in thought. But of course sometimes you
wonder about a critic, How could *anyone* possibly think *that*?

Collectors

In the early stages of an artist's career there are collectors who support you, and
at that time it's so very valuable. There are two kinds of collectors, though: those
who want personal contact and those who would rather not see you at all....
There is a story which I can't remember exactly about a musician who was playing
at someone's party. He discussed the fee with his hostess—$300. She said, "Of
course, you understand that the musicians are not to socialize with the guests."
And he said, "In that case, the fee will be $200."

Reproductions

I just received a card from the Tate Gallery in London with a painting of mine
on it. It's amusing that people who produce such cards usually don't let you know.
You sort of get them by surprise, from friends in the mail. I guess they're like
souvenirs at best. I enjoy postcards of other people's work more than my own.

Poetry

I read a lot of young poets just because things come in the mail—there's a con-
stant barrage of new poetry. I always complain that they write too much. There's
a painting of mine that refers to a poem by Hart Crane, and in another painting
I included the title page of Ted Berrigan's *The Sonnets*, which I like. I was talking
to the poet Anne Waldman the other day, trying to get her to explain to me
how those sonnets were written. She gave me a few clues, but she didn't seem to
think there was any systematic order. He used the same lines over and over, and
in some of the poems the lines were shuffled about in an entertaining way so that
they read backwards instead of forwards.... So James Merrill uses a Ouija board
when he writes his poems? I would *love* a device like that for painting. Everybody
could take the end of the brush and move it on the canvas! Hah, I could really
use that!

Materials

The use of encaustic contributed to my control, but that wasn't the reason I used
it. The reason was practical. I had been working with paint that wouldn't dry, and
I didn't want to smudge or pick up what was already on the canvas when I put
something else over it. I had read about encaustic, so I went out and bought some
wax and started working—it was just right for me. Everything I did became clearer.
It coincided with the thoughts I was having about the possibility of anything
being discrete. Encaustic keeps the character of each brushstroke, even in layers.
It's not like cooking, where things blend together to make a new substance.

You can see, I think, that these ideas were the thoughts of a young person who wanted to do something worthwhile, something with some rigor to it. I don't think my work is any less rigorous now. But now I use a lot of heat and melt everything and let it run. When you become more used to or more skillful with (I don't know which) ideas and media, you don't have to concentrate on them so much.

Painting
In my early work I tried to hide my personality, my psychological state, my emotions. This was partly to do with my feelings about myself and partly to do with my feelings about painting at the time. I sort of stuck to my guns for a while, but eventually it seemed like a losing battle. Finally, one must simply drop the reserve. I think some of the changes in my work relate to that. I think when you're young you set a lot of limits because you have the need to be very clear to yourself. Once, if I did something in my work that reminded me of someone else's work—an idea, a gesture, paint quality—I would try to get rid of it. But now it wouldn't faze me in the least.

I-43. Demosthène Davvetas, "*Jasper Johns et sa famille d'objets,*" Art Press (Paris) vol. 80 (April 1984): 11–12. Published on the occasion of the exhibition "Jasper Johns: Paintings," at the Leo Castelli Gallery, New York.

[…] DD: *From the beginning of your artistic endeavor and until your last exhibition at Castelli's, the object remains the fundamental characteristic of your work. Is this fetishism or mysticism?*

JJ: Call it what you wish. The fact is that I consider objects in the same way that I see painting.

DD: *For you, painting becomes an object.*

JJ: I have always had a particular sensitivity toward the object. I dare say that this passion for the object existed well before I ever acquired knowledge, before the aesthetic of architecture or sculpture became part of my experience. It is a sign of my "language."

DD: *What is Marcel Duchamp's legacy for you?*

JJ: I don't know what you mean by "legacy." At any rate, at the beginning, my work received various influences. Duchamp's work piqued my curiosity. Later I got to meet him, through the art critic Nicolas Calas. I was seduced by the man. His ideas, his creations, triggered an intense curiosity in me. I was (and I keep being) utterly conscious of his work, of his influence on me, and of my efforts to avoid doing what he has done already.

DD: *What is the meaning of the fragments of human bodies in your work?*

JJ: I would say that their meaning is emotional. I'm talking not of a sentimental emotion, but of a primarily psychological one. […]

DD: *There is a melancholy aspect to your last exhibition, and particularly in* Racing Thoughts: *the picture of the gallery director in his youth, a Barnett Newman work, and the Mona Lisa, among other things. What is the connection among them?*

JJ: I distinguish two aspects in this painting. First, all these objects were in my house or my studio. Castelli's portrait was a Christmas gift someone at the gallery offered me. All these objects are signs of the past. Which doesn't necessarily mean they are souvenirs. I am not sure what their connection to memory is. They must be things I was thinking of. Thought isn't automatically geared toward the present; it can also turn toward the past.

DD: *Does the artist have a relation to his environment?*

JJ: They are inseparable! It's his space, his existence, his very life. That's the second aspect of the painting: all these things have a psychological character.

DD: *Are you tied to these objects to the point of never having thought of abandoning them?*

JJ: I've probably thought of it. But it isn't easy. They are a part of me, of my personal "language." How could I work on a painting without finding the material in myself?

DD: *Are the three paintings in the show titled* Between the Clock and the Bed *a homage to the work of [Edvard] Munch?*

JJ: Yes, they are a reference to the work of Munch. One of my friends sent me a postcard. I liked it. A series of thoughts followed. [...]

DD: *Why do you continue to use encaustic to paint?*

JJ: Using that medium has helped me to master my work. But there is also a practical reason: for instance I was working on a painting, it wasn't dry, and I didn't want to blur what I had put on the canvas by adding something else. I had read something on encaustic. So I bought some wax and I set to work: I was right. Everything I did became clearer. Encaustic preserves the character of every stroke of the brush. This coincided with my thirst to use everything that was discrete. These were the ideas of a young man who wanted to do something important, something dynamic. Today I melt any kind of material and let it drip. [...]

DD: *There is a close relationship between your work and poetry.*

JJ: Yes, I have often honored poets. [...]
 I've always been attracted to poetry. [...] One finds harmony in poetry, but no systematic order. I wish I could say the same of painting.

DD: *What is your relationship to music and dance?*

JJ: I used to collaborate with John Cage and Merce Cunningham. I was interested in their work, even though I never participated in performances.

DD: *One notices a return to figurative painting today. Painters are returning to traditional means of expression. The element of mythology reappears in young painters' work. What do you think of that phenomenon?*

JJ: Society creates certain situations that vary through time. The needs and anxieties of the public are reflected by those who are in dialogue with it. The phenomenon you are referring to corresponds to what the public is expecting.

DD: *What is the current situation of young American artists?*

JJ: I don't often go to exhibitions, you know, so I don't know the work of many young painters. I go once in a while, when the occasion presents itself, but rarely because of the connection between those works and my own. That is to say that when I look at another artist's work I automatically think, "That's what I should avoid in my own painting." When, by chance, my work reminds me of someone else's—I don't know, it can be an idea, a gesture, the placement of an object—I immediately try to distance myself, to escape from that situation.

DD: *Yes, but do you also try to avoid repeating yourself within your own vocabulary?*

JJ: Of course! But I don't always succeed. We have ties, we coexist with certain people and certain objects, with which we become a single body, a single family. How could one easily separate oneself from a member of that family and make a different work?

DD: *At any rate, I am sure there must be some American artists you could name.*

JJ: You are stubborn. Fine! I would mention Terry Winters, Eric Fischl (whose work provokes my curiosity), and Donald Lipsky.

I-44. Gerald Marzorati, "Lasting Impressions: A Johns Print Retrospective," *Vanity Fair*, May 1986, pp. 116–17. Published on the occasion of the exhibition "Jasper Johns: A Print Retrospective," at The Museum of Modern Art, New York.

"Making a print is like any work," *Jasper Johns was saying, seated at a big wooden table in his New York City studio, a converted bank on the Lower East Side. […]* "You work, you do something, a little bit at first, then you see that you can do something else." *[…]*

[Johns] has made more than three hundred prints over the past twenty-six years. […] He wonders if anyone sees what he sees when looking at his prints, if anyone feels what he feels. "How can you be sure?" *he says.* "My own feelings can change about a work. Sometimes, when I'm working, I may feel a work has a certain … a certain spirit. But later I wonder how I ever had that feeling. I can remember having it, but can no longer feel it."

Johns, who will be fifty-six this month, began his first print in 1960. […] There is a story that Larry Rivers talked him into it, told him that prints can pay the rent. "I was never reluctant to do a print," *Johns says.* "I just never thought of doing one until Tatyana [Grosman] asked." *[…]* "Never having done it is what made doing it interesting," *Johns explains.* "I wanted to discover what the medium was about."

The images of numbers, like all images in Johns's prints, are ones from his paintings and sculptures: few and familiar. […] "What's interesting about using an existing image," *Johns says,* "is that you can see how other things affect the meaning. But you can't separate this from the way it was done. You work a certain way, you get a certain kind of meaning." *[…]*

I-45. Deborah Solomon, "The Unflagging Artistry of Jasper Johns," *The New York Times Magazine*, June 19, 1988, pp. 20–23, 63–65.

[…] At 58, Johns has found himself preoccupied by his own vulnerability in the face of age and loss, and eager to surrender his famous detachment to the imperatives of his discontent. […] His recent work pursues the autobiographical as diligently as his early targets and flags renounced it.

Johns […] speaks of the dramatic change in his work elliptically: "One wants one's work to be the world, but of course it's never the world. The work is *in* the world; it never contains the whole thing."

[…] In 1959, he recalls, he was befriended by Marcel Duchamp […]

Were the two artists close? "I wasn't inclined to approach him," *Johns says.* "I found it difficult to be with him in a graceful way because there were things I would have liked to ask him, but I couldn't imagine that he would be interested in giving me the information I wanted. Much of it dealt with the past, and who wants to sit around talking about the past?"

[…] Johns is particularly touchy on the subject of his childhood. But then, it wasn't a happy time for him.

[…] He was raised by his paternal grandfather, a Baptist farmer who took Johns in after his parents were divorced. When Johns was still in grade school, his grandfather died. The young boy was shuttled around to various relatives, and eventually ended up in a town called The Corner, living with an aunt. […] Asked why he lived with his father's sister as opposed to his father, Johns sits quietly before replying. "He didn't invite me," *he finally says, erupting into loud laughter.*

Johns recalls his years in The Corner as a time of intense isolation. "It was very rural—no telephone, no electricity at first. I had no sense of the world, and still have very little of it."

Early on, Johns retreated into the world of art. From the time he was five, he drew all the time. "Making drawings was something I liked to do," *he says,* "and probably it attracted attention. People said 'Oh, he does that!'" *He knew for sure he was going to be an artist someday, even though the only artist he had ever heard of was a grandmother he never met, a Sunday painter whose landscapes he saw in the homes of his relatives. He still remembers what her work looked like:* "Swans on a stream, cows in a meadow. A heron. I remember a tall painting with a tall heron on it."

[…] [In New York in the early 1950s], "I had no focus," *he recalls.* "I was vague and rootless. This image of wanting to be an artist—that I *would* in some way become an artist—was very strong. […] But nothing I ever did seemed to bring me any nearer to the condition of being an artist. And I didn't know how to do it."

A turning point came in 1954, when Johns became friendly with Robert Rauschenberg […] In those days, Rauschenberg was supporting himself designing windows for Bonwit Teller on a freelance basis; one day he asked Johns for some help. "I saw that what Bob did was do something, have some money, run out of money, find something to do, get some money." *Johns quit his job at the bookstore and began working with Rauschenberg.*

Now that he had time to paint, Johns decided to start over, and in 1954 destroyed every work in his studio. "I think I must have recognized some aspect of self-hatred in my aimlessness," *he says.* "I hoped to instigate a new state of affairs, to change the form of my thought and the content of my work."

[…] Johns […] was never one for hero worship. "I didn't want to do what they did," *he says of the Abstract Expressionists.* "I decided that if my work contained what I could identify as a likeness to other work, I would remove it."

[…] Racing Thoughts *of 1983 […] depicts a view of a bathroom cluttered with personal mementoes […] It's an elegiac painting that shows the artist racing to recapture a whole lifetime of experience, but able to retrieve little more than faded old photographs and other fragments of his past.*

Why would Johns, who is in good health, be moved to confront his own mortality with such directness and urgency? "I suppose I've become increasingly aware of the ways things can be cut off," *he says.* "I don't know whether it's the loss of friends…" *He stops and retreats to safer ground.* "I think my early work exposed me just as much as any other bit of my work." *[…]*

One of the more common complaints about Johns's work is that it's indulgently self-referential, featuring a narrow range of imagery and ideas. […] "It would be wonderful to leap over certain obstacles and be in a superior position to the one one is in," *Johns says.* "One sees that one is, in a sense, helplessly concerned with one's concerns. One has to have the thoughts one has, one can't just have the thoughts one would like to have." *[…]*

Johns's slowness as a painter, his careful application of pigment, his endless reworking of the surface, his difficulty finishing paintings—it all hints at the sense of doubt so pervasive in his work. […] "It seems to me," *Johns says,* "one can never make a comprehensive statement. One just continues to do things—this, that and the other—and then it stops." *[…]*

It was getting late, and I still needed to ask Johns about the shadow that had figured so prominently in The Seasons. *Why had he decided after so many years to paint his first explicit self-portrait? And why had he depicted himself as a quivering spook?*

Once again, Johns paused. "It was an easy solution to filling a large part of the canvas," *he finally said, letting loose one of his raucous laughs.*

But then the laughter stopped, and his long face assumed its usual inscrutable expression. "I wanted something that would be literal," *he said.* "It is less literal than I intended it to be, but nevertheless it started out as a literal tracing. I stood in the sunlight and there was a piece of paper on the ground and someone drew my shadow. I used that in the painting."

And so it turns out that Johns didn't draw the shadow after all. A friend drew it for him. No one but Johns could have thought to create his first and only genuine self-portrait in someone else's hand.

I-46. *Jasper Johns: Ideas in Paint*, 1989, 56-minute television documentary in color. Directed by Rick Tejada-Flores, narrated by Polly Adams. Produced by WHYY Inc. Productions (Philadelphia) in association with WNET/New York, for the American Masters series on PBS. Made on the occasion of the exhibition "Jasper Johns: Work since 1974," 1988, shown at the Venice Biennale and at the Philadelphia Museum of Art.

[Television documentary about the artist and the exhibition. Johns talks as he walks through the exhibition's installation in Venice. Comments on his work by Leo Castelli, Merce Cunningham, Anne d'Harnoncourt, Emile de Antonio, William Halsey, Hilton Kramer, Gene Moore, Paul Richard, Barbara Rose, Mark Rosenthal, Richard Serra, and Frank Stella, and readings of Johns's sketchbook notes and statements by John Cage. Includes a brief excursion to Allendale, S.C., where Johns grew up. —Ed.]

[…] JJ: There may or may not be an idea, and the meaning may just be that the painting exists. Then, like anything disturbs people, or calms people, or people find something to do with it, in the space in which they are, and they react to it as they would to anything else.

[…] JJ: It doesn't just refer to things which are images but ways of doing things, ways of painting. If it occurs to me that if there is a way of painting that I can introduce into the work that I have not used before, that somehow I will become a more skillful artist (laughs). I don't know that that's true at all.

[…] *[Artist William Halsey reminisces about a dowager telling Johns],* "Mr. Johns, I know you come from the Old South, and I assume you come from an old plantation family." And Johns looked her straight in the eyes and said: "No ma'am, I'm poor white trash."

[…] JJ: There was a period in my life when Merce, John, Bob Rauschenberg, and I were very close, and we all were together very often. And since all three of them were and are artists that I admire very highly, I looked to them for … probably for ideas but also for approval of what I did. John being the most sort of "teachy" member of the group, and probably having a clearer understanding of all the different media involved that we were all using, he was of extreme importance to me at that time.

Well you see I think often in my choices I go through a kind of … a process of psychological disturbance that would be very offensive to John. And he would find it absolutely foolish, and worse than foolish: offensive, I believe (laughs).

[…] JJ: Sometimes you will have an idea when you have a painting, whereas you had no idea before you had a painting. Sometimes there is a very clear image established ahead of time and you simply have to execute it. Sometimes you want to engage in a kind of activity and see what it'll produce.

JJ *[speaking of* In the Studio, *1982]:* I had seen an empty canvas propped against a painting in my studio, and that accounts for the sort of empty rectangle that

At his house in Stony Point, New York, in
October 1974. Photograph: Nancy Crampton.

goes in a slight perspective. I had some wax casts of an arm of a child; a three-dimensional object in relation to this representation of space in the canvas. It has a stick of wood that comes out from the painting. I was playing with that kind of thought on one level—of real things in space, and a suggestion of things in space, and a suggestion of space, and within the studio setting the representation of paintings, at least one of which is melting. So in a kind of setting where there are just a few elements, there was the suggestion that something was happening, I thought.

JJ *[speaking of* Racing Thoughts, *1984]*: I had had a period of a kind of anxiety, I suppose, where when I was trying to go to sleep, images, bits of images, and bits of thought would run through my head without any connectedness that I could see. And I was having dinner with I think a psychologist that I had met, and I explained that I had been having this for like a week, this situation, and he said: "Oh, we call those 'racing thoughts.'" And I was very pleased that there was a name for my condition (laughs).

[…] JJ *[speaking of* The Seasons, *1985–86]*: Well, they reflect a different kind of rhythm because they're fairly complicated in terms of imagery, suggesting almost a kind of natural abundance of detail; that they're cyclical in traditional terms. It gives them a sense of wholeness, I guess; they have that to a degree that not much of my work has. How's that?

JJ *[speaking of auction sales]*: I don't think I fully understand the process. When it begins, you're pleased that you can make something and sell it. It allows you to devote yourself to the work that you want to do. As it expands, and the value of the work increases, at a certain point you see that the society takes over in the determination of the value of the work and the meaning of the work.

JJ: To the degree that I have been influenced or moved by other people's work, I probably have an idea that perhaps someone might have that kind of use for my pictures. […]

I-47. Edward J. Sozanski, "The Lure of the Impossible," *The Philadelphia Inquirer Magazine*, **October 23, 1988, pp. 25–31. Published on the occasion of the exhibition "Jasper Johns: Work since 1974," at the Philadelphia Museum of Art.**

[…] "I feel some dislocation when I'm away from my working space," Johns confessed at the Gritti [the Gritti Palace hotel in Venice], "and … I'm anxious to get home and be in a place where I can work." […]

Take the famous American flag […] Why did he paint it and what did it mean to him? […] Johns explained that at the time, he was trying to find out who he was as an artist.

"At that time, I was very interested in separating myself from other artists, to clarify what I did as opposed to what I knew about what other people did. I was trying to do things I could look at and be very clear about what I had done.

"My early paintings were largely about one thing, one image. When I saw this was the case, I thought that painting didn't have to be like this. Maybe it could be something else."

[…] "Eventually, I pushed the brushstrokes forward and made them the subject of the painting."

In those early paintings, Johns would make images that showed his errors, "all the adjustments I had made. Everything could be sensed by looking. One thing this does is give a sense of time passing." […]

Perhaps the most enigmatic of Johns's motifs are the so-called cross-hatches, which he began to paint in [1972]. […]

"I think I began doing the cross-hatch paintings as simple mathematical variations about how space can be divided," *he said.* "I was trying to explain the structure of a cross-hatch painting to another artist yesterday, but I don't think he understood it. The structure isn't evident as you look at it, and he had no idea what it was all about.

"In fact," *Johns added, chuckling,* "I had trouble myself trying to figure it out. He was perfectly happy with the painting before I explained it. I may have just spoiled it for him." […]

The evidence that the "Mr. Inside" of American art had finally dropped his mask seemed overwhelming. Yet, on the record at least, Johns denies this is the case.

"To a large degree, I try to make paintings about paintings. […] I think the *Seasons* paintings have been given a personal interpretation because of the human shape. Parts of the pictures consist of references to places I've lived, to objects that I own and to other works by people I know. People recognize these things and think a statement is being made.

"They're not really self-contained, but to a large extent they're an effort to see the limitations of one's work and to try to overcome them. They have to do with control and skill, and curiosity about what painting could be."

In Winter, *for example, Johns said he was trying to deal with the kind of movement he associated with the phrase "thin snow," the title of a Japanese Noh drama that deals with the transience of beauty.* "I was trying to establish the idea of some kind of movement that couldn't be noticed but would still be there."

[…] *He concedes that his attitude toward making art has changed over the last 30 years—becoming* "weightier and calmer." *And the more work he makes, the more he realizes that an artist never really solves the basic problems; he only discovers additional ramifications of them.*

"Sometimes a direction that seems to consist of great complexities seems to collapse, and sometimes a simple thing can become complex and even confusing.… But that kind of thing keeps your mind working. Often it's just as apt to make you feel despair as feel joyful.

"Every work suggests that there is still another work to be done. No matter how large-minded you are, at the end of it you see that you have to start another painting. Often there's frustration because there's so much to be done, and the process seems so slow." […]

"It's possible that what there is to be done may be limitless," *he said.* "It's not just a question of time, it may be just that the more you work, the more you discover that your work is just a part of what can be done."

I-48. Amei Wallach, "Jasper Johns at the Top of His Form," *New York Newsday*, October 30, 1988, pt. II, pp. 4, 33. Published on the occasion of the exhibition "Jasper Johns: Work since 1974," at the Philadelphia Museum of Art.

[…] There was a time when [Johns] believed that his paintings could include everything that was real about the real world. That is why he chose a flat flag to paint on a flat canvas, so there would be no mistaking a third dimension. Lately, though, it has occurred to him that "what's awful about paintings is that they can't include everything. They are in the world, details among other details, parts among parts, wholes among other wholes," *he said.* "Despite all the different kinds of space they deal with, you still have to recognize there will always be spaces that are not in the picture."

[…] The early notoriety and praise made a difference.

"I'm the kind of person who responds well to praise," *he said.* "Some people need something negative to respond to."

[…] Recently, in life, and in paintings, Johns has begun to reveal himself.

"I don't think there's any choice," *he said. […]*

On either side of The Bath *is half of a distorted face from Picasso's 1936* Woman in a Blue Straw Hat. *She comes from a period in which, distressed in both his personal life and with the impending European war, Picasso was working up to* Guernica, *and there is every sort of ambiguity about her: where do the eyes belong, and the chin? And is that a flower or a tree growing out of her head?*

"I just happen to like this painting, and I've used it a lot," *he said.* "It looks simple and arbitrary and thoughtless and yet it's full of interesting …" *He paused, for a minute searching for the right word:* "Interesting—what? Thoughts, I guess. It's a still life with a book and a vase. The head can be seen as a [fruit hanging from] a branch.[15] It's rich in a kind of sexual suggestion, and extremely complicated on that level. And it seems so offhand. I just liked this painting, so I've been working on a number of paintings with it at once for the last year." *[…]*

He seems much too young to have made so desolate a painting of old age.

"I tried to resolve it," *he said.* "To get rid of it."

Johns has been intrigued with Picasso's teasing ways with perception and distortion for years. Two anecdotes in particular obsessed him. One was that when Picasso saw his first Willem de Kooning abstraction, he said, "Melted Picasso." The other, that Picasso used to sit in his bath, like Johns, and wonder why he didn't melt away like a lump of sugar.

Because anecdotes had given rise to his melting faces, Johns always thought the paintings would end up funny. "Then I made it very difficult. But even when it was lighthearted there was something disturbing about it," *he said.* "Even the connection to sugar is pretty weird." *[…]*

Not above Having Fun

[…] His most famous sight gag is the one that began his relationship with Picasso.

In 1971, The Museum of Modern Art asked Johns to make a print in celebration of Picasso's 90th birthday.

"I said I wouldn't do it," *said Johns.* "And then, of course, I stayed awake all night thinking: If I were to do it, I would do it this way."

*The result was [*Cups 4 Picasso*], a print in which you think you are looking at a white vase, until you realize that the point is really the two silhouettes of Picasso's face that form the back outline of the vase. Since then, Johns has substituted other profiles, including Nixon's and his own. […]*

I-49. Ann Hindry, "Conversation with Jasper Johns/*Conversation avec Jasper Johns*," *Artstudio* no. 12 (Spring 1989): 6–25. A special issue on Johns. In English and in French. Interview conducted on January 9, 1989, in Johns's house in Saint Martin.

[…] AH: Do you remember what the first original painting you saw was?

JJ: … No, I don't. But I remember the first original Picasso that I saw. He had been this mythological figure.… I went to New York and I saw it in some gallery. And I thought it was very unpleasant and uninteresting. I found it hard to believe that it was a Picasso. The point was that I had only seen Picasso in reproductions and this was real, so I had to come to terms with that!

AH: *When did you become aware of Duchamp?*

JJ: I probably had heard about the mustache on the Mona Lisa when I was in college. I think the idea was that well known. But I hadn't encountered his work. I read Robert Lebel's book when it appeared in 1959, I think. Shortly after that, Bob Rauschenberg and I went to Philadelphia to look at his works in the Arensberg Collection.

AH: *Did it make a strong impression on you then?*

JJ: His work interested me and I suppose there were some aspects of it that reinforced my own feelings about my work. Perhaps it set up some guidelines, I don't know. It's difficult to describe that kind of relationship because one tends to want to put it in a "cause-and-effect" sort of way, but I am not sure that is how it happened. Sometimes contact with works you have sympathy with refreshes your attitude towards your own work. Of course, round that time, Duchamp emerged as a more important figure than he had appeared to be, partly through the Lebel book, partly through the translations of his notes into English (none of that had been available to me since I didn't read French). Soon, most of his work was translated and I became very interested. Then I met him. […]

AH: *There is a very important European referential matter in your work: Picasso, Cézanne, Munch, Grünewald.… Also it is very cerebral, cultural, very European in that respect. Do you feel special affinities with Europeans? Have you ever felt the urge to live in Europe?*

JJ: Not at all. I wish I could speak another language, then I would be interested, but I have no facility, not even the nerve.

AH: *Language, words, are very important to you. […] Your work, without being literary, includes a lot of literary clues…. Have you ever felt the desire to write?*

JJ: Well…hasn't everyone? I have always thought that everybody would want to explain a feeling…. I haven't done it though.

AH: *So you've thought about it….*

JJ: Yes. Words are interesting. Painting isn't words, so you know that using words would mean making something else.

AH: *Is that why you so often include words in your paintings?*

JJ: I don't know…Maybe.

AH: *Apart from those you mention by name in your paintings, the American poets [Frank] O'Hara and [Hart] Crane, and then Céline and the English poet Tennyson for instance, are there writers that you particularly value?*

JJ: I can't say that I have any favorite. At different times, different aspects attract my attention. At one time I read a lot of Gertrude Stein. I'm a lazy reader and still have the Russians and most of Joyce ahead of me. It is only a few years ago that I first read *Moby Dick*.

AH: *Is there any literary work that you work with or go back to?*

JJ: Yes. Poets I go back to. Poetry is easy to look up. One forgets what a piece is like and wants to check and see! It is possible to do that in a relatively short time.

AH: *A little like looking at paintings?*

JJ: Yes…I guess it may have something to do with that.

AH: *What about Céline?*

JJ: At one point—I don't remember exactly when—I began to read Céline…. I was in some odd state of mind and it was the only writing I was able to concentrate on. There was something very special about the relationship between me and it at the time. There were *Journey to the End of Night* and *Death on the Installment Plan* and others whose titles I can't think of right now. But those two are the most astonishing. Something hallucinatory about them held my attention. I made my painting *Céline* then.

AH: *How did your collaboration with Beckett come about?*

JJ: […] I had imagined—well, one has no right to imagine what other people would do, but I had—that he would have a sentence or a part of a sentence, some really fragmentary structure that he would have saved. I had envisaged using these things as parts of the imagery so that they wouldn't have to present themselves as literature. Beckett said that he had such things in French and that he would translate them into English. Then I came here, to Saint Martin, for a long stay, and he began to send these pieces in English. Of course, they were not fragments in the way I had imagined them; they were very complete. Nevertheless, I continued to think that the images I would make would incorporate his texts. But, when I began to work on the etchings with Aldo Crommelynck in Paris, I thought it better to have the texts and images side by side.

AH: *You mentioned that you worked with Merce Cunningham in Paris: in what capacity?*

JJ: I did a stage design for Merce's *Un Jour ou deux* for the Paris Opéra Ballet. After Bob Rauschenberg stopped working with the Cunningham Company, I became "artistic advisor" for a few years. I didn't do much that was my own work, but I asked other artists to make designs and often I had to execute their ideas.

AH: *How did it feel, to execute what other people wanted? Relaxing?*

JJ: It was often very simple. Just hard work. For instance, I asked Bob Morris to do something, and he had an idea but no interest in doing it. So he told me what was to be done, and who else was there to do it except me? Another time, Bruce Nauman was asked to do a set and he said just to get ten or fifteen fans and put them along the stage to blow at the audience and have the dancers wear sweaters and leg-warmers. Well, that's fairly easy to say, then you have to dye the sweaters, color the leg-warmers—things like that.

AH: *When I asked you yesterday why you enjoyed so much making prints, you answered that, apart from the fact that it taught you things about your art, it was more social than painting, because it involved teamwork: did you feel that way about the theater too?*

JJ: No. I didn't feel that it was my work, and I didn't particularly enjoy it. I did it because I thought I might do it better, or less offensively, than would others who might be available. I soon realized the arrogance of my attitude.

AH: *Back to literature: have there been other projects similar to* Foirades/Fizzles *with other writers?*

JJ: I did one print with Frank O'Hara. At the time, we had planned to do a portfolio of images and poems, but somehow I never responded to the poems that Frank gave me, except that particular one. So the project never materialized and then he died. After his death a book of his poems was published by the MoMA and I did some drawings for it. I also did a frontispiece for a Wallace Stevens book a few years ago. I think that's all. To organize a book like *Foirades* is very difficult: keeping the scale right and getting the rhythm of everything moving through the book.

AH: *Are you interested in Andy Warhol's work?*

JJ: I am very interested to see the show the MoMA will do. I probably don't know a lot of his work. I enjoyed it. I have a painting of his, and some sculptures.

AH: *Did you know him?*

JJ: Not well, but I knew him. In the 1960s, everyone knew everyone else in the New York art world. I met him before he had his first show with Eleanor Ward. He did shoe illustrations for I. Miller ads, and they were very popular. On one occasion I had to help translate some of these into objects that could be used in a window display. I think I first met Andy when he bought a drawing of mine from a show at Leo Castelli. He introduced himself to me, and I told him that I knew his work—I meant his commercial work—and explained that I had been asked to do this job for I. Miller of making these objects based on

At his studio on East Houston Street, New York,
in June 1973. Photograph: Nancy Crampton.

At work on *Dancers on a Plane* (1980) at his studio
in Stony Point, New York, in c. 1980. Photograph:
Hans Namuth.

his drawing, at which point Andy exclaimed: "Why didn't they ask *me* to do it?" Later, Emile de Antonio took me to Andy's studio to see his paintings. I saw the earlier pieces made just before he began using silkscreens.

AH: *Were you struck by them? Did you see something radically new in them?*

JJ: Somehow I felt that something had been "omitted" from the pictures. I can't describe it better than that. It seemed to me that something was being done that left out things … and I didn't like it. Then, with the silkscreens, it seemed to me that he had solved what I didn't like about the other paintings: he had found a way of making a painting that in itself left out things, it was more complete, stronger.

AH: *What you say about this feeling of something missing in Warhol's work is all the more interesting, as a striking feature of your work, all along, is its extraordinary compactness. It seems that if anything were missing, it would be … just like the body … "wounded" … Do you see your paintings as bodies in space?*

JJ: I haven't had that thought but I realize that my paintings tend to be overly *picked at* with smaller and smaller divisions of fragments and I think it is something I can't help, it's not a choice or a decision; it's not a thing I would promote!

AH: *Your production is relatively small: is it because you devote a lot of time to each painting, or is it because you choose to do other things as well?*

JJ: I tend to devote a good deal of time to a painting, although much of it isn't actual working, it's trying to make myself do something to a painting. Sometimes I resist working on a picture even though I know one of the best ways to work is to begin to work. Working itself creates ideas and tells you what to do.

AH: *You don't have a finite idea of what you want to do before you start….*

JJ: No. Not usually. Maybe the general structure.

AH: *Do you draw on the canvas before you start painting?*

JJ: Occasionally. It depends on what has to be done. If it is to be a painting with divisions that have to be measured, then I draw them out with a pencil. But most often I work straight away in paint.

AH: *When do you decide that a painting is finished?*

JJ: I don't think you decide. Your energy just runs out. Probably because, at a certain point, if you continue to work on a picture, either you start making another one or you do things which are no longer of any importance to the picture you have. This is when you sense you must stop. If you go towards another picture, you may as well get another canvas.

AH: *Clement Greenberg quoted to me the old saying that it should take two to paint a painting—the painter, and someone to shoot him when he is through….*

JJ: I am sure that Clem was willing!

AH: *Why have you always used oil and encaustic?*

JJ: I have done two or three paintings in acrylic, but I don't like the colors in acrylic. […]

AH: *Do you find painting a pleasure, or is it a painful process at times?*

JJ: I am not sure. I don't think it is ... a pleasure. It is probably most pleasurable when you are in a state of quasi-unconsciousness, when you are just working automatically.

AH: *When are you in that state?*

JJ: When you are lucky!

AH: *Do you feel anxiety before you start, like the writer confronted with the blank sheet of paper?*

JJ: Often I do. I think that's an honest answer, even if it is not an attractive answer. I guess different things, anxiety mainly, keep you from acting. But sometimes acting dissolves the anxiety. As I was trying to say earlier, when one is hesitant about working, probably the best thing is to start and the work itself will change the state of affairs. However, knowing that doesn't mean that it is necessarily possible for you to do so. Then, when you are through with a painting, you have to start thinking about the next. I doubt that all people feel that way about painting, I hope not!

AH: *Do you always enjoy seeing a painting you have done years before, or do you feel like retouching it?*

JJ: Neither. Usually pictures have somehow so registered in my mind that when I see them, they look exactly the way they looked when I painted them. Occasionally, I have seen something that had some quality I had forgotten.

AH: *In which way do the places you work in influence your painting? On a regular basis, you work in at least two places: New York and Saint Martin....*

JJ: I don't think there is any great influence from a place, but to a certain extent, one is influenced by the space one works in, the kind of light ... and the noise. I imagine everything has its role.

AH: *Do you work here in Saint Martin as easily as in New York?*

JJ: When I am working well, I am working well wherever it is. And when I am working badly, I am working badly wherever it is! The main difference in New York is the constant interruptions and the turmoil of activity.

AH: *Where did you paint* The Seasons?

JJ: I painted one here, at least one: *Summer,* which was the first. And that was actually influenced by this place, because when I began the painting, I didn't even have in mind that I was going to do four paintings. In a certain way, *Summer* is connected to this place in terms of its imagery. It was definitely this house. The hummingbird was in *that* tree, things of that sort. Sometimes I take something unfinished and bring it to New York and vice versa. [...]

AH: *Why do you paint?*

JJ: Good heavens! ... OK.... What are my choices?

AH: *It seems to me, when I consider your work as a whole, that it is centered on what it means to be an artist. It is very autobiographical, it is apparently about looking for a place, physically, culturally, in the history of knowledge, a search to situate yourself as an artist...*

JJ: That is to say there is probably an infantile base to the activity, isn't it?

AH: *Let's say it's more introspective....*

JJ: Painting can be a conversation with oneself, and, at the same time, it can be a conversation with other paintings. What one does triggers thoughts of what others have done or might do—affects one's idea of what is possible. This introduces a degree of play between the possible and the necessary, which can allow one to learn from other artists' work that might seem otherwise unrelated or irrelevant.

AH: *When you use very specific cultural references in your work, do you let people take the time and trouble to find out or do you express it in another way?*

JJ: I think people come up with the question and I answer.

AH: *How do you feel about all the interpreting that has been offered of your work?*

JJ: I think it's overdone. It seems to me that something is made to be interesting in a way that it really isn't. I don't know what I would like them to do. You have to let them do their job. I don't want to become an art critic, so!

AH: *There are a lot of "riddles" in your painting, though.... For instance, how did the Grünewald reference come about?*

JJ: I am interested in the ways in which forms can shift their meanings. I had marveled at the Grünewald painting when I saw it in Colmar; and later, I was given a portfolio containing large-sized details from the work. Looking at these, I became interested in the linear divisions, the way the forms were articulated, and I began to make tracings of the configurations. It was a little like my work with the flag—the work one does with a given structure alters its character.

AH: *Do you think your work actually needs interpreting?*

JJ: I don't think so, but often it is interesting to talk about things, you can sometimes draw ideas from that. I am quite sure that occasionally I have read something that has given me ideas for future work.

AH: *Do you always keep works from each series you make?*

JJ: After my first exhibition, I just kept what was left. Later, I tried deliberately to keep things. I was making enough money that I could afford to do so.

AH: *Is it important to you where they go?*

JJ: Yes. In a sense, it probably has to do with how I grew up or my early experiences, but I favor the museum situation, because museums are meant for the public. It is not a matter of money or privilege, everyone has access. Pictures in that situation seem to me to have the possibility to function in an interesting way for the whole society. That seems to be changing at the moment. But I still have an idea that a museum has works that anyone can see, works that otherwise might not be available to the young and the poor.

AH: *How do you feel about the prices your works are reaching at the moment, at auctions for instance?*

JJ: Well, it makes one hesitant to speak when it becomes the prices rather than the paintings that are being discussed. Recently, entire collections which one assumed were destined for museums have instead been auctioned away. Does this mean that one has been naive, or does it indicate that the society and its relation to art and money are changing?

AH: *Do you think it affects your further work in any way?*

JJ: I can't see how it would not, but, also, I can't see how it would. I haven't imagined my "further work." I don't know what it will be. And there are always accidents along the way.

AH: *Do you personally feel you "owe" something to a society that's willing to pay so much for your work?*

JJ: To what degree is a society involved? Perhaps it is only an "aberrant" part, as it were. Indebted? I don't think so, but it's possible that such "rewards" suggest that one *ought* to be.

AH: *Do you collect other people's works?*

JJ: I wouldn't say collect, but, of course, I have works by other artists who became friends in the 1950s and '60s—[John] Chamberlain, Twombly, Rauschenberg, Stella, [Robert] Morris—a mixture of gifts, exchanges, purchases. And I have some drawings—Walter Murch, Terry Winters, de Kooning, [Saul] Steinberg, Fischl.

AH: *Are you interested in ceramics or just in George Ohr's?*

JJ: I think Ohr especially, but there is something interesting about such a primitive way of making forms, something touching in its fragility. It is all about labor and skill.

AH: *Are you interested in Picasso's ceramics?*

JJ: I don't like them.

AH: *Have you tried yourself?*

JJ: Not seriously. I've made a couple of things … of no interest. I don't know how to throw the clay, use the wheel.

AH: *Can you tell me about your relationship with your one dealer, Leo Castelli? It is a rather exceptional one.*

JJ: Leo and I were lucky to encounter one another when we did. Otherwise, I think things could have been different. […] I had lost most of my interest in the idea of showing when Leo appeared. He wasn't young and was beginning his gallery. We met more or less by chance; and when I showed him what I was doing, he expressed an enthusiastic curiosity about it and invited me to visit his gallery to see if I wanted to show there. I did.

AH: *Have you always, for thirty years, shown your latest work at Leo Castelli's first?*

JJ: Yes, I've rarely shown new work anywhere else. Leo negotiated two or three exhibitions of my work in France and Italy around 1959–60, and I instigated a couple of shows in Japan. I worked for a bit in Tokyo, and I've always been grateful for the early interest that Kuzuo Shimizu, who had the Minami Gallery there, and the critic Yoshiaki Tono showed in my work.

AH: *When you do have a show, in a museum or at the gallery, do you keep a close watch on the installation?*

JJ: At Leo's I always install my shows. In museums, it depends on how it is organized … they have their own thoughts.… If I am asked to participate, I do, but if I'm not … I only complain so much!

You know R. D. Laing's story about the child who demands that the psychologist stay in the room while he plays and apparently pays him no attention? I think painting is a little bit like that.

I-50. David Vaughan, "The Fabric of Friendship: Jasper Johns in Conversation with David Vaughan," in Susan Sontag, Richard Francis, Mark Rosenthal, Anne Seymour, David Sylvester, and David Vaughan, *Dancers on a Plane: Cage, Cunningham, Johns* (New York: Alfred A. Knopf, with Anthony d'Offay Gallery, London, 1990), pp. 137–42. Interview conducted in August 1989.

JJ: It's hard to reconstruct the past without lying… I first saw Merce dance at a performance, probably at the Brooklyn Academy of Music, early in 1954; they did the piece with music by [Louis Moreau] Gottschalk, *Banjo*, which gave me a great deal of pleasure. I hadn't gone to his first New York season at the Theatre de Lys at the end of 1953. I had heard about Merce, but I didn't go, I don't know why.

I had met Bob Rauschenberg, but I don't know that I had met John Cage or Merce. I never went to Black Mountain College—I had heard about it, but I didn't really know anything about it. Then I met these people who had all been there; there was a sort of community, maybe a dozen or so people in New York, who had been to Black Mountain.

I met John after one or two concerts of contemporary American and European music that he had arranged, somewhere on 57th Street; I think I met him at Sari Dienes's after one performance. David Tudor played in the concert, I believe. I met Merce shortly after that, I think, but I don't remember where.

When I started helping Rauschenberg with sets and costumes for Merce, I didn't think that I was doing it for Merce; I was helping Bob. The first piece Bob did was *Minutiae* and I helped him find a way to make the set stand up, that was all. I was close to Bob's working situation during those years and certainly offered my opinion about anything I happened to see, and frequently helped him dyeing tights—work on that level, whatever there was to be done.

I wasn't around Merce's company very much—I never went on any of the company's tours in the Volkswagen bus. They were happening, and I heard a lot about them, but I didn't go on them. I went up to Rockland County when that performance happened (October 1955) when there was a storm, and Franz Kline stole the liquor. Some of the local people gave a party for all these artists who had come up from New York to attend the performance, and Franz Kline walked away with the liquor supply.

Later I went to New London when something was done there (at the American Dance Festival, Connecticut College School of the Dance). I helped with painting the set for *Summerspace*, and the costumes for *Antic Meet* (both in 1958). Then there was the dance *Rune* (1959) where they wore fur collars—Bob's response to a suggestion from Merce that the costumes should have something to do with animals. John and Merce had a house while the company lived, I think, in dormitories; and I was staying in the house. John used to go looking for mushrooms and other wild things to eat, and I learned much of what I know about such things from him.

People say now that everything worked so well then, but I'm not sure that one

thought that at the time. Everything had a sense of novelty and of invention, in all the different aspects of the work. It was new and being invented at the same time—there were deadlines and necessities, and everyone knew that money was limited.

Bob, Emile de Antonio, and I decided to produce a twenty-five-year retrospective concert of Cage's music at Town Hall in 1958. We were happy that John allowed it. It wasn't often that one could hear an entire program of Cage, and the earlier pieces usually were not presented. New work took precedence over old. We were happy with the experience, and I suppose that led the three of us to organize a concert of Merce and his dancers at the Phoenix Theater on Second Avenue in 1960. We had the idea to do it, and we made all the arrangements, dealt with the problem of getting a theater, covering the cost of it, and ensuring that there was an audience. In those days, the Cunningham Company usually performed outside of or on the edges of Manhattan, often in the context of a dance series, or something of that kind. I think we had a strong sense that Merce was a force that should be seen more independently, that the meaning of his work should extend beyond just the devoted dance audience which kept up with such things.

Of course, painters were a large and important part of Merce's audience. The music was one of the strong attractions for them. I thought of John as a sort of teacher/preacher/soldier. His curiosity seemed wide-ranging and athletic, and he was able to connect his work to other fields of thought—to nature, philosophy, science, and whatnot. He was generous in his willingness to explain these connections, and seemed happy to convince others of the usefulness of his ideas. At some point he began to teach at the New School and younger artists attended his classes. I think many of us felt that ideas in one medium could trigger ideas in another medium—and that media could be mixed in new ways.

We began to see some of the Happenings. The first thing of that kind that I saw—though others might not think it *was* of that kind—was Red Grooms's *The Burning Building* in 1959, performed in a loft on Delancey Street, which Red called a Museum. Cage seemed to find it overly expressionistic, but I liked it a lot. There seemed to be a kind of catching fire of this idea of performance, led, I guess, by Claes Oldenburg and Allan Kaprow and Jim Dine—I think they were the main people at that time. I was never involved in Happenings, or only in the most modest way. Once, in 1959, Kaprow picked Bob Rauschenberg and me from his audience and asked that we work on opposite sides of a suspended piece of muslin. One of us was told to paint circles and the other straight lines. With a brush, I nervously drew unsteady verticals on my side of the cloth and, as Bob's circles bled through the material, I was again impressed by his brilliance. He, having discarded his brush, simply dipped the top of a jar into paint and then printed it onto the fabric.

Merce wanted to do a Broadway season—but, even anticipating large audiences, there would be a loss that would have seemed staggering at that time but would seem more modest now, maybe of twenty or twenty-five thousand dollars over the week or two weeks or whatever it was. A group of artists offered to give

works to be sold to raise money to cover this loss—Bob, me, Richard Lippold, are three I remember. At any rate, the donated works were going to produce more money than was needed, and I approached Merce and asked him what we should do with the excess. Merce said, "Everyone is in the same boat that I'm in, so why don't you use it to help other dancers?" That seemed a good idea, until one realized that what was left was hardly anything and wouldn't help many people very much. So we decided to ask a larger number of artists to contribute works to be sold to increase the fund. The artists were generous, and we had a rather large and nice exhibition at the Allan Stone Gallery. That was how the Foundation for Contemporary Performance Arts began.[16] And the funny thing is that the Cunningham season never materialized. I don't know what happened, I think there was a problem with the theater or something, I've forgotten.

Later the foundation did help with the Cunningham world tour in 1964, and has gone on to help many artists—dancers, musicians, poets, etc.—and umbrella groups. It is still supported by visual artists—American, European, and Oriental—and owes its continuing existence to their support. Of the original Directors, only John and I are on the current board.

You say that I made some costumes for a piece Merce did for Canadian television in the early '60s, but I don't remember anything about it—I probably just dyed some tights and leotards. That was often my approach—to do nothing, basically. I wasn't asked to be Artistic Adviser to the Company until 1967, and I was reluctant. In the theater, there is something about the setting up and taking down of things that I dislike. But when I thought of the people who might be available to do the work that I was being invited to do, I decided I might do it in ways that would offend me less when I went to see the performance. It was a poor way to make a decision, an arrogant way, but that was my feeling.

The first artist I got to do a set was Frank Stella. Actually, I think that Frank had mentioned to me that he would like to do a set for Merce; and, when the choreography for *Scramble* was begun, a model was made from Frank's idea, and Merce thought that it would work. After that, I usually suggested an artist and Merce would respond. If he thought the artist unsuitable, he would say, "Perhaps later."

When I approached Warhol to say that Merce would like him to design the decor for *RainForest*, Andy said, "Oh, just take a lot of those [silver] pillows." And I said, "What about costumes?" and he said, "Oh, they shouldn't wear any clothes." And I said, "I don't think that idea would work with Merce," and he said, "Oh." But he didn't suggest any other idea. And when the subject of the costumes came up with Merce, he brought this garment that I think he had been wearing when he practiced and tying knots in it as it got torn, and he said "I think something like this might be all right." So I imitated the thing he had brought me, cutting into the garments and tying knots. [...]

Is Merce's work emotion-packed? Well, everything is emotion-packed. Emotion is rarely the subject of his work, but it does seem to be a source of the work. It prompts the movement, qualifies the time, colors the kinds of space the dances offer. I always felt this, but maybe the feeling is intensified by the memory

of old experiences from the time when I felt there was only the present tense.

Now, of course, the three of us see less of one another than we once did—at one time John and I lived on opposite sides of a creek [in Stony Point, New York] and could almost yell at one another, if we wanted. The nature of our work has created different obligations for each of us, and it seems to me that the pull of professional responsibilities, and social changes brought about by those responsibilities, change the fabric of friendship.

I-51. Dodie Kazanjian, "Cube Roots," *Vogue* (New York) no. 179 (September 1989): 729. Published on the occasion of the exhibition "Picasso and Braque: Pioneering Cubism," at The Museum of Modern Art, New York.

[…] Does Cubism still seem the most important art movement of the twentieth century? […] Here, from […] some contemporary artists and critics, are thoughts about Cubism and its relevance today.

JJ: I suppose Cubism is one of the two great "isms" for people of my generation. The other is Surrealism, of course. Cubism and Surrealism were strong indicators of directions that one might move in. They were liberating, and in a way instructive. Not only did they free you, they made certain kinds of rules apparent.

As for my relationship with Bob Rauschenberg's being similar to Picasso and [Georges] Braque's, I really don't like this comparison. I think it's inappropriate. We were never working on the same idea. When Braque and Picasso worked, they were working on one idea they were trying to develop. (We'll see whether this is true in the show.) When they worked, they gave birth to a style. Bob and I certainly didn't. I don't think our work makes a style. It doesn't have the single-mindedness. But there was, I believe, a perfectly free and open exchange of thoughts about one another's work, with no feelings disguised and no idea that we might not understand the other's work more or less completely.

Perhaps it was very rare for two artists to exchange ideas in such a close fashion. I don't know. Sometimes I think it must be almost necessary. But at any rate, we came into a kind of public prominence together, so perhaps that kind of comparison just was natural. It's true that I painted a Rauschenberg. Actually, I made two Rauschenbergs. I made the gold-leaf painting and I made a later-period Rauschenberg, because I thought I understood them so well that I could make them. But they were missing something. So they were turned over to Bob, who completed them. I believe they were both sold, as Rauschenbergs.

I-52. *Jasper Johns: Take an Object. A Portrait: 1972–1990*, 1990, 26-minute film in color, 16 mm. Directed by Hans Namuth and Judith Wechsler. Produced by Hans Namuth and Judith Wechsler, Inc.

[Shows Johns in his Houston Street studio in 1971, working on Map (Based on Buckminster Fuller's Dymaxion Air Ocean World). *He later discusses his collaboration with Beckett, on the book* Foirades/Fizzles, *and his painting series* The Seasons.

Working at Gemini G.E.L., Los Angeles,
in 1976. Photograph: Sidney Felsen.

He is also shown at work on an etching of The Seasons *at ULAE in December 1989. The film also includes readings of Johns's words by John Cage, Mark Rosenthal, and Christopher Ricks (who reads from Beckett's text for* Foirades/Fizzles*), and their comments on Johns. —Ed.]*

[…] *[Johns working on an etching of* The Seasons *at ULAE in December 1989]:* These etchings are more or less renderings of four paintings that I made. Why did I decide to do it black and white? I think because … this kind of work is rendering, in a sense, the paintings that already existed. Much of the work to accomplish these is imitative of something that already existed. And I thought that I could use those plates and do something a little freer and a little more disconnected to the paintings, I suppose; independent of the painting.

When I started thinking about this, I thought, what would I do if I were going to make another thing out of these plates? And I thought, well the next thing would be to overlap them since that hasn't happened so far. So, I tried to think of how to cut them up and the only thoughts I had were the cross or a fan shape. I decided to do the cross. And then I thought, from my point of view, it was more interesting to do that than just to cancel the plates. […]

I-53. Jo Ann Lewis, "Jasper Johns, Personally Speaking," *The Washington Post*, May 16, 1990, pp. F1, F6. Published on the occasion of the exhibition "The Drawings of Jasper Johns," at the National Gallery of Art, Washington, D.C. Interview conducted in Johns's house on East 63rd Street, New York.

[…] *Wherever he is—Saint Martin, Manhattan, at his country house at Stony Point on the Hudson—Johns has one objective.* "I work on everything everywhere," *he says.* "My studios are set up pretty much identically, the three of them, so they have the same possibilities.

"That's the way I learned to work. When I was young, I never formed good working habits, and had to paint or draw in spare moments. So everything gains the same importance—swimming, gardening, painting, cooking."

A balanced life? "Not particularly," *says Johns.* "Juggling fragments." *[…]*

[…] *Johns turned sixty yesterday, although the National Gallery, at Johns's request, made no mention of the occasion as it celebrated the exhibition's opening with a dinner filled with friends and art-world luminaries.* "I never celebrate my birthday, I'm sorry it ever entered anyone's mind," *says Johns, filling two proper china cups and settling down at a round kitchen table overlooking the courtyard.*

"I do remember being six, and having a party in my grandfather's garden, behind the house," *recalls Johns, who rarely speaks of his childhood.* "After the cake and things, we all went to the movies," *where children under six were admitted free.* "For the first time, I got to pay," *he says, sticking out his chin in mock-childish pride.* "Lots of guests couldn't."

Born in Augusta, Georgia, young Johns was sent, after his parents divorced, to live with his grandfather, W. I. Johns, a South Carolina farmer, and his wife, who had the unusual first name of Montez.

"I remember my grandfather used to talk about how wonderful the corn looked, or the cotton, and I couldn't tell what he was talking about: they were only that tall," *says Johns, marking off two inches of air with his thumb and forefinger.* "They looked all the same to me."

Childhood memories, in fact, seem to be much with Johns these days, though he keeps boxing with the fact that his art has become more personal and autobiographical. "Of course it's about me," *he says, though that question has not been asked.* "But it's not a *story* about me, for heaven's sake!"

A new painting hanging in his studio suggests otherwise. [It is] titled Montez Singing *[…]*

[…] considering his childhood odyssey, it was not surprising to learn the history of Johns's rather disreputable-looking black-and-white collie mutt. "She's a dog from the pound," *he explained.* "Her name," *said Johns,* "is spelled either 'Bina' or 'Binah'— I don't know which. There's a folk song," *he said, and recited it in sing-song:* "'My name is JoBinah, from South Carolina, and I'm sellin' kindlin' wood to get along.' That's where I got the name."

[…] Johns recalls no training in art prior to his last year in high school, when he took one course, half mechanical drawing, half art. According to his sister, Owen Lee, he was encouraged by a teacher who thought he was the greatest artist she'd ever come across.

"I think most artists are self-taught," *says Johns.* "If you have the necessity, you quickly learn. I couldn't sit down and make a conventional drawing, I couldn't. Maybe if I felt I needed to do it, I'd learn how."

[…] "[Being an artist] requires an exchange of ideas, and information about other art and other people and an opportunity to interact." *[…]*

Johns has wisely held back many of his works over the years, hoping to form what he calls "a comprehensive picture, a good indication of my work."

As a result, what Johns will ultimately do with his collection is a subject of much discussion in museums around the world.

"I have a plan," *says Johns,* "but it could change. The art world could change." *[…]*

Castelli first met Johns during a visit to the studio of Robert Rauschenberg, who lived downstairs from Johns. The two artists shared a refrigerator.

Would Castelli have found him if Rauschenberg hadn't needed ice, and made the introduction after Castelli remembered being bowled over by one of Johns's Target paintings he'd seen somewhere? "I don't know. I don't know," *says Johns.* "It has a wonderful aspect of charm and fate and surprise, doesn't it? I simply don't know."

His sudden success, says Johns, "had to do with the time: coincidences, timing, changes in the atmosphere. There was already a second generation of Abstract Expressionists, but I didn't know them and they didn't know me. I worked for what seemed to me like a long time on my own, and Leo opened a gallery.

"All the coming together of these new elements was very important. And I think that my showing with Leo made it more interesting than it would have

seemed at another gallery. He made the impression that something was being made new, which it was, and that atmosphere gave it a freshness.

"Robert Rauschenberg has been the most important to me and my thought," *says Johns,* "particularly at that time. We were very close, and saw each other on a daily basis, to the exclusion of most other society. Cage, too, is a person of many ideas, and of missionary mind, bringing the word. And Merce Cunningham's work. Those are the essential people."

[...] [His house contains small artworks such as] a windowsill-full of treasured, naughty objects by Marcel Duchamp, a model mind for Johns; [and] large ones, like John Chamberlain's crushed metal sculpture. Two Heinz ketchup boxes by Andy Warhol serve as end tables.

"I don't pursue it in an orderly manner," *says Johns of his eclectic collecting, but he has sought out several pots by George Ohr. In the entranceway a large drawing of romping bathers by Eric Fischl hangs not far from a "Fish" lamp by architect Frank Gehry. A small painting of the head of a man asleep, by Lucian Freud, hangs nearby.*

Oddly, there is very little of Johns's own work around apart from the occasional map drawing or sculpted light bulb. There is, however, one luscious triptych titled Usuyuki *(which means "light snowfall") hanging by the kitchen window.* "It is the one, the original one, the first," *says Johns of this well-known series.* "All the others are just variations of that."

Johns has a short list of things he'd like to do, but hasn't done: "I'd like to travel," *he says, but he apparently hates doing it.*

"I've seen very little of the world," *says Johns, who had been to Italy only once when he went to the 1988 Biennale, but had never been to Venice before.*

There, he didn't even stay long enough to pick up his grand prize—the famed "Golden Lion," which had to be sent. Asked if he had it, Johns hadn't the slightest idea, but summoned his studio assistant, and a few minutes later he set the gilded object out on a table in the courtyard.

"That's the first time it's seen the light of day," *chuckled Johns.* "There he is. Quite a sight."

Johns is asked which, of all these treasures, he'd grab first if an emergency arose.

"Me," *he squealed, without hesitation, hugging himself.* "I'd grab me!"

I-54. Paul Clements, "The Artist Speaks," *Museum & Arts Washington* **6 no. 3 (May–June 1990): 76–81, 116–17. Published on the occasion of the exhibition "The Drawings of Jasper Johns," at the National Gallery of Art, Washington, D.C. Interview conducted in Johns's house on East 63rd Street, New York.**

[...] In 1978 Johns said of [his childhood], "It wasn't specially cheerful," *adding,* "Everything I do is attached to my childhood." *[...]*

In the '80s Johns began lifting art images for use in his own works. His generation felt the burden of art history and consequently denied itself the option of speaking in a great expressive language of great things. Today he refuses to discuss the similarities of and differences between his work and that of artists who emerged in the '70s and '80s

and also use appropriation. "One tends not to confuse oneself with someone else. I don't think I can analyze my work. What I like to do is to make work." [...]

Despite its intellectual aspect, Johns says, "A large part of the work is in the materials, in playing with the materials. Any idea that precedes the work is liable to change. The work is always different from the idea. The image is preestablished, but the realization of a work as a physical object shifts the meaning of it."

Surely, though, Johns knows from the start what he is setting out to do. "On the contrary," *he says, almost playfully.* "I don't have a preconception of the situation. It may be something I arrive at." [...]

"A drawing has a thinness that a painting doesn't have," *Johns says, explaining that no matter how much graphite is layered on paper, the work is still texturally thin. In light of the way his drawings tend to streamline the ideas of his paintings, does he mean "thinness" in an almost metaphoric sense?*

"I mean what I say," *he says, polite but insistent.* "It creates a difference in one's perspective. It doesn't have the same possibilities *[as painting]*."

[...] *Johns's largest drawing, the rarely exhibited charcoal and pastel* Diver *(1963), [...] is linked to Johns's works of the same period that make reference to poet Hart Crane, who leaped to his death from the stern of a ship in 1932. Johns has said the drawing has* "an ambiguous quality that can suggest either life or death." [...]

Says [Nan] Rosenthal [cocurator of "The Drawings of Jasper Johns"], "[...] I think around the time Johns made [the drawing Liar, *1961] he was very interested in relationships between the viewer and the object: what role does the interpreter play in establishing the meaning of a work?"*

But Johns says, "I don't think I think of the viewer. I just make the pictures."

And who is Liar *pointed at?* "I won't tell." [...]

Johns downplays assertions that the images are a means to express tragic issues. "Images continue to interest me," *he says.* "One creates a new image in any case. The thing that happens is that one deals with the experiences one has, and often things are used because one saw an image that one might not have thought about otherwise."

He started using the Grünewald image [from Matthias Grünewald's Isenheim Altarpiece, c. 1512–16], he says, when a stranger sent him a portfolio reproduction of the work, which now hangs from his studio ceiling. "I thought I should give this person something. I traced a number of these details, and sent a tracing to him. Some of these details seemed more interesting to me than others. Things like that happened in a natural way."

Johns's most recent work is airier and less claustrophobic than The Seasons. *With its warm colors, ambiguous anthropomorphism, and trompe l'oeil nails and shadows, it makes overt reference both to art history and to the artist's childhood. He describes the works as* "infantile—images of faces where features seem to float about. One tends to associate it with Picasso-esque distortion. So there's a conflation of infantile and adult, if you rank Picasso as an adult," *he laughs.*

On the eve of his sixtieth birthday, Johns says he is not ready for a break, a stoppage. "There are periods where I find it very difficult to work," *he concedes, and*

"frivolously, one considers stopping when one can't work." *But it is not time to make the choice to stop.* "You mean go into retirement, like a businessman?" *he asks with more than a hint of distaste.*

Is it imaginable? "I can imagine," *he says.* "I'm very good at imagining." *Reminded that other artists have retired, he says,* "I think it's a perfectly valid thing to do. But the thinking-to-do and the doing-it would have to happen at the same time."

Before a 1977 retrospective at the Whitney, Johns told an interviewer he expected it would tell him something about himself. Does he think the [National Gallery of Art] drawing show will raise any questions? "I don't really think so, but who knows? Mostly, work is registered so clearly in one's mind that it looks as it did 100 years ago…. There are rarely any surprises. Some disappointments." *[…]*

I-55. Paul Taylor, "Jasper Johns," *Interview* 20 no. 7 (July 1990): 96–100, 122–23. Published on the occasion of the exhibition "The Drawings of Jasper Johns," at the National Gallery of Art, Washington, D.C.

PT: *It has been said that the American flag in your paintings is a stand-in for yourself.*

JJ: Hm?

PT: *People have said that the flag, in your early paintings, represents you. Is that true? Is that how you used the flag?*

JJ: I haven't said that. Is that what you're saying?

PT: *No, but it has been said about you.*

JJ: Well, a lot of things have been said about me.

PT: *Nevertheless, I wonder if you think it's true.*

JJ: Do we have to go through this about everything that's been said? Do you think something's true just because it's been said?

PT: *No, but I would wonder whether this thing is true even if it had never been said.*

JJ: That the flag is a stand-in for me?

PT: *Yes.*

JJ: Where?

PT: *In your paintings.*

JJ: In my paintings? I don't believe so. The only thing I can think is that in Savannah, Georgia, in a park, there is a statue of Sergeant William Jasper. Once I was walking through this park with my father, and he said that we were named for him. Whether that is in fact true or not, I don't know. Sergeant Jasper lost his life raising the American flag over a fort. But according to this story, the flag could just as well be a stand-in for my father as for me. *[…]*

PT: *Jasper, you're renowned as being an inaccessible, even secretive person […] Perhaps it's no coincidence that the ideas in your work are hidden and that many of your motifs, such as flags and targets, are interpreted as masks. While there are clues everywhere, you seem to be playing a game of hide-and-seek with your viewers. Are you deliberately cagey?*

JJ: I don't think of myself in that way. In terms of work, it interests me to play

with aspects of images that become more or less available as you look. I'm interested in how changing aspects of the images can affect your recognition and your response to them.

PT: *The catalogues of your work in the last few years, those produced for your shows at Venice, the Walker Art Center, and now in Washington, D.C., exhibit a great deal of effort on the part of the curators to decipher your images and to trace the passages of your motifs from work to work. Everybody who writes about your work seems to have to look for clues and to hunt around.*

JJ: I think that people do that because then they can say that they see something that is difficult to see, and that gives them something interesting to write about.

PT: *But often the recurring motifs in your work are so hidden that they are unnoticed until someone points them out.*

JJ: That's true, but that's true everywhere in life, isn't it?

PT: *The hidden motifs in your work these days seem to be in marked contrast to your paintings of flags.*

JJ: No, they aren't. In all cases, the outlines of particular forms are followed rather faithfully, but not entirely faithfully, and filled in with some variation of color and texture.

PT: *But the blatantness of your early imagery is gone. I mean, there's no mistaking a flag. It's a nice, big, recognizable image.*

JJ: In some of the paintings, but not in all. One of my largest paintings is a flag. It's painted in whites, and probably yellows by now, and I remember having it in my studio when somebody—I've forgotten who it was, I don't think it was someone involved with art, except perhaps a mover or someone like that who had come to move something—simply went up to my painting and leaned against it. He saw it as the wall—it was hanging on a white brick wall. The flag images exist at different levels of recognizability. Some are in red, white, and blue and are easy to see. There's a gray one that I think is difficult to determine as a flag. But once you know the flag is something that I'm involved with, then you have clues to let you know what it is. That interests me—the degree to which what we know affects what we see. I'm also interested in how the eye and the mind work, because as we look from painting to painting we see the next painting differently, according to what we've seen before, probably.

PT: *Do you think an artist has only a few ideas?*

JJ: I think there are some limiting factors. It depends on what you consider an idea. An artist can have many ideas, but usually there's something that connects them, or limits how far apart they can fly. An artist probably has a particular energy that needs to be explored, some kind of central force. And anything he does connects to that in some way, so that many ideas somehow simplify into a larger idea, or a different idea, which means that you're able to connect different thoughts to one kind of thought. Then you realize that that's that artist.

PT: *In your case, do you think you have only a few ideas?*

JJ: I often think that I have many ideas. But then, when I look at things, I'm able to make connections, and then I think, Well, I don't have many ideas at all. I went down to Washington yesterday to look at the drawing show, and I saw that it's been organized in a kind of thematic way. The connections that can be made among various images have been exaggerated. If there are two of this and two of that and two of that, then they put all the twos together so that you see the "two-ness" of these different things, which wasn't an idea of mine necessarily. But it's there.

PT: *Do you believe in genius?*

JJ: Hm?

PT: *Do you believe in genius among artists?*

JJ: Well, one uses it as a way to express one's delight and amazement about certain work.

PT: *Is genius in society rather than in individuals?*

JJ: Well, that's a question that's interesting. It's about parts and wholes, and how they function. If genius is in the whole, then it's probably also in the part, don't you think?

PT: *You've said that you're not very good at drawing, that you "can't draw." So why are you so interested in drawing?*

JJ: Why am I so interested in it?

PT: *In the current drawing retrospective, there are over a hundred works. Is the meaning of a drawing very different from that of a painting?*

JJ: Yes, but I don't know exactly how much. Sometimes drawing can be a way to establish an idea. Sometimes it can be a way to quickly alter an idea, or to do something without giving it, say, the same weight that it would have in painting. Often it can be a question of speed or lightness or thinness, quickness. And it can be an entertainment, practice, relaxation. It can be all those things, whereas painting tends to be more weighty.

PT: *With the exception of a few works, including* Diver, *your drawings are made after your paintings of the same motifs are done.*

JJ: *Diver* started as a way to figure out a diagram for the painting, but then it was finished later as a kind of drawing.

PT: *Of course, most artists draw motifs before they paint them.*

JJ: That's one of the reasons I don't think I draw very well; drawing is not very natural to me.

PT: *Is this connected to the fact that you choose motifs, such as a flag, that have predetermined designs?*

JJ: Perhaps.

PT: *How do you feel when you see your works in reproduction?*

JJ: I often like them.

PT: *You've made black-and-white paintings, too. Of course, black-and-white is not to be found in nature—it's an effect of photography and printing processes. Is painting in black and white a reference to these intermediary processes?*

With Yoshiaki Tono in August 1978, when
Johns was in Tokyo to attend the opening of
his traveling retrospective at the Seibu (now
Sezon) Museum of Art, Tokyo. Photograph:
Shigeo Anzai.

JJ: I wonder. I wonder if black-and-white comes about because of photography, or because of drawing. Obviously it preceded photography, but I'm trying to think whether it did in painting or not. I don't know.

PT: *Well, now it's incredibly common.*

JJ: Yes, of course.

PT: *Is this connected to the spread of the media, particularly magazines, newspapers, movies, and television?*

JJ: You may be right.

PT: *Given the range of color in painting, it seems an arch, ironic thing to make black-and-white paintings, as you have done. Were you aware of the degree to which other media were influencing painting as an art form?*

JJ: I doubt that there was that awareness. I imagine it was something more subjective than that, but I don't really remember.

PT: *Did you imagine seeing those works in reproduction as you were making them?*

JJ: No.

PT: *Do they lose anything in reproduction?*

JJ: They probably lose and probably gain, both.

PT: *Does it ever inspire you to see one of your works in reproduction?*

JJ: I don't really think so. I'm trying to remember. Certainly early on, when my work first appeared in reproduction, I was probably interested to see it represented in a different scale. And I know I made a couple of paintings on top of those reproductions.

PT: *Have you ever made works expressly for reproduction? I don't mean editions of prints, but works designed for endless reproduction.*

JJ: No.

PT: *What about photographs?*

JJ: No. I've probably taken a dozen photographs in my life.

PT: *That's odd, isn't it?*

JJ: I don't like looking through the thing.

PT: *The so-called "viewfinder"?*

JJ: Yeah. I enjoy certain photographs, but I don't keep up with photography. I have acquired a few photographs. I have that portfolio that Diane Arbus did. I have a couple of Walker Evans photographs, and photographs of Jackson Pollock by Hans Namuth. That's about it.

PT: *You have rarely quoted directly from photographs in your work. There is, of course, the photo of Leo Castelli that appeared in* Racing Thoughts. *But I imagine that there are very few other quotations from photographs, if any at all.*

JJ: Well, I've used a few silkscreened images of my own work, of objects. But they're not art photographs, if that's what you mean. There's also a lot of collage material in my paintings where you can see newspaper photographs. But they don't tend to register as separate images.

PT: *Who took that photo of Leo?*

JJ: I think he did. I can't remember the story, but he told me that he had taken it. Apparently someone in the gallery came across it years ago, and I don't know

whether he gave it to all the artists in the gallery, or whether the person only gave me this object. But he blew it up and had a jigsaw puzzle made out of it. And that's the way I used it.

PT: *Last year you painted another one of your early map paintings. Why?*

JJ: I made another one, yes, because I was working on one that had been damaged. I don't know what had happened to it, but it had a lot of damage. It looked like it had been soaked in water for a long time. I was doing the restoration, and I said—just casually—that it would be easier to repaint this than to restore it. Then I started thinking about that, and I wondered, Well, would it be? So I decided to try it, and made another one. Also, I remembered something that Ad Reinhardt once said about a painting of his that belonged to The Museum of Modern Art and had been damaged, I think, by someone cleaning the floor or something. Something had splashed on it. It was one of those very dark paintings with—

PT: *Black on black?*

JJ: Yeah. Alfred Barr had asked him to repair the painting. And Ad said he had told Mr. Barr that it would be easier to repaint it. I don't know whether he kept his paints mixed or what, but you can see with that kind of surface that it would probably be difficult to go in and do something without its being noticed. It might be easier just to take a new canvas and repaint the forms. But Alfred Barr was insistent that he wanted the same painting back. He didn't want another painting. I thought that was an interesting idea.

PT: *Was it difficult to repaint it—I mean, to paint another one?*

JJ: No, it wasn't difficult. It was rather easy. It has a different quality, of course, because the way I apply paint changes over time.

PT: *Have you ever repainted an image like this before?*

JJ: Well, I've repeated many images over the years. Many people think that that's what I do all the time.

PT: *Were you posing a philosophical question to yourself by making that work again?*

JJ: I think I was simply replying to my idea that it would be easier, and wondering whether it would be easier.

PT: *What do you think of the differences between the new finished work and the old finished work?*

JJ: Well, I didn't get to compare the works, because I didn't have them together.

PT: *Do you think the new work, having been completed, changes the old work?*

JJ: No. I don't see why it would.

PT: *It makes it more like two of a kind, rather than one of a kind.*

JJ: Well, they're very different. Many people would think that all of my paintings are of one kind. It just depends on the way you see things, I guess.

PT: *What about Andy Warhol? Do you want to talk about him?*

JJ: I don't know what I can say about Andy.

PT: *I believe there was some reciprocity between both of your work in the '60s. At that point he had obviously been influenced by you. But you also made a reference to him in a piece of yours. You used one of his screens.*

JJ: I don't know what I had in mind. Andy gave me a screen which said—God, I've forgotten what it says—something like "Fragile Glass." It must have been something that he used in his paintings that he had left over. And I used it in my painting *Arrive/Depart*. I think it was the first screen that I used. After that I had screens made of my own to use. I always meant to make Andy a present using his screen, and I began, but I never finished.

PT: *Why did you use his screen?*

JJ: Because I knew he had them. I didn't know how you got them made or anything at that time, and I wanted to experiment with them.

PT: *Was it in any way a tribute to him or his way of making pictures?*

JJ: Well, not deliberately a tribute, but he was the person who came to mind to ask. It's a tribute in that he's the source. It wasn't meant as a tribute.

PT: *His book* POPism *describes his initial meetings with you. He mentions a kind of chilliness toward him, and that you thought he was swish.*

JJ: I haven't read the book, so I can't reply to that.

PT: *I think he said that both you and Rauschenberg thought he was "a swish."*

JJ: I would like to see that, to see if he said it or if he said someone else said it.

PT: *Perhaps there was an intermediary person that reported it to him.*

JJ: That's what I think.

PT: *Who do you think it was?*

JJ: A mutual friend. Initially I met Andy [when] […] Bob Rauschenberg and I were working together [on department-store-window displays], and one of the jobs that we had gotten was to interpret some of Andy's shoe drawings in a kind of three-dimensional window display. […]

PT: *So you were interpreting his commercial work commercially at the same time that he was interpreting your art work artistically?*

JJ: I don't know where he was with his own work at this point, because I didn't see his paintings until later. But at that time he had a kind of audience for his commercial work. It was considered very interesting by a lot of people. People would talk about him, and they would say that Andy would draw the lines and someone else would blot them, and then it all came out in the Sunday papers, in these ads. And certain people enjoyed them. I think the first person I heard talking about them was Cynthia Feldman, who was married to the composer Morton Feldman. […] Then at some point after that I was taken to Andy's studio. […] I don't think he had begun to use the screens at that point. There were things like the painting of the cosmetic operation on the nose. That's the time at which I first saw his paintings. Now, what am I coming to?

PT: *You were getting around to the "swish" word, I think.*

JJ: No, I'm not. I'm not getting around to that at all.

PT: *So what did you really think of him?*

JJ: What I think is, I don't think that was a proper statement. And I don't believe it's Andy's.

PT: *You mean you don't think he actually believed it.*

JJ: Well, I hope he didn't. I didn't care for the … I don't know what you'd call it …

all of the entertainment-world aspect of Andy. I didn't really like that. I liked a lot of his work, and still do. But there was something exaggerated about the theatrical aspect.

PT: *What are your favorite works of his?*

JJ: Oh, the ones I have are probably the ones I really like most. I have a Marilyn and a group of the sculptures.

PT: *Did he influence you?*

JJ: Well, it depends on what you mean. Everything influences me. I don't know how to respond to that one. I can't say he influenced me in this way or that. I've looked at an awful lot of Andy Warhol, and usually you don't look at things if you're not getting something out of them.

PT: *Warhol in the last years of his life, and Roy Lichtenstein in his murals, and you in your recent series* The Seasons, *have anthologized images that you used in the previous thirty years of your work. There are quotations from the '50s through to the '80s in these three different bodies of work, and I wonder what it means. It's interesting that the three of you did it at roughly the same time, during the 1980s.*

JJ: Well, those four paintings of mine, *The Seasons,* were concerned with places and properties, so that I see the use of my earlier motifs as having to do with the subject matter of the paintings. They contain numerous images that relate to things that are around me. So in a sense they represent, largely, possessions. Each painting relates to a studio where I was working. And I was moving. I had just moved into a studio in the Caribbean. And I had moved back into town from the country, and then I was moving another studio from downtown to uptown. I was doing a lot of shifting of things from place to place. So I had the idea to do the four paintings. It began with one painting, and it was just going to be one painting, *Summer.* And then I saw that I could do this other thing and made four paintings. Once you commission yourself to do something like that, then you have to execute it, and you have to draw on whatever you can find that's useful for accomplishing the work.

PT: *In these works you embarked on a narrative series for the first time. Up to that point your work seems distinctly antinarrative.*

JJ: There had to be four things that were related.

PT: *But this was a sequence, a temporal sequence, such as you find in narrative art, in fiction, and so forth. That's a change for you, because your earlier images were so emblematic.*

JJ: Well, it's just the convention of that subject, isn't it? It's the seasons.

PT: *Why did you introduce autobiography into your paintings?*

JJ: They're not particularly autobiographical. Where is the autobiography?

PT: *The different paintings pertain to particular stages of your life and artistic career.*

JJ: That's just a kind of clichéd tradition of representing the seasons, isn't it? What would you do?

PT: *The incorporation of flags, Mona Lisa, cross-hatching, and other motifs from your early work all suggest that you're narrating a form of autobiography. I wonder if*

you're telling the story of your own development by incorporating these elements in your work.

JJ: But I don't see that it tells of any development. That's the point I'm making. I don't really see that it's a narrative, in that I don't see what it narrates—unless you think that the representation of the seasons is in itself a narrative. I don't see it that way. In a sense none of it represents me. And, in a sense, all of it represents me. It's like any other painting in that respect. You can say it does, or you can say it doesn't.

PT: *In the '60s, Marcel Duchamp said that he thought art would go underground.*

JJ: Having already done so himself.

PT: *But it didn't. Instead, it became incredibly public.*

JJ: I wonder if there is the possibility that there is an underground art. I don't know.

PT: *Today there certainly seems to be just the opposite.*

JJ: As far as predictions go, Duchamp's certainly didn't work, did it? I have no feeling that there is anything that you would call underground art.

PT: *People used to talk about being outside of the system and about dropping out. But what is "outside" now? I don't know.*

JJ: I don't know either. But I would say that you may be becoming metaphysical.

PT: *I suppose it's a metaphysical question.*

JJ: Well, I can only say that I'm not aware that there is an outside or an underground. […]

PT: *What are your feelings about collections of art that once seemed destined for museums but that are now being split up and auctioned off? How do you feel about that when it involves your own art?*

JJ: I think it's terrible. But that's just because one assumed that these things would go to some public place. Of course one had no right, I guess, to assume that. But one did.

PT: *Why is it terrible? Do you mean that it's a pity that these collections are not being kept together?*

JJ: No, no. I don't think that's so bad. I just like the idea that art is publicly available. The first time I saw paintings they were in museums. I never knew anyone who had a painting. So that's how I think painting is available to people. But maybe that whole idea is ridiculous. I heard part of a radio program by accident the other day. I was in the country, and I was going mushrooming, and I turned the radio on. It was Sunday, I think. And Leo Castelli was hosting a lunch or breakfast at the Algonquin. And among all the art-market talk, this question came up. And Leo said, "It's not sad, because eventually they'll all be in the museums anyway." Which may be true. I hadn't thought like that. I think it's just that when one assumes something, one finds it upsetting to discover that one's assumptions have no real weight.

PT: *Is it important for you that your work be seen in museums?*

JJ: It's not that it's important to me that my work be seen in museums. It's that I think that museums are where most people, most young people and poor people, contact art. And I think of art—maybe wrongly—as being identified with the

young and the poor. I think that's where art comes from, from the young and the poor, and that their access to art is through museums. I mean, they're not generally going into the homes of rich people to look at pictures on the wall.

PT: *It's a liberal idea of yours, this one.*

JJ: I don't know whether it is or not. I haven't thought it through. It may just be a description of my own background.

PT: *Your paintings were never inexpensive. They were never affordable for the young and the poor. The joke is that now they're not even affordable for the wealthy. They're priced for the superrich. What do you think about this?*

JJ: I think that when that becomes the case, it's even more important that paintings be publicly available. That's what I think. And I think that has been the pattern—usually as works became very costly, the owners died off and left them to public institutions. And that seems to me a reasonable state of affairs. Who knows how it will continue?

PT: *I suppose you're gratified by the knowledge that at least one collector might leave his collection to The Museum of Modern Art.*

JJ: Are you talking about someone specific?

PT: *Newhouse, I believe, is going to leave—*

JJ: I didn't know that.

PT: *Well, that's what I heard the other evening from somebody in his family.*

JJ: Really? I hadn't heard that. Well, we'll see what he has in his collection then. It changes from time to time. I think the odd thing is to think that works in museums now have value, which of course they are thinking nowadays. That's really tragic. The earlier thought that they were priceless is certainly a much nicer thought.

I-56. Robert Tracy, "*Interview: Le Duo Johns-Cunningham*," *Vogue* (Paris) no. 709 (September 1990): 42. Published on the occasion of the Biennale de la Danse, in Lyons.

Sometimes Cunningham had very precise ideas for the costumes. For *RainForest*, for instance, for which Andy Warhol had made the decor, Merce showed me an ageless costume—maybe one of those he wears to work on his own in his studio—so I could imitate its tears for the tights and leotards. *[...]*

Rauschenberg, then artistic director of the company, influenced the way choreographies are lit. At that time, nobody was responsible for the lighting, and we often complained about the lights being too theatrical. They prevented one from seeing the dancers, and changed the colors of the costumes. So we worked on the lighting to give the maximum of visibility and generate the minimum of distortion. Later, in *Winterbranch*, Bob went for the opposite of that idea and dressed the dancers in dark sweatshirts, making them dance in shadow during most of the performance. *[...]*

I would imagine Merce could say that dance work is "some sort of anarchy where the artists are free to work together." But I wouldn't say that. Of course I would follow my own beliefs, but my primary interest was to serve his thinking rather than mine.

I-57. Michael Pye, "Behind Veils, the Elusive Heart," *The Independent on Sunday* **(London), November 18, 1990, pp. 21–22. Published on the occasion of the exhibition "The Drawings of Jasper Johns," at the Hayward Gallery, London. Interview conducted at Johns's house on East 63rd Street, New York.**

[…] This season, Leo Castelli, [Johns's] New York dealer, reckons $1.5 m[illlion] for a new Johns painting—it was $650,000 five weeks ago—and perhaps $400,000 for a drawing. […] "I never understand money," *Johns says.* "I don't understand why it behaves in the way it does. It makes me think one is not independent of the society in which one operates. That thought is always frightening to me."

[…] He doesn't woo collectors—they have to woo Castelli—because they love the work, and "here there are times when it becomes clear that your work and your self are different." *[…]*

[…] He thinks of all the ways critics interpret his work, and says that can be "interesting," *or* "pleasant," *when he agrees; but also that the whole notion of these ideas in other people's heads is* "weird." *In his prodigious reading, he often goes back to Wittgenstein—to showing and not telling things, to the issue of private language.* "I am still," *he says,* "terrified of Wittgenstein."

[…] He was born in South Carolina to a failed farmer, and a mother who left. He went from relation to relation, isolated in deep country; he has taken out the fireplaces in his house because they remind him of dragging firewood each morning. […] From a very young age, he liked to draw. "It had the effect of attracting attention from adults, and that was a kind of power." *He never thought of being involved in anything other than art.* "[…] In part, art represented an unknown place— something foreign to me, something not familiar, something distant from my background.

"That pattern of dissociation … " *he stops for a moment.* "Aspects of that continue in my life," *he says.* "I am not going to specify anything."

[…] "I had no preconception," *he says,* "of New York." *[…] He was drafted into the Army, but when he was discharged,* "I would not have known where to go except New York."

"It was a combination of growth, desperation, and accident," *Johns says.* "Something had to take a different turn." *At one point, he destroyed all the paintings he had made.* "It wasn't a judgment on them," *he says.* "It was more like reforming my identity." *Work and identity are so tangled together in his talk that you ask if he makes much distinction between the two?* "Probably not," *he says. He is laughing.*

He began to look at art, to tumble into the company of artists and not just painters; "I must have learned from them, but I didn't see it at the time. Work was the central issue for these people."

He […] met Robert Rauschenberg […] "To me, Bob was a successful artist— he had exhibitions in galleries, he had the background. He entered a period when he had no gallery affiliation—something happened. He was no longer exhibiting publicly. We were very close, sharing our ideas and our criticisms." *[…] Johns even tried to paint a Rauschenberg, an extraordinary thing for a man who thinks*

With master printer Hiroshi Kawanishi, working on a
screenprint at Simca Print Artists, New York, in 1980.
Photograph: Katrina Martin; taken during the shooting
of her film *Hanafuda/Jasper Johns* (1981).

work and identity are hard to distinguish: "It was a play," *Johns says, firmly, and then:* "There was a period during which the two of us formed a society and that was sort of that."

[…] He found a studio in Edisto Beach in South Carolina. […] Going to Edisto also changed his life; it was part of a growing rift with Rauschenberg, losing his teacher and lover after more than a decade. And it was towards the end of the small, closed art world he had known; big money was coming, and the "sense that art is like show business."

[…] He can be stirred by new work; for newcomers, he has kind concern. […] "So much information got into the hands of young people since the 1960s," *he says.* "They learned so much that people where I came from didn't learn. It increased their skills, and in a sense their resources, but it may also make choosing more difficult." *[…]* "I don't envy them," *he says. And there is something more. He once worked with Samuel Beckett and admired, even identified, with his* "combination of elegance and austerity, of negativeness, the things go together. *[…]* The tragic aspect almost, and the elegance," *he says.*

I-58. W. J. Weatherby, "The Enigma of Jasper Johns," *The Guardian* (London), November 29, 1990, p. 29. Published on the occasion of the London exhibitions "The Drawings of Jasper Johns" at the Hayward Gallery, and "Jasper Johns: New Drawings and Watercolours," at the Anthony d'Offay Gallery. Interview conducted at Johns's house on East 63rd Street, New York.

[…] When Johns exhibited his flags at Castelli's gallery in 1958, when he was twenty-eight, art critics made him an overnight celebrity, calling the exhibition a "brilliant assault on the high-minded strivings of the Abstract Expressionists." That made Jasper Johns laugh. "That wasn't the way I saw it," *he told me.* "There was no assault intended. It was a case of my coming to terms with my own ideas about what the possibilities were for an artist like me. The Abstract Expressionists seemed to be doing what they were doing well enough, so there was no point in my doing it." *[…]*

[…] Did he agree that he had changed and there was a new vulnerability in his middle age?

[…] "There was this idea associated with Abstract Expressionist painting that the work was a primal expression of feeling, and I knew that that was not what I wanted my work to be like. My work wasn't going to be an expression of my feeling, but something else. What that was I don't really know. I'm not sure of the role of feeling in art, but at least its product comes from feeling, thinking, behaving. As well as I can state it, at some point or perhaps gradually, the necessity not to expose my feelings disappeared. So when I saw an aspect of my work was an expression of my feeling, I no longer said, 'Go get rid of that.'"

[…] [Johns's] later works have been received more critically than his earlier, more detached paintings and have been described as self-involved puzzle pictures with sly clues to his own life and cross-references to other artists. "I don't know why the work is seen that way," *he told me,* "I often wonder whether such interpretations really

interest people. I am not deliberately provocative. I think part of the reason is because a lot has been written about my work and I think some people take such ideas from others and it is the information in their heads when they look at a picture. It's hard to see a picture for what it is."

Like looking at flags? "The critics accuse me of putting things in to provoke, but I don't. Something that interests me about painting is that things can be transformed into other things, much as a certain kind of imagery can exist in a way that is ambiguous at a certain time in a certain way. My interest in optical illusions is such that I like to create an image that when looked at becomes something else and there's no in between. You see the one or the other with no in between. That aspect of seeing or knowing—or whatever are the visual or mental operations responsible—offers equal access to two possibilities. I'm fascinated by that kind of thing and other kinds of material that make possible that either/or situation where things become slurred and uncertain. That's why I tend to play with that kind of possibility. Not knowing exactly is something that I find fascinating. Whatever the basis, it probably moves one to see life in an ambiguous way. There may be an infantile foundation to it, a kind of sensitivity, a predisposition towards that way of seeing."

He crossed and uncrossed his long legs restlessly, obviously brooding […]. He said at last, "I assume everything I do has an effect on my work. But it would be very difficult to relate a cause and effect. What you do alters what you want to do. Everything changes the way you move about in the world a little bit. As you read and think or have accidents or work, it all affects your own handling of materials." […]

And what was he working on now in that studio guarded by the black dog? Was it more autobiographic work exposing his feelings? "I am uncertain about what I'm doing," *he slowly replied.* "What I have been doing for the last year or so I hope will come to an end, but so far it keeps on going. I go on doing what I'm doing because my thought continues and I see possibilities and things I have neglected, but I would like some new ground to open that would be filled with mysterious delight rather than a sense of obligation."

I-59. Richard Cork, "The Liberated Millionaire Is Not Flagging," *The Times* (London), November 30, 1990, p. 21. Published on the occasion of the London exhibitions "The Drawings of Jasper Johns," at the Hayward Gallery, and "Jasper Johns: New Drawings and Watercolours," at the Anthony d'Offay Gallery.

[…] Johns's preeminent stature was resoundingly reinforced two years ago when a celebrated early painting fetched $17 million (£9.5m): an auction record for a living artist. […] The artist himself views these dizzying figures with conflicting emotions. "What does it really mean?" *he asks hesitantly.* "It is weird and questionable and distasteful on some level, but the fact that I have been able to live comfortably from my work has helped me a great deal." […]

Although he acknowledges that his millionaire status "might have an inhibiting effect on my work," *he also sees it as a liberation.* "It has made me more willing to take chances, to question the possibilities of my thought and what might or might not be considered interesting," *he explains.* "It throws finished work into the past more quickly, and provides me with a trigger for the new."

[…] As for the suffering figure in Grünewald's painting, Johns grew involved with him after receiving a large portfolio of the Isenheim Altarpiece "with a lot of very beautiful details. Looking at them, I thought how moving it would be to extract the abstract quality of the work, its patterning, from the figurative meaning. So I started making these tracings. Some became illegible in terms of the figuration, while in others I could not get rid of the figure. But in all of them I was trying to uncover something else in the work, some other kind of meaning."

[…] Johns thinks of himself as lazy, and says "I would be delighted if I could do a quick drawing. A long time ago my friend John Cage said to me: 'You should have a way of working that doesn't take such a long time.' So I made a drawing called *Broken Target* in half an hour. I was very happy, but I have since relapsed." *[…]*

While working, he thrives on the ability to "look away and then look back," *incessantly revising and deciding that a void needs a filling, or that lightness should become dark.*

Maybe a stern work ethic impels him as well, for he admits that "I may have inherited something from my Protestant farming background in South Carolina." *[…] But one new drawing […] contains an affectionate reference to early memories.* "I think of it as a portrait of my grandmother," *he says, describing with relish how* "she used to sit a the piano and sing 'Red Sails in the Sunset.'" *The laugh explodes all over again, filling the dull November morning with infectious, puckish delight.*

I-60. Sarah Kent, "Jasper Johns: Strokes of Genius," *Time Out* (London), December 5–12, 1990, pp. 14–15. Published on the occasion of the London exhibitions "The Drawings of Jasper Johns," at the Hayward Gallery, and "Jasper Johns: New Drawings and Watercolours," at the Anthony d'Offay Gallery.

[…] "I wanted to be an artist since I was a child, but didn't see any evidence that I was one. I realized that, if I were to be an artist, I had to be myself. It was a revelation. I tried to eliminate aspects that resembled other people's work and to establish what I was and could think and do.

"My concern was to use marks that anyone could make. I was interested in their literalness—marks that are perceived as nonexpressive and do not tell you about something larger, yet are connected to what is real. And the perception of 'thingness'—if something is made of something else, what do you see? The one something or the other something, or a relationship between the two? I was pursuing my own education in this realm. I later came to believe there are no literal qualities to anything—everything is unstable."

We enter a philosophical quagmire. Could he make a mark that was meaningless?
"Not unless something that exists in the world is meaningless." *I raise the issue of accident versus intention.* "These are my questions," *he replies with a chuckle.* "You mustn't take them away from me! But the work doesn't arise out of mental analysis. I don't know what the basic triggers are—often it's just a pressure—I assume they're infantile. The only conscious question is how to make or complete a work."

In 1972 Johns began using a pattern of cross-hatched marks, in one instance made by dragging paint-laden fingers across the paper. It was as though he had reduced his vocabulary to a basic building block—whether infantile finger painting or an enlarged version of Renaissance cross-hatching. Johns has a more literal explanation. "I was driving on Long Island when a car came toward me painted in this way. I only saw it for a second, but knew immediately that I was going to use it. It had all the qualities that interest me—literalness, repetitiveness, an obsessive quality, order with dumbness, and the possibility of complete lack of meaning." *This does not explain why the results are so eloquent.* "They become very complex," *explains Johns,* "with the possibilities of gesture and the nuances that characterize the material—color, thickness, thinness—a large range of shadings that become emotionally interesting." *[…]*

Personal concerns are also creeping in. A headline about AIDS *accompanies the image of a skull and the tracing of an ulcerated demon from Grünewald's Isenheim Altarpiece, commissioned in 1512 for a hospital caring for plague victims. Characteristically, Johns talks in terms of making rather than meaning.* "I think in terms of understanding different kinds of space." *But while he concentrates on the process, other levels of consciousness are activated.* "Things very easily become charged, suggestive on an emotional level." *But he's not delving further.* "You can only talk about what you know you do, though you know you do things that you don't know you do." *Given his rejection of expressionist gesture, there's a certain irony in that.*

I-61. Amei Wallach, interview conducted on February 22, 1991, in Johns's house on East 63rd Street, New York City, on the occasion of the New York exhibitions "The Drawings of Jasper Johns," at the Whitney Museum of American Art, and "Jasper Johns Paintings and Drawings," at the Leo Castelli Gallery. This interview was the basis for Wallach's article "Visual Guessing Games," *New York Newsday,* **February 28, 1991, part II, pp. 57, 64–65.**

[…] AW: *[…] You go into the "Drawings" show and* Diver *is the pièce de résistance, and there is the last work in the show, which is, I think, an* Untitled, *[…] the work in the back room in gray. […] It has all the eyes, it has the green angel, and it has the Picasso; it has everything [] What does it have for you?*

JJ: I have to consider it.... To me it's just a painting I made, and it involves a tracing of an image—I had no concern what it was. […] I didn't know people refer to it as the green angel (laughs). […]

AW: *And why haven't you said what it is this time?*

JJ: Because I got tired of people talking about things that I didn't think they could see in my work—from some of the Grünewald tracings. It interested me that people would discuss something that I didn't believe they could see until after they were told to see it. And then I thought, What would they have seen if they hadn't been told about these things, because the same painting is there. And when I decided to work with this new configuration, I decided I wasn't going to say what it was or where it had come from. One of the things that interested me was that I knew that I couldn't see it without seeing it, seeing *that*, because I knew, and I knew that someone else wouldn't know and wouldn't see, and I wondered what the difference was in the way we would see it. And, of course, I'll never know. […]

AW: *[In the painting* Montez Singing*] I am trying to find out who [your grand- mother is].*

JJ: […] I think that in the painting, […] I was really working with this face in a rectangle with all these features moving about in the background and I think I was just trying to relate it to something. To make it less abstract for myself. And of course it has this infantile quality: that image of the face, features floating about....

AW: *Well, it's kind of like Betty Boop, with that mouth.*

JJ: I think it's also like some infantile drawings, an infant's first drawings; but I'm not sure. I think it's an early recognition, one of the first images or forms—

AW: *Like a doodle?*

JJ: I wouldn't say like a doodle. I have a kind of memory of seeing some drawings of children, I don't know what age they were—I should try to find them.[17]

AW: *[…] Once you choose an image or an object, it's sacrosanct, isn't it? You'll do anything to it, except change it: bounce up against it, you can put it in a different place, you can change the color, but […] the shape doesn't change, right?*

JJ: To a degree, I mean of course that's what interests me about things. The degree to which they can be changed in some way and yet remain what they are. It interests me why things stay what they are when they undergo change and […] how we perceive them in that way.... So what you're calling the thing that doesn't change—what is it that doesn't change? […]

AW: *Well, once you've chosen it, nothing changes: the coat hanger doesn't change, a watch doesn't change; when you do the face on the veil it never changes—that's what it is. Even when you repeat it, you repeat in the same sequence. Picasso will take it and distort it, de Kooning will just throw it up in the air and pull out whatever he can, but you never do that—the coat hanger always remains a coat hanger, the watchband always remains that exact watchband, even though you change the color, you change the strokes around it, you change the juxtaposition.*

JJ: Not just change—you see it that way, the proportions change. […]

AW: *Really, the proportions change in relationship to each other—or in relationship to other things? […]*

JJ: The proportions of the watchband change, I believe. The flags in proportion to the width to height, but you don't really perceive it that way.

[...][They are looking at the series of twelve drawings that Johns made for the 1991 calendar published by the Anthony d'Offay Gallery, London —Ed.]

JJ: Now, you see here's what I did. This image, I had done that, I don't mean this particular image, I had done something like this. Then I wanted this information to be the background, and this information to be the thing that was pinned on top, so this was there. I think that's the first time that happened.

AW: *What do you mean, the first time what happened?*

JJ: The pin through the eye.

AW: *Except the one with the pin through the eye, you're not aware that it is pinned on, because it takes up almost the whole drawing.*

JJ: But I think there is a painting there, I think there are paintings like this, I think the two paintings together with the background and foreground in reverse, and one is almost this, and the other is the opposite of this.

AW: *So you were referring to the paintings when you were doing the watercolor? Okay, well there are lots of them actually which do the flip, aren't there, there's a lot with the watch and then you put the watch on this or....*

JJ: And then there is the question of whether the rectangle is stiff or soft.

AW: *And what determines that? It's just another thing to play with?*

JJ: Yes, sure.

AW: *The nails and the shadows. I guess you're going to do more with this, you have a little bit of the wood stuff in some of the paintings, is this something you're going on with?*

JJ: I have no idea; it's been in earlier things.

AW: *Right, and this is the wood from your floor in upstate, right?*

JJ: It's the wood from anywhere, its just a symbol for wood (laughs). It's just a cartoon of wood.

AW: *Well, okay, that's what I am saying, thank you. There's a cartoon quality in these. Tell me about that, what's that about?*

JJ: I don't know. I think it's just that way of an image being recognizable and having not much other quality. [...]

AW: *Except that you kind of go into a state of expecting to smile in a cartoon, right? Or expecting something delightful to happen—something pleasant or silly.*

JJ: Not necessarily—think of Guston's late works, which have a cartoon quality, and they are not very amusing. [...]

I was trying to define the quality that suggests cartoon. I just don't know what makes something appear to be a cartoon—probably some kind of shorthand way of representing an image. I don't know the answer to that. And I was just saying that some of Guston's work had a cartoon quality but that it was not amusing, but you still see it as having an association with a cartoon. *[...]*

AW: *But are you consciously trying to forge a new body of work?*

JJ: No, what I hope to do is get rid of these images and get on to something else, and do what I think to do. Your thought takes a certain form and you have to follow it. Maybe there are devices to slip out of that pattern, I'm not concerned; I find it difficult, so I simply try to deal with my thought as best I can.

With *Untitled* (1984), in 1984.
Photograph: Richard Leslie Schulman.

With *Fall* (1986) at East Houston Street, New York,
c. 1988. Photograph: Lizzie Himmel.

AW: *Do you think you are finished with the Isenheim images?*

JJ: I don't know, I have no idea.

AW: *Are you still busy now in any way?*

JJ: I'm barely working. I have one painting in the works, which I am returning to soon, I hope.

AW: *Jasper, you said you were barely working when you were doing all this!*

JJ: This work is [done] over a long period of time—five years—of course it's not all my work either from that period. I wanted to collect just this concern with basically the pictures that had the features of the face; I just wanted you to see what they look like together, since I realized they had this accessible quality ... (laughs). I thought I would isolate them and put them together and see what they looked like and that's what I did.

AW: *And? What do they look like?*

JJ: You can decide for yourself what they look like.

AW: *To you?*

JJ: ... I don't know. I don't know, I am still thinking, and I see possibilities.

AW: *Of somewhere else to go?*

JJ: Well, not far, but ... (laughs).

AW: *The other thing you do in these that I find very interesting, I don't remember your doing this sort of thing with color before, especially in the ones that have both the mother, daughter, and the Picasso. The green doesn't seem to change, it's that very limey, whatever you call that green, that doesn't seem to change, although I don't know enough about color theory to know whether in fact it does. But the pink changes in all of them, doesn't it? Or do they both change?*

JJ: I'm sure the green has changed....

AW: *Because in the past you've made yourself do the primaries and the complementaries, right? So these are not as literal takes on the primaries and complementaries. So what are you doing [now], are you going to explore some more color?*

JJ: I don't know, I think I intended to do that for a long time actually. Of course I still have that tendency to stick to some form of schematic organization.

AW: *And what is the scheme here, then?*

JJ: I think this is less of it, I think this is to a certain extent working with color rather than working with a scheme.

AW: *Oh, that's right, because you don't play as many tricks with that image. That image pretty much repeats in all those paintings—it's the color that changes. Are you going to do more of that?*

JJ: I don't know.

AW: *That's interesting, because the color is very beautiful. I mean is it that color hasn't interested you in the past?*

JJ: I don't know what it is. I don't know whether it's an increase in skill or a change of attitude, or maybe those things are connected.

AW: *An increase in skill, meaning you have more confidence in how you can use color?*

JJ: Perhaps, or more sensitivity or awareness of color. It has as much to do with

the color as it has to do with me, certainly. But much of my early work was concerned with what I considered "pure" color. [But with red, for instance], the recognition of it is generally just red, even though it's not just red. My work is gradually moving in a slightly different direction, but I can't describe it. It's done intuitively, so it's very hard to state what it is [I'm] doing.

AW: *Well it's very odd, I mean it's an odd palette, like that pale blue face, and this particular pink, and the green, these are odd color combinations. I also think they are what make people say that you're trying to become more expressionist or more whatever, more out-loud, vulgar, outrageous, you know. […] But that could just be the color, it could be nothing but the color. But do you think that when you were younger, the point was to set yourself limits, and now maybe the point is not to so much?*

JJ: […] I had a different idea of clarity, what constituted clarity. […] I was concerned with the things I just mentioned, in terms of color. A kind of rigid idea of purity, and that's perfectly normal. And now, an off color seems to me just as pure as the central color in the spectrum, within limitations—there is not a huge range of possibilities presented in this way, but still, while working I am not concerned to keep something in the purest representation of itself, of the name red or the name yellow.

AW: *Well, that has to do with being literal about the object too, right? Say, if you limit yourself to the most obvious, the most everyday, the most mundane—*

JJ: Yes, I think it connects too.

AW: *So where else doesn't purity matter as much? […] For instance, you still have to be pure about setting a system.*

JJ: It's not so much that I set systems, it's just that you see what I do and you recognize that it's restricted in some way. That's not a conscious restriction, generally it's just the way I work; it's not something I am trying to promote (laughs).

AW: *Now, what upsets you about what people saw in the Isenheim things, is it AIDS? Is that what upsets you, or the altarpiece?*

JJ: I'm not upset and wasn't upset. It's just that what interested me was that you can come to see something through language that you couldn't have come to see through looking. That was what interested me, and the extent to which knowing things influences seeing. That has always interested me, and continues to.

AW: *For instance, when the Rembrandts are reattributed, suddenly they look different.*

JJ: Absolutely, that whole thing I find very peculiar, and when I do look, I consider that.

AW: *It's been very interesting how you've let your work be perceived all along, which is that on the one hand it had very hidden arcane imagery after the very first stuff, and on the other hand people were always writing iconographies of it, and you would drop hints….*

JJ: I didn't drop hints; I answered questions.

AW: *People would put questions to you and you would either answer them or not, or you would answer them in a certain way or not answer them in a certain way, and so the whole thing became these great reams of things written about what in*

fact something meant, it became a way of looking....

JJ: Well, here is an example of the kind of thing that interests me. In some of the pictures using tracings from the Grünewald, someone would look at a painting using one tracing and talk about it as though it were the other tracing, with a different subject matter, and go right on doing that. And I find that interesting. Well, what is the difference between their being correct and their being incorrect? What really is the difference? If one person looks at this picture and says it is this, this and this, when it isn't, and you know it isn't, and if the person were saying that it were the correct thing, and they couldn't see it, what difference does that make too? It's very funny.

AW: *And there was meaning in your choice? You meant to be saying something specific about which one you used?*

JJ: Only after, in certain cases, after a certain amount of talk.

AW: *So the talk also affected how you saw.*

JJ: Of course it does, certainly. But you know a thing that interested me like this was Duchamp's sculpture called *Objet Dard*, and it's a very strange configuration, very simple. Do you know it? It's kind of a phallic shape. I could never understand how anyone could come to make that particular object; I couldn't understand out of what it would come, out of what thought process you would arrive at this form. Once I asked Marcel how he had come to make it, and he simply smiled, puffed on his cigar, and wouldn't tell me. And Teeny Duchamp said, "Oh Marcel, why don't you tell him?" Then I thought, Well, there must be something to tell, but he didn't. Then after he died, Teeny must have told me what it was. It was apparently a brace from the mold for his last piece in Philadelphia [*Étant Donnés...*]. It was a brace under a breast in the negative mold, I think, and he must have smashed it and patched the little pieces and played with it a little bit. I don't know that my perception of the piece has changed now, having that information—not having had it all those years— and yet when I think of the piece I think of that information also now.

AW: *Well, you've got the sexual content, that's for sure. You got what it was about in a certain way, right?*

JJ: Well, more interesting to me is that now I think [that] what I wanted to know is by what process would he have made this thing, when, in effect, he didn't make it by any process (laughs). But that's what I wanted to know: how he had thought to do it, and he obviously didn't exactly think to do it. It was something because it registered with him, and he did "do" it—I mean I am sure he did something to it. But it didn't come about in the form of formal thought that I was trying to uncover. I couldn't imagine it—that's what interested me—and then when it was revealed, obviously he didn't imagine it either, so it's quite nice.

AW: *Yes, but that's his point in a way, that whether it's a found object or a made object doesn't matter. I mean, it's the shovel in a way.*

JJ: That's an aspect of it, of its interest. It brings back the importance of the thing itself, freed from the information. But the information too is interesting. [...]

AW: [...]Do you feel this burden of being our great American painter?

JJ: Who said that?

AW: It is being said to you in other ways. You are being pushed into being an old master.

JJ: Well, I suddenly became very old as soon as I hit sixty. You suddenly age twenty years overnight; or it sure seems like it.

AW: That's right. But not only that, in importance, weightiness, money....

JJ: I don't know what to say to all of that. I don't know why there is a tendency to do that with artists, to separate artists from other artists. From the point of view of the artist, I think it's a mistake.

AW: You mean from the point of view of an artist, you think it's a mistake, because?

JJ: Because artists only have a function in relationship to other artists, and it's a mistake because it is a way of cutting them away from society and culture. [...]

AW: The thing that strikes me about your work is that you're really (on the surface at least) dealing with a lot of primal childish imagery in a childish way—you know the watch and Montez and all that. That's interesting; it isn't like anything you were interested in doing in the past.

JJ: I'm probably regressing (laughs). I think of these things as representing my second childhood.

I-62. Billy Klüver and Julie Martin, unpublished interview with Jasper Johns. Conducted on February 26, 1991, in Johns's house on East 63rd Street, New York.

[...] BK: Was there a museum [that you went to when you were young]?

JJ: I don't think there was a museum in South Carolina. There was something called the Gibbs Art Gallery in Charleston, South Carolina, which I began to go to when I was in the Army, the first time; and I don't know what, if anything, they had shown. There is a museum now, the Columbia Museum of Art in South Carolina, which must have begun ... I don't know when it began ... probably around '49, '50. I think it began after I left Columbia, but before I was in the Army. [...]

BK: [When you were in New York before going into the Army,] did you have any contact with the Modern, or any of the [museums]?

JJ: I missed it. I was not a good student, but still you gather a certain amount of information, just by seeing things, whether you are aware of any interest or not.

BK: Were you aware of Pollock?

JJ: Yes.

BK: You were at the time? How did that happen?

JJ: Well, he was in art magazines. It depends upon when you're talking about; this is over a period of several years. I remember a Pollock (I can't remember the year) in the old Whitney museum downtown, where the New York Studio School was. I guess they must have done biennials at that time. I remember a Pollock in the Biennial. I remember the first time I saw a Noguchi was there; Jacob Lawrence; Hofmann, lots of American art.

BK: Were you aware of Hofmann at school?

JJ: I was aware of him in Provincetown; didn't he teach in Provincetown? Well somewhere. I had teachers in South Carolina who would go away during the summer and study with some well-known artist somewhere, like Hofmann, or [Amédée] Ozenfant, or [Ben] Shahn. So you would hear that these people existed.

BK: *Where did you go to school?*

JJ: I went to a commercial art school [Parsons School of Design, New York, in 1949].

BK: *Did your parents tell you to do that?*

JJ: I suppose it was a teacher who had sent many students to that school, but I don't remember what my parents' involvement was, if anything, but of course any kind of input from my family would have been directed towards their idea of something practical. I remember it being suggested that I go to architecture school at Clemson University, which didn't interest me.

BK: *This was in '48, '49?*

JJ: Yes.

BK: *Did you have a sense of what was going on in New York, like 10th Street?*

JJ: No. I had a sense that there was something happening in art, but I didn't see any way that I could be a part of it. Since I saw the [1950] Pollock show (I can't remember the dates) at Betty Parsons, when he had paintings on glass, I saw Barney's [Barnett Newman's 1951] show at Betty Parsons, and these things were very impressive, but they seemed to be a part of the world that I wasn't part of—they *were* a part of the world that I wasn't a part of. It was only after I returned to New York from the Army [in the summer of 1953] that I began to form any social connections in the art world that allowed me to feel a part of any kind of thing.

BK: *Who were the first people you met when you got back, in the sense of the community? Did you meet Barney?*

JJ: Much later. When I met Barney... by that time he was (I don't know how to express this) he seemed a part of the older scene. I met a lot of people, but I didn't come close to them. When I first returned to New York, I met Suzi Gablik, I met Mark Rothko, I met Sari Dienes, I met Bob Rauschenberg, I met John Cage; all of this quite rapidly.

BK: *Did you go to classes at the New School?*

JJ: No, I didn't, but I wasn't around at that time. That's a little bit later. I knew Allan [Kaprow]. I knew various people who were going, but I didn't go.

BK: *Did John [Cage] live out in Stony Point then?*

JJ: Yes, I think so. I may be wrong.

BK: *Was Lois Long part of this at the time?*

JJ: I can't keep all the dates up. Lois came a little later. John must have met Lois and De [Emile de Antonio] when he moved out to Rockland County. I met Lois and De when there was to be a performance of Cunningham and Cage in Rockland County [October 15, 1955]. I went out with Robert Rauschenberg to help him with the sets for *Minutiae.* We were in rehearsal in the theater, and

De came in with Paula [Madawick?] and her brother and the children. And that was the first encounter with them. Then later, I think Bob and I helped with a brochure for the Cunningham Company that De and Lois were organizing. Then we became sort of friendly, played poker and things like that.

BK: *That was before the Town Hall concert [May 15, 1958]?*

JJ: Yes. [...]

BK: *Did you meet Bob after he had been at Black Mountain?*

JJ: Yes.

BK: *Was Bob as exuberant as he is?*

JJ: I think not; I don't think one would have described him in that fashion. No, he had a completely different role, I would say.

BK: *Had he sold paintings?*

JJ: I'm sure he had sold some paintings; he had had exhibitions. But he didn't sell pictures like people sell pictures now, to supply an income.

BK: *Were you involved in any of the 9th Street shows?*

JJ: No; I think that happened while I was in the Army. That was in '51.

BK: *Bob was in there. When did you first show a painting?*

JJ: I think the first thing I showed in New York was at the Tanager Gallery on 10th Street, in a group show; and I think Bob arranged it. It was a little (I forgot the title of it)—it's a collage on top of a little piano.[18] It's in the Kunstmuseum in Basel.

BK: *Who was involved with the Tanager Gallery?*

JJ: Many artists were. Actually I tried to get a picture of that. Several years ago there was an exhibition done as a kind of memorial to the Tanager Gallery somewhere in New York, and I saw it. In the show there was a photograph of a wall which had my piece on it, and Bob Rauschenberg's piece as well. I've tried to get a copy of it, but I've not succeeded. [...]

BK: *And the other person who was involved in that, [the artist] Wolf Kahn? Did you come across him?*

JJ: No, I met Wolf much later, I guess.

BK: *Was there a sense that the group belonged together?*

JJ: I think there were splits and fragments, sort of opposing groups. I mean there must have been a very strong sense of community around 10th Street because I think a lot of people lived around there, those artists. Whereas Bob at that time was living on Fulton Street or somewhere, and I was living on Pearl Street downtown, and they developed that other community down there. And then the Coenties Slip people came.

BK: *You were aware of the Coenties Slip group? [Ellsworth] Kelly?*

JJ: Yes. [Robert] Indiana, Agnes [Martin]. The woman who does these weavings. Her name is going out of my head right now.

BK: *Pollock, de Kooning, Kline? Did you ever have any contact with anyone?*

JJ: Well, you see, I don't know when we're talking about. I met Pollock once.

BK: *Did you hang out at the Cedar Bar?*

JJ: Occasionally; not very much.

BK: *I mean Kline was a very social fellow. Did you have any contact with him?*

JJ: I saw him in the Cedar Bar a few times, and I visited him in his studio on [14th] Street once.

BK: *Same thing for de Kooning?*

JJ: You see, you are talking about a time during which things changed very rapidly for me. So that it's very hard to put it all together. I met de Kooning because he came to my show at Leo's [in 1958]; it was the first show.[19] And [Castelli's wife] Ileana [later Sonnabend] or Leo said de Kooning is here, so I was introduced. I had nothing to say to him of course. And then we had dinner—a group of us had dinner at Café Nicholson, on 57th Street, with Bill. Bill called me Mr. Johns the entire time (laughs).

BK: *That was the famous beer-can story?*

JJ: No, that was later.

BK: *How were the Europeans regarded, like Picasso, Matisse? Did you have any sense of their presence?*

JJ: Well you see when I was a student in South Carolina, one knew that there were these Europeans, Picasso, Matisse, etc. One was almost not aware of an American art world, down there. The American art world then would have been [Reginald] Marsh and [Currier?] and those original painters. That would have been the idea of American art in South Carolina. So when I first came to New York that was one of the things that I couldn't ... I mean I hadn't seen any of the European art, much less any recent American art, so it was very hard for me to get any kind of understanding of this. I didn't know what had happened. It was only after I came back from the Army that I began to see that there was an art world in America with these people who had backgrounds, experiences, and histories, that they had developed art forms that one had to consider very seriously and to come to terms with it somehow. And within all of this structure, there was an older generation, a younger generation, and opposing schools; it was very complicated. So that European painting at that moment seemed very old and distant as it were. Not something of immediate concern really.

BK: *Did you ever meet anybody who [was close?] to the great painters?*

JJ: Well, we assumed that they were great. So what? (laughs) I think that was the general assumption.

BK: *So many of them were in New York during the war, like [Fernand] Léger, etc. Was there any trace of that?*

JJ: Not among the people that I had anything to do with. Later, when I met [Nicolas] Calas and Duchamp and such. But of course John Cage had some experience with those people, I assume, I don't really know. But it didn't interest him to discuss that; he was so involved with his own program.

BK: *Did John strike you as an extraordinary personality?*

JJ: He *is* an extraordinary personality.

BK: *Were people more hidden in those days? Well, in a certain sense you can say that today people are more hidden than they were in the '60s.*

JJ: I don't know what you mean by "hidden."

BK: *Well, you talked about his program. Was it clear what it was? He had concerts, you got to understand what he was doing?*

JJ: Well, he was a great talker, a teacher. Even when he wasn't teaching, if you happened to join him at a bar, there was something happening, intellectually. Because ideas were very important to him, in a way that I would say he has moved away from now. But at that time, I guess, he was studying Zen, and involved with, perhaps, what he was teaching; involved with a lot of younger people in other disciplines. He was always very good at finding ideas that could connect and separate disciplines. It always seemed interesting to him to form an idea about the relationships among these different kinds of activities.

BK: *Did you feel that for yourself?*

JJ: Oh of course, because he is one of the main people I had any social life with who was constantly expressing ideas, and deliberately organizing ideas, I would say. That's very useful to me, because (I would say) my idea of an idea was not as sophisticated as John's idea of an idea (laughs), at that time, or maybe now too. To me he was like a magician, that he could do this. He was like a teacher, and this kind of ability or interest, whatever it was, seemed to come from a very superior position, and yet he always seemed generous in explaining, or saying... however to put it. You thought that you were learning something, or I felt that I was learning something, usually, when I was around John. It was just an automatic feeling that I had. So of course he influenced me a great deal.

BK: *What about Barney?*

JJ: I was never around Barney that much. I liked Barney a lot. The degree to which I was exposed to Barney.... The time during which I was closest to Barney was later, after I had begun showing my work and had some ground to stand on. Whereas I met John earlier than that.

BK: *At that time, Bob was never really involved with ideas in that sense?*

JJ: Not in that way, but [he was] very much [involved] in ideas, certainly, in the making of [his] art. I was around that; that was very important to me. In fact it was more important to me than the relationship to John. It was closer to what I was doing.

BK: *Did you see the Stable Gallery shows? Bob had two or three?*

JJ: No, I think he had one with Cy [Twombly], and I think that's all. He showed the red paintings at Egan [the Charles Egan Gallery].

BK: *So when did you first see his work?*

JJ: I think I first saw his work just before he began the red paintings, or maybe he had begun to work on them, I don't know. I remember in his loft some of the white paintings and the black paintings that had been shown at the Stable [Gallery], I think.

BK: *Whatever happened to the white paintings?*

JJ: He remade some of them. At that time he used them as canvases, and worked on top of them. Then later (ten or fifteen years ago) I think he remade them.

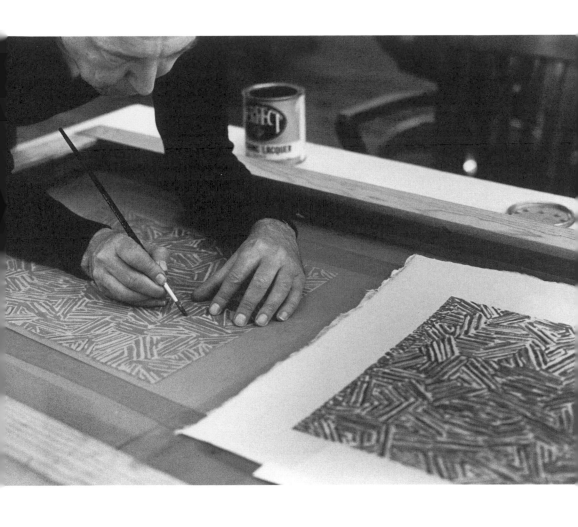

Working on a screenprint at Simca Print Artists,
New York, in 1980. Photograph: Katrina Martin;
taken during the shooting of her film *Hanafuda/
Jasper Johns* (1981).

BK: *What about Leo?*

JJ: I didn't know him until he came down to Pearl Street, where Bob and I had studios. He had just opened his gallery.

BK: *It's that story; he went to see Bob....*

JJ: I had a painting in a show at the Jewish Museum.[20]

BK: *The [art historian Meyer] Schapiro show?*

JJ: Whose show was it? Not Meyer's. I don't know how that came to be.

BK: *Kaprow sort of initiated it.*

JJ: Oh, he was certainly responsible for my being in it.

BK: *And then [Kaprow] called in Schapiro and there was the question of what to take out....*

JM: *Well, Schapiro confirmed his choices, but the Jewish Museum itself was very nervous about some of the paintings. They called in Schapiro, whom they considered more of an expert than Allan was.*

JJ: Do you want to hear my version? Because that was very interesting. Allan said he was advising this man who was organizing a show at the Jewish Museum, and that he would like to bring him by to look at my work, and Bob's. He had the name of one of the Dadaists... Richter. So he was going to bring in Mr. Richter, and I assumed it was the Dada [Hans] Richter. And there arrived this man who grew peaches in North Carolina or something. He wasn't Hans Richter at all. He wasn't the Dadaist. So Richter[21] looked at my work and said that he wanted to have two of my paintings in the show. If there was room, he would like to have a third painting in the show, and that I should send up three paintings. This was done. Among the paintings of Bob's that Richter picked, there was the painting with the goat that's in Stockholm [*Monogram*, 1955–59]. But at this time the goat had a different form; the painting hung on a wall and there was a shelf, and the goat stood on the shelf, and under the shelf there were light bulbs which shone down on another part of the painting. So to get it up to the Jewish Museum it had to be disassembled. And on a Sunday morning Bob said, "Would you please go with me to the Jewish Museum to put my painting together." And I said, "Sure," so we went up there.

We walked into what appeared to be a jury looking at these works. There had been no mention of anything, the only thing that Mr. Richter had told me was that he would definitely show two of these paintings, and would like to show a third one. There was *White Flag* and something else; it could have been *Tango*, I can't remember. We walked into this very big room; there were these people looking at pictures, putting some here, and some over there. And obviously the ones over there were the noes and the ones over here were the yeses. And Mr. Richter, I guess, introduced me to Mr. Schapiro; we said "How do you do," and I helped Bob put his goat on his painting. Mr. Richter came to me and said, "Jasper, I think you should speak to Dr. Schapiro about your paintings." And I said, "I have nothing to say to Dr. Schapiro about my paintings," and (let me get it right) then I think I said, "I'm going home," and I started walking out through this huge room, and as I did, Richter yelled out and said,

"Dr. Schapiro, Jasper Johns would like to speak with you about his work." Do you know Meyer? He is a very modest and gentle man. Meyer Schapiro turned and smiled. I said, "Dr. Schapiro, I assume that means I am supposed to talk to you about my work, but I have nothing to say." And Meyer was embarrassed and said something, and we stood there exchanging a few words. And this man approached and said. "Oh Dr. Schapiro, there is another painting of Jasper Johns and there just wasn't room for it in here, so we have it in another space"—it's a huge space with thousands of paintings! We walked through a hall or something, and opened a broom closet, and in it was my *Target with Plaster Casts.*

I was livid; I didn't know what to do, and I was also very polite. They pulled this thing out and Meyer Schapiro and these people started looking at it. I went back in and said something to Bob: "I'm getting out of here, when you finish, come on back; I'm furious!" Then this man came in and said, "Jasper, Meyer Schapiro likes that painting of yours very much, and thinks it ought to be in the exhibition. But my colleagues tell me that if it's in the show, I will lose my job. Now would it be all right with you if we close some of the compartments?" There were plaster casts, and one of them was a penis. "And wouldn't that add to the mystery of the piece?" I said, "Perhaps it would, but mystery is not something of any particular interest to me. If I had wanted to add mystery to the piece, perhaps I would have already done it (laughs). I think you should send my work back to my studio." I left, went home, and started writing a letter, complaining that this man had represented himself as selecting an exhibition not having anything to do with a jury, and of course to organize such thoughts took me a long time (laughs). And the telephone rings, and there was a man, whose name I can't remember, Dr. Somebody, that I had been introduced to while I was in this situation up at the Jewish Museum; a very nice man. At any rate, he said, "This is Dr. so-and-so, and I would like to come down to your studio to select a painting for this exhibition."

BK: *Had they sent back the three others?*

JJ: I don't know that [my other works] had been sent back yet or not; I don't think so, because it was almost immediately, like the following day. I said, "Come along." This man came down to the studio and looked around and went around talking about Zen and the art of archery and all that stuff; he was very sweet. He picked this *Green Target* and said, "We would like to have this in the show." I said fine; and it went up and was in the show. That's when Leo saw that painting of mine. It's very interesting, and it was really Allan's doing, that whole thing. Nobody else knew my work. Allan knew it.

BK: *What about Bob? Did the goat get in the show?*

JJ: Something got in, but something very slight.[22] Certainly not the goat; no, no, no. I think even Meyer thought that was…. I don't know how he would have stated it, but he didn't think it was art.

BK: *So he didn't catch on, did he?*

JJ: I don't know about catching on, but I don't know what his role was there.

Obviously something happened. Either things were misrepresented, or things were done and then somebody higher up said this has to be changed. I don't know what happened. I can just tell you my experience.

BK: *Well, Allan advised it…*

JJ: I suspect that's true; I suspect this Mr. Richter simply didn't know very much and that Allan just told him what to do, and then when it was done, some of the people didn't like Allan's aesthetics and judgment.

JM: *He said that he had a piece that they took out; it's possible even that they put it in the show; I can't quite remember…* [23]

JJ: I don't know. And Leo Steinberg gave a talk about that show just before it opened. I mean it caused me so much anger that I don't really remember the situation. I didn't hang around (laughs). And the fallout of it, of course, was wonderful for me, because of my connection with Leo which was triggered by that. […]

BK: *Who else was in it? Was it a very large show?*

JJ: Very large, yes. It was about New York School painting. I imagine Al Leslie and Joan [Mitchell] were in it. Certainly, everybody. And I guess some of the people from that gallery on Central Park South; some of the Hansa people. [24]

BK: *Do you think the jury was a last-minute idea?*

JJ: I don't know. I really don't know. I'm not sure it would have been called a jury; I don't know what it was. That's what it looked like.

BK: *So what happened with Leo then—he saw your painting? Had he started his gallery already?*

JJ: Either he had just started it or… […] [25]

BK: *Has Leo changed much since then?*

JJ: I don't know. He is probably still very much the same. Paul Brach used to do a wonderful imitation of him shaking hands, saying hello while looking at his watch. I think he was thought to be very smooth, and he's still thought to be very smooth, in that respect.

BK: *Did you meet Michael?*

JJ: Michael Sonnabend? No, not until a bit later; but close to that time.

BK: *Your first show was in 1958. Did Leo decide that immediately?*

JJ: Leo said, "I think I would like to give you a show. Would you like to come and look at the gallery, and see what you think about it." So I did. Then (I don't know what time of year that was) he made a group show at the end of the year [1957], and then went away and came back, and then I had a show.

BK: *Were you present, and was it [Museum of Modern Art curator] Dorothy Miller or [Museum of Modern Art director] Alfred Barr who came?*

JJ: I think both of them. Alfred Barr came and called Dorothy.

BK: *[So that's how Dorothy Miller included your works in the "Sixteen Americans" show about a year later].* [26] *You must have been surprised when they bought the paintings.*

JJ: Of course.

BK: *How did Barr manage? He had some kind of limit on how much money he could*

spend at his discretion.

JJ: Surely mine didn't go above the limit (laughs). I don't know what the total of the three paintings cost altogether, not very much.

BK: *Was it known that he bought paintings of young artists? Was it known to the community?*

JJ: I didn't know it. I didn't know anything about how it worked.

JM: *You say you were in the group show that Leo did before that?*

JJ: Yes, I was. I had the *Flag* that is at the Modern now and that Philip [Johnson] bought. I think that's what was in that show, hanging above a Marisol sculpture....

BK: *In bronze?*

JJ: No, of wood, and I think on wheels. I'm not certain, I may be wrong about that.

BK: *When did Steinberg write his article?*

JJ: After I had a couple of shows.

BK: *Did he talk to you?*

JJ: Oh yes. Much of the work was at the studio. He visited to see it.

BK: *Did you have any sense of the whole business with Clement Greenberg and his whole dialectic of modern art, his approach to art?*

JJ: I knew that Clem existed. I never read Clem's criticism, except a couple of magazine articles. I guess he was very involved with that gallery where Gagosian is now: French and Company. He was involved in that, wasn't he? [...]

BK: *Did you have any personal contacts with him?*

JJ: With Clem? At some point I did. I think he wrote something about me. I think he did; I'm not sure where or what.²⁷ I remember once he and his wife came to Charleston, South Carolina, and they were supposed to come out to my place, but they didn't and I drove into town to have dinner with them.

BK: *Did you have any sense of his political [stand]?*

JJ: I don't have that kind of sense of anything about him; I just thought he was a person identified with a certain group of artists and a certain group of ideas. [...]

BK: *Did you have any contact with [Artnews editor Thomas] Hess?*

JJ: No. I had very little contact with Hess ever. But he was responsible for using a painting of mine on the cover of *Artnews* during my first show.²⁸ But I met him later, I don't know when, and saw very little of him.

BK: *What about the "Sixteen Americans"? Had you met Stella?*

JJ: Yes.

BK: *Barbara Rose and Stella? [...]*

JJ: Yes, I had met Frank and advised him not to be in that show.

BK: *Why?*

JJ: I thought it was going to be too sensational, his being in it without having done anything else, and I thought that he should have a show first. He didn't take my advice, but it didn't seem to hurt him.

BK: *It was true; it was sensational.*

JJ: Yes, it was. [...]

JM: *But did they look that different from anything else in the show?*

JJ: It was full of things that looked different one from the other.

JM: *That's true.*

BK: *Did you have the impression that the show was put together by Miller or by Barr, or both?*

JJ: By Miller. I think all of those shows were her shows, those "Americans." I don't know how many she did. She was very close to Barr, worshiped him, adored him, so I doubt that there was any opposition, but it was her doing it.[29] [...]

BK: *Did you have any contact with Al Leslie? or other younger....*

JJ: I had very little contact with other artists that early; but I met Al at the Cedar Bar. [...]

BK: *Apart from Philip and the [Museum of] Modern [Art], were there any other collectors who were buying anything? Did [Ben Heller] buy anything?*

JJ: Yes. He not only bought a painting, he wrote about my work. [...]

BK: *When was your first contact with Europe?*

JJ: Well I don't remember the first show. Leo made a show in Europe; I didn't go. I think it was in Paris and in Italy, but I'm not certain. The first time I went to Europe was... I don't remember the year... I had a show at the [Galerie] Rive Droite, it was probably '63 or '64: *0 through 9* paintings. It was a series that I did for the show. [...][30]

[...] All of my shows were Leo's doing.

BK: *[...] Does Leo have all the archives, or is that you?*

JJ: I would suggest that you compare the two. Leo is often wrong, but sometimes we are wrong. [...]

BK: *Did you have contacts with Alan Solomon?*

JJ: Did I? Well, a fair amount, because I met Alan when he was up at Cornell. When Bob and I had studios on Front Street, Alan came by a few times, to look at work. When he took over the Jewish Museum, of course he did shows with each of us.

BK: *I don't remember if we talked about this with Gene Moore: did you do any of the windows?*

JJ: Certainly. [...] We [Rauschenberg and Johns] did the things that went into the windows. It's very important, and it's constantly presented in another way.

JM: *Some of those objects are most impressive; the fruit displays....*

JJ: I think they look awful in photographs. They looked much better. Well, it was one thing to look at them, but it was almost impossible to photograph them through the windows at night. They always have to do it at night, and it's a very difficult thing to do. [...]

Gene was very helpful to Bob and me, letting us do so much work, because most people he only used once a year. He used us quite a lot.

JM: *Did he ever put your name in the window [to indicate] that you'd done it?*

JJ: We made up a name that we used [Matson Jones]. Because we did it as a separate enterprise. We didn't do it as our own work. We thought of it as something else.

BK: *Did you do other things to survive?*

JJ: I would say yes, but I don't know what you're talking about (laughs).

BK: *You didn't teach?*

JJ: No, I never taught. No, during that period of time that's how we did survive, by making objects to be used in display.

[...] I remember [Gene] had some shoes made as a display item. They were shoes covered with peacock feathers, made into slippers, which were sold immediately (laughs).

JM: *He says now that he tends to use just works of artists.*

JJ: He did that sort of once a year at Bonwit's. He would do windows with a work by each of the artists. I had work there shown twice; once a small white flag of mine—well, it was not so small: about seven feet long. Once a *Flag on Orange Field* of mine was shown.

JM: *So each one would have a different artist?*

JJ: Yes. [...]

BK: *Did you know about Duchamp before the Lebel book came out?*

JJ: I knew the name, as a student at South Carolina; I knew about the Mona Lisa's mustache. I mean, everybody must know. But that's as much as I knew. But I don't know that I had any ideas about what that meant, or who had done it, or what it meant that this man had done it; and I don't think my interest was triggered to find out anything about Duchamp. So it's really after I had shown work here. Well, there's a combination of things. When I was in that group show at Leo's, there was a suggestion of Neo-Dada, and I didn't know what Dada was. And I think Bob Rauschenberg had an interest already in Duchamp, and perhaps had seen the show that [Sidney] Janis had done; I don't know when it was. I'm not sure that that's right. And John of course sometimes referred to Marcel. At any rate, when the Lebel book appeared, it must have been when I read a book called *Dada and Surrealist Papers*, that Wittenborn book[31] ... I read that, I think, then Bob and I went to Philadelphia to look at the Arensberg collection. I don't know the order of these things; they all happened very quickly together. And then the Lebel book appeared and was remaindered, and that's when I got it, when it was remaindered (laughs). Then I was able to read it.

BK: *But your work was already set by then ...*

JJ: Well, some of it, certainly.

BK: *I mean, you weren't influenced in that sense. Did it represent a breaking?*

JJ: No, I would say it represented a reinforcement, when I found out about Marcel's work and Calas brought Marcel down to the studio at some point to look at work. Then after that I occasionally saw him.

BK: *So you met Calas through the exhibition at Leo?*

JJ: Yes. I remember seeing him standing there, and thinking how tall he was standing there.

BK: *So then did you meet Teeny and Marcel at their house?*

JJ: Well, I met them separately. I think I met Teeny at a party by herself. And I

With an untitled painting from 1984, in 1984.
Photograph: Mark Lancaster.

Working on a print based on the *Seasons* paintings
at ULAE, West Islip, New York, 1989. Photograph:
Hans Namuth.

think I first met Marcel at one of two places, either at Nicolas's house, when Peggy Guggenheim was there, or at the house of the woman who used to work at the Metropolitan with [Hale?]; what is her name? Black hair…She had a kind of open house every Friday—a party or something—and she visited Bob and me. And Marcel was there playing chess and I saw him, but I didn't speak to him. And then I think I met him at Nicolas's and then Nicolas brought him down to the loft. And then I met Teeny somewhere down the line, I don't know how we had any further contact, but we did. I went to dinner a couple of times at the Duchamps. I bought a *Green Box* from him. Bob and I had Christmas dinner in Chinatown with him once, when he had just done a TV show I think with [Mike?] Wallace, or radio; I don't know. And he said that wonderful thing to me. He said two wonderful things, but one was [about how stopping painting was like breaking your leg].[32] The other thing he said at that point—we were eating lemon chicken, and Teeny said, "Oh Marcel, you're eating so much tonight." And I said, "He is not, he's hardly eaten anything. He's taken about three bites." And Marcel said, "The least things seem to fill me up" (laughs).

BK: *Did you sense any connection between him and John?*

JJ: Well, on that same evening, something came up about that, and John's interest in multiplicity. And Marcel said that to him, to get to the figure three implied multiplicity, and he was not interested in it beyond that.

BK: *[inaudible] I don't know, maybe today they can do it, because of computers [inaudible]. Did you see the [Jean] Tinguely machine [*Homage to New York, 1962*]?*

JJ: The one that destroyed itself? No, I wasn't here; I think I was in South Carolina at that time.

BK: *You were not involved with any of the Martha Jackson shows? Those two shows, "New Forms New Media"?*[33]

JJ: A painting of mine was in there. That's the show Claes [Oldenburg] did the announcement for. My *Target with Four Faces* was in that. I don't know about another one; I only know about one. […] I don't remember what was in it; I just remember that Claes did the announcement. I can't remember what it was, with all the names of the artists; I think I was part of it. […] Leo objected to where my painting was hanging, I remember.

JM: *He told her?*

JJ: Yes.

JM: *Did she change it?*

JJ: That I don't remember; I just thought how odd, that one would object to where a picture is; that Leo wanted it somewhere that he thought was a better position. […]

JM: *What is it about Merce [Cunningham]. Merce was a very different kind of person from John….*

JJ: Well, Merce was tied to his company, and to his class. He taught classes, whether it gave him an income, I assume [it] did, but I don't know. I never really understood if it had that function or whether it was just a way to clarify his ideas. Probably both. And then he was always making dances, so he was

less available than John at that time. He still is, because now they're both so busy running around. Merce has tended always to work until he was exhausted. He just followed that pattern.

BK: *Did you see any of the Happenings?*

JJ: Yes. I saw Red Grooms's *Burning Building* [1959]. I don't know whether that could be called a Happening but that was something I liked a lot. I think I saw it twice, down on Delancey Street. And I was in one of Allan's. Bob and I had been recruited by Allan to perform one of his. And I have forgotten what I saw, or what I didn't see. I think I saw one of Jim Dine's, I don't know if I saw one of Claes's. But I must have.

BK: *Did you have any sense about the younger generation?*

JJ: Younger than who, me?

BK: *Like Roy [Lichtenstein], Jim, and Andy [Warhol], who came out later.*

JJ: I can't remember what kind of sense I had. I remember a general sense of there being "others," but one was very preoccupied with oneself (laughs).

BK: *It's called survival.*

JJ: Well that and also just the energy was all focused on your idea, so it didn't, or at least mine didn't, really go out very much to other people.

BK: *I think that was true about almost everybody.... Allan was sort of the only person....*

JJ: Well I wonder if that was affected by ... I mean maybe it's a difference in personality, but Allan was affected by the habit of teaching. Because teachers, obviously have to have some concern for other people (laughs).

I-63. Paul Taylor, "Soho's Avant-Guardian," *Connoisseur*, September 1991, p. 102. An article on the art dealer Ileana Sonnabend.

[...] Castelli's greatest early successes were with Rauschenberg and the young, previously unknown Jasper Johns, whom he and Ileana discovered by accident while visiting Rauschenberg. [...] When Castelli heard that Johns, an artist whose work he had spotted in a group exhibition,[34] *was somewhere in the building, he visited Johns's studio, became elated, forgot about Rauschenberg, and left filled with plans for Johns instead. Rauschenberg was speechless. Many accounts of this episode have the distraught artist subsequently running to the gallery and being consoled by Ileana, who promised him a show soon after Johns's.*

But this version is contradicted by Johns, who says he actually swung the deal for his friend. "I have heard Leo's report and I've heard Ileana's and I've heard Bob's and none of them jibes with my own memory," *says Johns. Johns remembers a party two months after the studio visit:* "Leo said he was going away for the summer and that when he came back he thought he might like to give me a show and he would be very interested to see what I had done. And I said, 'What about Bob?'"

[...] [In c. 1961] Johns and Rauschenberg had a bitter breakup, and Rauschenberg moved to Florida. Then the rivalries set in for real. Johns, who is normally silent on such matters, states, "I suppose I learned more about painting from Bob than I learned from any other artist or teacher, and working as closely as we did and

more or less in isolation, we developed a strong feeling of kinship. When that ended, each of us seemed to develop—where there had been none before—some sense of self-interest."

And he offers a similar comment about Leo and Ileana. "I have the feeling that at a certain point Leo wanted to manifest his own taste more clearly and make it known that it was his. I would say that it was when they split up. That's very hard to read because it's difficult to tell what was going on in a situation like that. But if you follow what Ileana has done since, she's certainly made strong decisions that have nothing to do with Leo's taste." [...]

I-64. Mark Rosenthal, "Jasper Johns," in *Artists at Gemini G.E.L.: Celebrating the 25th Year*, exh. cat. (New York: Harry N. Abrams, Inc., in association with Gemini G.E.L., Los Angeles, 1993), pp. 58–67. Prepared in conjunction with the exhibition "Both Art and Life: Gemini G.E.L. at 25," at the Newport Harbor Art Museum, Newport Beach, Calif., 1992. Interview conducted on September 2, 1992, in New York.

MR: *How many plates were used with each of these lithographs [two untitled prints of 1992, reproduced in* Artists at Gemini G.E.L. *on pp. 64 and 65]?*

JJ: I counted five, some of which were used for more than one color.

MR: *Does a print with so many plates involve more planning than usual?*

JJ: Oh yes, since you can only put certain things on a plate and if you are going to use colors, you have to use different plates.

MR: *Do you enjoy that process?*

JJ: Well, of course, or I wouldn't have been doing it since 1960!

 Working with this medium is interesting because it has to do in part with time: whether you think of something before or whether you think of it after, whether you do something that shows or whether you do something that doesn't show when you did it or how you did it. It's very different from painting or drawing, in which everything on the surface can at any moment be changed. When something is printed, it has to be done in an order. You have to consider how it can be printed, and how it will be printed. And, of course, it's also a problem in economics, because every new plate you add to a print means that much more work for the printers. One thinks of their time and interest in the project. Part of the pleasure of printmaking is, of course, that you work with other people, whereas in painting you don't. At least I don't.

MR: *What was it like to go to Los Angeles to work at Gemini? Was it in part a vacation?*

JJ: No. I never go anywhere to work that I think of as a vacation. I feel too much anxiety about my work. But I enjoyed it very much, working at Gemini. It was there, I guess, that I developed a pattern of working in series, because I would go out there for a certain length of time. Here in New York I was used to going to a print workshop for just a day. At Gemini, I usually thought of a group of related works that I could concentrate on during several weeks.

MR: *Is there a particular painting that relates to these latest prints?*

JJ: Several paintings relate to them, but in a piecemeal fashion. And a number of recent drawings contain similar elements.

MR: *Is that a trompe l'oeil frame?*

JJ: You mean the wooden part? I think of it as the back of a stretcher. I hadn't thought of it as a frame. You see, here I have the little stretcher keys.

MR: *Are these letters reversed?*

JJ: The letters are not reversed; they are simply upside down. I intended that they be reversed, but after I had drawn them, I realized that I had drawn them backwards, so they print forwards.

MR: *Have you ever before played with the illusion of the folded-over piece of paper?*

JJ: I have on occasion. There is a drawing of flags from 1969 in which a corner has been bent back, something like this. But it began again when I made a poster for the Festival d'Automne in Paris last year. Someone had given me a Piranesi [the engraving *Del Castello Dell'Acqua Giulia*, 1761], and I was taken by his representation of folded paper, curling paper, so I used something like that in the poster. I have used it a couple of times since.

MR: *How did you decide to use the device of the folded paper at Gemini?*

JJ: It was something amusing to play with. At first glance the Piranesi seemed to represent architectural studies. Later I saw another level of representation, suggesting that the studies were on several unrolled sheets or pages. This complication, this other degree of "reality" or "unreality," interested me.

MR: *What is the image you've paired with a Barnett Newman drawing?*

JJ: Both small images represent drawings of Barney's, maybe upside down or backwards.

MR: *And the general background of the pictures is from the Grünewald altarpiece?*

JJ: Yes. The tracing was made from the detail of the fallen soldiers [in *Resurrection*, a section of the altarpiece]. I think they're in a state of awe.

MR: *What is the source of the swirling pattern?*

JJ: That's based on a photograph of a spiral galaxy. As I worked on copperplates for my *Seasons* etchings, some of the stars turned into small spirals. More recently, I've worked with the galaxy image on a larger scale.

MR: *In the last decade or so, it seems as if your work has increasingly been based on a kind of collage aesthetic, combining things that you've used before. Is that a fair comment?*

JJ: It's certainly an ongoing activity, though countered by other things. Existing units become details in other works; something connects the images, but I don't know what it is. It's difficult to understand because it's not based on a decision, but on the activity of making pictures.

MR: *I've been fascinated by seeing the combination of Newman and Grünewald in your work of the last few years.*

JJ: One thing that is interesting about art—about painting—is that we accept so many different kinds of things as painting. And certainly these seem superficially to suggest two poles—the Grünewald and the Newman.

MR: *It seems as if the 1982 painting* In the Studio *was the beginning of a very*

dramatic change in your work. When you look back, does that seem true?

JJ: I continue to use the indication of a receding plane, which I think I first used there.

MR: *The familiar vase that you've used, with the profiles of Queen Elizabeth and Prince Philip, seems to have a new coloring here.*

JJ: The patterning was suggested by George Ohr's pots, that kind of stippling and spotting.

MR: *Will the imagery in these two new prints continue into other works?*

JJ: I have no idea. I'm working on a painting that somehow relates to these. I don't know what will follow it. I find that if I use something (I don't know what "something" means, but "something"), I tend to use it again, even though I had no intention of using it again. In such circumstances, I don't know if something is a source or a kind of habit—whether it's a good thing or a bad thing. I just know that I do it. I've used the Newman drawings in too many things for my taste, but that's the way my mind works. I can't do what I don't think to do.

MR: *Is it fair to call your frequent citations of Newman and Grünewald an act of homage?*

JJ: I don't know whether that's the word or not. Obviously, it reflects an interest of mine. But I don't know whether "homage" is the right word.

MR: *In other words, inclusion doesn't show a lack of interest.*

JJ: Yes, exactly.

MR: *Have you titled these prints, or do you plan to?*

JJ: No. I think they will be untitled. I've thought about that. I would like to give works titles; but when I repeat so many images, I have to title them all the same, or number them. So I think they'll just be untitled.

MR: *Regarding the print you did to benefit the Harvey Gantt [North Carolina Senate] campaign [*Untitled, *1990; reproduced in* Artists at Gemini G.E.L. *on p. 183], is the Grünewald detail that of the demon of the plague, from the* Temptation of Saint Anthony *[section of the Altarpiece]?*

JJ: He is the demon, yes, upside down.

MR: *How did you begin to use that shroudlike effect?*

JJ: That started in some untitled etchings I did in Paris, and then appeared again in *Perilous Night* (1982). It may have been triggered by a print of Picasso's that hung in Aldo Crommelynck's room, where we often had lunch—a print of a weeping woman with a handkerchief. In her hand? Between her teeth? Such things are represented, but they're thin somehow. They are, as you were suggesting earlier, like collage, because they have no great depth.

MR: *The image that can be seen as either a duck or a rabbit has its source in the writings of Ludwig Wittgenstein, but was your interest in it based on a philosophical point made by him?*

JJ: No. What interests me, in part, is that something can be seen in two different ways, and the question whether seeing it one way necessarily obliterates seeing it the other way. Or whether it's possible to see both at once.

MR: *What do you find to be the case?*

JJ: I don't know. Sometimes I think that I'm able to see two things at once, but I'm not sure, because I play with that kind of material so much that there are probably very rapid shifts of perception.

MR: *That would be something to strive for.*

JJ: Maybe it's something we do all the time. Certainly we can watch a television program and read the weather report that's being scrolled along the bottom of the screen at the same time. So what we see is made up, perhaps, of lots of things. In seeing one thing we probably see many.

MR: *I wonder, though, with something as tricky as the duck-rabbit image, if the same can happen.*

JJ: I don't know. As well as I can understand from what I've read, it's somewhat uncertain. But it may be possible.

I-65. Milton Esterow, "The Second Time Around," *Artnews* 92 no. 6 (Summer 1993): 148–49.

[...] Artnews *asked artists, historians, collectors, and dealers: Do artists change a work of art after it leaves the studio?* [...]

In the 1960s I made a painting in Edisto Beach, South Carolina, where I lived at that time. I had to go to New York and wanted the painting sent there. I gave it to a gentleman who did work near the town and asked him to make a crate for it and send it to me. When the painting arrived in New York, I found that instead of making a crate he had used the painting itself as the sides of the box and simply nailed two pieces of plywood to either side. The painting was surrounded by an interior frame of nail holes when it got to New York. There was a nail hole through the painting about every three inches.

I had to fill those in. I just continued painting the painting over the holes, disguising the holes. The painting is now in a private collection.

Then there was the painting based on Bucky [Buckminster] Fuller's map that had been commissioned by Alan Solomon to go into Bucky's big dome at the Montreal World's Fair [in 1967]. I made this very large painting that I was never able to see in one piece. It was made up of a group of triangular sections, following the divisions in Bucky's map.

When I finished the painting, I sent it up to Montreal. Then I went to the fair to look at it. It was the first time I had seen the painting put together. I didn't like it. It just looked like a map to me. When I got the painting back—by then I had moved into a very large space down on Houston Street in New York City—I could have it all together and look at it as one thing. I completely repainted it.

I can't remember any other occasions when I changed a painting after it left my studio. But I've had things like accidents happen to paintings, and I've had to repair them.

Once, I had put up a temporary wall in my studio. Someone at a party leaned against the wall and knocked the wall over. On the back of the wall was

the flag painting that now belongs to The Museum of Modern Art. The painting was damaged.

The painting consists of a kind of collage of newspapers. When I had to repair it, which was several years after I had finished it, I used current newspapers. The newspapers were of a much later date than the painting is dated.

Well, someone at the museum was very upset when they discovered these bits of paper with the wrong date on them and thought I had falsified the date. They thought I had said I had done the painting earlier than I had done it. Until I explained what happened.

I-66. Bryan Robertson and Tim Marlow, "Jasper Johns," *Tate: The Art Magazine* (London) no. 1 (Winter 1993): 40–47. Published on the occasion of the exhibition "American Art in the Twentieth Century," at the Royal Academy of Arts, London.

[…] BR: *We've seen very little of your work in London in the past few years, Jasper. When you have a show you arrive for the opening and then depart almost immediately. Have you ever considered spending longer in Europe working, or do you feel unhappy, like most artists, away from your studio?*

JJ: I've traveled very little. That's why I have a studio in the Caribbean: it's not like traveling, it's more like home—like going into the next room.

TM: *The Royal Academy survey of American art in the twentieth century has nothing you did after 1963. Do you resent the historical fixation with your earlier work?*

JJ: I haven't thought about it at all. I think it's very easy, in a linear way, to give my earlier work a sense of influence or importance … or placement, so it's not surprising that the focus remains on it in large survey shows.

TM: *As you say, curators and art historians tend to focus on the idea of significant works as staging posts with which to map artists' careers. Do you find this approach convincing?*

JJ: No. I don't see my own paintings in those terms. I'm just wondering if I can see other people's art in that way … and I think the answer is still no. There are works by other artists which remain significant for me over a long period of time. I may refer to them in my painting. But a particular work may seem important at one time and later lose its significance. Then it's difficult to recapture the memory.

BR: *How did you first meet Marcel Duchamp?*

JJ: In 1959 or 1960, Nicolas Calas brought him to Front Street where Bob Rauschenberg and I had studios. Nico thought Marcel might enjoy seeing our work. […]

BR: *How did you find him, meeting for the first time?*

JJ: He was reserved and charming.…

BR: *And witty?*

JJ: I guess … well, let's say he was.

TM: *Do you still feel affinities with the spirit of Duchamp?*

JJ: Yes, but he has qualities that are foreign to my nature. I think he's more cheerful in his skepticism and more detached.

TM: *Does that make you subjective and morbid, at least in comparison?*

JJ: I'm aware of my own morbidity, my feelings of shortcoming. One senses these things in oneself, a whole range of things to be overcome, that one doesn't in other people. This makes it difficult, impossible even, to compare oneself with or judge others.

BR: *Did you and Duchamp talk much about painting?*

JJ: Very little. He had a reputation even then for no longer working. He was a good deal older than me and I had no sense that he would be interested in the questions that I had to ask. But that's not to say that past experiences and his judgment on present experiences weren't interesting to me. They were.

BR: *Were there any American painters whom you admired, not necessarily contemporaries?*

JJ: A number, I guess: Eakins, Marin, and the older painters who were alive and working then: Rothko, Newman, de Kooning, Kline ... but they were distant in my thinking. I met a number of them and was friendly with them. I saw Barney [Newman] more than the others. He appeared to be interested in the work of younger artists, but I wouldn't say we were ever close.

BR: *How did you come to know Merce Cunningham? And how did his work seem to you at the time?*

JJ: I met him around 1953 after a performance I saw. He was teaching and making dances for his company and was already working with John Cage. What interested me initially wasn't just the movement but also the music he worked with, which was unfamiliar to me. Not just Cage, but [Erik] Satie, Gottschalk, Pierre Schaeffer, [Pierre] Boulez, and others. Later, Bob Rauschenberg had been doing sets and costumes for the Cunningham Company, and he traveled with them working on site, and then he resigned and they asked me to do it. I declined but said that I would try to get other people to design, and so that became my job. I persuaded Stella, Warhol, Neil Jenney, Bob Morris, and Bruce Nauman to design, although I sometimes ended up executing them myself. In 1968, I supervised a set based on Marcel Duchamp's *Large Glass* for Cunningham's *Walkaround Time*, and in 1970 made costumes for *Second Hand*. I designed the decor for *Un Jour ou deux* at the Paris Opéra Ballet in 1973. All three dances use Cage's music.

BR: *Has your friendship with Cage and Cunningham affected your work in any way? In the sense, maybe, of dramatic presentation?*

JJ: Certainly. I can't say exactly how, but for a period of time, Cage, Cunningham, Rauschenberg, and I saw each other frequently and exchanged ideas. John [Cage] was very interested in presenting his ideas to other people, so it was impossible to be around and not to learn.

BR: *Did he listen?*

JJ: Yes, but usually he thought his own ideas were more interesting. He could apply his ideas on space and time to painting or music or architecture. I am

not able to point to his direct influence.... I don't have a clear sense of cause and effect in my painting, but it is probably there.

BR: *Does the idea of variations in speed in your work interest you? I certainly sense it, particularly in contrasting sections of certain diptych paintings.*

JJ: Speed has interested me a lot, but that kind of thing often becomes diminished by other factors involved, so it's not always in the foreground of what I do. But sometimes the sense of things having been done at different speeds within one work is interesting to me.

TM: *Is painting a cathartic process for you?*

JJ: *I* don't see it as a cathartic process. I have a sense that it's necessary. For me, catharsis suggests a sense of release or energy spent ... but there's no sense of this or of accomplishment involved, or if there is, it must have only the slightest suggestion of duration because the anxiety always seems present when I finish a work.

TM: *There seems to be an immense amount of control in your work with little room left for accident. Are you interested in chance as a creative force?*

JJ: I tend not to think that accident exists, although I'm very grateful when it happens. I will sometimes apply ink on a sheet of plastic and let it dry. I put it there and it does something. It performs independently. Now, some people would see that as chance, but I would see it simply as a way of working. The idea of chance seems to suggest something more haphazard in the way that things interact. I'd love not to be in control, but that's not what I'm interested in. I think there's a play between the subjective and the objective that is in operation constantly when I'm working that tackles the idea of chance from both directions.

BR: *There seems to be a part of your work in which nocturnal mood predominates. It's not morbid or haunting, but it certainly creates a strange sensation. I'm think-ing of* Diver *(1963),* Night Driver *(1960), and* Perilous Night *(1982) as examples.*

JJ: I can't say it's something of which I'm strongly aware, but in the works that you mention there is a sense of darkness which was part of the intention, coupled with a feeling of anxiety.

TM: *Is anxiety a reason for painting?*

JJ: I don't know what makes people work or incapable of working.

TM: *So why do you still want to draw or paint?*

JJ: I don't know. I could say that it's simply what I do, but that's the problem: I don't think I do it to do anything. I think the cause is more hidden. I don't like the word compulsive, but there's no other word really. It's my nature to do it.

BR: *There are submerged references to the Isenheim Altarpiece by Grünewald in some of your recent paintings and drawings. So much in twentieth-century art seems to have come out of it: aspects of Picasso, Bacon, Matta, [Graham] Sutherland, [Alberto] Giacometti—the list is endless. How has it touched you?*

JJ: I've made tracings of various details: the afflicted demon near Saint Anthony, two soldiers from *The Resurrection* who seem to have collapsed in awe. I trav-eled to see the painting, but I traced from a portfolio of reproductions that I

had been given. I was attracted to the qualities conveyed by the delineation of the forms and I wanted to see if this might be freed from the narrative. I hoped to bypass the expressiveness of the imagery, yet to retain the expressiveness of the structure. In some tracings, this seemed to happen, but not in others.

BR: *What first drew you to the idea of deploying some sort of measuring device as an object or an image in your work? I'm thinking of protractors or calipers, a ruler or chromatic scale, for example.*

JJ: I suppose that has to do with an interest in the idea of measurement and with the play of what measures against that which can or cannot be measured. A work may be the result of following or investigating some procedures and the work may reveal a connection to that procedure. I've made works which obviously contain signs of their making, but some works do not or cannot display such signs.

BR: *Is there any sense in my notion that the flagstone shapes that appeared in 1967 were foreshadowed very loosely by the way in which some earlier paintings, the flags for instance, were painted in clusters of marks, loosely registered, a bit like Abstract Expressionism in slow motion?*

JJ: I'm not sure. The flagstone motif came from a painted wall I saw in Harlem. […] I had to remember or reinvent it. And in a sense, I continued to remember and reinvent it in a number of subsequent works.

BR: *What have you produced this year?*

JJ: No finished paintings yet, but I've been working on two. They're very much like *Mirror's Edge* from the last Castelli show earlier this year. Then I've been working on prints, some related to the paintings and others based on tracings of a Holbein drawing, a portrait of a young boy which I think is in Basel.

BR: *Has working with highly skilled printers over the years been of any use in developing or triggering off ideas? I don't mean content, whatever that is, so much as technical procedures which might suggest a fresh approach or departure.*

JJ: I suppose painting and printing contribute to each other in largely unnoticed ways. That the print is the reverse of the image drawn on the stone must impress even novice printmakers. In the shop, one is always conscious of these mirror images, and this awareness has influenced my paintings in which images are sometimes mirrored or deliberately reversed. The procedures of painting and printing are different, part of the life of any painting being in the weight of the paint, its unique thickness or thinness. Printmaking is more indirect and more social. Painting is an isolated activity for me, but printmaking involves and requires the presence of other people to accomplish the work. You want them to be pleased with what they are doing, so there are needs of economy.

BR: *When you work with printers, do you feel as if you are giving a performance? As if you're on stage?*

JJ: Not quite. It's more like a party. […]

TM: *When paintings are described as poetic, as they frequently are, it seems to be a very nebulous word. But can painters forge valid links with poetry without just illustrating poetic text?*

With *The Bath* (1988) at East 63rd Street, New York,
April 18, 1988. Photograph: Hans Namuth.

JJ: I agree that the word "poetic," when applied to painting, is usually ambiguous. It can be used evocatively and pejoratively. But I don't think we need to worry about forging links between painting and poetry... here we are, it's done!

BR: *You've worked quite closely with the poetry of Frank O'Hara, haven't you?*

JJ: Well, Frank and I intended to make a portfolio of poems and images, but only one lithograph, *Skin with O'Hara Poem*, was accomplished. After he died, I made illustrations for *In Memory of My Feelings* when MoMA published a book of his poems. I also made a sculpture, *Memory Piece*, in which a rubber cast of his left foot is attached to the underside of the lid of a wooden box. There are three drawers in the box filled with sand. When the lid is pressed down and lifted, it leaves a footprint in the sand. There are also references to Hart Crane in a painting I made called *Periscope*, and in *Diver.*

BR: *What particular poetry are you reading at the moment?*

JJ: I recently encountered the poems of Paul Celan, and I'm in love with them. I'm often surprised that when you fall in love with something it almost shocks you that you never knew it before.

TM: *Do you see any contemporary American art which strikes a chord in you, that you find significant?*

JJ: Significant in the sense of new?

TM: *To a certain extent, yes, but which excites you for whatever reason.*

JJ: I see things I like, that interest me, but I don't see anything completely new. I think one may become insensitive to that sort of thing as one gets older. There's a tendency to be more self-preoccupied, and usually your work has developed to a point where it absorbs your own interest. When you get older, you become content to be on your own more and to explore your own work.

I-67. Barbaralee Diamonstein Spielvogel, *Inside the Art World: Conversations with Barbaralee Diamonstein* (New York: Rizzoli, 1994), pp. 114–20.

BLDS: *You were generous enough to show me the large drawing in your studio that, as best you and your relatives can recall, replicates the house, the environment in which you grew up. An environment that had a great deal to do with shaping you and, ultimately, your sensibility. Is that image one that you've carried with you for a very long time?*

JJ: The plan of the house? No, because I'm having such trouble remembering it. I don't know what triggered my trying to reconstruct the plan, but I had decided I wanted to use it. And when I began to draw it, I realized that certain parts didn't exactly go together, and so I consulted my cousins, to see if they could remember. They remembered some things—other things they remembered less well than I. They had never lived in the house, whereas I had.

BLDS: *Does the house still exist?*

JJ: I think not. I think it was torn down maybe five or six years ago—I'm not sure. Obviously it was torn down, or my cousin would have gone over and looked at it, and explained to me what it was we couldn't remember. I have two half-

sisters; both live in South Carolina, one in Edisto Beach and one in Greenville.

BLDS: *You had a house and a studio in Edisto Beach that, unfortunately, burned down with a great deal of your work when you were away in the 1960s.*

JJ: Yes, in [1966]; I was in Japan. Well, I don't know what a great deal is, but it contained work of mine and work of other people—works that had never been recorded, which, of course, makes you sadder.

BLDS: *After leaving South Carolina, where you attended school, you came to New York. Why did you decide to leave the South?*

JJ: Why did I leave? I think, probably, in order to leave. But also to go to school in New York. I attended a commercial art school here.

BLDS: *Did you also attend Hunter College?*

JJ: Later, for one day. That was Hunter College in the Bronx. I went to school one day and then I collapsed in the street. When I got home I was sick for a couple of weeks—so then I never went back.

BLDS: *What did you plan to study there?*

JJ: I studied art and a few other things. We had to study *Beowulf.* I was probably taking a course toward some sort of degree. Before that, when I had come up from South Carolina, I had attended a school for commercial art. I came in the winter, I think, and I attended through the following summer. So it was the equivalent of one year's work.

BLDS: *And what did you do, or learn, there?*

JJ: The things you learn or that you used to learn—not that I was good at it or learned much! We were taught design and color theory. They had various classes: life drawing, anatomy. I don't remember it well, but there were all kinds of things.

BLDS: *I recall your saying that it was very early on that you knew that you had some facility for art. I guess when young persons have some talent for drawing, people commend them for it. And, of course, it is very comforting to be praised. Is that what happened to you?*

JJ: Actually, yes. I don't know about the facility, but I had an interest in making art. And it does, to a degree, attract the attention of adults. More importantly, it was a private activity.

BLDS: *Did you have any role model as an artist?*

JJ: My grandmother, Evaline, painted. [...] She was dead and I had never met her. Her paintings were not very imaginative, but they excited my own imagination.

BLDS: *You've talked about one particular large-scale picture of hers that included a heron.*

JJ: I think a number of her pictures included herons! I imagine that they were copied from some model, but I don't know.

BLDS: *Why couldn't it be from nature? There are a lot of herons in South Carolina.*

JJ: It could have been, but I just wonder if that's the way people worked. I don't know how she did it. But I know that she also decorated china, so that would suggest that there was a place where she learned to make such things.

The things that I remember of my grandmother's were just gold on porcelain. I don't remember any use of color, but there may have been some.

BLDS: *It is interesting that more than fifty-five-ish years ago you realized that one could make a life in art.*

JJ: I didn't know that one could, but I knew that some people had—not my grandmother, of course.

BLDS: *Were you surrounded by works of art other than hers?*

JJ: No, I don't even know whether there were any paintings in the houses where I grew up. There must have been reproductions, but I don't remember.

BLDS: *So how, and where, did you first encounter so-called higher art?*

JJ: Not until very late.

BLDS: *High school?*

JJ: I saw a few books—that was it.

BLDS: *Did you study art in high school?*

JJ: I studied mechanical drawing and whatever the other kind of drawing is. I think I had half the year of one, and half the year of the other. [...] Sometime later, I went into the army. [... And] I was sent to Japan for about six months. This was in 1952–53.

BLDS: *Where were you based?*

JJ: Sendai, north of Tokyo.

BLDS: *While in Japan, did you manage to see any art?*

JJ: Yes, but I didn't know what I was seeing. I did see a huge show of surrealistic or dadaist works by Japanese artists. It was very entertaining. One work I remember was a woman's glove hanging from a pedestal, held in place by a preserved elephant's foot that rested on one finger of the glove.

BLDS: *What does that all mean?*

JJ: I don't know.

BLDS: *It sounds very un-Japanese.*

JJ: I wouldn't say it was un-Japanese. It suggested a good-spirited nihilism.

BLDS: *Did that experience have any influence on you?*

JJ: Well, I can recall many things during the time I was there, but I think the main effect it had on me was to give me the idea that the world was real. I had grown up in a very limited kind of environment, where here was here, and there was elsewhere. And I had no real sense of where elsewhere was.

BLDS: *I wouldn't think that was considered unusual then.*

JJ: No, not unusual, but it's limiting if you grow up like that. So, in a way, it made me aware that the world had reality, and that you could move about in it. I tend not to move about a lot even now, but I'm aware that one can.

BLDS: *Is there any particular reason why you don't?*

JJ: Once I'm there, I'm willing to stay there.

BLDS: *You are more involved with architecture than almost any artist that I know.*

JJ: I'm not at all involved with architecture.

BLDS: *Involved in the sense that you created two environments that are very specific— both for your needs yet respecting that which has come before. You own three*

houses—structures that you have shaped to your own needs.

JJ: The three studios are similar and have the same equipment. That makes it easier to work.

BLDS: *And in that way you know that everything you need is always there?*

JJ: Well, you hope it is!

BLDS: *Let's come back to New York, where, early on, you were working in a bookstore. Did that window-display job have any influence on you?*

JJ: I didn't have a window-display job. Bob Rauschenberg and I made objects that were used in window displays, mostly by Gene Moore, who was then the display director at Bonwit's. And then Bonwit's, or whatever the corporation was, bought Tiffany, and so we began doing Tiffany things as well.

BLDS: *What kind of objects did you make?*

JJ: Sometimes Gene would have in mind something that he wanted and he would ask that we make it. Sometimes, when we needed work, we would propose an idea of our own.

BLDS: *For how long did that arrangement last?*

JJ: Three or four years, something like that. Until I began to show with Leo Castelli.

BLDS: *Gene Moore, by the way, often featured the work of artists, and also credited them. Were you ever acknowledged in these windows?*

JJ: We were credited as Matson Jones, the name that we had invented for that work.

BLDS: *Did either of you want to be identified with this window-display work?*

JJ: Not personally, but we wanted Matson Jones to get credited so we could get other commissions.

BLDS: *Did you?*

JJ: Yes, occasionally. Emile de Antonio—do you remember who Emile de Antonio was?

BLDS: *The filmmaker....*

JJ: Yeah. He was a kind of agent at that time for artists and photographers and he got a couple of jobs for us. He was a friend of ours.

BLDS: *How did that come to an end? Was it because of Leo that you no longer had to do that kind of work?*

JJ: We each sold some pictures. That brought it to an end.

BLDS: *Were you living on Pearl Street then—and is that where you met Bob Rauschenberg?*

JJ: I was, yes, but I met Rauschenberg on 57th Street at Madison Avenue.

BLDS: *How did that come about?*

JJ: I had gotten off work from the Marlboro Bookstore on 57th Street; it must have been ten o'clock or midnight, whatever time it closed. It used to be next to the Russian Tea Room. And I was walking somewhere, and I ran into some friends—Suzi Gablik, another writer, and Bob Rauschenberg.

BLDS: *Was that your first encounter? How did the friendship develop?*

JJ: I think it must have been through Sari Dienes, who had a studio on the corner

of 57th Street and Seventh Avenue. It was a large room with very high ceilings. She entertained a lot, and she was a friend of Bob's and a friend of John Cage's.

BLDS: *Is that where you first met John Cage, too?*

JJ: I perhaps met him at a concert, but I think I met him at Sari's. Bob Rauschenberg at that time was a kind of janitor for the Stable Gallery, which then was on that side of town, so he had reason to be in that part of town at night, to clean the gallery. I would occasionally go by Sari's and have a drink with her after work, and sometimes Bob would be there. Sometimes I would help Sari with her work in the streets. She went around making rubbings of the streets in the early hours of the morning with sheets of paper twelve feet or longer. They were rubbings of manhole covers and things like that. She was very uninhibited, I thought. People would come up and ask what was going on, and she would talk as she continued to work, in the middle of the street.

BLDS: *What was her intent?*

JJ: She made works of art by putting some material over a textured surface and then applying paint with rollers. Betty Parsons showed some of that work.

BLDS: *Did that work influence the Rauschenberg tire pictures?*

JJ: Those were made before I knew them, so I don't know. And I don't know when Sari began this work. They're very different, actually. For Bob and John the street just supported the automobile.

BLDS: *Were you then living in a loft?*

JJ: At that time I was living up in Germantown—is that what it's called?—no— Yorkville. In a tiny railroad apartment that was painted egg-yolk yellow.

BLDS: *For how long were you there?*

JJ: I don't know—a year?

BLDS: *Did you ever think of embellishing your environment in any way? Or did you think of it as a "container" to which you came and went?*

JJ: Well, I don't know how I thought of it. But I was there until I got an apartment on the Lower East Side, on East 4th Street and Avenue B, I think. Later, I moved into a loft on Pearl Street. And when another floor became available, Bob Rauschenberg took it. It was there that Allan Kaprow came to see us, saying that he was guiding Horace Richter around studios in New York to select an exhibition for the Jewish Museum. Bob and I thought wrongly that he was the Dadaist Hans Richter; instead I think he was a peach grower from North Carolina or Georgia. [...]

BLDS: *Was this your first museum exhibition?*

JJ: Yes.

BLDS: *Had you shown work in galleries before?*

JJ: Maybe two small works. [...]

BLDS: *I assume the [Jewish Museum] people were in an anxious state then, as they fared forth into uncharted waters for them, often to the dismay of their trustees.*

JJ: Absolutely, because I think this was the very first time they had shown this sort of work.

BLDS: *Work that was secular art?*

JJ: Exactly. I believe this was the first time the museum showed this sort of work. So this gentleman called me and said, "Can I come down to your studio and pick out a painting for this show?" And I told him to come along. And he came down.

BLDS: *Who was that?*

JJ: I can't recall his name; a charming gentleman interested in Oriental philosophy came to my studio and […] asked me to send my *Green Target* up for the show. So Leo Castelli had seen that exhibition by the time he came to visit Rauschenberg, and […] Leo came down and looked at paintings and said, "I think that I might like to give you an exhibition. Have you been to my gallery?" I said no. He said, "Well, why don't you come up and see what you think of it."

BLDS: *How long afterward did you have an exhibition at the Castelli gallery?*

JJ: Leo had a group show […] in which one painting of mine was included along with one work each by artists Leo was interested in—Marisol, Rauschenberg, and others. Then in January 1958 there was the first one-person show of my work. […]

BLDS: *There is a great deal of information, both art-historical tradition and reference, contained in your work and in your speech. How did someone who had never studied formally acquire all of that?*

JJ: Seems to me I have very little of that even now.

BLDS: *That sounds like an expression of your modesty.*

JJ: No, I don't think so! I think I've been relatively ignorant about such things.

BLDS: *How did you feel when you were called a Pop artist?*

JJ: I never felt that it was appropriate.

BLDS: *So how do you feel when you're still called the father of Pop Art?*

JJ: By now I'm indifferent, pretty much. […]

BLDS: *Was Duchamp a friend of yours, or an influence?*

JJ: He was not a close friend of mine. […]

BLDS: *His wife, Teeny, was a very good friend of yours….*

JJ: She continues to be.

BLDS: *I've read, and heard, many times that your first image of the flag came to you in a dream.*

JJ: That's true.

BLDS: *Have you had any other big dreams lately?*

JJ: No, my dreams are limited.

BLDS: *Perhaps you'd better start dreaming in color again!*

JJ: I don't know that it was in color.

BLDS: *Maybe it wasn't—and that may be why the flag was white to begin with. What were you thinking when you chose a flag as the very first emblem?*

JJ: Well, I didn't choose it; that's part of it. It presented itself to me.

BLDS: *How did you settle on targets and numbers?*

JJ: I don't know how it worked. I guess you just do what you think to do. Somehow they shared something with what I was doing. Or you could say that I made an association with the flag that led me to something else.

BLDS: *[…] In a rather lengthy and obscure article, William Gass refers to the arti-facts that you make out of artifacts, things from things, and images out of images.*[35] *Then, ultimately, you recycle those images in new work, a range of work that includes oil painting and lithography and etchings and posters and monotypes; then you reuse them again in a new painting. Are these objects—artifacts—emblematic in your work? Are they metaphoric? Did they originate accidentally, or was it a deliberate notion to recycle the material?*

JJ: I think it happens through a concern for parts and wholes and through seeing that anything that one thinks of as a whole can become a part, and that any-thing that one thinks of as a part can be treated as a whole. Something to do with that.

BLDS: *Does it relate to process as well?*

JJ: Well, of course, one thing changing into another involves process. If the whole can become a detail, we see the mutability of the world, and shifts of meaning or of image or definition follow.

BLDS: *For a very long while you gave your pictures titles that have been accurately described as "aggressively neutral":* Targets. *And even works that were called* Untitled.

JJ: I'm afraid I have too many of them. Most of them are now called that.

BLDS: *There was certainly a period when you gave very specific titles. What came to mind—especially so soon after John Cage's sudden death—was the picture you called* Perilous Night, *that has a very specific referential meaning to John's career. It has been of interest to me to try to understand what goes on in your mind and heart, and especially when you select a title from the work of someone for whom you have great respect and affection. You named that piece during one of the most troublesome periods in Cage's work.*

JJ: Well, it's hard for me to remember, but I don't think it had to do with honoring John, and it was painted ten years before he died. It had to do with—what *did* it have to do with? I don't know.

BLDS: *It was a panel, and I wondered if you found it a troublesome departure for you, too. It was about 1985—that piece did mark a change in your work—the leap from the so-called linear abstraction to the personal realism. That's what they say, Jasper!*

JJ: Let them say it.

BLDS: *Either as a collaborator or as a philosopher-humanitarian, did John Cage influ-ence you in your work? And I know you've said that's not the way you usually think.*

JJ: Right, I don't usually think in terms of influence. I feel that only things one is insensitive to are not influences. John Cage had a serious concern for philo-sophical ideas and he was able to consider judiciously a number of complex ideas at the same time. From such practice, he seemed to gain abstract and practical insights which reinforced his music, his philosophy, his ambitions. Art and life structured by principle seemed the suggested norm.

BLDS: *You did say that you didn't want your work to be an exposure of your feelings. But since the change in your own work—at least to this observer—to more of a personal realism, it does pursue autobiographical material as diligently as the early targets and flags renounced it. What made you become so forthcoming?*

JJ: Autobiography isn't necessarily an exposure of feelings. It can be.

BLDS: *Don't you think when you choose something, that what you choose is given weight by its selection, and is revealing, in and of itself?*

JJ: Mmm-hmmm—but anything is.

BLDS: *Everything is.*

JJ: Yeah.

BLDS: *What sort of work did your grandfather do?*

JJ: He was a farmer.

BLDS: *What were the crops?*

JJ: He had a number of crops. I remember cotton, melons, asparagus. My grandfather died when I was about seven or eight.

BLDS: *So you never did any farm work.*

JJ: We didn't live on a farm, we lived in a small town. Occasionally I'd drive with my grandfather to look at his fields, and I was completely mystified how he would know what this green stuff was. He would be very excited about the cotton or melons or rye just coming up, and I couldn't understand how he could tell one thing from another.

BLDS: *Don't you really believe that this work is more revealing, Jasper, even though its iconography is more obscure?*

JJ: I'm not even sure it's not *less* revealing. But I don't know. What is it that work reveals? Work reveals itself, really.

BLDS: *You do have an iconography that is mysterious, and I assume the drama of concealment is something that you nurture.*

JJ: Wouldn't you say that about an Amish quilt?

BLDS: *Would I say that about an Amish quilt? No, I would not—and certainly not the way I've just referred to it.*

JJ: It seems to present itself as one thing, and then when you look at it you see something else. Often there are several possibilities in any visual structure.

BLDS: *Then what was that image meant to be?*

JJ: Meant to be? It's meant to be exactly what it is. It was only withheld out of annoyance with all of the gobbledygook that was being suggested about imagery.

BLDS: *And what, therefore, is it?*

JJ: It's what you see. Do you mean what's it based on? I'm not going to tell you. And I haven't told anyone—except the person who gave me the image, who didn't recognize what it was, either.

BLDS: *In this great hide-and-seek game, I can recall people who were convinced that Montez was Lola Montez, as opposed to the actual name of your grandmother!*

JJ: Absolutely.

BLDS: *A little bit of information can be not only dangerous, but sometimes interesting and amusing. At least it must amuse the artist from time to time. And did your grandmother really sing, and play at the piano "Red Sails in the Sunset"?*

JJ: Well, of course it's interesting that one thing leads us to think of something else and that having a bit of information, or a name, may stop our curiosity about what we are looking at. I remember years ago reading that someone

sitting in a room looking at a [László] Moholy-Nagy was not able to take her eyes off it. She kept turning to it. Finally, she stood up, walked over to the mantle, and looked and read the title, "Oh, *Space Modulator*, that's what it is!" And then she sat down and never looked at it again. There is something like that in all of us, I think, that wants "space modulator," whatever it is you can say that will satisfy our curiosity.

BLDS: *Very often I see things in your pictures that don't square with what I read that other people see in them.*

JJ: Well, I think titles help in referring to pictures. But often I can't remember them, and then I think that they don't help me very much. And then, when I use the same configuration in a number of pictures, it seems weird to use the same title for all of them.

BLDS: *You could use code references, and even Roman numerals—which would be an even worse method of titling them!*

JJ: I'll try to remember that!

BLDS: *When you first started to paint and began to see yourself in the spectrum of both art history and the world of art, where did you think your place was going to be? What did you have in mind?*

JJ: Well, I wanted to do what I had to do. And I wanted not to do what others might do, even though I might find what they were doing interesting. So I suppose I wanted to define myself as an artist, to see what I was.

BLDS: *Does that process still go on?*

JJ: Maybe, but in a less rigid or restricted way.

BLDS: *But you are publicly cautious, as you know; and guarded.*

JJ: I'm talking about the making of pictures. My early work seemed to be an attempt to see what I was or could do, that other people weren't or couldn't. To some degree, the works were limited or focused by such concerns. Later, as practice and skill increase, the sense of possibility enlarges.

BLDS: *When did you realize that Jasper Johns had become "Jasper Johns," part of the public domain, often referred to as the preeminent artist of our age? Is that an enormous burden?*

JJ: I think that's meaningless. Making a picture, which somehow has a public life, is not making a picture of oneself to have a public life. So, in presenting the picture, one is not presenting oneself. But in that kind of space, there is ample room for confusion.

BLDS: *You have about another thirty years left to paint. To have a value attached to your work that is the highest monetary value ever attached to the work of a living artist seems daunting, pleasing, and maybe even a tiny bit troubling or offensive.*

JJ: I guess I never bothered to figure it out; there is an unpleasantness attached to it—the idea that monetary value may be of more interest than the work. We notice this in many fields within our society—maybe in any society. But—thirty years?

BLDS: *Why doesn't it liberate, also?*

JJ: Perhaps, but it also points out that there are ways in which the artist is defined by society. […]

BLDS: *On what are you working now?*

JJ: I have a painting in Saint Martin. I think all I have to do is add six strips of masking tape and it will be finished. Then I'll roll it up and bring it back. I've just finished an etching with ULAE, a couple of lithographs for Gemini G.E.L., and a drawing.

BLDS: *If you had it to do over again, what would you do otherwise?*

JJ: It's hard to know. I assume if I had it to do over again—I just don't think I would (laughs). I would do everything a little differently.

BLDS: *For example?*

JJ: I haven't the slightest idea.

BLDS: *It seems to have worked out for you—in a brilliant, and I hope for you, satisfying, way.*

JJ: Well, it hasn't worked out at all. It's still in process.

Notes

1. The Museum of Modern Art purchased *Green Target* (1955), *Target with Four Faces* (1955), and *White Numbers* (1957) from Johns's 1958 show at the Leo Castelli Gallery, New York. Another painting from that show, *Flag* (1954–55), was purchased by Philip Johnson and given to the Museum in 1973.

2. See plates 6, 7, and 10.

3. See plate 9.

4. Betty Kaufman, "Jasper Johns," *Commonweal* vol. 80 (April 24, 1964): 157–59.

5. See item I-9.

6. Johns has discussed the content of this interview in a conversation with Yoshiaki Tono; see entry I-25.

7. See plate 9 and item I-11.

8. The actual title is *Self-Portrait in Profile* (1958). See Roberta Bernstein, "'Seeing a Thing Can Sometimes Trigger the Mind to Make Another Thing,'" in Kirk Varnedoe, *Jasper Johns: A Retrospective* (New York: The Museum of Modern Art, 1996), pp. 45–46, 71 (note 39).

9. Tono has published articles titled "About Legs, or Duchamp and Johns I," *Bijutsu Techô* (Tokyo) 27 no. 393 (April 1975): 176–93, and "About Legs, or Duchamp and Johns II," *Bijutsu Techô* (Tokyo) 27 no. 394 (May 1975): 196–207. In Japanese.

10. Johns further discusses his set for *Walkaround Time* in David Vaughan, "The Fabric of Friendship: Jasper Johns in Conversation with David Vaughan," in Susan Sontag, Richard Francis, Mark Rosenthal, et al., *Dancers on a Plane: Cage, Cunningham, Johns* (New York: Alfred A. Knopf, in association with Anthony d'Offay Gallery, London, 1990), pp. 137–42, and in Elliot Caplan's film *Cage—Cunningham* (1991), produced by the Cunningham Dance Foundation and written by Vaughan.

11. See item I-9. Annelie Pohlen's interview was conducted in English, then translated into German by its author; it appears here in translation from Pohlen's German. The word "indecisions" does not appear in item I-9, an interview by Gene Swenson; it is unclear what English phrase of Johns's Pohlen was referring to—perhaps "shifting relationships."

12. The books Johns refers to are Robert Motherwell, ed., *The Dada Painters and Poets: An Anthology* (New York: Wittenborn, Schultz, 1951); Robert Lebel, *Marcel Duchamp*, trans. George Heard Hamilton (New York: Grove Press, 1959); and *The Bride Stripped Bare by Her Bachelors, Even: A Typographic Version by Richard Hamilton of Marcel Duchamp's Green Box*, trans. George Heard Hamilton (New York: Wittenborn, 1960, The Documents of Modern Art no. 14). On the latter, see item W-3.

13. In 1957, Johns was included in "Artists of the New York School: Second Generation," a group exhibition at the Jewish Museum, New York; Leo Steinberg wrote the introduction to the show's catalogue. The "long" article Simons is alluding to, however, is presumably Steinberg's "Jasper Johns," *Metro* (Milan) no. 4/5 (May 1962): 87–109. See item I-6.

14. See item I-6.

15. In conversation with Roberta Bernstein on May 21, 1996, Johns revised this quotation to agree more closely with his intention.

16. Johns discusses the creation of the Foundation for Contemporary Performance Arts in two articles not included in this book: "Pictures from Modern Masters to Aid Music and Dance," in *Artnews* 61 no. 10 (February 1963): 44, and "Artists for Artists," *The New Yorker*, March 9, 1963, pp. 32–34.

17. One such drawing is illustrated in Bruno Bettelheim, "Schizophrenic Art: A Case Study," in *Scientific American* vol. 186 (April 1952): 31–34. See, e.g., Roberta Bernstein, "'Seeing a Thing Can Sometimes Trigger the Mind to Make Another Thing,'" in Kirk Varnedoe, *Jasper Johns: A Retrospective* (New York: The Museum of Modern Art, 1996), p. 60.

18. *Construction with Toy Piano* (1954) was exhibited in a group show at the Tanager Gallery on East 10th Street, New York, in December 1954–January 1955.

19. "Jasper Johns: Paintings," Johns's first one-man show, at the Leo Castelli Gallery, January 20–February 8, 1958.

20. Johns's painting *Green Target* was included in the exhibition "Artists of the New York School: Second Generation," at the Jewish Museum, New York, March 10–April 28, 1957.

21. Presumably Horace Richter, a member of the Jewish Museum's Administrative Committee, who receives an acknowledgment in the foreword to the exhibition's catalogue. Meyer Schapiro also receives an acknowledgment "for assisting greatly in the selection."

22. Robert Rauschenberg had two works in the show: *Red Import* (1954), and *Three Collages: Opportunities #2, #7, #9* (1956).

23. Allan Kaprow had two collages in the

show: *Pheasant Caged* and *Writing* (both 1956).

24. Besides Rauschenberg and Johns, the show included Elaine de Kooning, Robert de Niro, Helen Frankenthaler, Grace Hartigan, Wolf Kahn, Kaprow, Alfred Leslie, Joan Mitchell, Milton Resnick, George Segal, and other artists.

25. According to Leo Castelli's 1957 appointment book, he went to the Jewish Museum on Thursday, March 7, 1957, at 8:15 P.M, and the visit to Rauschenberg's and Johns's studios took place the next day, Friday, March 8.

26. Two of the three paintings (*Target with Four Faces*, *Green Target*, and *White Numbers*) purchased by The Museum of Modern Art in 1958 were among the nine paintings by Johns included in Dorothy Miller's exhibition "Sixteen Americans" at The Museum of Modern Art, New York (December 16, 1959–February 17, 1960), and all three were reproduced in the catalogue. See "Painting and Sculpture Acquisitions," *The Museum of Modern Art Bulletin*, January 1, 1958–December 31, 1958, p. 21; a photograph reproduced on that page shows the three works hanging side by side. See also Lynn Zelevansky, "Dorothy Miller's 'Americans,' 1942–63," *Studies in Modern Art* no.

4, "The Museum of Modern Art at Mid-Century" (1994): 79–80.

27. Clement Greenberg, "After Abstract Expressionism," *Art International* (Lugano) 6 no. 8 (October 25, 1962): 24–32.

28. *Artnews* 56 no. 9 (January 1958).

29. See Zelevansky, "Dorothy Miller's 'Americans,' 1942–63," pp. 57–107.

30. Johns had shows at the Galerie Rive Droite, Paris, in January 1959, and at the Galeria d'Arte del Naviglio, Milan, in March of that year. A second show at the Galerie Rive Droite in June–July 1961 included a series of *o through 9* paintings.

31. See footnote 12 above.

32. See p. 151.

33. "New Forms New Media I," June 6–24, 1960, and "New Forms New Media II," September 24–October 22, 1960, at the Martha Jackson Gallery, New York.

34. The exhibition "Artists of the New York School: Second Generation," at the Jewish Museum, New York, in 1957. See pp. 272–74, 294–95.

35. William Gass, "Jasper Johns," *The New York Review of Books*, February 2, 1989, pp. 22–27.

The original place and date of publication of each item in the "Writings" and "Interviews" sections above are included in the items' headings. Listed below, in addition to copyright information for these texts, are additional publications in which they appeared subsequently. The phrase "REPRINTED IN" indicates publications that reprint the relevant item in its entirety, usually citing the original publication. "EXCERPTED IN" describes publications that reprint a significant part of an item. The "Interviews" section includes a few items "REPRODUCED IN" a book featuring photographic reproductions of documentary material on Johns.

Copyright information, where called for, appears at the beginning of each entry.

Unless otherwise indicated, the material in the "Sketchbook Notes" section is drawn from the sketchbooks themselves. Some of this material has been previously published or reproduced, however, and the relevant publications are listed below. "QUOTED IN" indicates places where an item was published in full. "EXCERPTED IN" describes publications that print or reprint a significant part of an item. Items and parts of items published here for the first time are described as such. "REPRODUCED IN" indicates a photographic reproduction of a sketchbook page. In the present volume, the notes appearing in plates 3, 4, 6–11, 16, and 17 have been previously reproduced, for the most part in Japanese periodicals; plates 1, 2, 5, 12–15, and 18–21 have not been reproduced before.

A number of interviews and statements not included in the present volume are listed at the end of this section.

Writings

For Johns's writings, copyright holders are listed below. The artist's writings are also © Jasper Johns/Licensed by VAGA, New York, N.Y.; this notice appears at the request of the artist.

W-2. A typescript of Johns's statement (hand dated October 15, 1959) can be found in The Museum of Modern Art Archives, New York: the Dorothy C. Miller Papers: I.15.k.

REPRINTED IN: 4 Amerikanare: Jasper Johns, Alfred Leslie, Robert Rauschenberg, Richard Stankiewicz, exh. cat., ed. K. G. [Pontus] Hultén (Stockholm: Moderna Museet, 1962), p. 11 (in Swedish translation). Jun Miyakawa, "Jasper Johns: The Words; The Idea of a Changing Focus," Bijutsu Techô (Tokyo), July 1968, p. 63 (note 3) (in Japanese translation). Barbara Rose, ed., Readings in American Art since 1900: A Documentary Survey (New York: Frederick A. Praeger, Inc., Publishers, 1968), pp. 165–66. Barbara Rose, ed., Readings in American Art 1900–1975 (New York: Holt, Rinehart and Winston, 1975), pp. 146–47. Roberta Bernstein, Jasper Johns' Paintings and Sculptures 1954–1974: "The Changing Focus of the Eye" (Ann Arbor: UMI Research Press, 1985), p. 59 (a version of Bernstein's Ph.D. dissertation, Columbia University, New York, 1975). Kristine Stiles and Peter Selz, eds., Theories and Documents of Contemporary Art: A Sourcebook of Artists' Writings (Berkeley: University of California Press, 1996), p. 323.

EXCERPTED IN: John Cage, "Jasper Johns: Stories and Ideas," in Alan R. Solomon, Jasper Johns, exh. cat. (New York: The Jewish Museum, 1964), pp. 21–26.

W-3. REPRINTED IN: Christian Geelhaar, Jasper Johns: Working Proofs, exh. cat. (Basel: Kunstmuseum, 1979; London: Petersburg Press, 1979, 1980), pp. 33–34 (note 18).

W-5. REPRINTED IN: Yoshiaki Tono, ed., "Jasper Johns: Sketchbook Notes," av (Art vivant, Seibu Museum of Art [now Sezon Museum of Art], Tokyo) 4 no. 10 (July 1, 1978): n.p. (translated into Japanese).

W-6. © Artforum November 1968.

REPRINTED IN: *Dialogues with Marcel Duchamp by Pierre Cabanne* (New York: Viking Press, Documents of 20th-Century Art, 1971), pp. 109–10. Anne d'Harnoncourt and Kynaston McShine, eds., *Marcel Duchamp*, exh. cat. (New York: The Museum of Modern Art, and Philadelphia: Philadelphia Museum of Art, 1973), pp. 203–4. Susan Hapgood, *Neo-Dada: Redefining Art, 1958–62*, exh. cat. (The American Federation of Arts, 1994), p. 139.

W-7. Courtesy Art in America, Brant Publications, Inc., July–August 1969.

W-8. Reprinted here by permission of the College Art Association, Inc.

Sketchbook Notes
All sketchbook material © Jasper Johns/ Licensed by VAGA, New York, N.Y.

I. Johns's sketchbook notes have been published and/or reproduced in the following publications, in chronological order:

Yoshiaki Tono, "Statements by Contemporary Artists," *Mizue* (Tokyo) no. 700 (June 1963): [6], 18–19 (translated into Japanese).

Yoshiaki Tono, "Jasper Johns in Tokyo," *Bijutsu Techô* (Tokyo), August 1964, pp. 5–8 (translated into Japanese).
REPRINTED IN: Tono, *After Pollock* (Tokyo: Bijutsu Shuppan-sha, 1965), pp. 265–75 (translated into Japanese).

Alan R. Solomon, "Jasper Johns," *Jasper Johns*, exh. cat. (New York: The Jewish Museum, 1964), pp. 5–19.
REPRINTED IN: Alan R. Solomon, *Jasper Johns: Paintings, Drawings and Sculptures 1954–1964*, exh. cat. (London: Whitechapel Gallery, 1964), pp. 4–25.

John Cage, "Jasper Johns: Stories and Ideas," in Alan R. Solomon, *Jasper Johns*, exh. cat. (New York: The Jewish Museum, 1964), pp. 21–26.
REPRINTED IN: Alan R. Solomon, *Jasper Johns: Paintings, Drawings and Sculptures 1954–1964*, exh. cat. (London: Whitechapel Gallery, 1964), pp. 26–35. *Art and Artists* (London) 3 no. 2 (May 1968): 36–41. John Cage, *A Year from Monday: New Lectures and Writings* (London: Calder and Boyars, 1967, and Middletown, Conn.: Wesleyan University Press,

1969), pp. 73–84. Carlo Huber, ed., *Jasper Johns Graphik*, exh. cat. (Bern: Klipstein und Kornfeld, 1971), n.p. (translated into German). Gregory Battcock, ed., *The New Art. A Critical Anthology* (New York: Dutton, 1966, 1973), pp. 29–45.
EXCERPTED IN: Ellen H. Johnson, ed., *American Artists on Art, from 1940 to 1980* (New York: Harper & Row, 1982), pp. 72–78.

Jasper Johns, "Sketchbook Notes," *Art and Literature* (Lausanne) vol. 4 (Spring 1965): 185–92.
REPRINTED IN: John Russell and Suzi Gablik, *Pop Art Redefined* (London: Thames and Hudson, 1969, and New York: Frederick A. Praeger, Inc., Publishers, 1969), pp. 84–85. Johns, "*Skizzenbuch-Notizen*," in Carlo Huber, ed., *Jasper Johns Graphik*, exh. cat. (Bern: Kornfeld und Klipstein, 1971) (translated into German). Johns, "Notes on According to What?" in Barbara Rose, ed., *Readings in American Art: 1900–1975* (New York: Holt, Rinehart and Winston, 1975), pp. 176–78. Francis Naumann, *Jasper Johns: According to What & Watchman*, exh cat. (New York: Gagosian Gallery, 1992), pp. 66–67. Kristine Stiles and Peter Selz, eds., *Theories and Documents of Contemporary Art. A Sourcebook of Artists' Writings* (Berkeley: University of California Press, 1996), pp. 325–26.
EXCERPTED IN: Roberta Bernstein, *Jasper Johns' Paintings and Sculptures, 1954–1974: "The Changing Focus of the Eye"* (Ann Arbor: UMI Reseach Press, 1985), p. 114. Michael Crichton, *Jasper Johns*, exh. cat. (New York: Harry N. Abrams, Inc., in association with the Whitney Museum of American Art, 1977), p. 51 and (1996), p. 49.

Jun Miyakawa, "Jasper Johns: The Words; The Idea of a Changing Focus," *Bijutsu Techô* (Tokyo), July 1968, pp. 60–63 (translated into Japanese).

Yoshiaki Tono, "Jasper Johns: The Point 'According to What'?," *Bijutsu Techô* (Tokyo), July 1968, pp. 64–65, 70–74 (translated into Japanese).

Johns, "Sketchbook Notes," *Juillard* (Leeds) 3 (Winter 1968–69), pp. 25–27.
REPRINTED IN: Carlo Huber, ed., *Jasper Johns Graphik*, exh. cat. (Bern: Klipstein und

Kornfeld, 1971) (translated into German). Yoshiaki Tono, ed., "Jasper Johns: Sketchbook Notes," *av* (*Art vivant*, Seibu Museum of Art [now Sezon Museum of Art], Tokyo) 4 no. 10 (July 1, 1978): n.p. (translated into Japanese). Richard Francis, *Jasper Johns* (New York: Abbeville Press, 1984), pp. 109–11 (also published as Francis, *Jasper Johns* [Tokyo: Bijutsu Shuppan-sha/New York: Abbeville Press/ Modern Masters Series, 1990], translated into Japanese by Yoshiaki Tono and Tetsuo Iwasa).

EXCERPTED IN: *Art Now: New York* 1 no. 4 (April 1969): n.p.

Johns, "Sketchbook Notes," *0 to 9* (New York) no. 6 (July 1969): 1–2.

REPRINTED IN: Yoshiaki Tono, ed., "Jasper Johns: Sketchbook Notes," *av* (*Art vivant*, Seibu Museum of Art [now Sezon Museum of Art], Tokyo) 4 no. 10 (July 1, 1978): n.p. (translated into Japanese). Richard Francis, *Jasper Johns* (New York: Abbeville Press, 1984), pp. 111–12 (also published as Francis, *Jasper Johns* [Tokyo: Bijutsu Shuppan-sha/New York: Abbeville Press/Modern Masters Series, 1990], translated into Japanese by Yoshiaki Tono and Tetsuo Iwasa).

Johns, "*Neue Skizzenbuch-Notizen*" (New sketchbook notes), in Carlo Huber, ed., *Jasper Johns Graphik*, exh. cat. (Bern: Klipstein und Kornfeld, 1971) (translated into German).

James Klosty, ed., *Merce Cunningham* (New York: E. P. Dutton & Co., Inc., 1975), p. 131.

Yoshiaki Tono, "About Leg, or Duchamp and Johns II," *Bijutsu Techô* (Tokyo) 27 no. 394 (May 1975): 196–207 (translated into Japanese).

Yoshiaki Tono, ed., "Jasper Johns: Sketchbook Notes," *av* (*Art vivant*, Seibu Museum of Art [now Sezon Museum of Art], Tokyo) 4 no. 10 (July 1, 1978): n.p. (translated into Japanese). Issue dedicated to Johns on the occasion of the exhibition of his 1977 Whitney Museum of American Art retrospective in its Tokyo venue.

REPRINTED IN: Yoshiaki Tono, *Jasper Johns And/Or* (Tokyo: Bijutsu Shuppan-sha, 1979), pp. 209–24 (translated into Japanese).

Tadashi Yokoyama, "The Structure of *Watchman*," *av* (*Art vivant*, Seibu Museum of Art [now Sezon Museum of Art], Tokyo) 4 no.

10 (July 1, 1978): n.p. (translated into Japanese). Issue dedicated to Johns on the occasion of the exhibition of his 1977 Whitney Museum of American Art retrospective in its Tokyo venue.

Artists' Sketchbooks, exh. cat. (New York: Matthew Marks Gallery, 1991).

II. The publication histories of the individual notebook pages transcribed and reproduced in this book are outlined below. (Full bibliographic information for the publications cited appears above.)

S-1. QUOTED IN: Cage, "Jasper Johns: Stories and Ideas," 1964.

EXCERPTED IN: Tono, ed., "Jasper Johns: Sketchbook Notes," 1978 (translated into Japanese).

S-2. EXCERPTED IN: Tono, "Jasper Johns in Tokyo," 1964 (translated into Japanese). Cage, "Jasper Johns: Stories and Ideas," 1964. Miyakawa, "Jasper Johns: His Words; The Idea of a Changing Focus," 1968 (translated into Japanese). Tono, ed., "Jasper Johns: Sketchbook Notes," 1978 (translated into Japanese).

S-3. QUOTED IN: Tono, "Jasper Johns in Tokyo," 1964 (translated into Japanese). Solomon, "Jasper Johns," 1964. Cage, "Jasper Johns: Stories and Ideas," 1964.

S-4. EXCERPTED IN: Cage, "Jasper Johns: Stories and Ideas," 1964. Tono, ed., "Jasper Johns: Sketchbook Notes," 1978 (translated into Japanese).

S-5. Previously unpublished.

S-6. QUOTED IN: Cage, "Jasper Johns: Stories and Ideas," 1964. Tono, ed., "Jasper Johns: Sketchbook Notes," 1978 (translated into Japanese).

REPRODUCED IN: Tono, ed., "Jasper Johns: Sketchbook Notes," 1978.

S-7. EXCERPTED IN: Tono, "Jasper Johns in Tokyo," 1964 (translated into Japanese). Cage, "Jasper Johns: Stories and Ideas," 1964.

S-8. EXCERPTED IN: Cage, "Jasper Johns: Stories and Ideas," 1964.

REPRODUCED IN: Klosty, ed., *Merce Cunningham*, 1975.

QUOTED IN: Tono, ed., "Jasper Johns: Sketchbook Notes," 1978 (translated into Japanese).

S-9. EXCERPTED IN: Cage, "Jasper Johns: Stories and Ideas," 1964.

QUOTED IN (except the last two lines, previously unpublished): Tono, ed., "Jasper Johns: Sketchbook Notes," 1978 (translated into Japanese).

S-10. QUOTED IN: Tono, ed., "Jasper Johns: Sketchbook Notes," 1978 (translated into Japanese).

S-11. QUOTED IN: Tono, "Statements by Contemporary Artists," 1963 (translated into Japanese). Lil Picard, "Jasper Johns," *Das Kunstwerk* 17 no. 5 (November 1963): 6–12 (translated into German). Solomon, "Jasper Johns," 1964. Miyakawa, "Jasper Johns: His Words; The Idea of a Changing Focus," 1968 (translated into Japanese). Tono, ed., "Jasper Johns: Sketchbook Notes," 1978 (translated into Japanese).

S-12. QUOTED IN: Tono, ed., "Jasper Johns: Sketchbook Notes," 1978 (translated into Japanese).

S-13. QUOTED IN: Alan R. Solomon, "Jasper Johns," 1964. Miyakawa, "Jasper Johns: His Words; The Idea of a Changing Focus," 1968 (translated into Japanese). Tono, ed., "Jasper Johns: Sketchbook Notes," 1978 (translated into Japanese).

EXCERPTED IN: Cage, "Jasper Johns: Stories and Ideas," 1964.

S-14. QUOTED IN: Tono, "Jasper Johns in Tokyo," 1964 (translated into Japanese). Tono, ed., "Jasper Johns: Sketchbook Notes," 1978 (translated into Japanese).

S-15. QUOTED IN: Tono, ed., "Jasper Johns: Sketchbook Notes," 1978 (translated into Japanese).

S-16. QUOTED IN (except first six lines, previously unpublished): Johns, "Sketchbook Notes," *Art and Literature*, 1965. Tono, ed., "Jasper Johns: Sketchbook Notes," 1978 (translated into Japanese).

S-17. QUOTED IN: Tono, "Jasper Johns: The Point 'According to What'?," 1968 (translated into Japanese). Tono, ed., "Jasper Johns: Sketchbook Notes," 1978 (translated into Japanese).

S-18. EXCERPTED IN: Tono, "Jasper Johns: The Point 'According to What'?," 1968 (translated into Japanese). Tono, ed., "Jasper Johns: Sketchbook Notes," 1978 (translated into Japanese).

REPRODUCED IN: Tono, "About Leg, or Duchamp and Johns II," 1975.

S-19. QUOTED IN (among the notes in s-28): Johns, "Sketchbook Notes," *Art and Literature*, 1965.

REPRODUCED IN: Tono, ed., "Jasper Johns: Sketchbook Notes," 1978.

S-20. EXCERPTED IN: Johns, "Sketchbook Notes," *Art and Literature*, 1965.

REPRODUCED IN: Tono, "Jasper Johns: The Point 'According to What'?," 1968. Tono, "About Leg, or Duchamp and Johns II," 1975.

QUOTED IN: Tono, ed., "Jasper Johns: Sketchbook Notes," 1978 (translated into Japanese).

S-21. EXCERPTED IN: Cage, "Jasper Johns: Stories and Ideas," 1964. Tono, "Jasper Johns: The Point 'According to What'?," 1968 (translated into Japanese).

QUOTED IN: Johns, "Sketchbook Notes," *Art and Literature*, 1965. Tono, ed., "Jasper Johns: Sketchbook Notes," 1978 (translated into Japanese).

REPRODUCED IN: Tono, "About Leg, or Duchamp and Johns II," 1975.

S-22. QUOTED IN: Tono, ed., "Jasper Johns: Sketchbook Notes," 1978 (translated into Japanese).

S-23. QUOTED IN: Johns, "Sketchbook Notes," *Art and Literature*, 1965. Tono, ed., "Jasper Johns: Sketchbook Notes," 1978 (translated into Japanese).

S-24. QUOTED IN: Johns, "Sketchbook Notes," *Art and Literature*, 1965. Tono, ed., "Jasper Johns: Sketchbook Notes," 1978 (translated into Japanese).

S-25. EXCERPTED IN: Johns, "Sketchbook Notes," *Art and Literature*, 1965.

REPRODUCED IN: Miyakawa, "Jasper Johns: His Words; The Idea of a Changing Focus," 1968.

S-26. QUOTED IN: Johns, "Sketchbook Notes," *Art and Literature*, 1965. Tono, "Jasper Johns: The Point 'According to What'?," 1968 (translated into Japanese). Tono, "Jasper Johns: Sketchbook Notes," 1978 (translated into Japanese).

REPRODUCED IN: Yokoyama, "The Structure of Watchman," 1978.

S-27. QUOTED IN (except the last four lines, previously unpublished): Tono, "Jasper Johns in Tokyo," 1964 (translated into Japanese). Johns, "Sketchbook Notes," *Art and Literature*, 1965. Miyakawa, "Jasper Johns: His Words; The Idea of a Changing Focus," 1968.

EXCERPTED IN: Tono, "Jasper Johns: The Point 'According to What'?," 1968.

REPRODUCED IN: Tono, "About Leg, or Duchamp and Johns II," 1975.

S-28. QUOTED IN: Johns, "Sketchbook Notes," *Art and Literature*, 1965.

These notes do not appear in the photographs taken from Book A in 1964, which leads us to suppose that they were written between the time when those photographs were taken and the time when the book was lost by fire, with their publication in *Art and Literature* in the spring of 1965 providing a *terminus ante quem*. In that journal, the line "OCCUPATION— Take up the space with 'what you do'" (see item s-19) was included in this passage.

S-29. EXCERPTED IN: Johns, "Sketchbook Notes," *Juillard*, 1968–69.

S-30. Previously unpublished.

S-31. QUOTED IN: Johns, "Sketchbook Notes," *Juillard*, 1968–69. (We have been unable to locate these lines in Book B, but we assume they come from there, for this book is the source of all the other notes published in this issue of *Juillard*.) Tono, ed., "Jasper Johns: Sketchbook Notes," 1978 (translated into Japanese).

S-32. QUOTED IN: Johns, "Sketchbook Notes," *Juillard*, 1968–69. (As with item s-31, we assume these lines appear in Book B, although we have been unable to locate them there. We have also been unable to verify that both paragraphs fall on the same page.) Tono, ed., "Jasper Johns: Sketchbook Notes," 1978 (translated into Japanese).

S-33. Largely unpublished; two lines EXCERPTED IN: Johns, "Sketchbook Notes," *Juillard*, 1968–69.

S-34. QUOTED IN: Johns, "Sketchbook Notes," *Juillard*, 1968–69. Tono, ed., "Jasper Johns: Sketchbook Notes," 1978 (translated into Japanese).

S-35. QUOTED IN: Johns, "Sketchbook Notes," *Juillard*, 1968–69. Tono, ed., "Jasper Johns: Sketchbook Notes," 1978 (translated into Japanese).

S-36. QUOTED IN: Johns, "Sketchbook Notes," *Juillard*, 1968–69. Tono, ed., "Jasper Johns: Sketchbook Notes," 1978 (translated into Japanese).

S-37. QUOTED IN: Johns, "Sketchbook Notes," *Juillard*, 1968–69. Tono, ed., "Jasper Johns: Sketchbook Notes," 1978 (translated into Japanese).

S-38. QUOTED IN: Johns, "Sketchbook Notes," *Juillard*, 1968–69. Tono, ed., "Jasper Johns: Sketchbook Notes," 1978 (translated into Japanese).

S-39. EXCERPTED IN: Johns. "Sketchbook Notes," *Juillard*, 1968–69. Tono, ed., "Jasper Johns: Sketchbook Notes," 1978 (translated into Japanese).

S-40. Previously unpublished.

S-41. Previously unpublished.

S-42. Previously unpublished.

S-43. Previously unpublished.

S-44. REPRODUCED IN: *Artists' Sketchbooks*, 1991.

S-45. REPRODUCED IN: *Artists' Sketchbooks*, 1991.

S-46. Previously unpublished.

S-47. Previously unpublished.

S-48. Previously unpublished.

S-49. QUOTED IN: Johns, "Sketchbook Notes," *0 to 9*, 1969. Tono, ed., "Jasper Johns: Sketchbook Notes," 1978 (translated into Japanese).

S-50. QUOTED IN: Johns, "Sketchbook Notes," *0 to 9*, 1969. Tono, ed., "Jasper Johns: Sketchbook Notes," 1978 (translated into Japanese).

S-51. QUOTED IN: Johns, "Sketchbook Notes," *0 to 9*, 1969. Tono, ed., "Jasper Johns: Sketchbook Notes," 1978 (translated into Japanese).

S-52. QUOTED IN: Johns, "Sketchbook Notes," *0 to 9*, 1969. Tono, ed., "Jasper Johns: Sketchbook Notes," 1978 (translated into Japanese).

S-53. EXCERPTED IN: Johns, "Sketchbook Notes," *0 to 9*, 1969. Tono, ed., "Jasper Johns: Sketchbook Notes," 1978 (translated into Japanese). Johns, "*Neue Skizzenbuch-Notizen*," 1971 (translated into German).

S-54. QUOTED IN: Johns, "*Neue Skizzenbuch-Notizen*," 1971 (translated into German).

S-55. QUOTED IN: Johns, "Sketchbook Notes," *0 to 9*, 1969.

EXCERPTED IN: Tono, ed., "Jasper Johns: Sketchbook Notes," 1978 (translated into Japanese). Johns, "*Neue Skizzenbuch-Notizen*," 1971 (translated into German).

S-56. QUOTED IN (except last eight lines, previously unpublished): Johns, "Sketchbook Notes," *0 to 9*, 1969. (We have not located a few lines that appear in *0–9*: "A string with several ends./Sensibel pensel/Sensible pencil.") Tono, ed., "Jasper Johns: Sketchbook Notes," 1978 (translated into Japanese).

S-57. Largely unpublished; last three lines EXCERPTED IN: Johns, "*Neue Skizzenbuch-Notizen*," 1971 (translated into German).

S-58. Largely unpublished; first seven lines EXCERPTED IN: Johns, "*Neue Skizzenbuch-Notizen*," 1971 (translated into German).

S-59. Previously unpublished.

S-60. Largely unpublished; first six lines EXCERPTED IN: Johns, "*Neue Skizzenbuch-Notizen*," 1971 (translated into German).

S-61. QUOTED IN: Johns, "*Neue Skizzenbuch-Notizen*," 1971 (translated into German).

S-62. Previously unpublished.

S-63. Previously unpublished.

S-64. Previously unpublished.

S-65. Previously unpublished.

S-66. Previously unpublished.

S-67. Previously unpublished.

Interviews

I-1. Reprinted here by permission of Newsweek, Inc. © 1958. All rights reserved. REPRODUCED IN: Susan Brundage, ed., *Jasper Johns—35 Years—Leo Castelli* (New York: Harry N. Abrams, 1993), n.p.

I-2. Courtesy Time, Inc.

I-3. Reprinted here by permission of Louisiana State University Press © 1960.

I-4. Courtesy the *Milwaukee Journal*.

I-5. Courtesy *The State*. REPRODUCED IN: Susan Brundage, ed., *Jasper Johns—35 Years—Leo Castelli* (New York: Harry N. Abrams, 1993), n.p.

I-6. Courtesy Leo Steinberg. REPRINTED IN, in revised form: Leo Steinberg, *Jasper Johns* (New York: Wittenborn, 1963). Revised again in: Steinberg, "Jasper Johns: The First Seven Years of His Art," *Other Criteria: Confrontations with Twentieth-Century Art* (New York: Oxford University Press, 1972), pp. 17–54. REPRINTED IN: Susan Brundage, ed., *Jasper Johns—35 Years—Leo Castelli* (New York: Harry N. Abrams, 1993), n.p. This book also contains an explanatory note, "Back Talk from Leo Steinberg" (dated December 13, 1992), on how Steinberg "patched together," and Johns approved, the quotations of Johns in the essay. EXCERPTED IN: *Art 1963—A New Vocabulary* (Philadelphia: Arts Council of the YM/YWHA, 1962), n.p.

I-7. The text published on the record album in *The Popular Image*: courtesy Billy Klüver. The text published here for the first time: tape recording courtesy Billy Klüver. © Billy Klüver 1963, 1996.

A transcript of the interviews and a remastered cassette of the original record included in the catalogue *The Popular Image* has been published as "Record of Interviews with Artists Participating in the Popular Image Exhibition, The Washington Gallery of Modern Art (April 18–June 2, 1963), recorded and edited by Billy Klüver, March 1963," *On Record: 11 Artists 1963. Interviews with Billy Klüver* (New York: Experiments in Art and Technology, 1981), pp. 12–16 (© Billy Klüver 1981, 1993).

I-8. Courtesy the Estate of Lil Picard. Excerpted from a typescript in English in the Leo Castelli Gallery Archives, New York; translated from the German by Henry F. Odell. There is another typescript in English in the Lil Picard archives, New York.

I-9. © February 1964, *Artnews*; reprinted courtesy the publisher. REPRINTED IN: John Russell and Suzi Gablik, *Pop Art Redefined* (New York: Frederick A. Praeger, Inc., Publishers, 1969, and London: Thames and Hudson, 1969), pp. 82–83. Barbara Rose, ed., *Readings in American Art: 1900–1975* (New York: Frederick A. Praeger, Inc., Publishers, and New York: Holt, Rinehart and Winston, 1975), pp. 147–49. Barbaralee Diamonstein, ed., "The Art World: A Seventy-Five Year Treasury of Artnews," *Artnews* 76 no. 9 (November 1977): 170–72. Alberto Boatto, *Pop Art* (Bari: Laterza, 1983), pp. 207–11 (translated into Italian). Marco Livingstone, with Norman Rosenthal, *Pop Art* (London: Royal Academy of Arts, 1991), pp. 45–47, and in the French-Canadian edition of the same book, *Pop Art* (Montreal: Musée des Beaux-Arts, 1992), pp. 44–45 (translated into French). EXCERPTED IN: William C. Seitz, *São Paulo 9. Environment USA: 1957–1967/Meio-Natural USA: 1957–1967*, IX Biennial, Museum of Modern Art, São Paulo, Brazil (Washington D.C.: Smithsonian Institution Press, 1967), pp. 80–81 (in English and translated into Portuguese). *Art Since Mid-Century: The New Internationalism*, vol. 2: *Figurative Art* (Greenwich, Conn: New York Graphic Society, 1971), p. 325. Ellen H. Johnson, ed., *American Artists on Art, from 1940 to 1980* (New York: Harper & Row, 1982), pp. 89–92. Kristine Stiles and Peter Selz, eds., *Theories and Documents of Contemporary Art. A Sourcebook of Artists' Writings* (Berkeley: University of California Press, 1996), pp. 323–24.

I-10. Courtesy Yoshiaki Tono and Geijutsu Shincho, Tokyo. Translated from the Japanese by Tadatoshi Higashizono.

REPRINTED IN: Yoshiaki Tono, *Chatting with Artists* (Tokyo: Iwanami-Shoten, 1984), pp. 130–43 (in Japanese).

I-11. Courtesy Yoshiaki Tono and Bijutsu Shuppan-sha, Tokyo. Translated from the Japanese by Tadatoshi Higashizono.

REPRINTED IN: Yoshiaki Tono, *After Pollock* (Tokyo: Bijutsu Shuppan-sha, 1965), pp. 265–75 (in Japanese).

I-13. Courtesy Walter Hopps, and © *Artforum*, March 1965.

EXCERPTED IN: Marco Livingstone, with Norman Rosenthal, *Pop Art* (London: Royal Academy of Arts, 1991), p. 48, and in the French-Canadian edition of the same book, *Pop Art* (Montreal: Musée des Beaux-Arts, 1992), p. 46.

I-14. Courtesy David Sylvester and the Hayward Gallery (SBC).

REPRINTED IN: Sylvester, "*Entretien avec Jasper Johns*," *Artstudio* (Paris) no. 12 (Spring 1989), pp. 26–37 (translated into French). Edna Moshenson, *Jasper Johns: Prints from the Leo Castelli Collection* (Tel Aviv: Tel Aviv Museum, 1991) (translated into Hebrew).

EXCERPTED IN: Marco Livingstone, with Norman Rosenthal, *Pop Art* (London: Royal Academy of Arts, 1991), p. 48, and in the French-Canadian edition of the same book, *Pop Art* (Montreal: Musée des Beaux-Arts, 1992), p. 46.

The full interview will be published for the first time in a book of David Sylvester's interviews scheduled to be published by Chatto and Windus, London, and Jack Macrae Books/Henry Holt & Co., Inc., New York, in 1997.

I-15. Courtesy the *Charleston Post and Courier*.

I-16. Published by permission of Educational Broadcasting Corporation; courtesy Thirteen/WNET New York.

I-17. Courtesy *The New York Times*, © 1966.

REPRODUCED IN: Susan Brundage, ed., *Jasper Johns—35 Years—Leo Castelli* (New York: Harry N. Abrams, Inc., 1993), n.p.

I-18. Courtesy *Art in America*, Brant Publications, Inc., March–April 1966.

I-19. Reprinted here by permission of Newsweek, Inc. © 1968. All rights reserved.

I-20. Courtesy *Art International*.

I-21. Courtesy Mrs. Gunnar Jespersen, and *Berlingske Tidende*. Translated from the Danish by Scott de Francesco.

I-22. Reprinted here with permission from the *New York Post* © 1970, NYP Holdings, Inc.

I-23. Courtesy *The Print Collector's Newsletter*.

I-24. Copyright © March 1973, *Artnews*; reprinted here courtesy the publisher.

I-25. Transcribed from tape recording of original interview, in English, courtesy Mr. and Mrs. Tono, Tokyo. Published here in English for the first time, courtesy Yoshiaki Tono.

First published in: Tono, *Chatting with Artists* (Tokyo: Iwanami-Shoten, 1984), pp. 144–54 (translated into Japanese).

I-26. Courtesy James Klosty.

I-27. Courtesy Edmund White.

I-28. Courtesy Edmund White.

REPRINTED IN: *Ameryka* (United States Information Service) no. 264 (November 1978): 36-43 (translated into Russian).

I-29. Reprinted here by permission of Newsday, Inc., © 1977.

I-30. Typescript of interview courtesy David Bourdon. Published here for the first time, in an edited version, by permission of David Bourdon.

I-31. Courtesy *The New York Times* © 1977.

I-32. Reprinted here by permission of Newsweek, Inc. © 1977. All rights reserved.

I-33. Copyright *Artnews* © November 1977; reprinted here courtesy the publisher.

I-35. Courtesy *Heute Kunst/Flash Art*, Milan. Translated from the German by Ingeborg von Zitzewitz.

I-36. Courtesy *Art Monthly*.

I-37. Courtesy Anne-Marie Schweingruber-Geelhaar.

REPRINTED IN: Geelhaar, "Interview with Jasper Johns," *Jasper Johns Working Proofs* (London: Petersburg Press, 1980), pp. 37–56 and p. 35 (note 34). Geelhaar, "*Entrevista amb Jasper Johns*," *Jasper Johns: Proves de Treball*, exh. cat. (Barcelona: Obra Social de la Caixa de Pensions, 1980), pp. 37–56 (translated into Catalan). Geelhaar, *Jasper Johns*, exh. cat. (Copenhagen: Statens Museum for Kunst, 1980), n.p. (translated into Danish). Edna Moshenson, *Jasper Johns: Prints from the Leo Castelli Collection* (Tel Aviv: Tel Aviv Museum, 1991) (translated into Hebrew).

I-38. © *San Francisco Chronicle*. Reprinted here by permission.

I-39. Reprinted here courtesy Roberta Bernstein and New York Literary Forum.

EXCERPTED IN: Fred Orton, *Figuring Jasper Johns* (London: Reaktion Books Ltd., 1994), p. 46.

I-40. © 1980 Katrina Martin.

REPRINTED IN: Martin, "*Entretien avec Jasper Johns sur la sérigraphie*," *Jasper Johns: symboles—impressions* (Montreal: Musée des Beaux-Arts, 1990), pp. 14–18 (translated into French). Martin, "Interview about Silkscreens," in Vincent Baudoux, Kathleen Slavin, and Martin, *Jasper Johns: Prints from the Leo Castelli Collection* (Brussels: Galerie Isy Brachot, 1991) (in English and translated into Dutch and French).

Excerpts of this interview were used for the soundtrack of the film *Hanafuda/Jasper Johns*, 1981 (35 minutes, 16 mm., color); produced and directed by Katrina Martin. The film, made over the course of two years and completed in autumn 1981, shows Johns at work on four screenprints (including *Cicada*, 1979, and *Usuyuki*, 1980) at Simca Print Artists, New York. See "Starring Jasper Johns," *The Print Collector's Newsletter* 12 no. 6 (January–February 1982): 178.

I-41. Courtesy Riki Simons. Translated from the Dutch by Christel Hollevoet.

I-42. Courtesy Mimi Thompson and April Bernard.

REPRODUCED IN: Susan Brundage, ed., *Jasper Johns—35 Years—Leo Castelli* (New York: Harry N. Abrams, Inc., 1993), n.p.

I-43. Courtesy *Art Press*. Translated from the French by Christel Hollevoet.

I-44. Reprinted here by permission of Gerald Marzorati.

I-45. Courtesy Deborah Solomon.

I-46. Published here for the first time by permission of WHYY, Philadelphia.

I-47. Courtesy *The Philadelphia Inquirer*.

I-48. Reprinted here by permission of Newsday, Inc., ©1988.

I-49. Courtesy Ann Hindry.

I-50. Courtesy David Vaughan.

There is an earlier edition of *Dancers on a Plane*, published by the Anthony d'Offay Gallery, London, in 1989, as an exhibition catalogue; Vaughan's interview does not appear there. It did appear, however, in an edited, shorter version, as: "The Art of Friendship: Jasper Johns Talks to David Vaughan," *Sunday Times Magazine* (London), October 29, 1989, p. 95.

REPRINTED IN: Vaughan, "*Jasper Johns interrogé sur son amitié et ses collaborations avec Merce Cunningham et John Cage*," *Mouvement* no. 1

new series (October-November-December 1995): 13-15 (translated into French, and abridged).

I-51. Copyright © 1989 by Dodie Kazanjian, reprinted here with the permission of The Wylie Agency, Inc.

I-52. Transcribed here by permission of Peter Namuth and Judith Wechsler; © Hans Namuth and Judith Wechsler Inc. There is another typed transcription, produced by the Museum of Fine Arts, Houston, in the Leo Castelli Gallery Archives.

I-53. Courtesy Jo Ann Lewis and the *Washington Post*.

I-54. REPRINTED IN: Paul Clemente (*sic*), "*Jasper Johns, habla el artista*," *Reverso* (Bilbao) no. 2 (Summer–Autumn 1990): 57–59, 61–63, 65–67, 69 (translated into Spanish).

I-55. Courtesy *Interview*, Brant Publications, Inc., July 1990.

REPRINTED IN: Paul Taylor, "*Ein Ami Zeigt Flagge*," *Zeit Magazin* no. 44 (October 26, 1990): 104–14 (translated into German). Taylor, "*Paul Taylor im Gespräch mit Jasper Johns*," *Künstler. Kritisches Lexikon der Gegenwartskunst* (Münich) no. 25 (1994): 14–15 (translated into German). Issue dedicated to Johns.

EXCERPTED IN: Fred Orton, *Figuring Jasper Johns* (London: Reaktion Books Ltd., 1994), pp. 104–6.

I-56. Courtesy *Vogue* Paris © September 1990.

I-57. Courtesy Michael Pye.

I-58. Courtesy *The Guardian*.

I-59. Courtesy *The Times*.

I-60. Courtesy *Time Out London*.

I-61. Tape recording of interview, previously unpublished, courtesy Amei Wallach © 1996. The article Wallach based on this interview, "Jasper Johns and His Visual Guessing Games," *New York Newsday*, February 28, 1991, pt. II, pp. 57, 64–65, is REPRODUCED IN: Susan Brundage, ed., *Jasper Johns–35 Years–Leo Castelli* (New York: Harry N. Abrams, 1993), n.p.

I-62. Typescript, published here for the first time, courtesy Billy Klüver and Julie Martin © 1996.

I-64. Reprinted here by permission of Harry N. Abrams, Inc., New York. All rights reserved.

I-65. © *Artnews* Summer 1993; reprinted here courtesy of the publisher.

I-66. Courtesy *Tate: The Art Magazine*.

I-67. Courtesy Barbaralee Diamonstein Spielvogel.

Additional Sources

A number of additional interviews and statements by the artist, not included in the present volume, are listed here in chronological order.

"Pictures from Modern Masters to Aid Music and Dance," *Artnews* 61 no. 10 (February 1963): 44. Statement by Johns on the Foundation for Contemporary Performance Arts. Published on the occasion of a group show, at the Allan Stone Gallery, of works donated by artists to raise funds for the Foundation for Contemporary Performance Arts. Johns, a cofounder of the Foundation, participated in the show and was its primary organizer.
QUOTED IN: L.J., "Paintings for Sale: Profits for Performers," *Dance Magazine* 37 no. 3 (March 1963): 44.

"Artists for Artists," *The New Yorker*, March 9, 1963, pp. 32–34. A statement by Johns on the same topic as "Pictures from Modern Masters...."

Calvin Tomkins, in: *Leo Castelli: Ten Years* (New York: Leo Castelli Gallery, 1967), n.p.

Joseph E. Young, "Jasper Johns Lead-Relief Prints," *Artist's Proof* (New York) vol. 10 (1970): 36–38.

Painters Painting, 1972 (color and black and white film in 16 mm, 116 minutes). Directed and produced by Emile de Antonio, with Mary Lampson. Produced by Turin Film Corporation.
A transcription of the soundtrack has been published as: Emile de Antonio and Mitch Tuchman, *Painters Painting: A Candid History of the Modern Art Scene 1940–1970* (New York: Abbeville Press, 1984), pp. 86–87, 96–100, 102.

Works in Series: Johns, Stella, Warhol, 1972 (color film in 16 mm film, 30 minutes). Directed by Barbara Rose. Produced by Blackwood Productions, Inc.

Calvin Tomkins, "Profiles: The Moods of a Stone—Tatyana Grosman," *The New Yorker*, June 7, 1976, pp. 65–66.

Roberta Bernstein, "Johns & Beckett: Foirades/ Fizzles," *The Print Collector's Newsletter* 7 no. 5 (November–December 1976): 141–45.

Michael Crichton, *Jasper Johns* (New York: Harry N. Abrams, Inc., in conjunction with the Whitney Museum of American Art, 1977 and, in a revised and expanded edition, 1994). Quotations from interviews with Johns in 1976 and, in the later edition, in 1991–92.
EXCERPTED IN: Crichton, "Surface Tension," *New York Magazine*, September 19, 1977, p. 64. Crichton, "Jasper Johns: The Artist and The Man," *Sky* (Delta Airlines) 7 no. 2 (February 1978): 54–61. Crichton, "Jasper Johns: Adventures in Paradox," *California Magazine* (Pacific Southwest Airlines) 13 no. 10 (October 1978): 78–83. Crichton, "Art in the Can," *Sunday Times Magazine* (London), May 22, 1994, pp. 5, 18–29.

Jerry Tallmer, "A Broom and a Cup and Paint," *New York Post*, October 15, 1977, p. 20. Published on the occasion of Johns's retrospective at the Whitney Museum of American Art, New York.

Joan Rubin, "Retrospective: Jasper Johns at the Whitney," *Lofty Times* (New York) no. 5 (November 1, 1977): 22. Published on the occasion of Johns's retrospective at the Whitney Museum of American Art, New York.

Philip Smith, "Jasper Johns," *Interview* 7 no. 12 (December 1977): 36–37. Published on the occasion of Johns's retrospective at the Whitney Museum of American Art, New York.

Interview by Yoshiaki Tono, conducted, in English, on August 22, 1978, at the Hotel Okura, Tokyo, on the occasion of the exhibition of Johns's 1977 Whitney Museum of American Art retrospective in its Tokyo venue, the Seibu Museum of Art (now Sezon Museum of Art). There is a transcript of the interview in Johns's archives.
PUBLISHED IN: Tono, "Painting Records a Concept," *Sekai* (Tokyo), December 1978, pp. 126–44 (translated into Japanese).
REPRINTED IN: Tono, *Jasper Johns And/Or* (Tokyo: Bijutsu Shuppan-sha, 1979), pp. 187–208. Tono, *Jasper Johns—A Source for American Art* (Tokyo: Bijutsu Shuppan-sha, 1986) (both translated into Japanese).

Morris Gay, "A Major Modern Artist Who Puts Ideas into Action," *Palo Alto Times*, October 23, 1978, section II, p. 11. Published to coincide with the exhibition of Johns's 1977 Whitney Museum of American Art retrospective in its San Francisco venue, the San Francisco Museum of Art.

Joseph McLellan and Carla Hall, "Living Portraits," *The Washington Post*, February 23, 1979, pp. B1, B3. Artist's statements about their video portraits at the 36th Corcoran Biennial.

"Personalities," *The Washington Post*, February 24, 1979, p. C3. On a tea at the home of Vice-President Walter Mondale on the occasion of the Corcoran Biennial.

Tatyana Grosman: A Life with Painters and Poets, 1980 (color film in 16 mm, 29 minutes). Directed and produced by Barbara Rose. Barbara Rose Productions.

Whitney press release # 465, September 26, 1980. Johns discusses the creation of *Three Flags* after the Whitney's acquisition of the painting in the fall of 1980.

"Quotation of the Day," *New York Times*, September 27, 1980, p. L25. A statement by Johns on the Whitney's acquisition of *Three Flags* in the fall of 1980.
 QUOTED IN: Alexandra Anderson, "From the Horse's Mouth," *Portfolio* 3 no. 1 (January–February 1981): 8 (expanded by the addition of one sentence). Marian Marsh, "Artist with Sumter Ties Hailed as Generation's Best," *The Sumter Daily Item* August 19, 1982, p. 1B.

Claudia Wallis, "People," *Time Magazine*, October 13, 1980, p. 109. On the Whitney's acquisition of *Three Flags* in the fall of 1980.

Grace Glueck, "The Artists' Artists," *Artnews* 81 no. 9 (November 1982): 94–95. Artists are asked to choose colleagues who deserve more recognition.

Richard Francis, *Jasper Johns* (New York: Abbeville Press, 1984), pp. 17, 98. Excerpts from an interview with Johns conducted in November 1982. Also published as Francis, *Jasper Johns* (Tokyo: Bijutsu Shuppan-sha, and New York: Abbeville Press/Modern Masters Series, 1990) (translated into Japanese by Yoshiaki Tono and Tetsuo Iwasa).

David Shapiro, *Jasper Johns Drawings 1954–1984* (New York: Harry N. Abrams, Inc., 1984), notes 14, 18, 31, 69, 70.

The Tate Gallery Illustrated Catalogue of Acquisitions 1980–82 (London: The Tate Gallery, 1984), 145–46. Statement by Johns on the Tate's acquisition of his painting *Dancers on a Plane*, 1980–81.

Jennifer Allen, "Jasper Johns' Beautiful Banalities," *New York Magazine* vol. 17 (February 20, 1984): 32. Published on the occasion of the exhibition "Jasper Johns: Paintings," at the Leo Castelli Gallery.

Leslie Bennetts, "Modern Art Museum Is on Display and a Week of Celebration Begins," *New York Times*, May 8, 1984, pp. B1, B4. On the reopening of The Museum of Modern Art, New York, after an expansion of its space.

Roberta Bernstein, *Jasper Johns' Paintings and Sculptures, 1954–1974: "The Changing Focus of the Eye"* (Ann Arbor: UMI Reseach Press, 1985). Refers to her conversations with Johns.

Esther Sparks, *Universal Limited Art Editions. A History and Catalogue: The First Twenty-Five Years* (Chicago: The Art Institute of Chicago, and New York: Harry N. Abrams, Inc., 1989), pp. 122–47 (see p. 147, note 2, and p. 15, note 34). Interviews with Sparks on October 17, 1985, and with Amei Wallach, on September 10, 1985.

Joanne Mattera, "Jasper Johns: From Pop to MoMA," *Women's Wear Daily*, June 3, 1986, p. 24; August 11–18, 1986, pp. 18–19; and July 21–27, 1992, p. 150.

Mark Rosenthal, *Jasper Johns: Work since 1974* (Philadelphia: Philadelphia Museum of Art, 1988). Quotes from interviews with Johns in August, September, October, November, and December 1987, and in January and June 1988.

Irene Vischer-Honegger, "*Ich bringe nichts mehr in meinen Kopf,*" *Bilanz* (Zürich), June 1988, pp. 94–96. Interview with Johns (translated into German).

John Yau, "Jasper Johns. Proofs Positive: The Master Works," *Artnews* 87 no. 7 (September 1988): 104–6. A day at Maurice Payne's print studio.

Amei Wallach, "Jasper Johns: On Target," *Elle*, November 1988, pp. 152, 154, 156. On the occasion of the exhibition "Jasper Johns, Bruce Nauman, David Salle," at the Leo Castelli Gallery, New York.

Charles A. Twardy, "Jasper Johns: Artist's Works Come Home for a Visit," *The State* (Columbia, S.C.), April 23, 1989, pp. 1F–2F. Excerpts from a letter from Johns responding to questions sent by *The State*, on the occasion of an exhibition of Johns's at the University of South Carolina's McKissick Museum.

Ruth E. Fine and Nan Rosenthal, "Interview with Jasper Johns" (June 22, 1989), in Nan Rosenthal and Ruth E. Fine, *The Drawings of Jasper Johns* (Washington, D.C.: National Gallery of Art, and New York: Thames & Hudson, 1990), pp. 69–83.

Cage/Cunningham, 1991 (color film in 16 mm., 95 minutes). Directed by Elliot Caplan. Produced by Cunningham Dance Foundation/La Sept.

Marjorie Welish, "When Is a Door Not a Door?" *Art Journal* (New York) 50 no. 1 (Spring 1991): 48–51. Interview conducted on February 22, 1990.

Jeremy Gilbert-Rolfe, *Jasper Johns, Brice Marden, Terry Winters: Drawings*, exh. cat. (Los Angeles: Margo Leavin Gallery, 1992), pp. 5–12.

Interview conducted by Sharon Zane, The Museum of Modern Art Oral History Project, August 23, 1994. Transcript in The Museum of Modern Art Archives, New York.

Robert Saltonstall Mattison, *Masterworks in the Robert and Jane Meyerhoff Collection* (New York: Hudson Hills Press, 1995), pp. 17–48. Interview conducted January 18, 1993, and statements made to Jane Meyerhoff and communicated to Mattison, January 20, May 12, and October 13, 1993.

Acknowledgments

KIRK VARNEDOE

When I first formed a conception of the accompanying publication for the exhibition "Jasper Johns: A Retrospective" at The Museum of Modern Art (October 20, 1996–January 21, 1997), I believed it would be important to include in that book a selection of Johns's written or recorded verbal statements about his life and art. When we surveyed the body of possible texts, however, it became clear that the volume of worthy material was too large to include, even in narrowly selected form, in the catalogue. At that point we conceived the idea of a separate, companion volume, aimed primarily for a *reading* audience. I am very grateful to Osa Brown, Director of the Museum's Publications Department, for supporting this added project, and I offer my warmest thanks to Emily Fisher Landau, who, on hearing the proposal, immediately and enthusiastically agreed to provide the financial support necessary to produce both the illustrated catalogue and the present volume of readings.

The great majority of the work needed to realize this anthology was done by Christel Hollevoet. For two years she tirelessly pursued every lead, tracked down every obscure reference, and ferreted out every unpublished manuscript, tape recording, or film script. Her scrupulous devotion to the task, and her inventive resourcefulness in pursuing it, have been exemplary, and a point of inspiration for myself and others involved in the various other projects related to the retrospective exhibition. She also organized and supervised the coordination with foreign researchers, translators, and other collaborators that her complex challenge required. For their help in her work, Christel joins me in thanking Laura Christian, Géraldine Dennys, Alan Duffy, Scott de Francesco, Jean-Noël Herlin, Tadatoshi Higashizono, Yasuko Higashizono, Seiji Morimoto, Makiko Ushiba, and Ingeborg von Zitzewitz.

We are also appreciative of the help and cooperation of the many writers and filmmakers who initially brought the interviews published here into being. Virtually without exception, they were supportive of our endeavor, patient with our requests, and willing to allow us to print and edit their work gratis or for only a nominal fee, in order to keep the book's price within reach of a broad public. We would like to express our special gratitude to Peter Namuth, Judith Wechsler, WHYY, and EBC, for enabling us to print dialogues excerpted from films, and to Yoshiaki and Akyo Tono, Billy Klüver and Julie Martin, David Bourdon, and Amei Wallach, for contributing unpublished material. We also extend our appreciation to the photographers whose portraits of the artist are included in this book.

The textual editing of the book has been the work of Stephen Robert Frankel. This has been an extensive and exacting labor, requiring maddening precision with regard to detail and broad good judgment in regard to larger issues of content.

He has handled all the complexities of ordering, coordination, and revision of the many texts with a carefully focused attention and an enthusiasm for which I have been very grateful. In the final corrections and checking of the manuscript, Lilian Tone, the Curatorial Assistant working with me on the Johns exhibition, also took time from her many other responsibilities to contribute an invaluable labor of attentive copy-editing. David Frankel, despite the heavy demands of his role as editor of the larger illustrated catalogue, *Jasper Johns: A Retrospective*, also somehow found the time to oversee and help coordinate the work on this anthology. Similarly Bethany Johns, who designed that catalogue, has also somehow found the additional energies and aesthetic clarity to give this book its handsome layout, with important contributions from Kathleen Oginski. We also benefited from Cynthia Ehrhardt's patience and dedication in the book's production.

As with all other matters relating to Johns's studio, the artist's assistant Sarah Taggart has been a patient and tremendously helpful collaborator in this project. I am finally most grateful to Jasper Johns himself, especially for allowing me to study his sketchbooks and to select for publication the several excerpts and illustrations that appear here for the first time.

Index

Trustees of The Museum of Modern Art